THE FROZEN WORLD

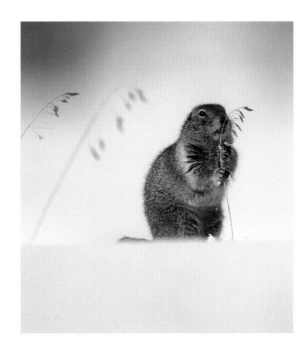

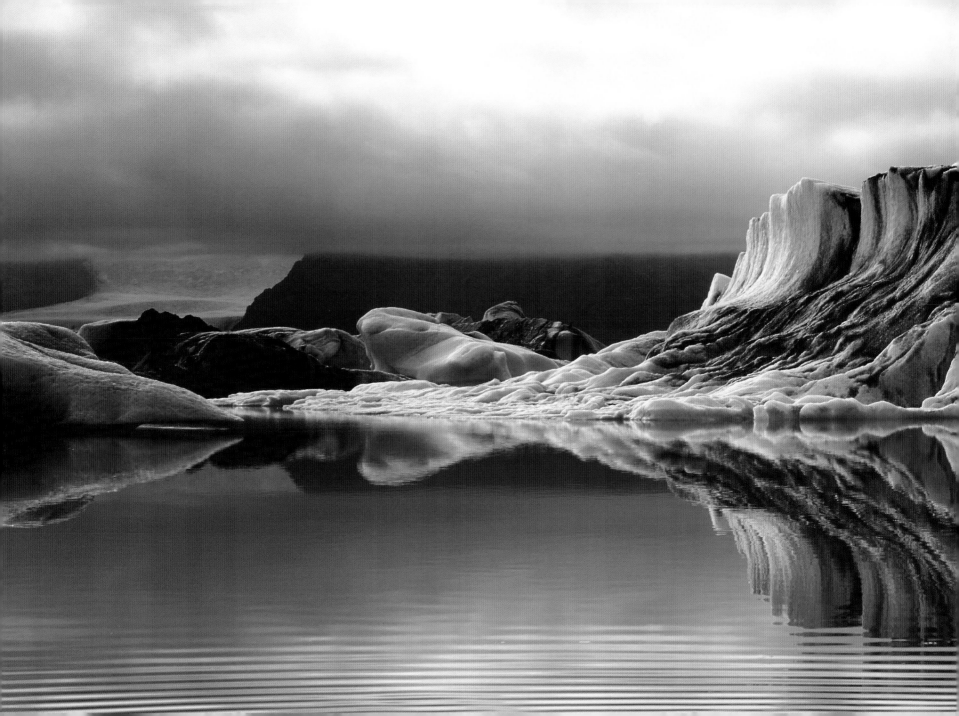

THE FROZEN WORLD

Patrick Hook

CHARTWELL
BOOKS, INC.

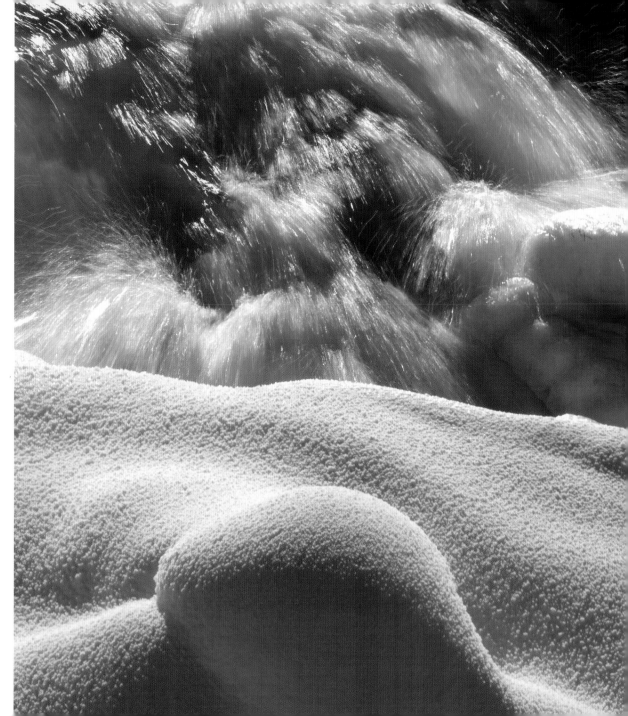

CHARTWELL BOOKS, INC.
A Division of
BOOK SALES, INC.
114 Northfield Avenue
Edison, New Jersey 08837

ISBN -13: 978-0-7858-2241-7
ISBN-10: 0-7858-2241-0

Designer: Danny Gillespie

Maps: Mark Franklin

Color reproduction: anorax

Printed and bound in China

PAGE 1: Arctic ground squirrel eating grass seed: surviving in the frozen world is all about food supplies.

PAGES 2–3: The serene beauty of the frozen world is best exemplified by the colors and shapes of icebergs.

RIGHT: In the subarctic, rivers supply an important source of food and life becomes especially grim when it's cold enough for them to freeze.

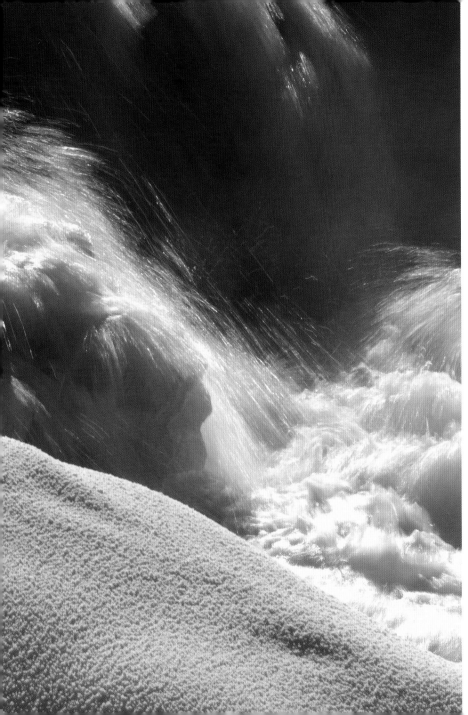

CONTENTS

INTRODUCTION

This book is one of four volumes that examine the last remaining wild places in the world. Although the planet's human population is expanding at an incredible rate, fortunately, there are still vast areas where few people venture. These can be subdivided into four main categories:

- Deserts—places that are dry and very hot, and have little to no vegetation.
- Rainforests—places that are wet and very hot, and have large amounts of lush vegetation.
- Oceans—open waters that cover most of the world's surface.
- Rrozen World—Polar caps and other "frozen" habitats—places that are very cold for much or all of the year.

This volume presents the last of the categories listed above. It breaks the subject down into:

- The Arctic and Subarctic regions
- The Antarctic and Sub-Antarctic regions
- Non-Polar Alpine regions

Although the three regions are often far from each other, they share several characteristics, including the extreme environments they can exhibit. The low temperatures and high winds that are experienced in all these areas make them harsh places for humans to survive. There is usually little or no food to be found, and finding adequate shelter can be very difficult. Even in the milder places life can be very hard. As a result, most of the frozen places of the world are largely unpopulated—many are, however, still being badly damaged by human activity. The main threat to these regions is global warming—rising temperatures are causing vast areas of ice and snow to melt. This not only deprives many animals and plants of places to live, it also changes global weather patterns and raises sea levels, causing widespread flooding. As with so many other things, however, the scientists do not agree about exactly what is going on.

One of the biggest problems that mankind faces if global warming continues is that most of the ice held in the glaciers of the polar caps and the alpine regions of the world will melt. This will cause a significant rise in sea level, and it will dilute the sea's salinity, as well as change the temperature of the oceans. Not only will this mean that vast areas of land will be permanently flooded, it will certainly have a major impact on global weather systems. This is likely to generate climate changes that will seriously affect how humans live the world over.

Glaciers, which cover about 10 percent of the world's surface, are large bodies of ice that have become heavy enough to start flowing. If the ice is not very thick, the pressures generated are low, and progress can be very slow—it can take years for any noticeable movement to have occurred. In other places, however, they can move

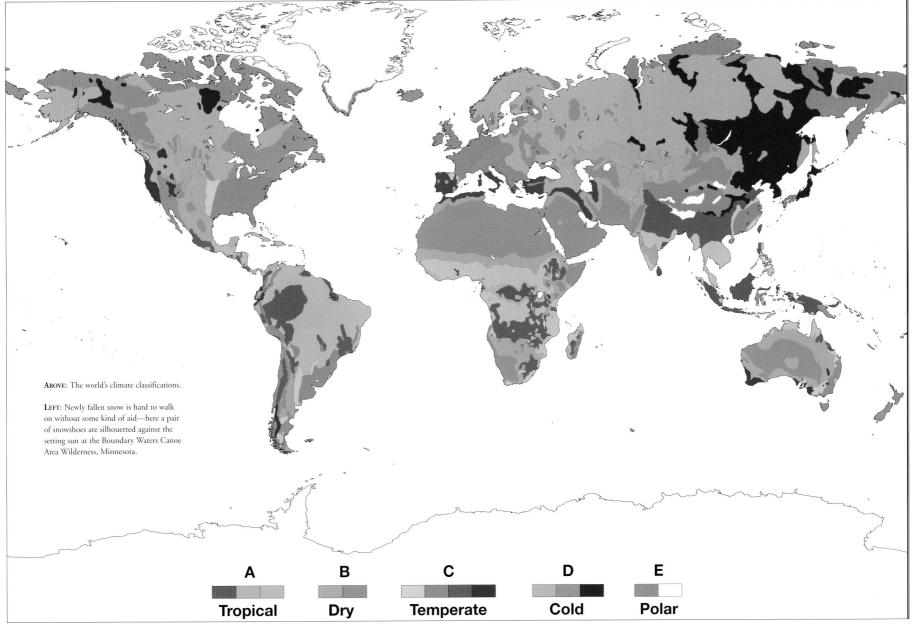

ABOVE: The world's climate classifications.

LEFT: Newly fallen snow is hard to walk on without some kind of aid—here a pair of snowshoes are silhouetted against the setting sun at the Boundary Waters Canoe Area Wilderness, Minnesota.

A	B	C	D	E
Tropical	**Dry**	**Temperate**	**Cold**	**Polar**

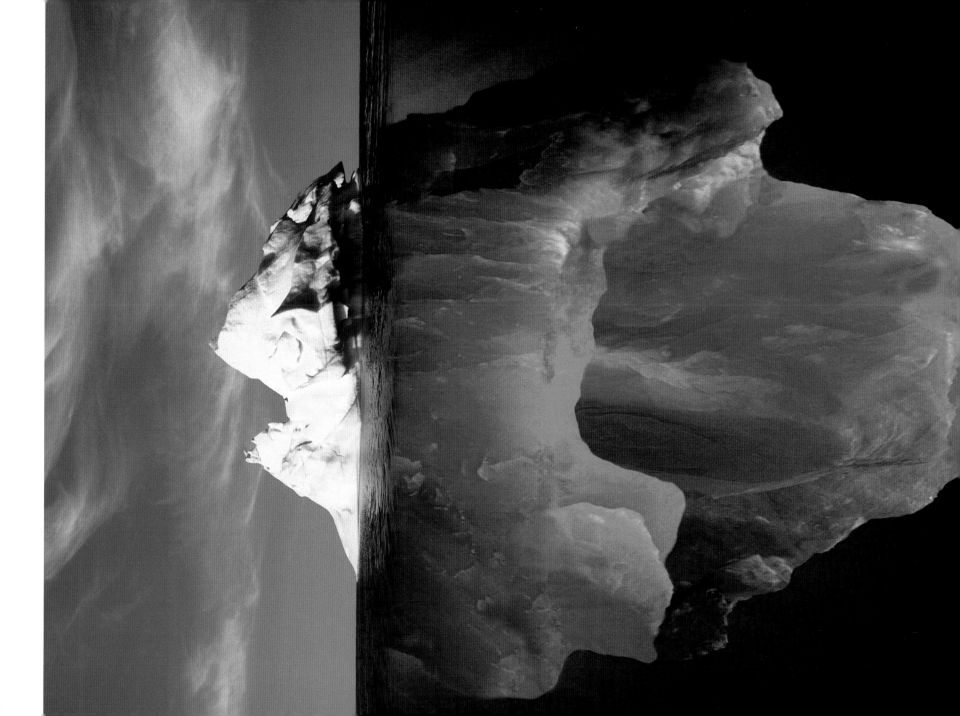

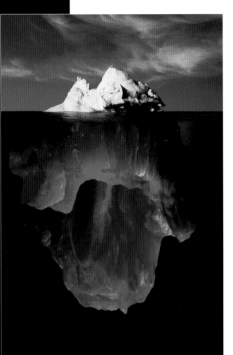

at up to several meters per day. They start to form when temperatures are low enough for snow and ice to accumulate in permanent layers. Usually a certain amount of the fallen snow melts in the warmth of the summer sun; however, each winter more snow is added and the layers get increasingly thicker.

Since snow has an intricate crystalline microstructure, a lot of air gets trapped within it. Consequently, it is not nearly dense enough in its natural state to become solid ice. If snow is left alone in a cold enough environment, it will remain more or less as it fell, with a density of between 50 and 300 kilograms per square meter. As additional snow falls, however, the crystals get compressed, and some melt. This is the start of a complicated process that sees the formation of ice crystals called "firn." These have a much higher density of around 500 kilograms per square meter. When there are enough layers of firn, the lower ones get compressed into solid "blue" ice, which has a density of around 900 kilograms per square meter. The process of converting powdered snow into solid ice can be quite fast if the environmental conditions are right—sometimes it can take place in as little as five years. On the other hand though, it can also take a very long time—up to three thousand years.

If the ice becomes thick enough, a glacier starts to form; however, it will not actually start to move until it is around 50 meters thick. This is because it needs to be subjected to enormous pressures to cause it to flow, a process known as "plastic deformation." In fact, if there is sufficient pressure, a glacier can even flow uphill. Since ice is not given to flowing, it tends to crack instead, especially when there is a rapid change in gradient or direction. These cracks then propagate through the glacier, and often form large crevasses. When fresh snow falls it can easily cover them up, which makes them extremely dangerous to mountaineers and explorers.

Where the ground temperature is low enough, the ice freezes to the underlying bedrock, which anchors the ice to it, so the lowest layers often do not move at all. Instead, the layers above slide over them, with each corresponding strata moving slighter faster than the one below. It is therefore the surface layers that move the fastest. These are known as "cold glaciers."

A "warm glacier" is one where the friction caused by the combination of movement and the sheer weight of ice generates enough heat to melt the lowest layers. There is a corresponding increase in the amount of movement all the way up through the ice, and so warm glaciers move much faster than cold ones. If there is a lot of meltwater flowing at the interface between the ground and the ice, it tends to acts as a lubricant, and so the speed increases further.

The area where new ice is being created is known as the "source," and if this is sufficient, the glacier will become a permanent feature. When the rate of addition is greater than the rate at which it melts, it will start advancing across the landscape—the frontal part is called the "snout." If the local environment warms up too much, however, the glacier will either become stationary or will start reced-

ing. The way that a glacier melts or loses pieces is known as "wastage" or "ablation," and when large parts break away entirely as a result of meeting a river or the sea, the process is known as "calving." Icebergs are formed when especially large areas of glaciers break away and fall into the sea. As the world continues to warm up, the future for glaciers—and therefore mankind—is far from certain.

That global warming is happening is not in doubt—it is the causes that are still being contested vigorously. In some cases, there are political agendas behind the arguments. However, to understand the issues, it is best to examine the facts. The first concept to look at is what is known as the "greenhouse effect." This is where the amount of heat reaching the Earth exceeds the amount that is lost to outer space. The phenomenon is caused by the insulating effect of the atmosphere, which when unpolluted allows as much heat out as it lets in. With the addition of certain gases, however, the balance is lost, and as a result, the planet gradually heats up.

The warming effect of the atmosphere is necessary for life to exist—it keeps the planet 33ºC hotter than it would be without it. The changes have been brought about by a change in the atmosphere's chemical composition. The pollutants that have caused the problem are referred to as greenhouse gases, and include water vapor, carbon dioxide, methane, and various forms of nitric oxide.

The change in temperature is imperceptible to most of us because the enormous masses of the land and oceans combine to absorb the extra heat. Scientists, however, can measure the changes very accurately. Figures from the National Academy of Sciences indicate that the surface of the Earth has increased in temperature by about 10°F over the past one hundred years, during which time global sea levels have risen by between 4 and 8 inches. The rate of change, however, has increased significantly over the last two decades. The hottest year on record was 1998, and the ten warmest years of the 20th century all occurred between 1985 and 1999. While this is bad enough, the situation near the poles is much worse. Over the past 30 years, winter temperatures in parts of Europe, Asia, and Alaska have increased by nearly 10°F. The blame for this is being laid at the feet of mankind, and is thought to be due to wide-scale industrialization and the consumption of fossil fuels.

It has been calculated that since the industrial revolution began, the amount of carbon dioxide in the atmosphere has increased by almost 30 percent, that there is twice as much methane, and that nitric oxides have risen by about 15 percent. It is thought that most of these increases have been the direct result of burning fossil fuels, including oil, coal, and gas. Some pollutants have the opposite effect of the greenhouse gases, however, and reflect the sun's heat back into outer space. These include small droplets of airborne materials known as aerosols, of which sulphates are an example.

The overall scene is extremely complicated though. The world's climate has varied considerably over the past millennia, and the many components that influence the global picture have gone through a

series of cycles, many of which are superimposed over each other. The processes of the decomposition of natural organic matter and plant respiration actually release about ten times more carbon dioxide than is produced by mankind's activities. Over the course of time, nature managed to establish an equilibrium where the fauna and flora of the lands and oceans absorbed these natural emissions.

Recent industrialization has upset this balance though—it has been shown that in 1997, the United States was responsible for the emission of about one-fifth of the total output of global greenhouse gases. Domestic and commercial activities were responsible for around 98 percent of the carbon dioxide, along with 24 percent of the methane emissions and 18 percent of the nitric oxide emissions. Further contributions were made by intensive agricultural practices, as well as deforestation, landfill sites, industrial production, and mining.

There are many different predictions as to what is likely to happen over the next one hundred years or so. Some calculations show that the average global surface temperature could rise between 2.2 and 10°F (1.4–5.8°C). If this happened, it would not be equally distributed across the world, and so in some areas the changes would be much worse. It is thought that sea levels along the coast of the United States could rise by as much as two feet.

Scientists working at both the North and South poles have been monitoring the ozone layer—which filters out ultra-violet radiation from the sun—for many years now. As the amount of certain pollutants in the atmosphere increases, so the layer at each pole gets thinner. This allows more of the sun's potentially harmful radiation through. It is not known what the long-term effects of this will be on the wildlife of the regions.

A further problem that arises out of increases in global temperatures is that the permafrosts are thawing out. If this continues, it will destroy the ecosystems of large areas of tundra, which will be a major catastrophe. For many years now environmentalists have been putting pressure on governments in an attempt to influence their decisions. These actions have not been restricted to the west, however. In Russia pressure exerted by local people brought about the cancellation of a large hydroelectric project in the Chukchi Autonomous Okrug and held back expansion of a gas development on the Yamal Peninsula in northwest Siberia.

There are many natural resources to be found in the wild areas around the poles, including vast deposits of aluminum, gas, coal, zinc, silver, and other valuable commercial commodities. All these are attracting attention from companies wanting to exploit them. The most significant by far though, is oil. This has become increasingly valuable

RIGHT: The landscape in mountainous areas can often be visually stunning—here the moon rises against mountains lit by the glow from a dramatic sunset.

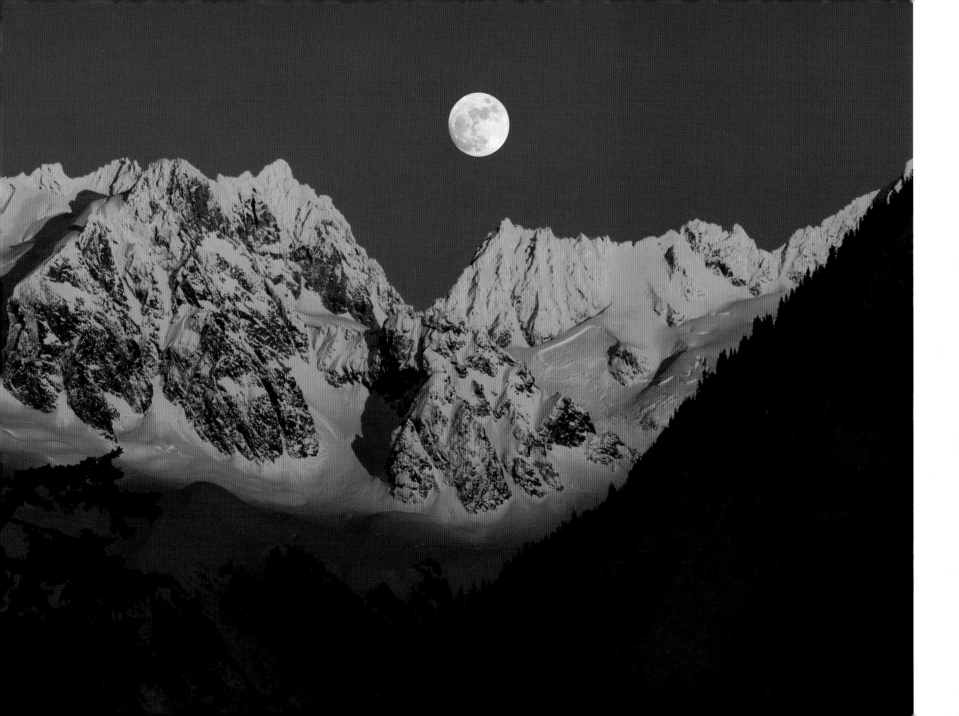

due to massive rises in global fuel prices in recent years, and as a result more and more is being spent on prospecting for it. Reserves that were previously too remote or difficult to extract are now economically viable. The root cause of the extra demand is the simple fact that there are now more customers than ever before. While the western world has maintained its love affair with motorized transport, countries which previously had few vehicles per capita have started to catch up. The biggest contributors to this new market are China and India, whose enormous populations are switching from bicycles to cheap cars.

This is not the whole story, however, because there is also an important political dimension to the search for oil. With much of the world's supply located in the Middle East, a few small countries are effectively able to control a large proportion of the world's economy. This is a recipe for global instability, and has already been responsible for wars starting. In an attempt to reduce the reliance on the vagaries of local politics in the Middle East, prospectors have been given licenses to search in areas that were previously too environmentally sensitive.

Over the last few decades the oil companies did themselves no favors, often displaying a totally reckless attitude toward the environment. In Alaska, for instance, there was outrage when widespread ecological destruction was exposed at the Prudhoe Bay oil development. This, the largest oilfield in North America, was very badly managed for years, and when it was discovered that millions of gallons of oil industry waste had been wantonly dumped in open pits the public was incensed. On top of this it was found that thousands of acres of valuable wildlife habitat had been destroyed. Since then the oil industry has been under a spotlight, and it has made huge efforts to clean up its act. Oil prospectors have recently found new deposits just off the coast of the Arctic National Wildlife Refuge in northeast Alaska, and this has raised furious debate about what should, or should not, be permitted there.

While the debate goes on, the situation continues to get worse. Recent summer visitors traveling to the North Pole by ship have been surprised to find that where once there was ice between six and nine feet thick, there is now a patch of water about a mile wide. Scientists believe that the last time the pole melted was more

RIGHT: When crevasses are visible, they need not present much danger; however, when they are hidden by snow or bad weather, they can be lethal.

FAR RIGHT: In some parts of the world frozen landscapes exist right alongside arid deserts—here snowy mountains rise above the Gobi Desert, Mongolia.

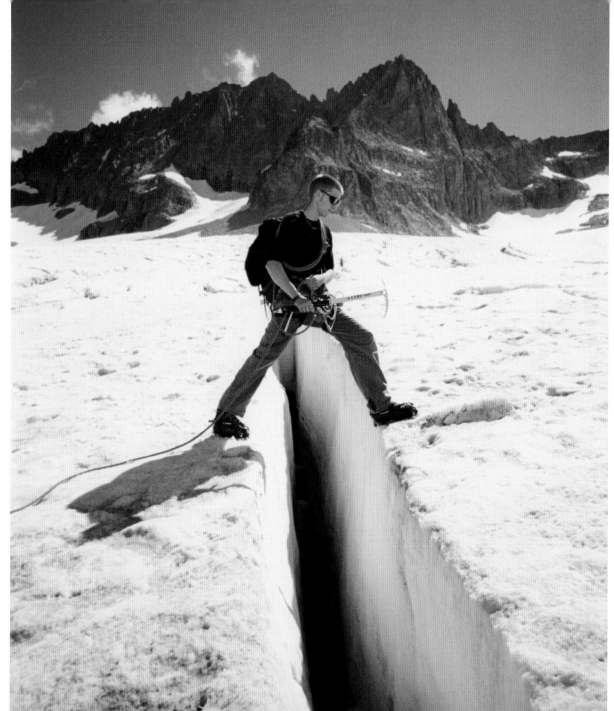

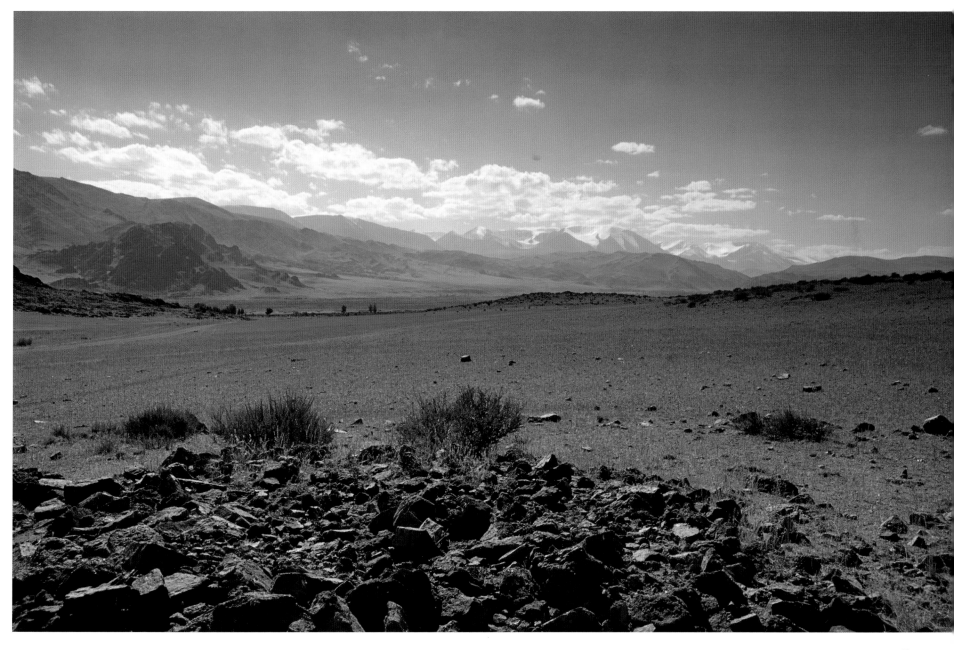

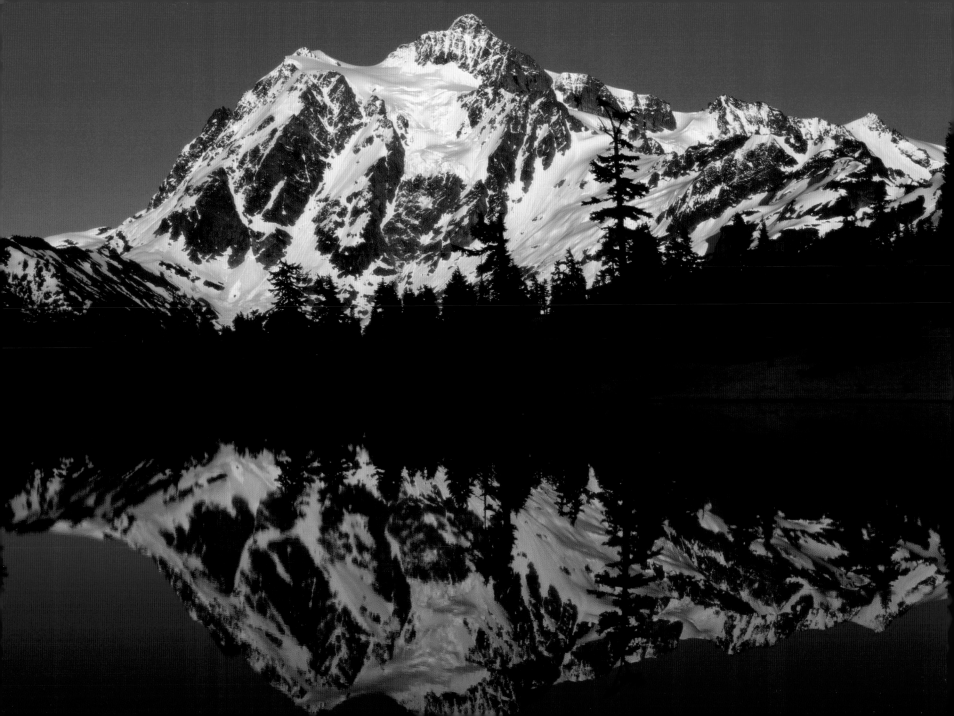

LEFT: Snow-covered mountains are usually spectacular places, but when their form is reflected in a nearby stretch of open water the visual effect is often magnified.

RIGHT: When snow is blown around by the wind, it can create wonderful shapes—here, in the Jasper National Park, Alberta, Canada, a beautiful undulating pattern has emerged.

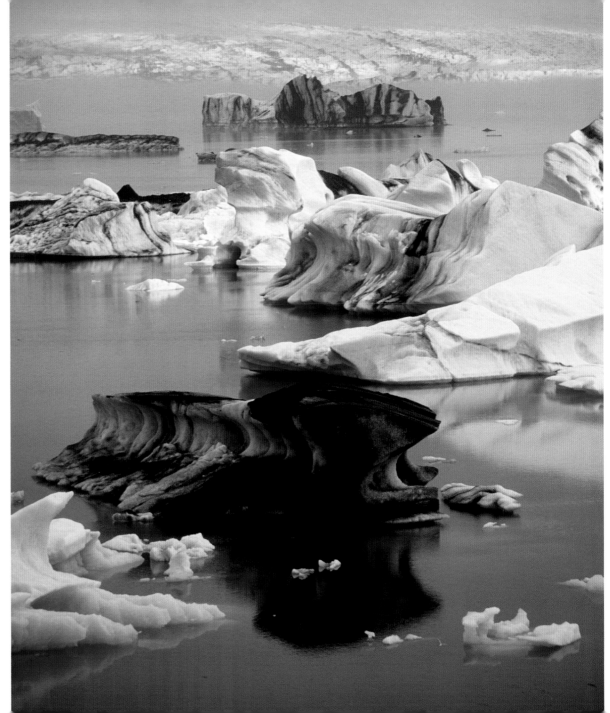

than 50 million years ago. In an attempt to find out just what is going on, studies are being conducted that measure a wide variety of environmental conditions. These include such atmospheric parameters as air temperature, wind circulation, and precipitation data, as well as the amount and depth of snow cover. Other measurements include the thickness of the sea ice, the strength of ocean currents, permafrost temperatures, glacial masses, and even observations of plant growth.

The geography of the Arctic region has meant that the area has been of great strategic importance for several hundred years. In the early days of exploration it was thought that there might be a shipping channel from Europe to the Far East between North America and the North Pole. The search for what became known as the "Northwest Passage" claimed many lives, and in the end was abandoned. In more recent years, tensions between the former Soviet Union and the United States of America led to the Cold War, where both sides prepared to defend themselves against the other. Since the shortest route between them was across the Bering Strait, large numbers of observation posts and missile detection sites were established on both sides, and the waters were regularly patrolled by nuclear submarines. Since the end of the Cold War, tensions have evaporated, but there are still many military facilities in the area. On the whole these are not a threat to the local wildlife; however, there are concerns that whales and dolphins are being adversely effected by underwater submarine-detection systems.

It is not only the Arctic region that holds large reserves of valuable natural resources. Antarctica also has rich mineral deposits—the Trans-Antarctic Mountains, for instance, hold huge quantities of coal, as well as copper, lead, zinc, silver, tin, and gold. It is thought that there are large oilfields under the Ross Sea, and in other places there are reserves of iron, molybdenum, chromium, platinum, and nickel ores. In 1991 the signatory nations of the Antarctic Treaty established a fifty-year suspension on mining activity, so the region is relatively safe for now. No one knows what will happen if global pressures for new fuel sources lead to this being annulled.

The Antarctic Treaty does not just deal with mining though—there are many other resolutions and measures that control more or less all human activity in the region. For instance, an agreement called

RIGHT: As icebergs form they can create all manner of weird and wonderful shapes. Depending on where they came from, they can also vary tremendously in color.

FAR RIGHT: Global pressure for fuel—and the large petrochemical companies' need to keep their shareholders happy—have led to exploration and exploitation of natural resources in many frozen areas of the world. To date that has not included Antarctica.

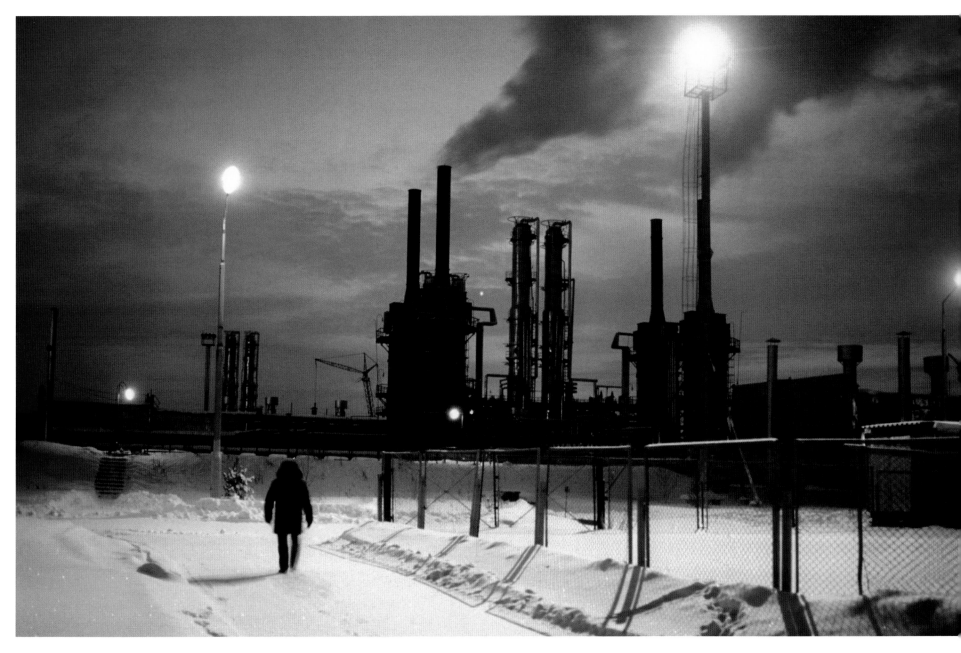

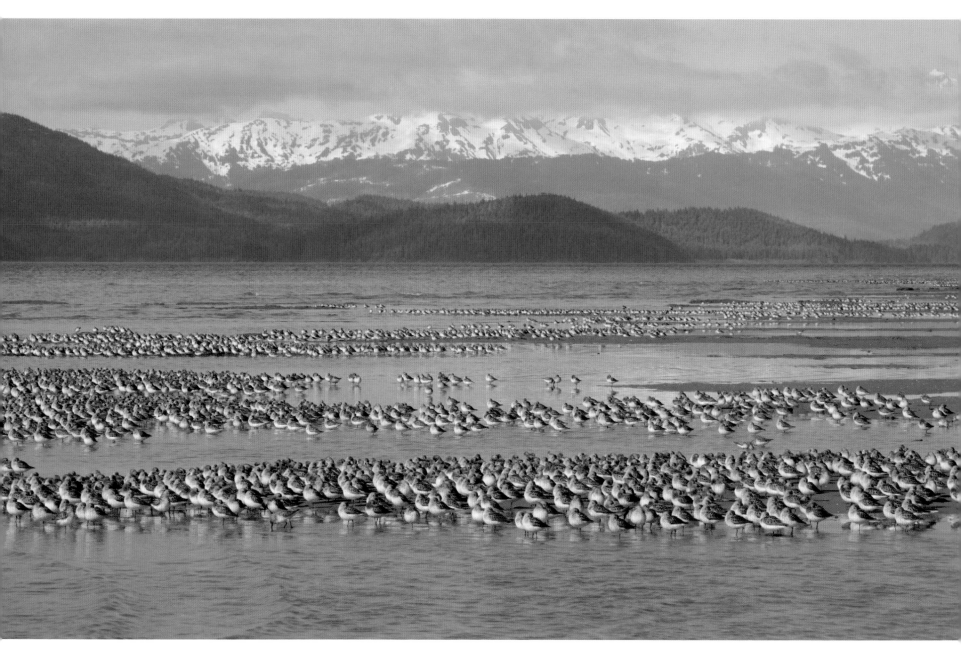

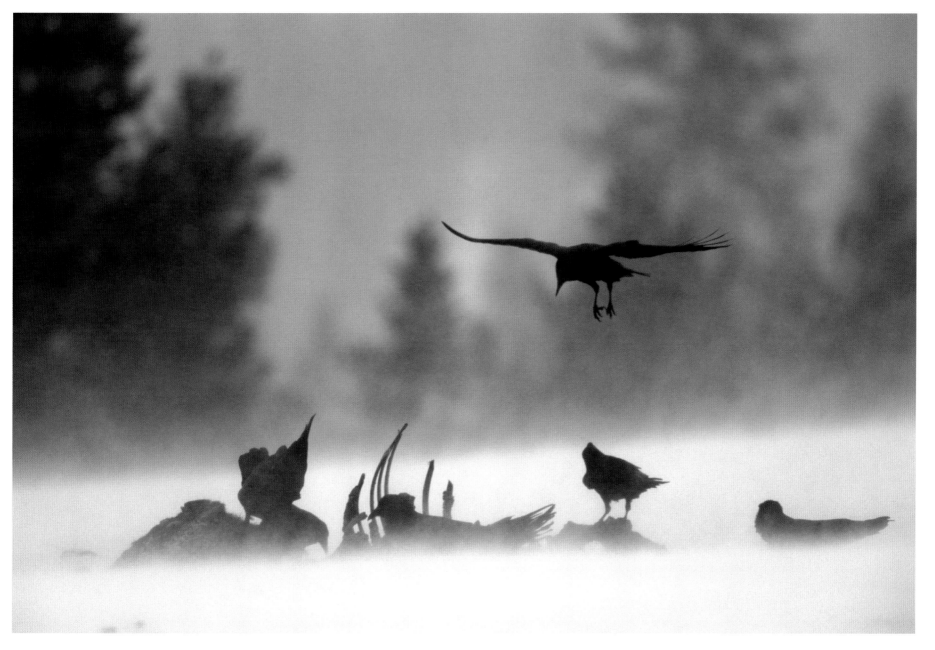

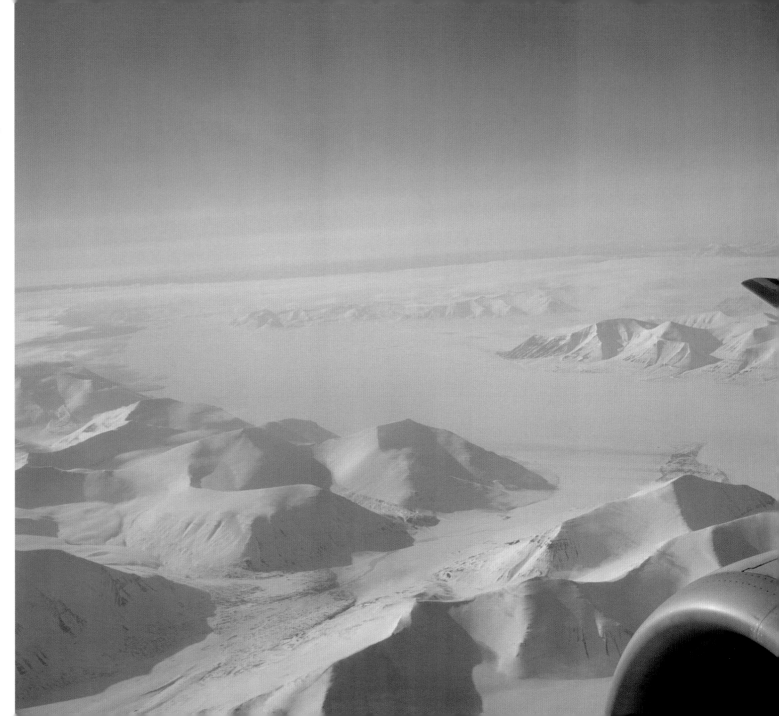

PAGE 20: When winter passes and the ice melts, large quantities of nutrients are released—this feeds vast numbers of microscopic organisms, which in turn attracts large flocks of aquatic birds.

PAGE 21: Winter is a harsh time, and when an animal dies, its remains are rarely wasted. Here ravens feast on a carcass in the snow.

RIGHT: Often the best way to see a remote landscape is from the air—here a snow-covered mountain range stretches away below an aircraft wing.

FAR RIGHT: Seals are mammals, and as a result need to breathe air. In order to do so, they make holes in the ice; however, when temperatures drop, they have to work hard to keep them from freezing over.

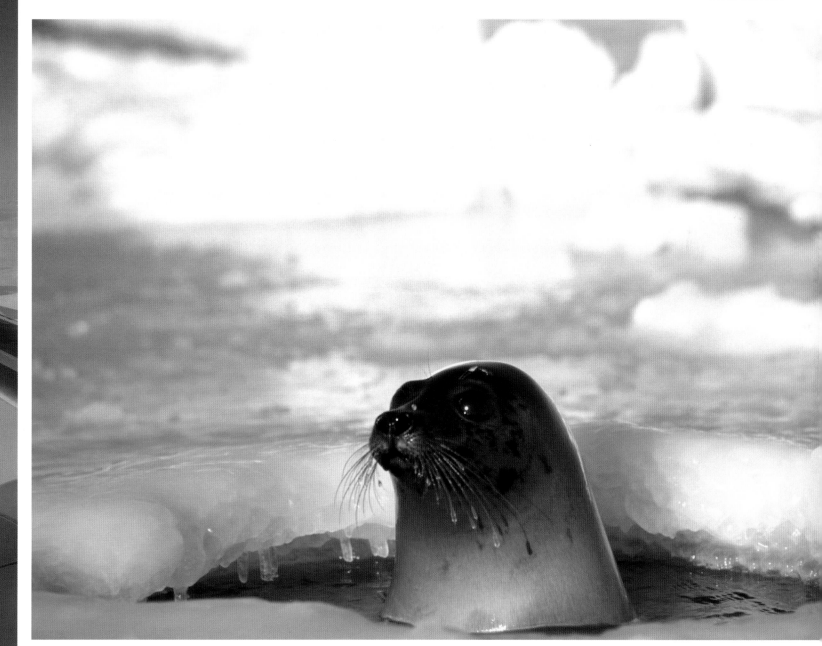

the "Conservation of Antarctic Marine Living Resources (1980)" was established to manage commercial fisheries in the Southern Ocean, while the "Protocol on Environmental Protection," also known as the Madrid Protocol (1991), aims to preserve the environment of Antarctica. Outside the Antarctic Treaty System, there are also other bodies that help to protect the region's environment. The International Whaling Commission, for example, established an Antarctic whale sanctuary in 1994 to protect important feeding grounds.

All the regions covered in this book have fragile ecosystems that need to be looked after if they are to remain in anything like their current form. It is our responsibility to do what we can to support those who campaign for cleaner commercial operations, for improved habitat management, or for any other work that helps to sustain the environments of these magnificent places. If all goes well, generations to come will also be able to enjoy the fabulous landscapes presented in this book.

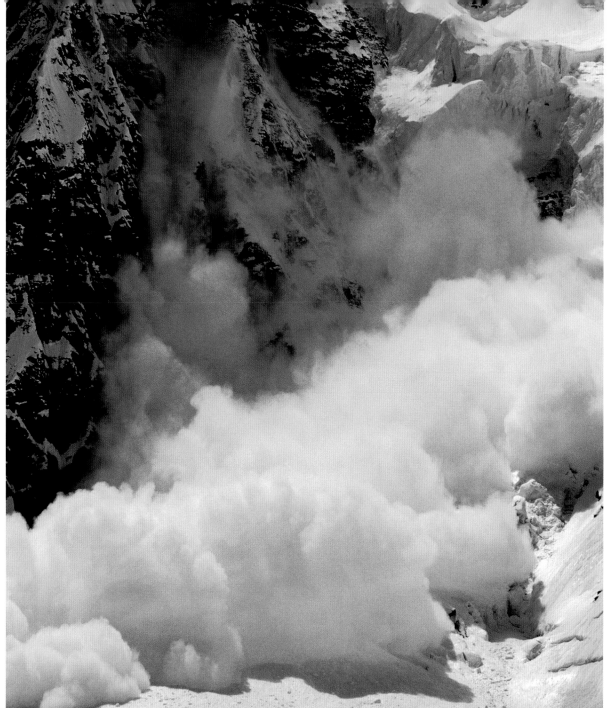

RIGHT: Large accumulations of snow can be extremely dangerous to walkers and climbers, as demonstrated by this avalanche in the Karakoram Range, Pakistan.

FAR RIGHT: It's difficult getting around the frozen world, particularly for humans used to moving distances at speed. Snowcats and other similar vehicles use caterpillar tracks to increase grip.

PAGE 26: The Trans-Siberian Railway, which runs 5,778 miles from Moscow to Vladivostok, as seen from the space shuttle Endeavour. It appears as a dark line against the white background of snow.

PAGE 27: Here the ice has been carefully carved away to create a novelty bedroom in a ice-hotel in Ste.-Catherine-de-la-Jacques-Cartier, Quebec, Canada.

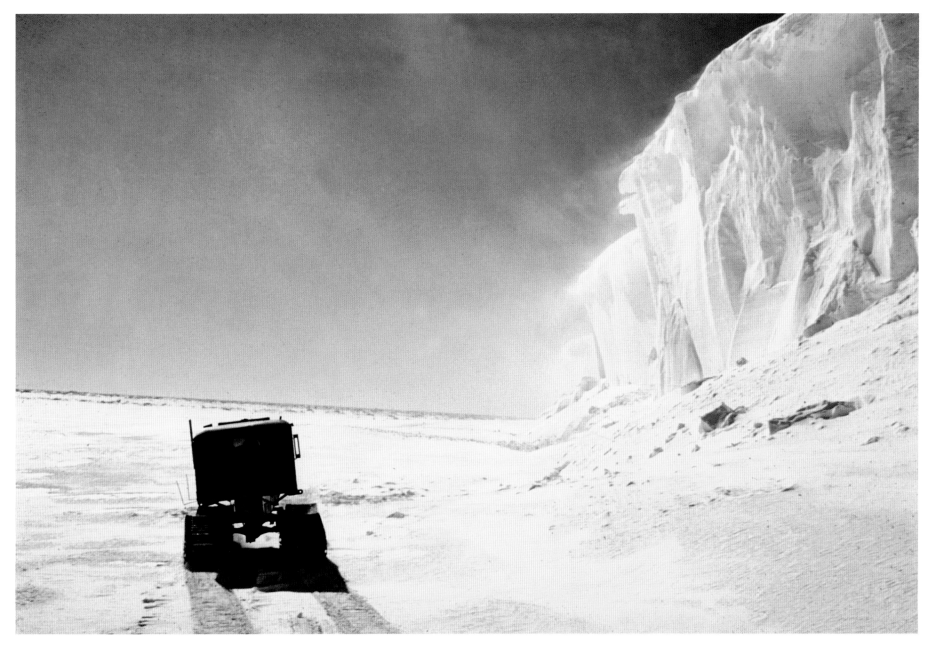

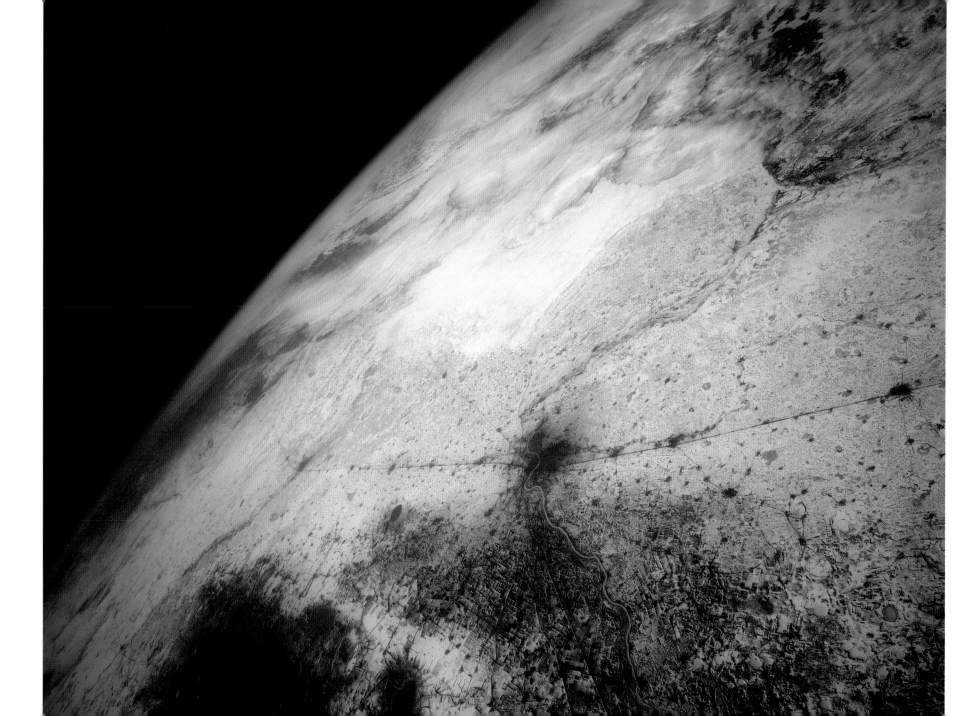

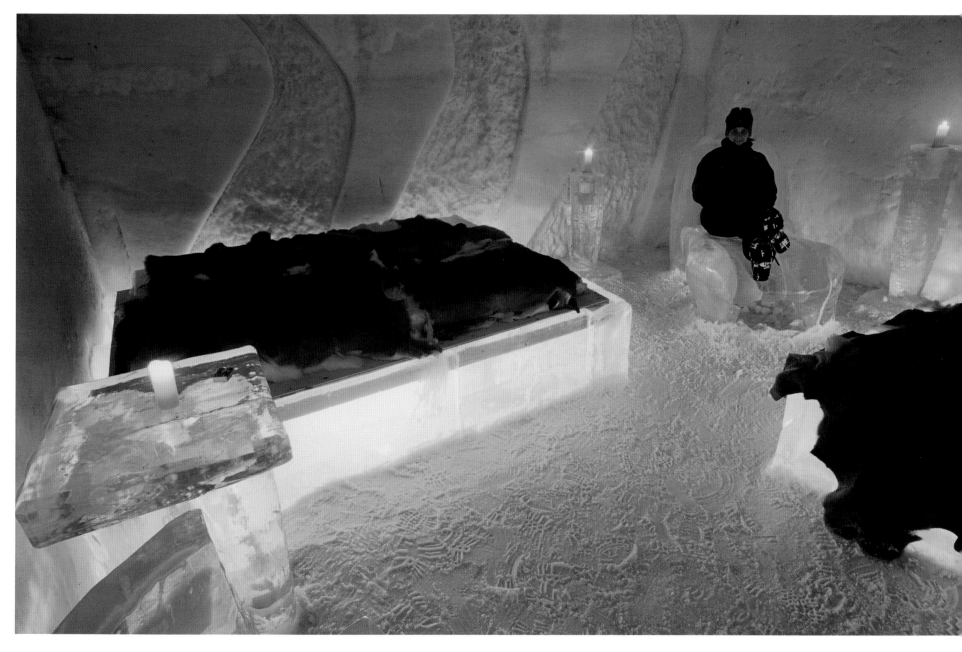

THE ARCTIC REGION

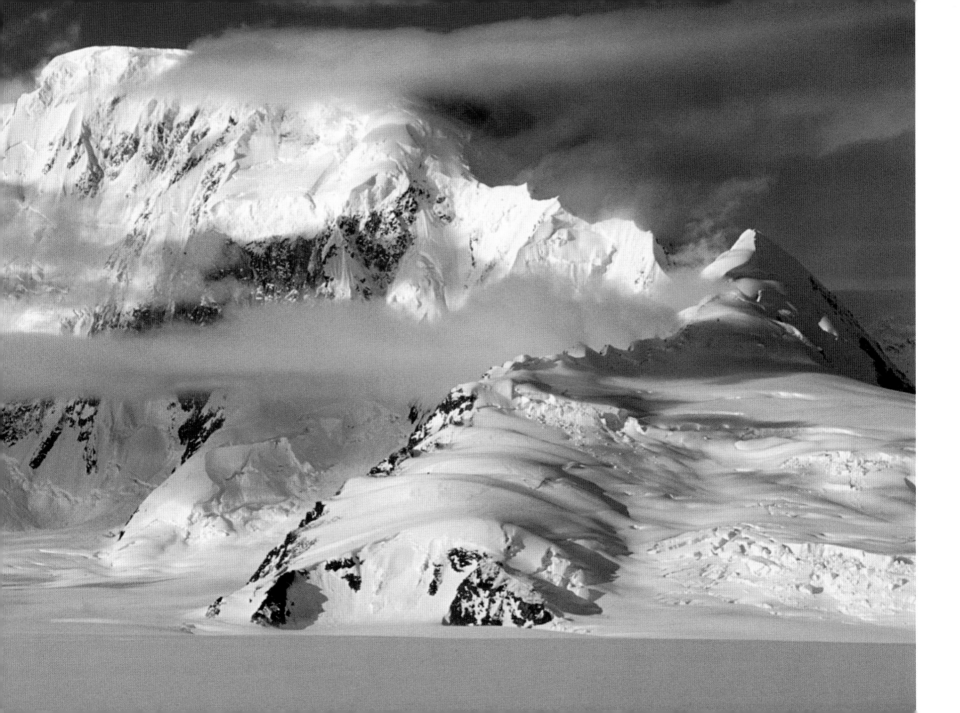

Introduction

The Arctic Region is often defined as the area around the North Pole where the average temperature for the warmest month is less than 100C. In the strictest sense, however, it is that area that lies north of the Arctic Circle—this is a line around the world that lies at approximately 66.5º north of the equator. At these latitudes the sun never sets at midsummer, and never rises above the horizon at midwinter. At its center is the North Pole—this is the northernmost point of the axis around which the Earth rotates. The pole itself is not on land—it is in the middle of the Arctic Ocean; however, since the sea there is frozen solid, it is possible for explorers to reach it on foot. The Arctic Ocean contains thousands of islands—both large and small, and is almost entirely surrounded by land.

Although the Arctic Region has an extremely harsh environment, there are several native peoples who live nowhere else. Most are nomadic reindeer herders, as characterized by the Nganasan, Nenets, and Sami, or hunter-fishers, such as the Inuit. Until recently humans had made little impact on the area; however, this is starting to change as the ravages of oil exploration and mineral extraction move ever northward. There is also clear evidence that the Arctic is warming up. Whether this is part of a natural cycle, or due to global warming is a hotly disputed subject. Whatever the cause, it is undeniable that vast areas of ice have disappeared, and lands that have been permafrost for thousands of years have thawed out. If this continues, many animal species will not be able to survive, and will quickly become extinct. While this is bad enough, the tundra and taiga (subarctic forest) regions of the world also hold around one-third of the world's soil-bound carbon. This is of great significance—permafrost traps carbon, but if it melts, it releases more than it can hold, sending massive quantities of carbon dioxide into the atmosphere. This will make the problems associated with global warming even worse.

The Climate and Environment of the Arctic Region

During the winter the Arctic is a place of extremely harsh conditions where only the hardiest of creatures can survive. Vast areas of the sea freeze solid, forming great swathes of pack ice as the temperatures fall to -70°C and high winds scour the region. As winter gives way to summer most of the sea ice melts and the environment warms up considerably. As this happens, many different species of animals are attracted to the area, including whales, dolphins, bears, foxes, owls, sea birds, and many other fascinating creatures.

In the warmer areas of the more southerly regions there are many species of plants and small trees to be found. At the right times of year meadows of brightly colored flowers appear almost overnight. Across most of the Arctic and Subarctic, however, no trees grow, and only a few primitive plant species such as reindeer moss can survive.

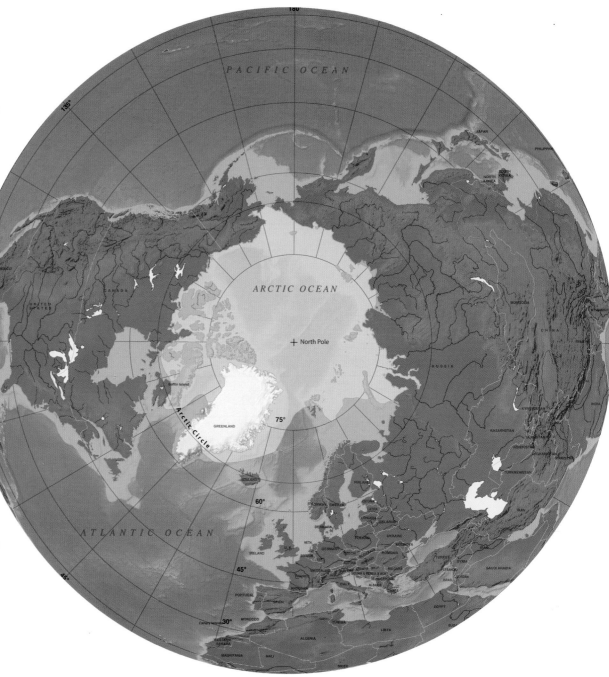

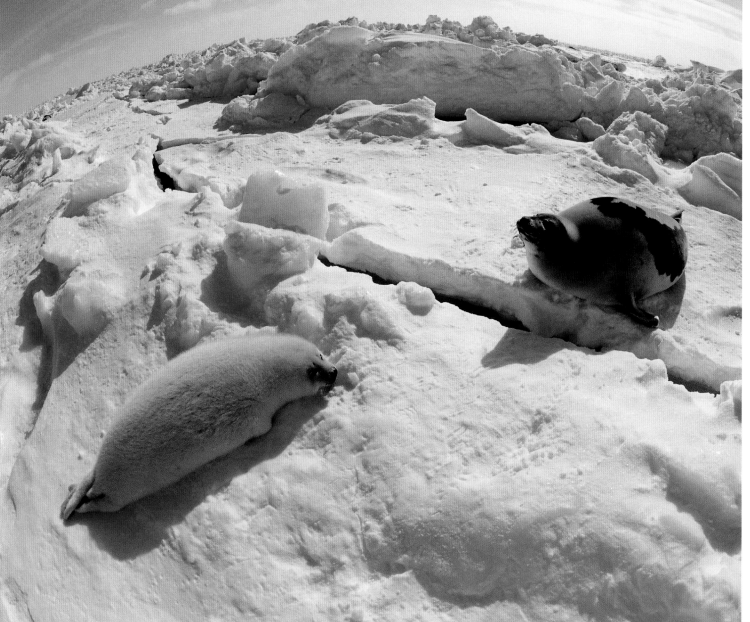

PAGES 28–29: A spectacular view of the St. Elias Mountains and the Bagley Ice Field, which are located in the Wrangell-St. Elias National Park, Alaska.

FAR LEFT: Map of the Arctic Region.

LEFT: A juvenile harp seal is separated from its mother by a crevasse in an ice field.

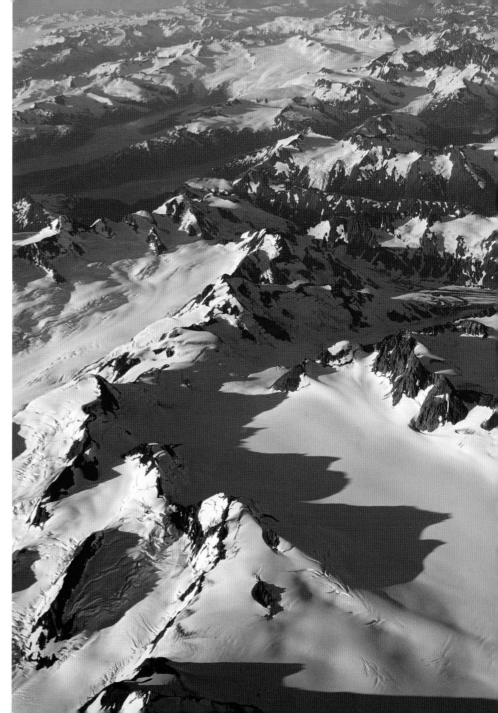

This is because just under the surface of the soil there is a permanently frozen layer known as "permafrost" that prevents any rainwater from draining away. As a result of this, countless thousands of freshwater ponds, lakes, marshes, and swamps form, creating havens for many different kinds of animals, ranging from mosquitoes to ducks. These vast areas of open water and low-lying scrub, known as "tundra" or "muskeg," are harsh places to survive in, however, and so only those species of animals that are well adapted to the environment are able to flourish there.

The Geography of the Arctic Region

If one moves eastwards from the Bering Strait, the first land mass encountered is Alaska. This massive tract of land measuring around 600,000 square miles (1,600,000 square kilometers) originally belonged to Russia, but was purchased by the United States in 1867 for $7,200,000. This equates to about $90 million in today's terms. At the time there was an enormous amount of political dissent about buying such a distant and barren land—Alaska was even labeled "President Andrew Johnson's polar bear garden." When gold was found just over the border in Canada in 1896, the Klondike Gold Rush began and all doubts about Alaska's value were erased. A second gold rush occurred in 1900, and since then many other natural resources have been exploited, including petroleum, natural gas, coal, timber, and salmon.

The regions that lie to the north of the Bering Strait and along the coast of the Chukchi Sea to the Beaufort Sea are north of the Arctic Circle, and continuing eastwards the land becomes Canada. The Canadian Arctic includes many islands—Banks Island, Victoria Island, the Queen Elizabeth Islands, Ellesmere Island, and Baffin Island to name but a few. The coast of Baffin Island marks the point where Baffin Bay begins—on the opposite shore lies Greenland, a vast country that belongs to Denmark. On the far side of this massive island, the Greenland Sea begins—this in turn gives way to the Norwegian Sea and the coast of Norway. In between lie many islands, most of which belong to Norway.

Continuing eastwards once again, the next countries to be found are Sweden and Finland—the northernmost tips of which extend well into the Arctic Circle. After this lie the massive tracts of Russia, which, when following the Arctic Circle, extend nearly halfway around the world. Between the mainland coast of Russia and the North Pole lie the Barents Sea, the Kara Sea and the Laptev Sea. Distributed throughout these seas are many islands, including Novaya Zemla, Franz Josef Land, Severnaya Zemla, the New Siberian Islands and Wrangel Island. At this point, the globe has been fully circumnavigated, and the Bering Strait is reached once again.

The Fauna of the Arctic Region

Those animal species that do thrive in the Arctic often do so in vast numbers. A good example is the caribou (*Rangifer tarandus*). There are several different subspecies, although their taxonomy is not fully

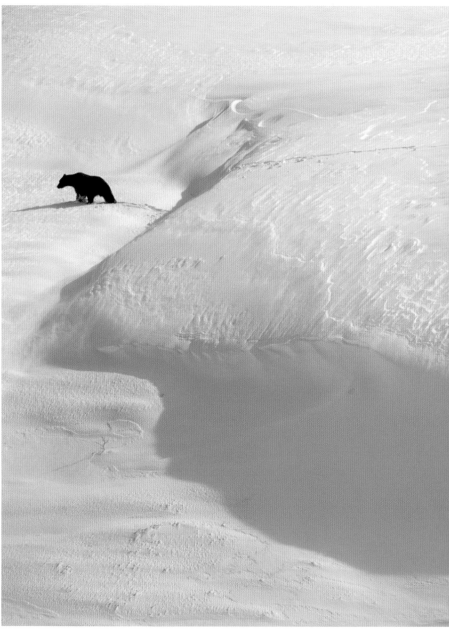

understood yet. The Greenland caribou is thought to be the same as the European reindeer. They all have similar habits though, gathering together in massive herds, moving throughout the year across vast areas in search of food—this consists of lichens, mosses, grasses, and dwarf willows. It is not unusual for some to travel 1,000 kilometers during the winter.

The other large land herbivore of the Arctic region is the muskox—unlike the caribou though, these hardy creatures usually form small groups. At one time they were common, and were spread throughout the northern wilderness; however, their habit of forming defensive circles instead of running away made them easy targets for human hunters armed with rifles, and their numbers plummeted. These days muskox are protected by law, and their populations are making a slow recovery.

Lemmings are another characteristic animal of the region, and various species of these small, vole-like rodents are distributed across most of the Arctic, wherever tundra occurs. These small animals, which feed exclusively on plant matter, normally live in dispersed groups. When the right conditions prevail, however, their populations explode and huge swarms gather together in a communal quest for new territories. This occurs about every four years, and the state of the lemming population has a massive effect on the numbers of the animals that feed on them. These range from snowy owls to wolves, foxes, polar bears and wolverines. When the lemmings are scarce, these predatory animals have little else to feed on, and often starve to death or move off to other areas. When the lemmings are plentiful, however, there is enough food for the predators to produce large broods of young, and their numbers recover.

The Arctic hare is another characteristic animal of the region whose populations also go through periodic cycles. All Arctic hares have a thick coat of white fur during the winter. Those which live at high latitudes retain this coloring all year; however, those that inhabit warmer areas shed it for brown fur during the summer. In the months leading up to winter the white coloration is regrown.

Another animal that has a white coat is the Arctic fox. It is predominantly a scavenger—a major part of its diet is composed of scraps taken from the carcasses of animals killed by polar bears, lynx, wolves or other large predators. It has heavily furred feet, which act both as snowshoes and as insulation against the extreme cold. Likewise, its ears are smaller than those of fox species of temperate zones so that they lose less heat. While most foxes need big ears so that they can detect small animals while hunting, the Arctic fox's scavenging habits make it less reliant on its hearing.

The polar bear, which is the largest predator of the high Arctic, is an excellent swimmer that mainly hunts seals on ice floes. While polar bears are primarily predators, they are also opportunists and will also feed on stranded whale carcasses. If they can catch them, polar bears will also eat birds, and when times are especially hard, they even eat vegetation. This omnivorous behavior can bring them into conflict with mankind. When seal numbers are low, they will sometimes visit human settlements to look for food. This is dangerous both for the bears and the humans. Their numbers have been dramatically reduced in recent decades as a result of humans hunting them for sport. Fortunately, they now have a semi-protected status in many areas, and their numbers are beginning to recover. Small numbers are still killed for their fur by native hunters. For most of the year these spectacular creatures are solitary, but in the mating season they gather together to seek out mates. The females then deliver their cubs. Usually only one or two are born, in snow caves during the winter, so that the offspring are large enough to take advantage of the many seal pups that appear in the spring.

The Climate and Environment of the Subarctic Region

The subarctic environment is characterized by wild seasonal extremes—in the depths of the long winters temperatures can plummet to -40°C, whereas in the brief summers they can rise to 30°C. Most of the subarctic region is covered with what is known as taiga forest vegetation—the types of tree species that can be found there depend on the winter climate. In the colder areas they are mostly coniferous, but in the milder places broadleaf deciduous trees also thrive. The soil of the taiga regions is usually acidic, and the ground cover is mostly composed of mosses and lichens—while these are of low nutritional value, they provide a vital source of nutrients for many of the animals of the region.

There is typically a moderate level of precipitation in these areas—usually between 40 and 100 centimeters per year, much of which falls as snow. In the maritime areas of the subarctic, however, the level of precipitation can be very high. In these places there are often large glaciers—these are large bodies of ice that move slowly down a slope or a valley. They then either melt and form fresh water rivers, or fall directly into the sea.

Where the soil remains waterlogged throughout the year, trees cannot survive, and these areas usually become peat bogs where the main vegetation is a mix of grasses and sedges. Other parts of the subarctic are too cold for the soil to thaw out completely, and as a result they are covered with permafrost.

The Geography of the Subarctic Region

The subarctic regions lie in the Northern Hemisphere immediately to the south of the Arctic Circle. Defining exactly which areas are included in this region is far from simple, as localized geographic variations mean some areas that lie at similar latitudes are warmer than others. For the purposes of this book, it will be taken to mean any lands that lie to the south of the Arctic Circle, and that display Arctic-like weather conditions for some or all of the year. Most of the lands in this category lie between 55° and 66.5° north of the equator, and typically have average monthly temperatures above 10°C for at least one month, but for no more than three months of the year.

The subarctic regions include large areas of Canada and Siberia, as well as the south of Greenland. Iceland lies entirely in the subarctic, but only the northernmost parts of the British Isles are included. Moving eastwards, countries in the north of Scandinavia—Norway, Sweden, and Finland—also lie in the zone, as do the northern parts of Estonia and Latvia. A large proportion of Russia is subarctic, as are northern Mongolia and most of Alaska.

The Fauna of the Subarctic Region

Many of the animal species found in the subarctic range over wide areas, and are therefore also found further north in the true Arctic. Examples include the Reindeer (*Rangifer tarandus*), Moose (*Alces alces*), and the Wolf (*Canis lupus*).

Although there has been farming—mostly of animals—for thousands of years, the most visible effect on the environment of the subarctic regions has been through mining, quarrying, and oil extraction. Canada, Greenland, and Siberia all have vast reserves of valuable minerals—these include the ores of aluminum, uranium, lead, zinc, cobalt, nickel. and molybdenum.

Significant impact from human involvement in the subarctic regions is a relatively recent affair. This mostly due to the fact that building on permafrost soils is difficult and expensive. Eking a living from the harsh environment also limits the number of people who are able to support themselves. The largest subarctic city is Yakutsk, in central Siberia. It was originally founded as a fort, and soon became a center for trading timber, but when gold, diamonds and other minerals were discovered nearby in the 1880s, the city's population expanded considerably. Today the houses there are mostly built on concrete piles to raise them above the permafrost—even so, it is still a difficult place to live in. During the winter temperatures regularly fall below -40°C, and in the summer they often reach 30°C.

The subarctic seas have been a rich source of fish for mankind since the earliest days of human habitation; however, the future of these stocks is far from certain. In the last few decades the enormous depredation imposed by factory fishing techniques have all but wiped out some fisheries.

Apart from the milder areas that came under the influence of warm air taken north by the Gulf Stream, most of the subarctic remained unexplored until the eighteenth and nineteenth centuries. This was because the extreme weather conditions made it very difficult to construct roads and bridges necessary for transporting supplies. It was only when substantial mineral deposits were found that large numbers of people moved into the region. Many of these settlements, such as those in the Yukon and the Northwest Territories, have since been abandoned, and are now ghost towns.

In Russia, the Trans-Siberian Railway, which was built between 1891 and 1916, allowed access to many previously inaccessible places across the subarctic region. Running from Moscow to Vladivostok, it provided the means to transport heavy equipment and supplies, and as

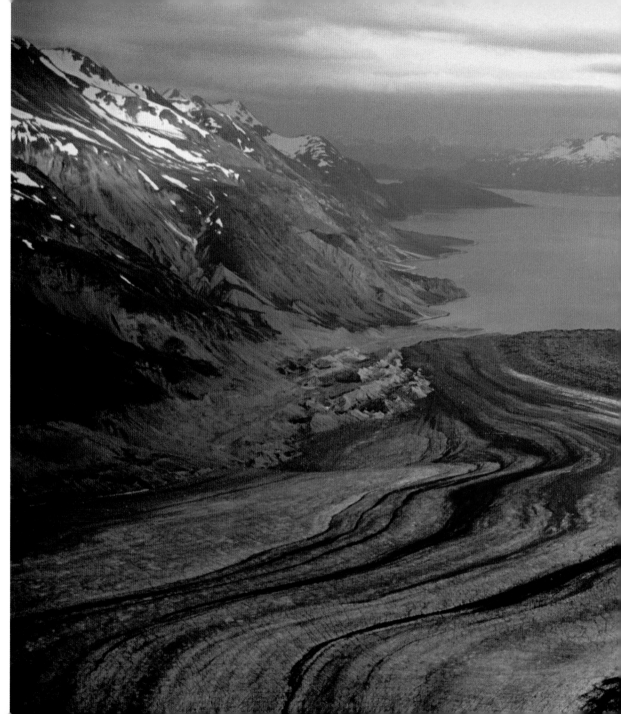

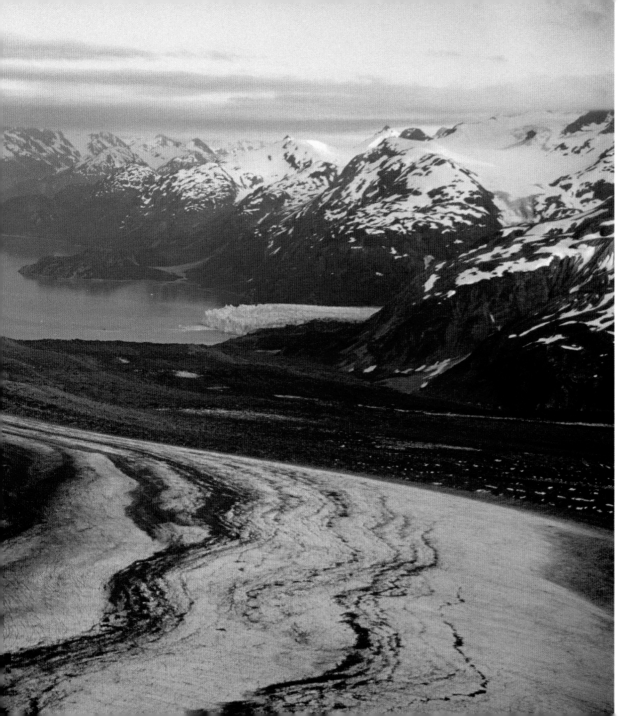

a result many types of mines and quarries were established to exploit the mineral resources there. Many of these were established during Stalin's push to industrialize the country in the 1940s and 1950s. Before long, towns and cities sprang up to house the workers and support the industries. Now that communism no longer funds these institutions, however, many have closed down, and consequently a lot of the settlements have gone into sharp decline.

Elsewhere in the subarctic, communication remains difficult, with few roads or railways encroaching on the vast wilderness. As a result, the easiest way to move around is via floatplanes, helicopters, and boats. This has placed significant constraints on the growth of tourism; however, many countries are doing all they can to exploit the natural beauty of these wild places. In areas where there are few opportunities for generating revenue, tourism represents an ideal method of boosting the economy without damaging the environment.

LEFT: The Grand Pacific Glacier and Tarr Inlet, Glacier Bay National Park and Preserve, Alaska. The glacier is around two miles wide, and is striped by the large amounts of rock it has collected over the millennia.

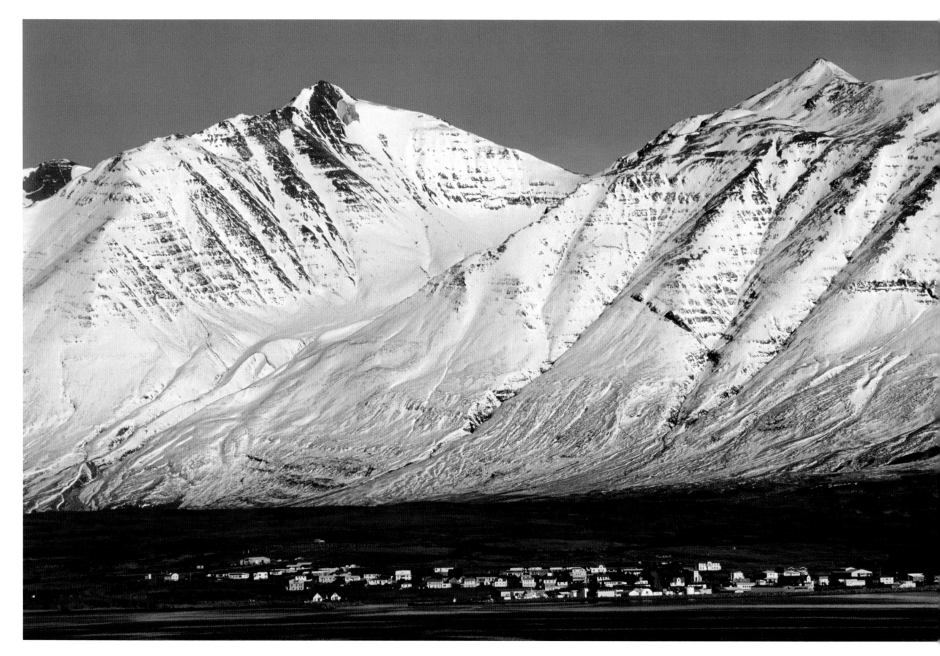

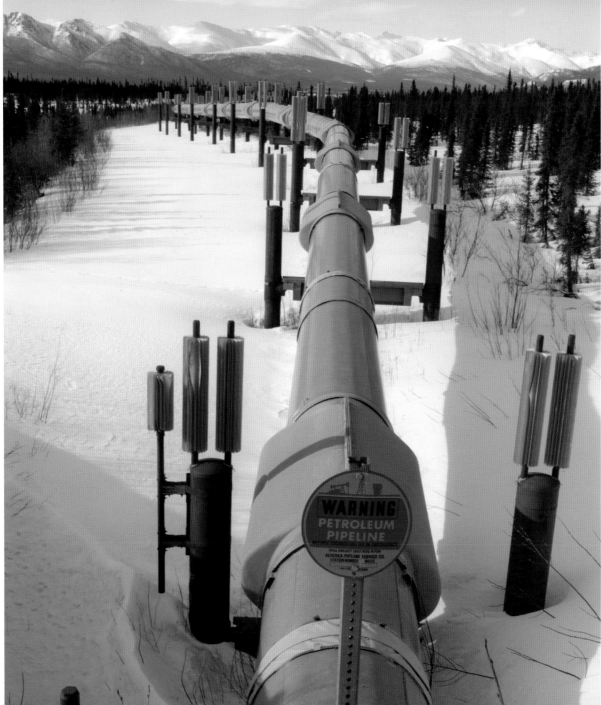

LEFT: The worldwide need for oil means that pipelines cross even the most inhospitable parts of the frozen world.

FAR LEFT: This small village, at the water's edge on the island of Hrisey along Eyjafjordur Bay in northern Iceland, is dwarfed by the adjacent mountains.

WARNING
PETROLEUM
PIPELINE

LEFT: One of the many ridges of Mount Hunter, which is immediately south of Denali (Mount McKinley), just to the east of the Kahiltna Glacier. Denali National Park and Reserve, Alaska.

RIGHT: Greenland is the world's largest island—it is believed that it was first discovered by Vikings in the 10th century. The mountains seen here are in East Greenland.

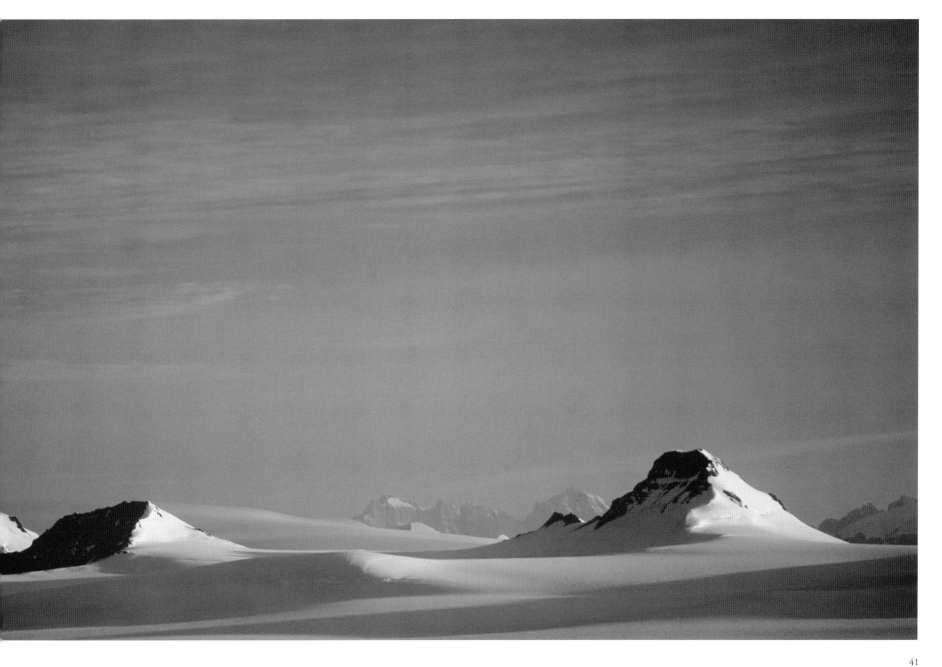

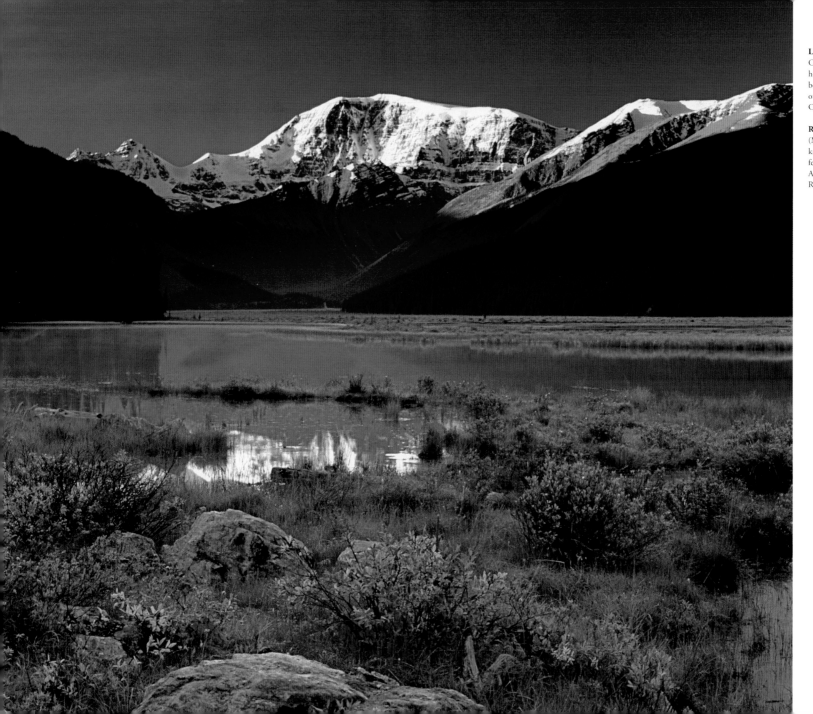

LEFT: The stunning scenery of Beauty Creek and the Columbia Mountains is home to many large animals, including bears, wolves, elk, moose, caribou, and others. Jasper National Park, Alberta, Canada.

RIGHT: Morning sunlight lights Denali's (Mount McKinley) south side which is known as Little Switzerland. At 20,320 feet it is the highest peak in North America. Denali National Park and Reserve, Alaska.

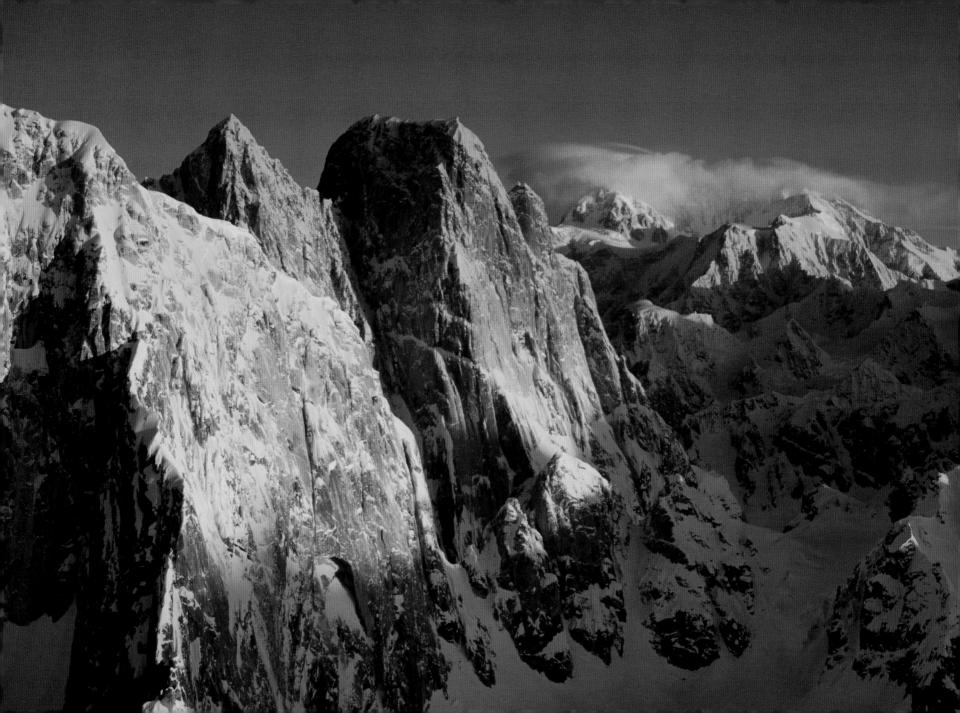

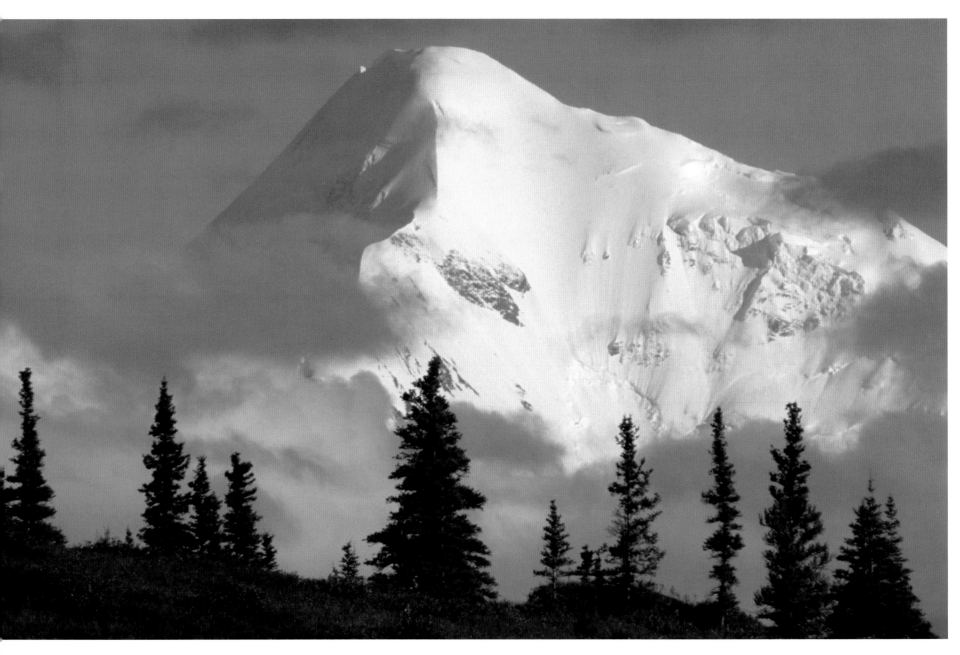

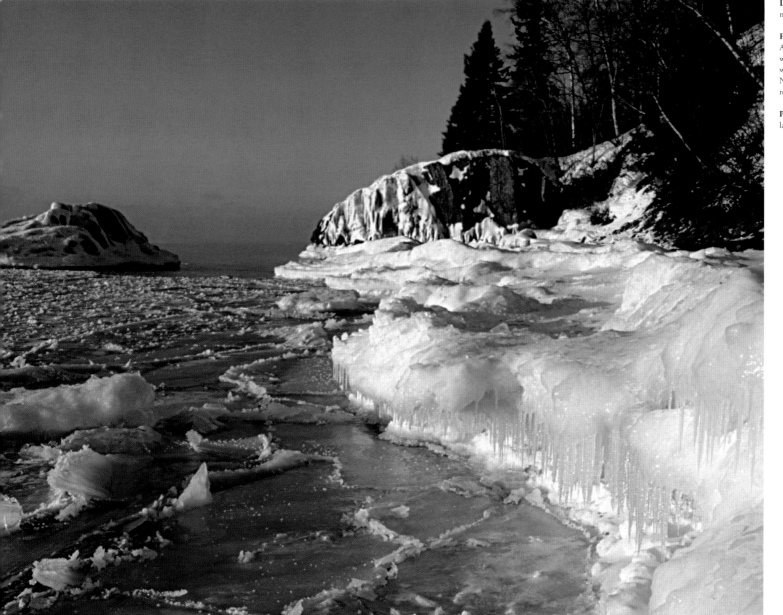

LEFT: Winter ice along Lake Superior's northern shore.

FAR LEFT: One of the many peaks in the Alaska Range of the Denali National Park, which covers more than 6 million acres. It was first established as Mt. McKinley National Park in 1917, but has since been renamed and extended.

PAGES 46–47: The Jokulsarlon glacial lagoon in Iceland.

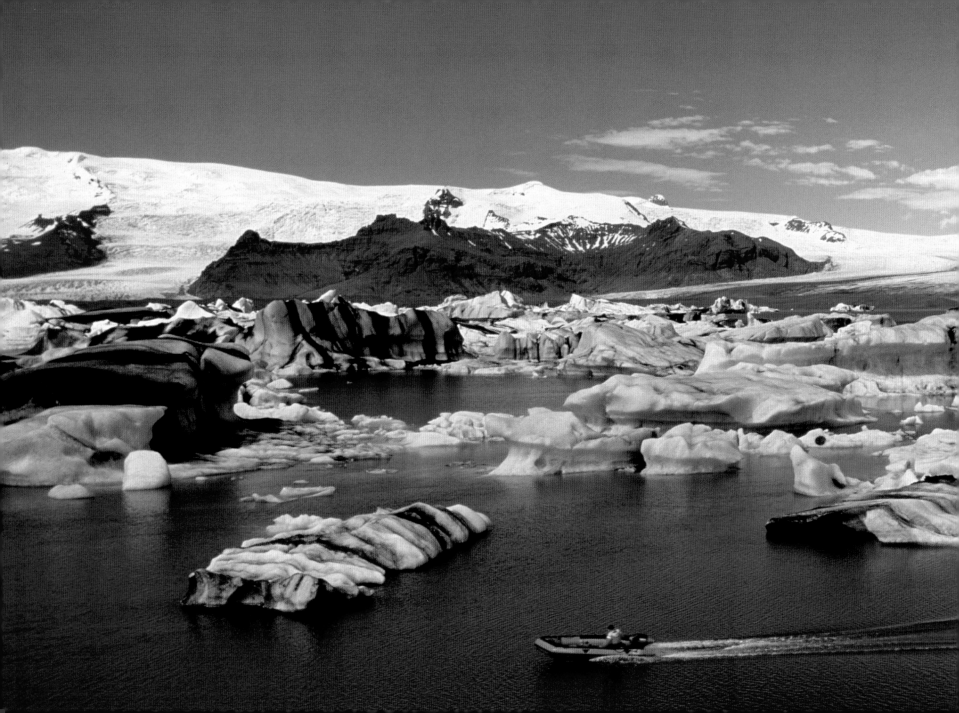

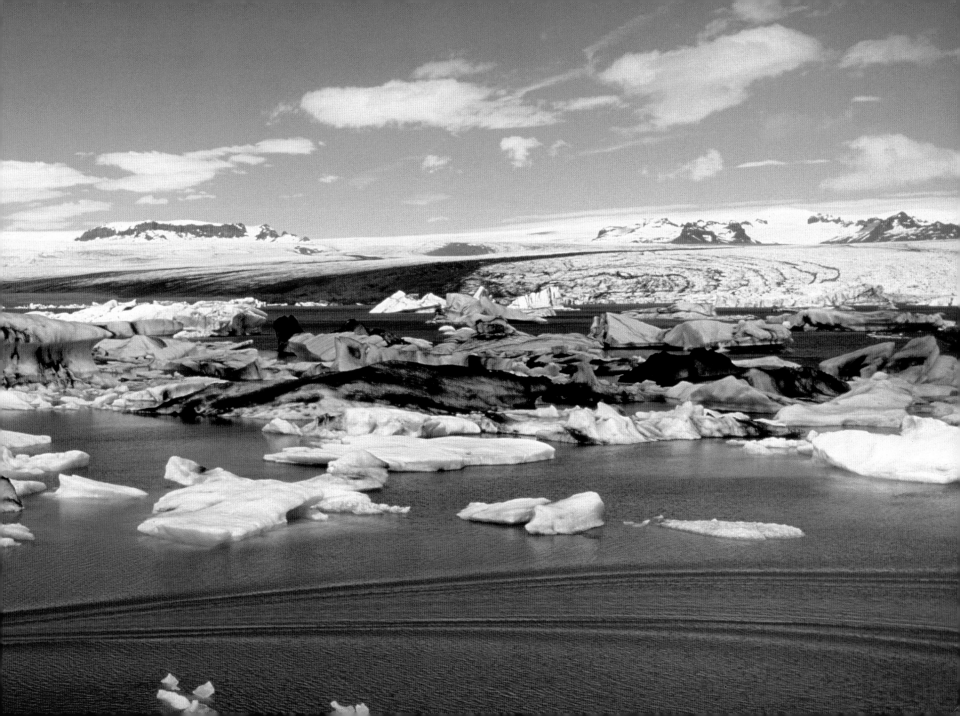

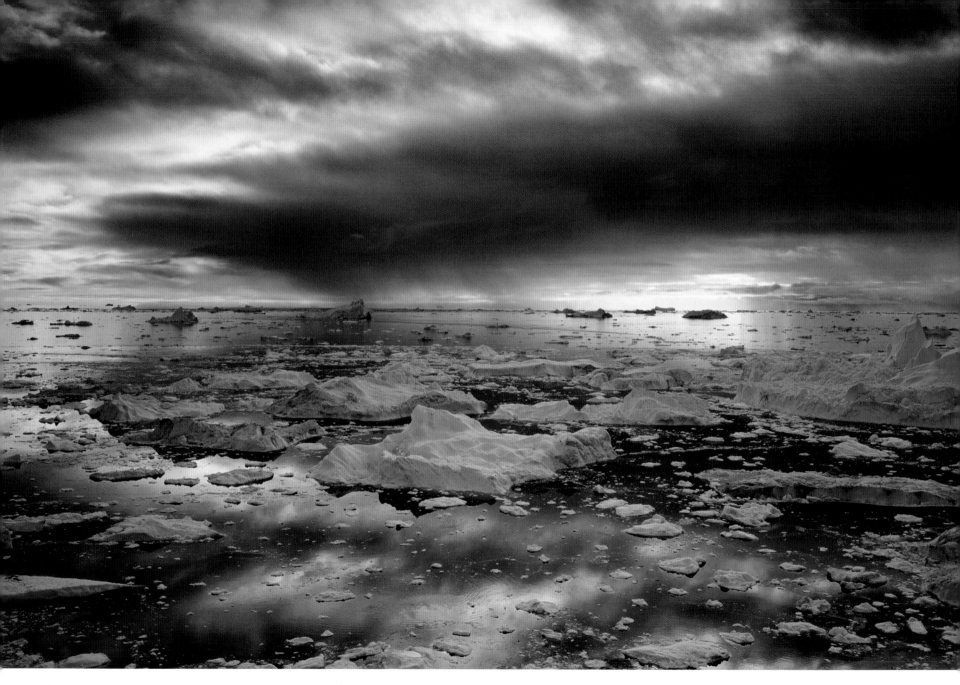

LEFT: Disko Bay, which is filled with icebergs, forms an entrance to Northern Greenland, 300 kilometers north of the Arctic Circle. Ice cubes are produced commercially from icebergs in the area.

RIGHT: Harp seal near a crevasse—difficult for humans to cross, crevasses and ice splits are even more difficult if you are a seal!

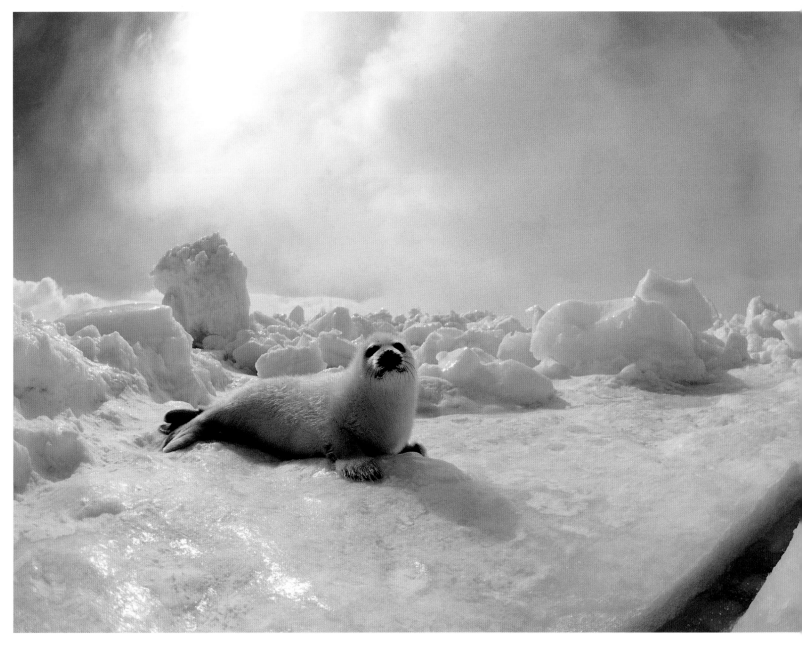

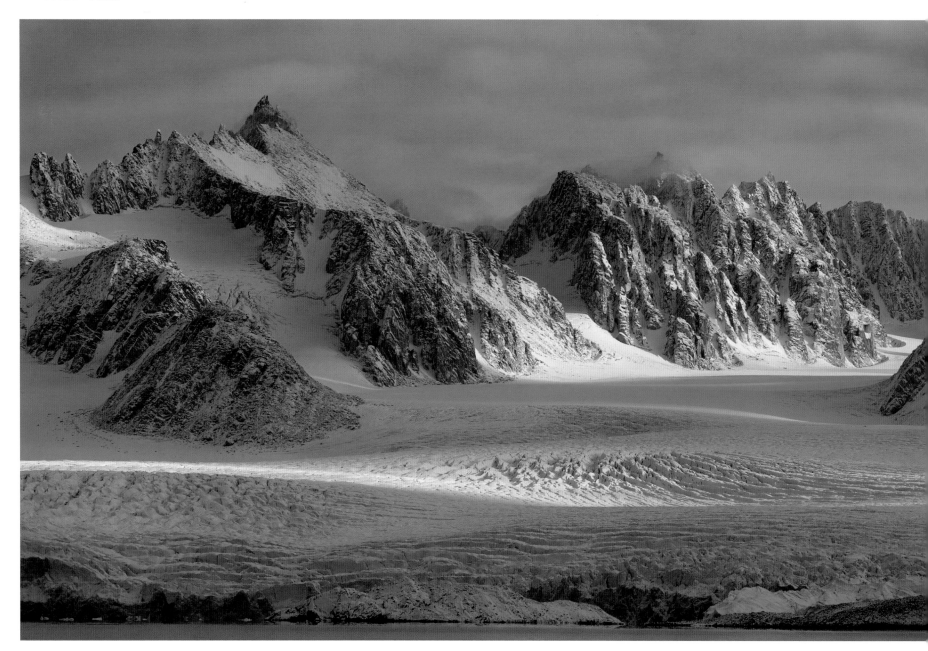

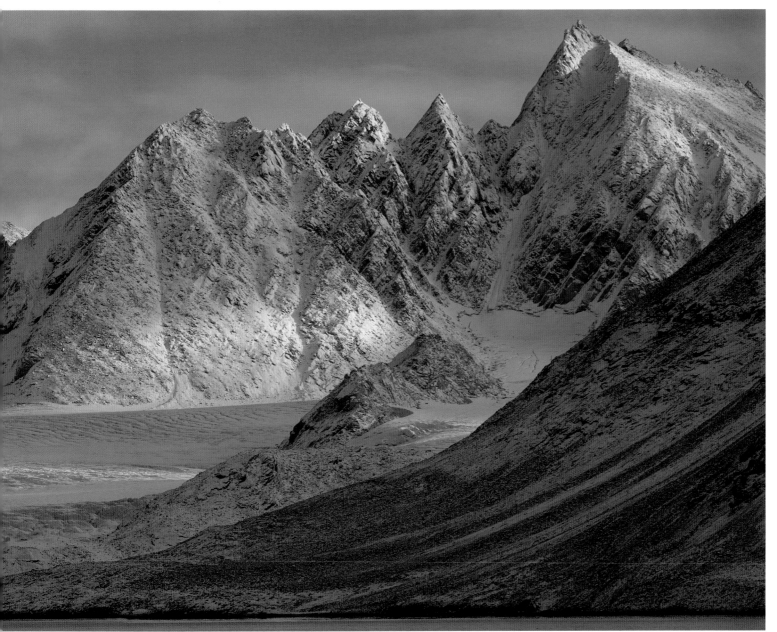

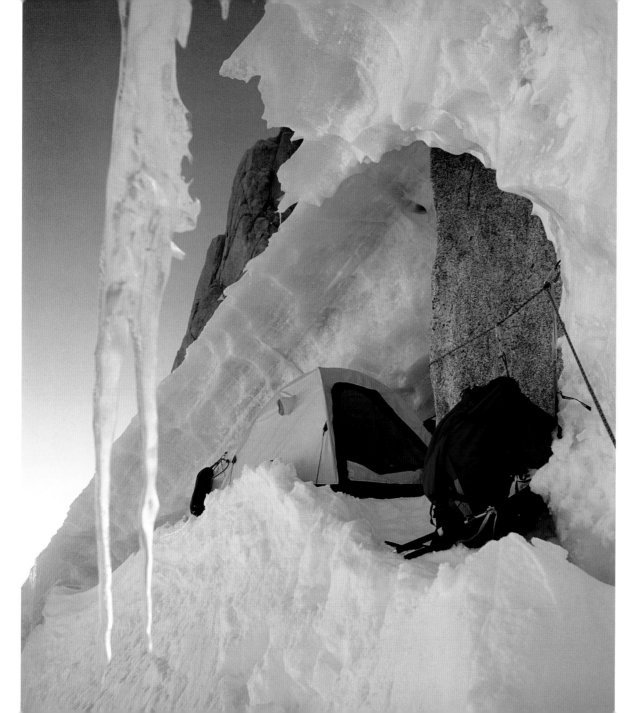

LEFT: Camping on Cassin Ridge on Mount McKinley in the Denali National Park, Alaska.

RIGHT: The Vatnajokull Glacier in Iceland is the largest glacier in Europe—its average thickness is about 400 meters, and it covers about 8 percent of the country's land mass.

PAGE 54: A view of a remote part of the Cassiar Mountains, Canada, at night, with one of the peaks lit by the aurora borealis. They are part of the Rocky Mountain Range in the Yukon Territory of Canada.

PAGE 55: Three granite spires above Sam Ford Fjord on Baffin Island, Nunavut, Canada. From left to right they are called the Belvedere Ridge, Broad Peak, and Polar Sun.

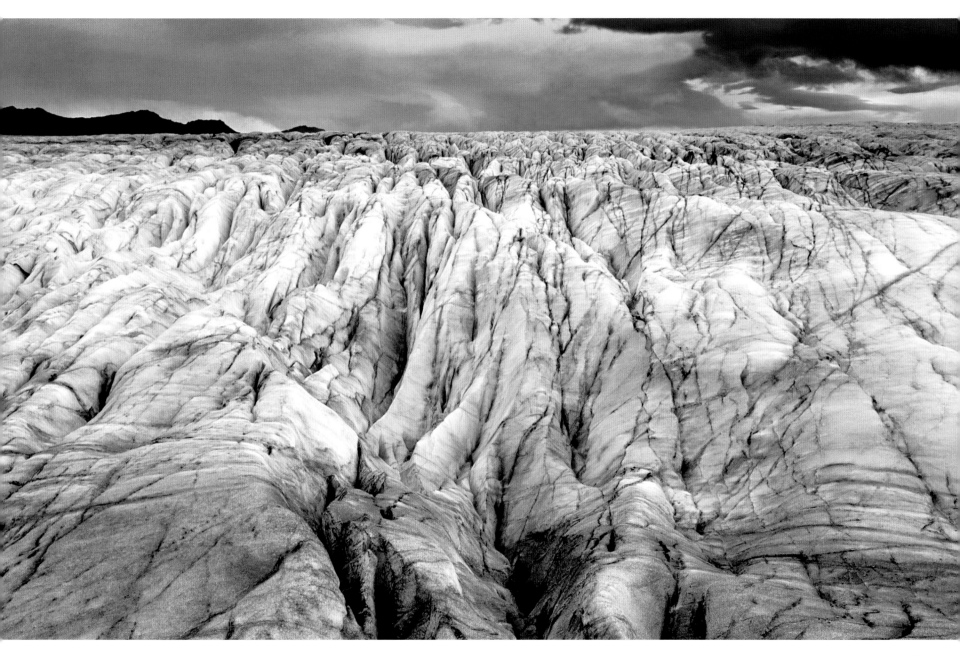

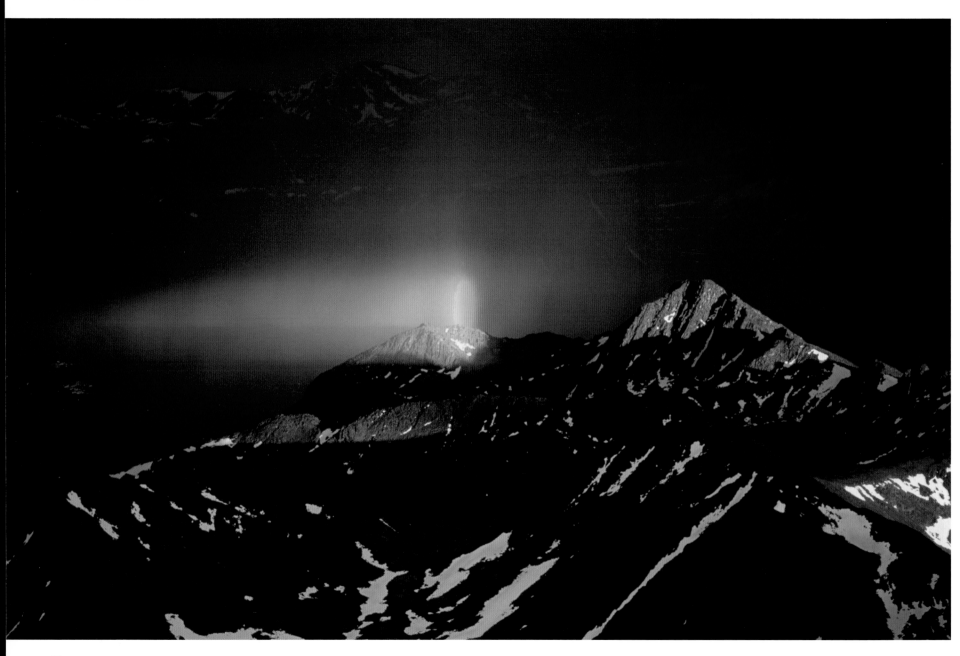

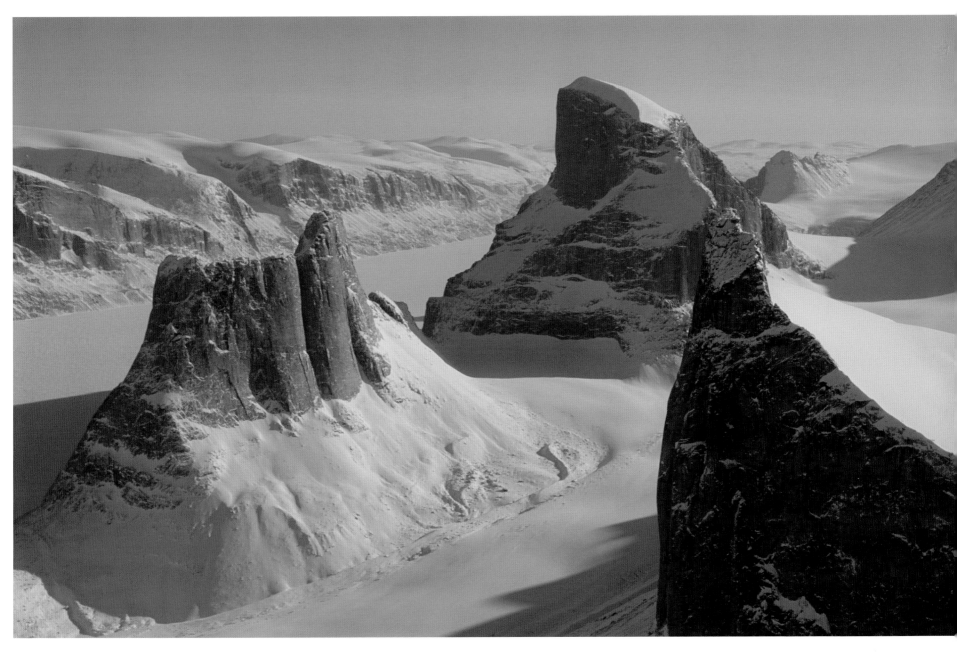

RIGHT: This small boat is passing the Lamplugh glacier, which lies at the head of the inlet that leads to the Johns Hopkins Glacier. Glacier National Park, Alaska.

FAR RIGHT: The aurora borealis or northern lights create an eerie scene over a winter landscape at the Chena Hot Springs, Alaska.

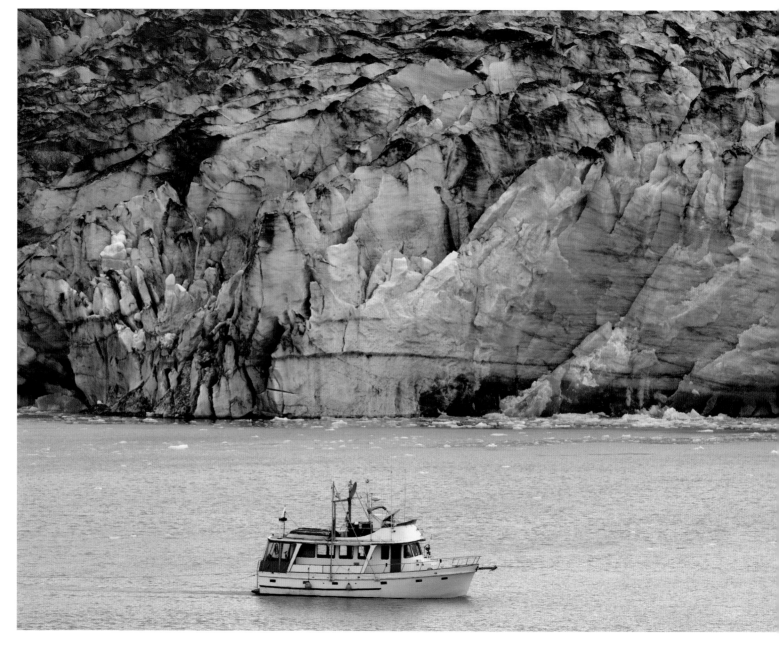

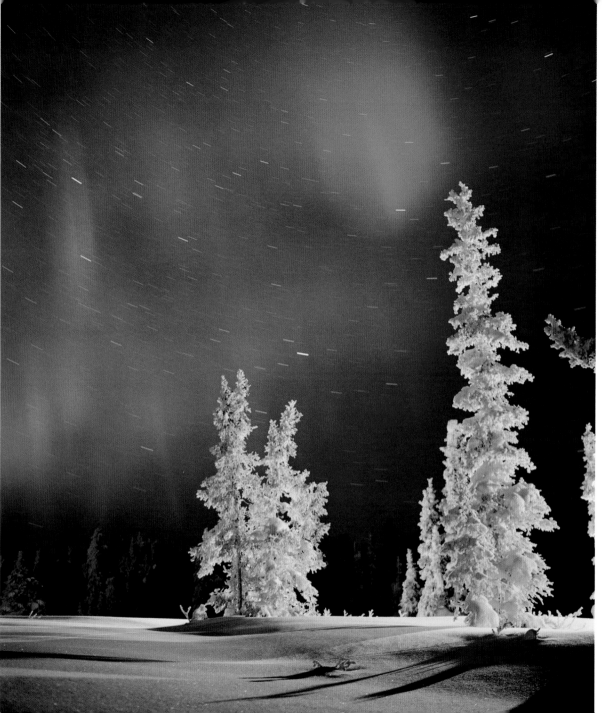

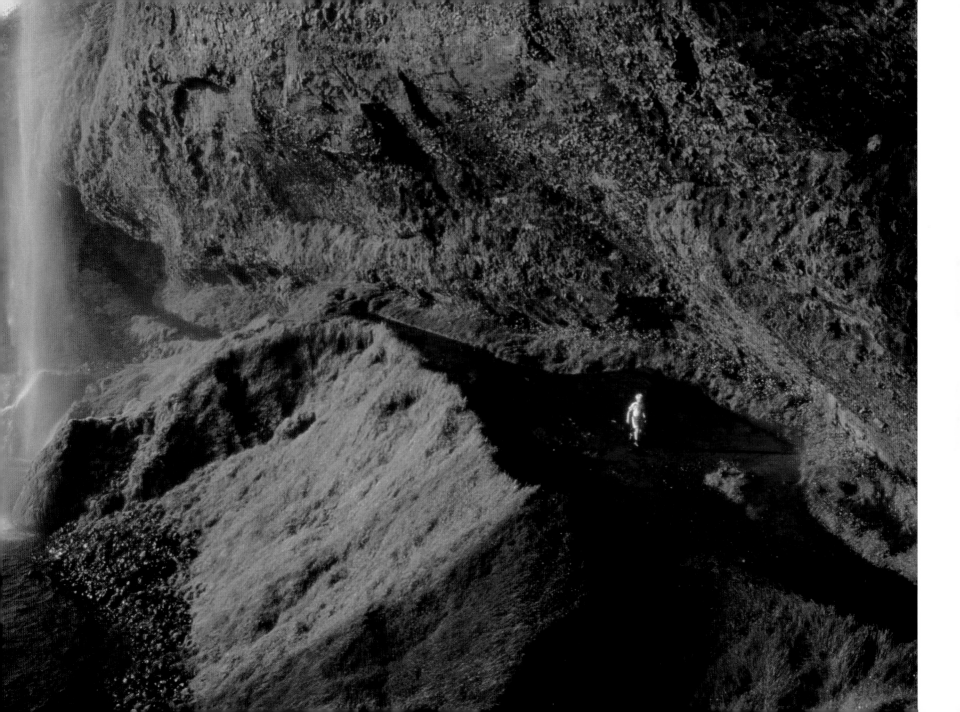

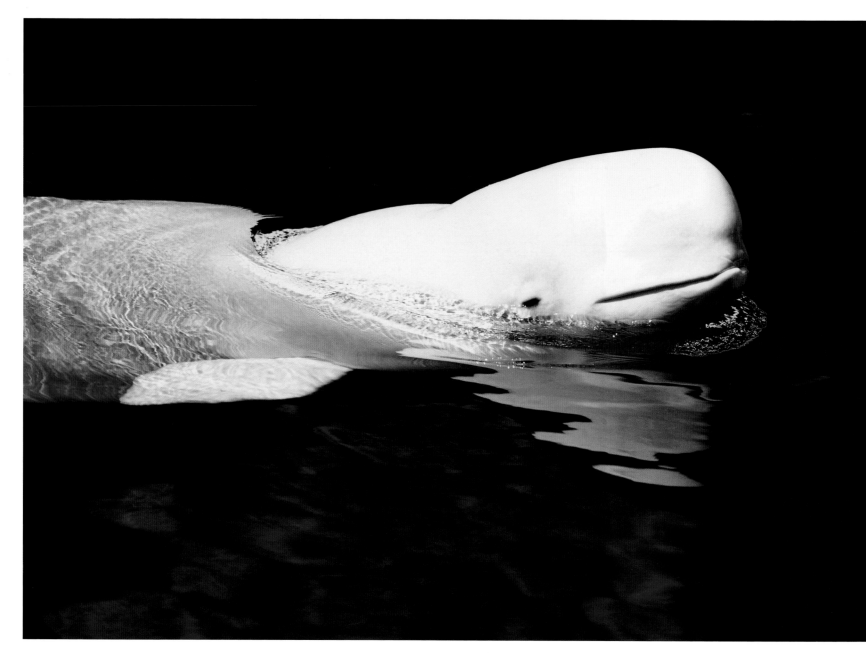

LEFT: The Beluga Whale is a small, toothed whale that usually live in the cold waters of the Arctic and Subarctic regions. Some, however, migrate south to warmer areas in the summer.

RIGHT: The bald eagle was named at a time when 'bald' meant 'white.' This individual is in Alaska, where half the world's population live.

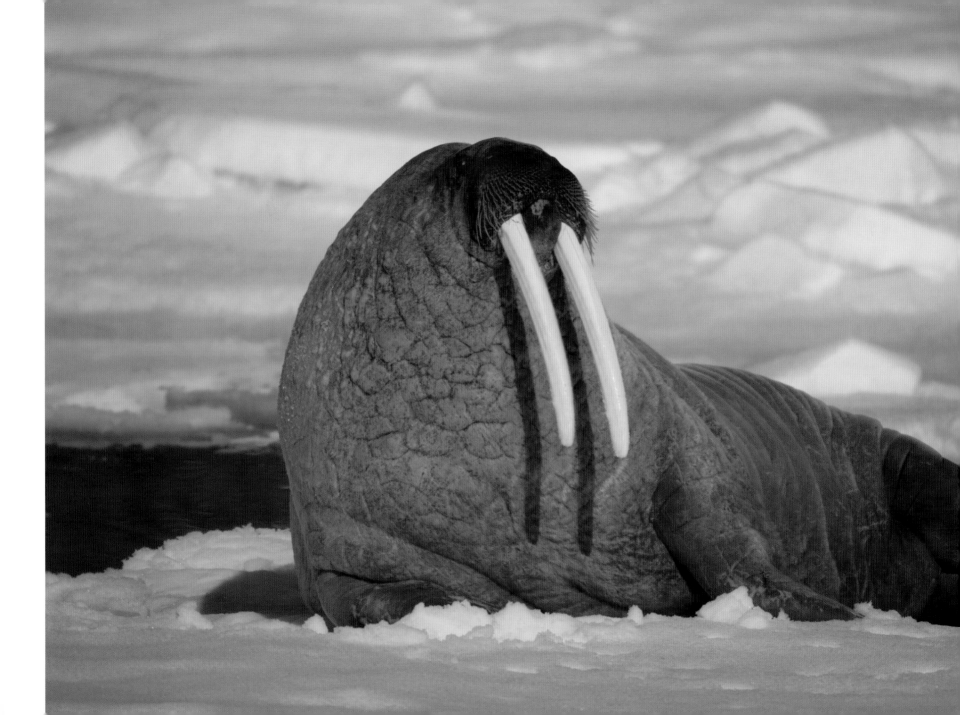

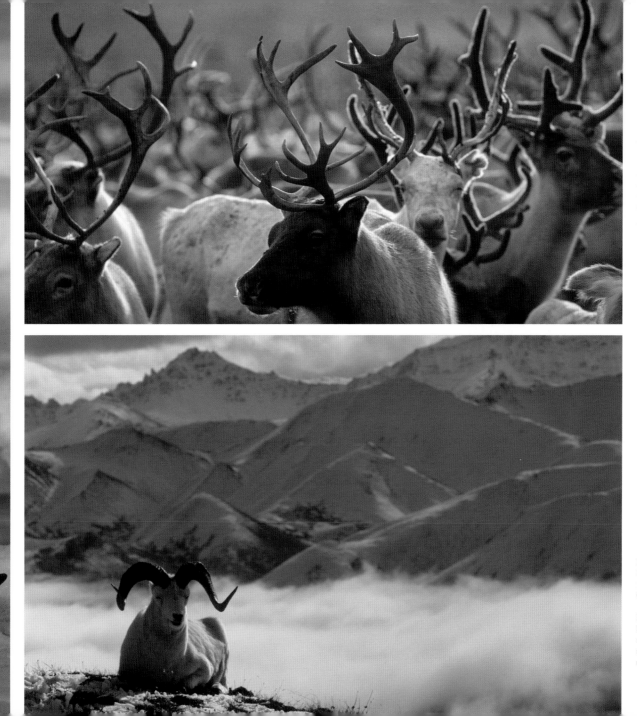

LEFT: Caribou are the only members of the deer family where both the males and females sport antlers.

BELOW LEFT: Dall sheep are relatives of the bighorn sheep, and graze the alpine tundra for young shoots. Here a ram lies on a mountain peak surrounded by the snow-covered peaks of the Alaska Range in Denali National Park, Alaska.

FAR LEFT: The diet of the walrus is mostly centered on mollusks, such as clams, although they will also feed on squid, crustaceans, fish, and even young seals if no other food is available. Svalbard, Norway.

PAGE 64: As winter ends and the sea ice of Hudson Bay begins to melt, more than 1,200 bears move into the region around Churchill, Manitoba, Canada.

PAGE 65: Polar bears are the world's largest predators with adult males reaching more than 1,500 pounds. Seals are their main prey; however, they will also scavenge given the opportunity.

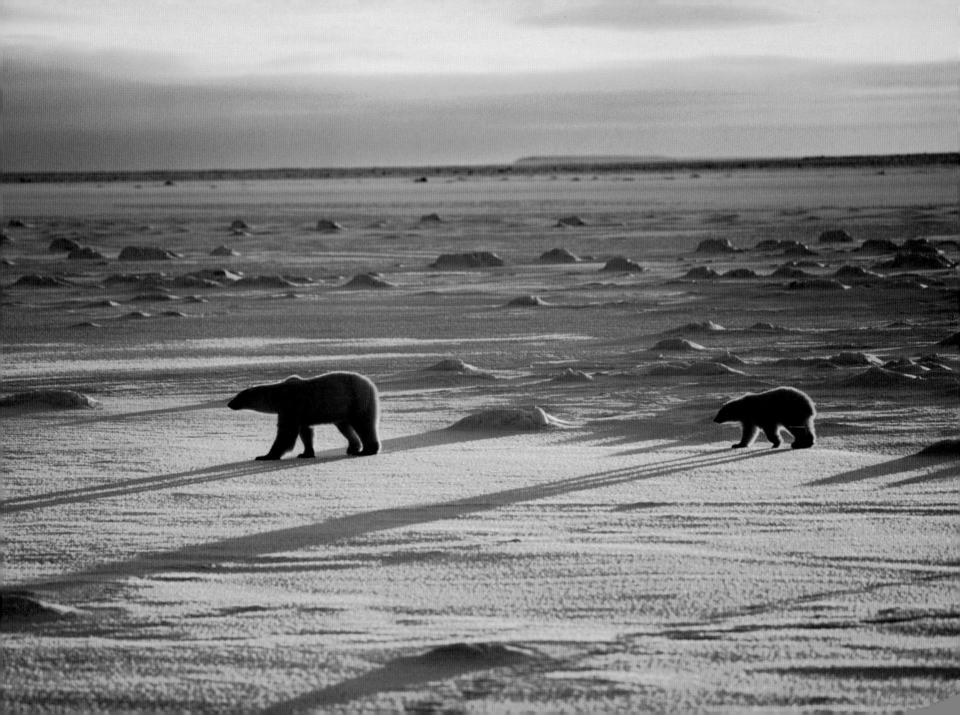

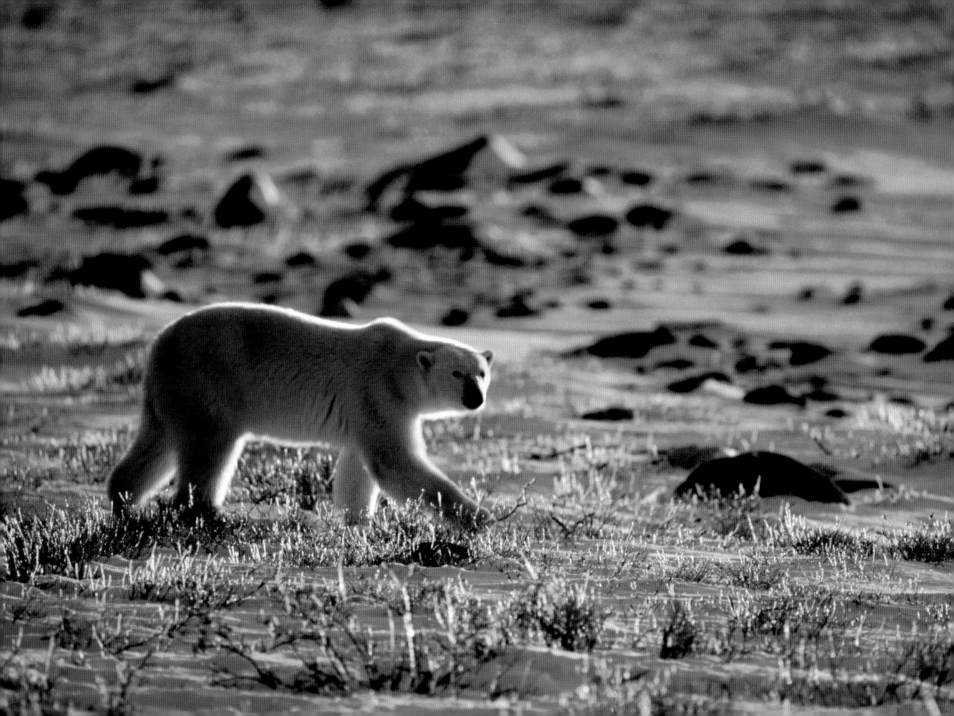

LEFT: Polar bears can be found in five countries—the United States (Alaska), Canada, Russia, Denmark (Greenland), and Norway.

RIGHT: The Arctic tern is a remarkable bird—it migrates more than 22,000 miles (35,000 kilometers) each year, farther than any other bird. It feeds on small fish, shrimp, krill, and small invertebrates.

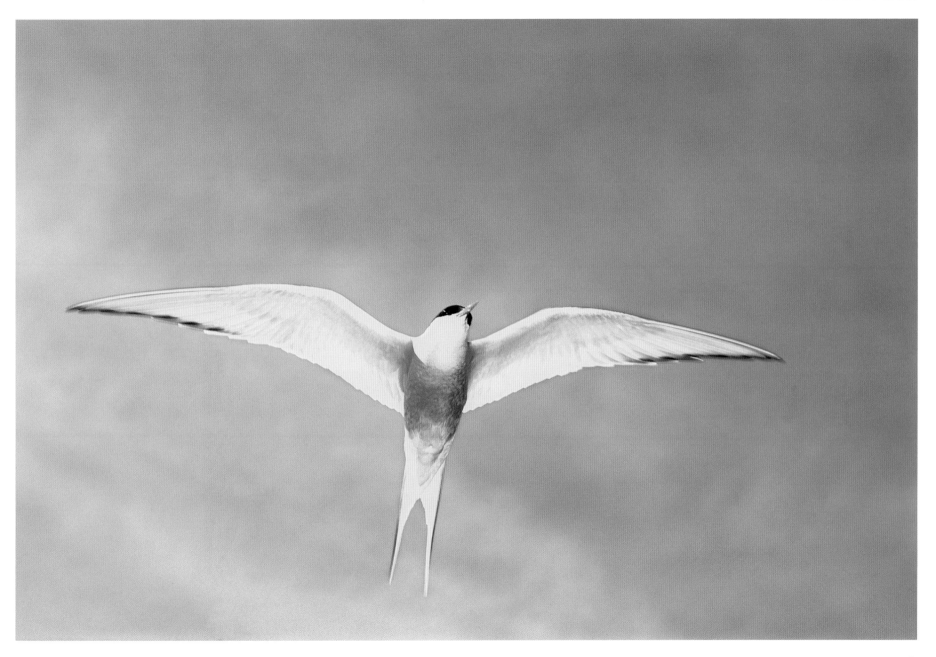

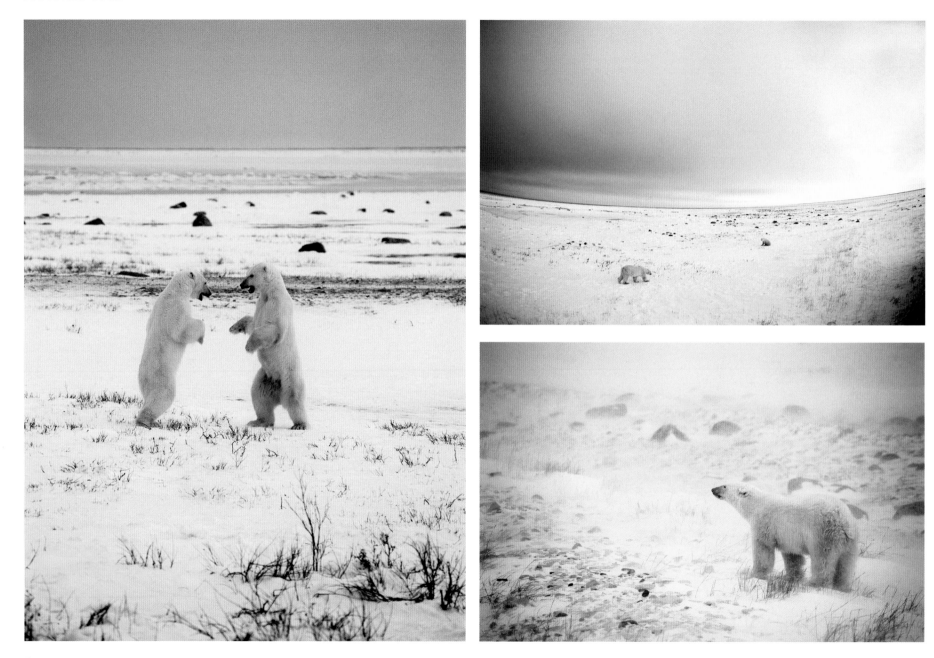

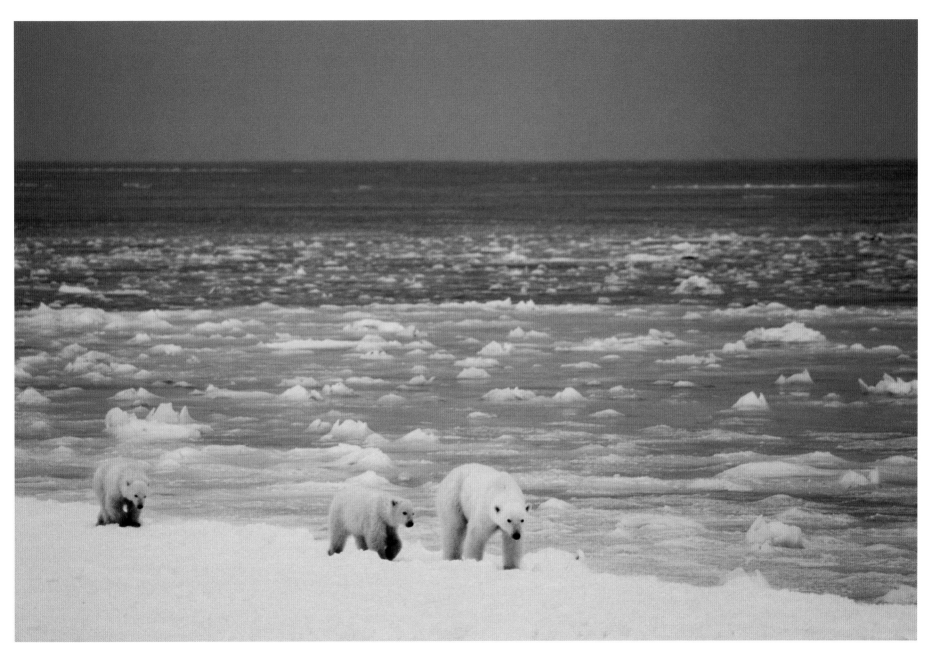

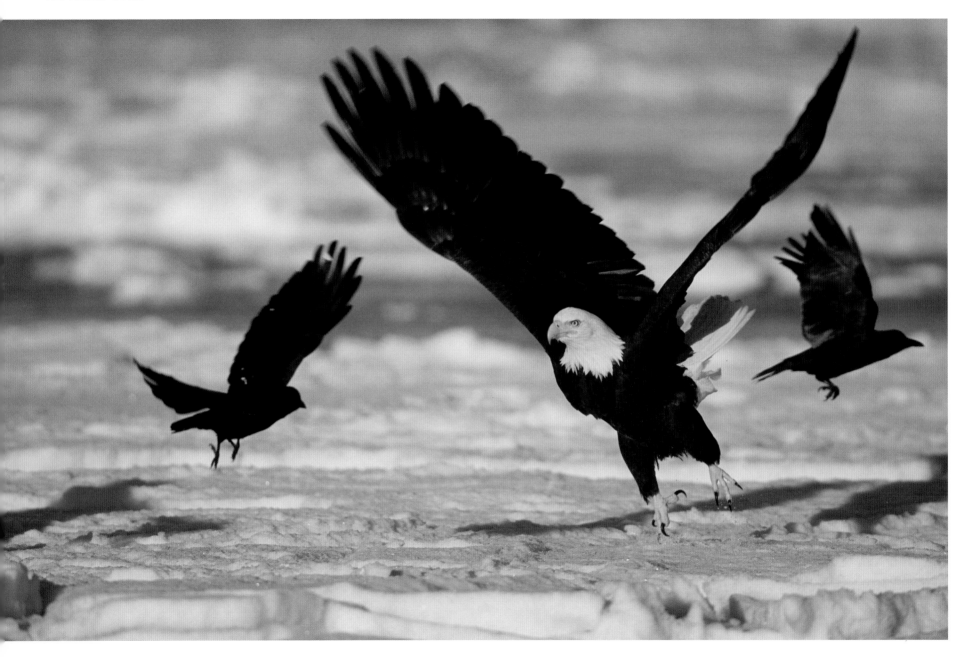

LEFT: Bald eagles can be found over most of the North American continent, from Alaska and Canada to northern Mexico. They are fish eaters, but will take whatever food they can find.

RIGHT: As polar bears grow up, they practice play-fighting so that when they are adults they know how to do it for real. This pair is fighting at dawn near Manitoba, Canada.

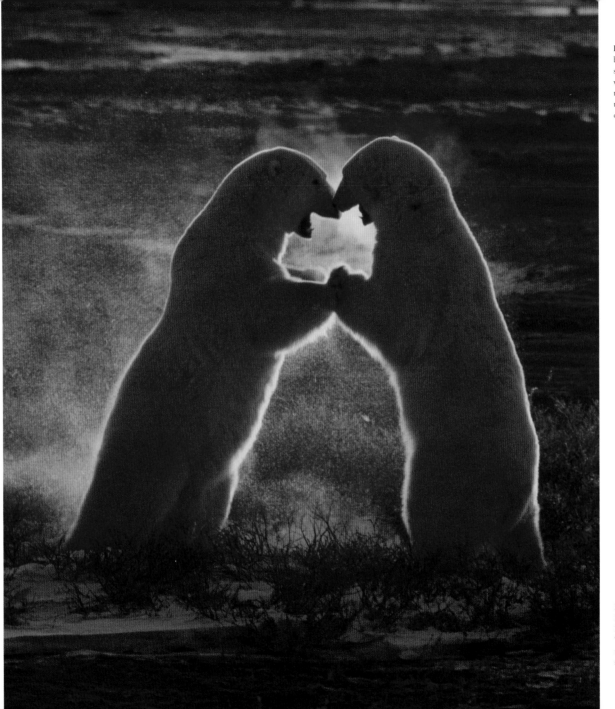

PAGES 68–69: Polar bears inhabit a cold, blue-white world and are completely suited to the environment. Global warming threatens their habitat and, as the ice melts and the pack ice retreats, they will not be able to move as freely over such long distances as before.

PAGES 72–73: This mountain in the Kenai Mountains, Kachemak Bay State Park, Alaska, is being lit by alpenglow. This is an optical phenomenon caused by the rays of the setting sun reflecting off snow and ice.

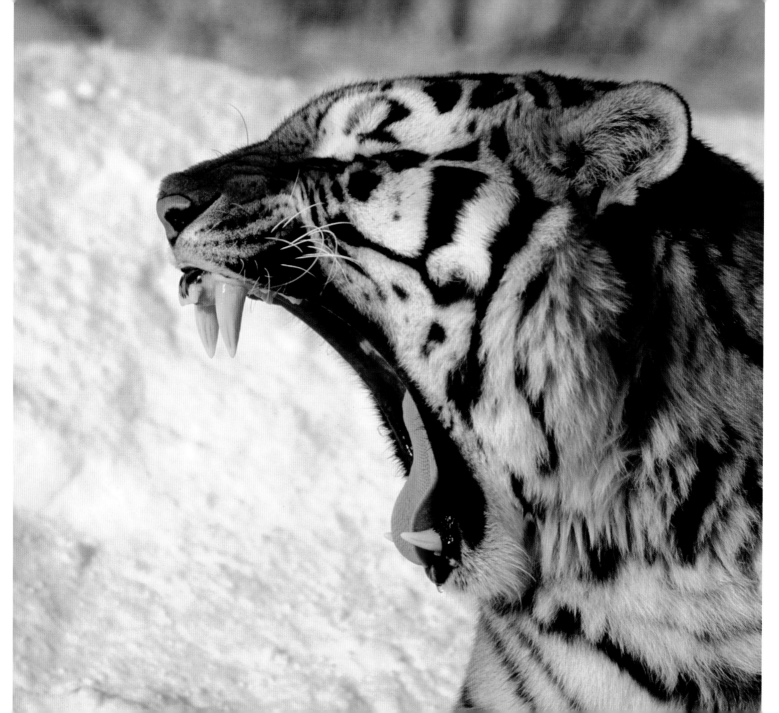

LEFT: Siberian tigers are endangered, and there are fewer than 5,000 left in the forests of eastern Asia, northern China, and Manchuria. They eat all types of animals ranging from deer to frogs.

RIGHT: In the winter the fur of the Arctic fox turns white so that it can approach its prey without being seen. This individual is resting near Hudson Bay, Churchill, Cape Churchill, Manitoba, Canada.

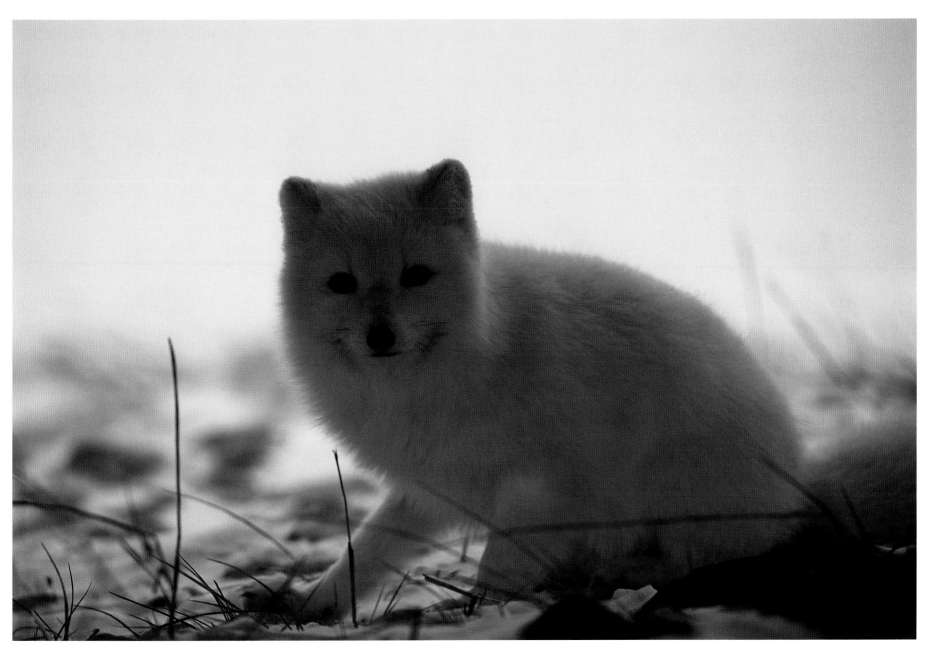

RIGHT: The numbers of lynx in a given area are linked to the numbers of snowshoe hares in the region. When the hares are numerous, the lynx does well, but when they are scarce, the cats suffer.

FAR RIGHT: The gyrfalcon is a bird of prey that nests across the Arctic regions of North America, Europe, Asia, Greenland, and Iceland. It uses a fast, low flight to chase ptarmigan, grouse, and other small creatures.

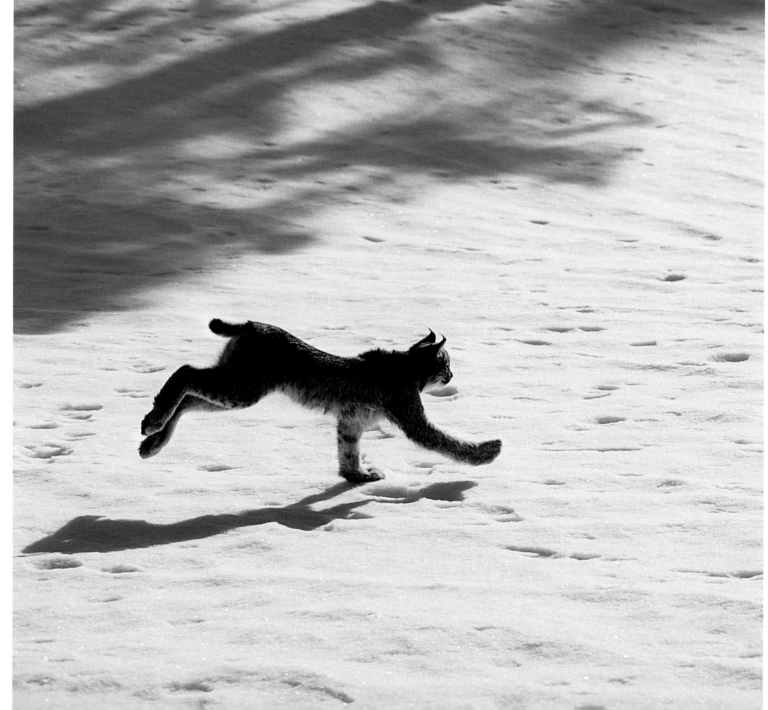

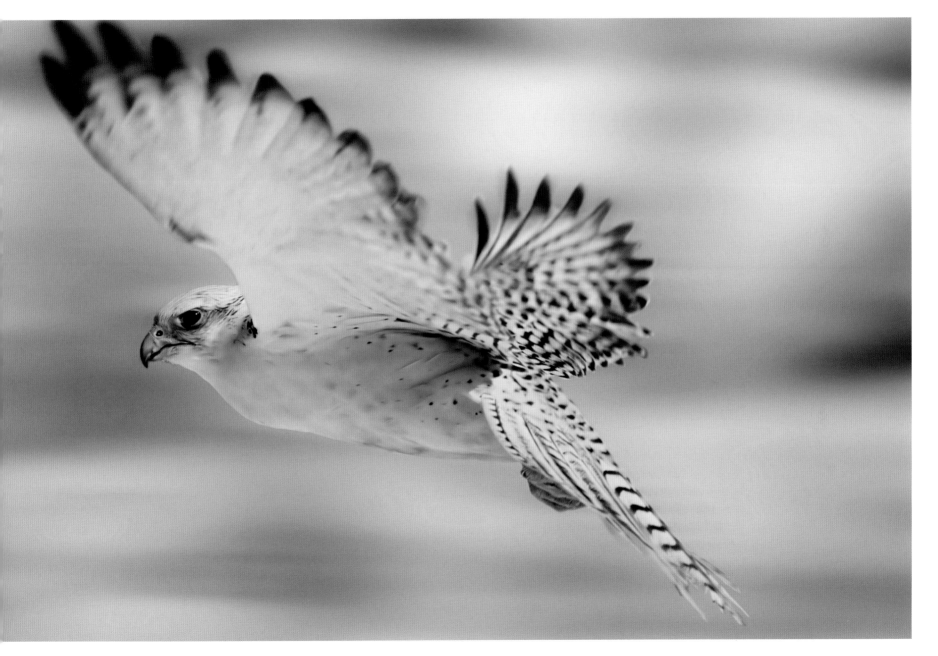

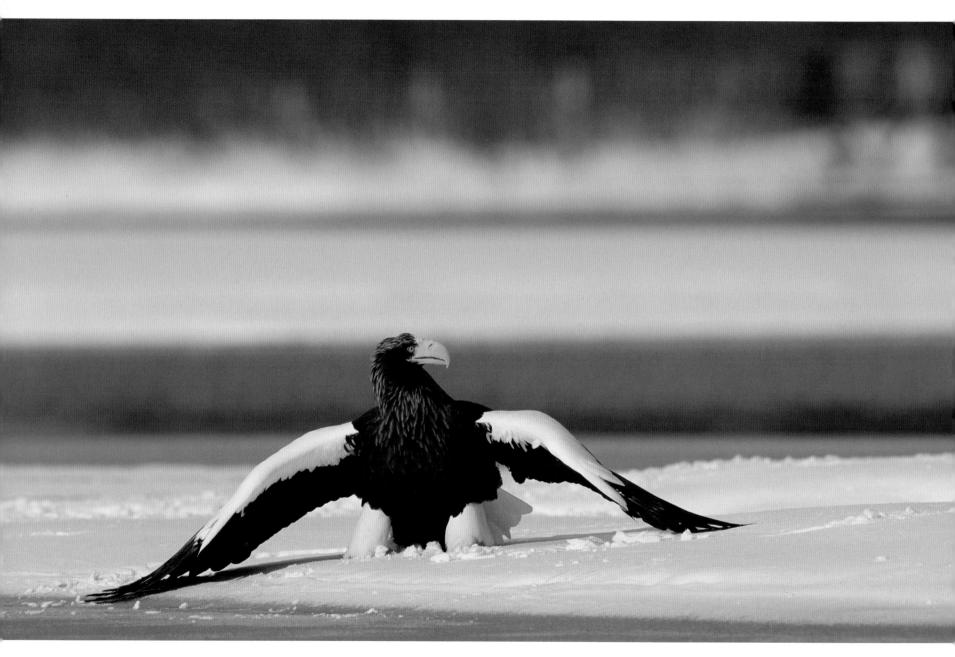

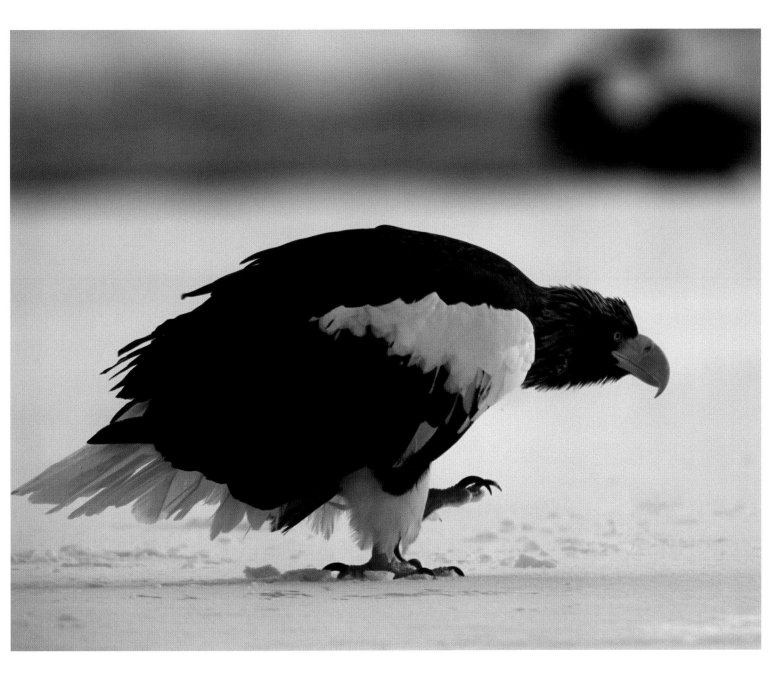

LEFT: The diet of the Steller's sea eagle consists mainly of salmon—it is equally happy catching and eating them alive or scavenging from dead ones. Kamchatka Peninsula, Russia.

FAR LEFT: The impressive Steller's sea eagle only occurs in eastern Asia, where it breeds inland along river valleys and on lakes. This individual is on the Kamchatka Peninsula, Russia.

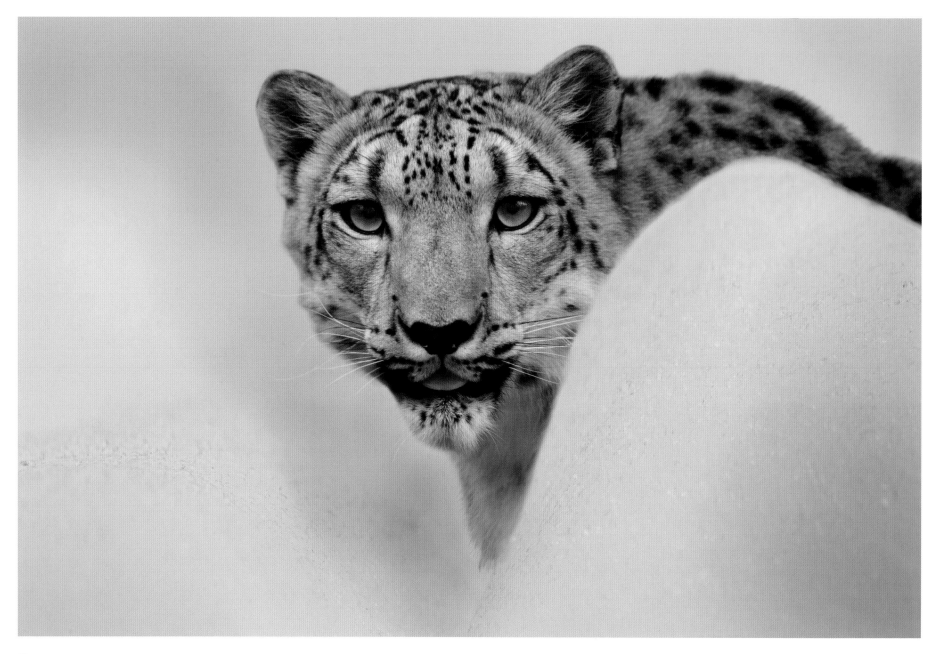

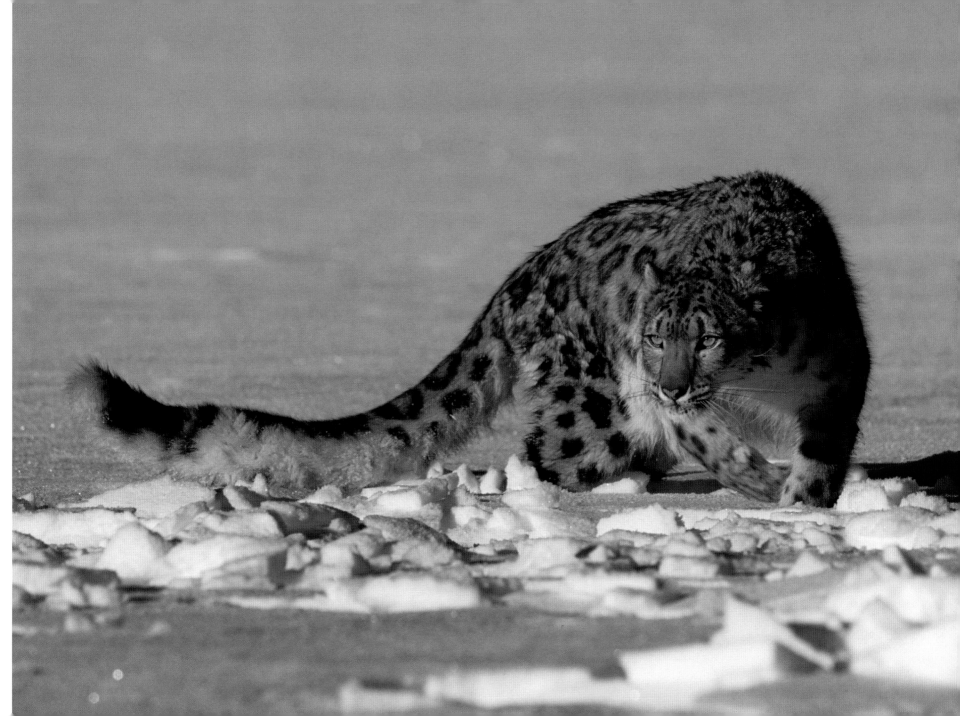

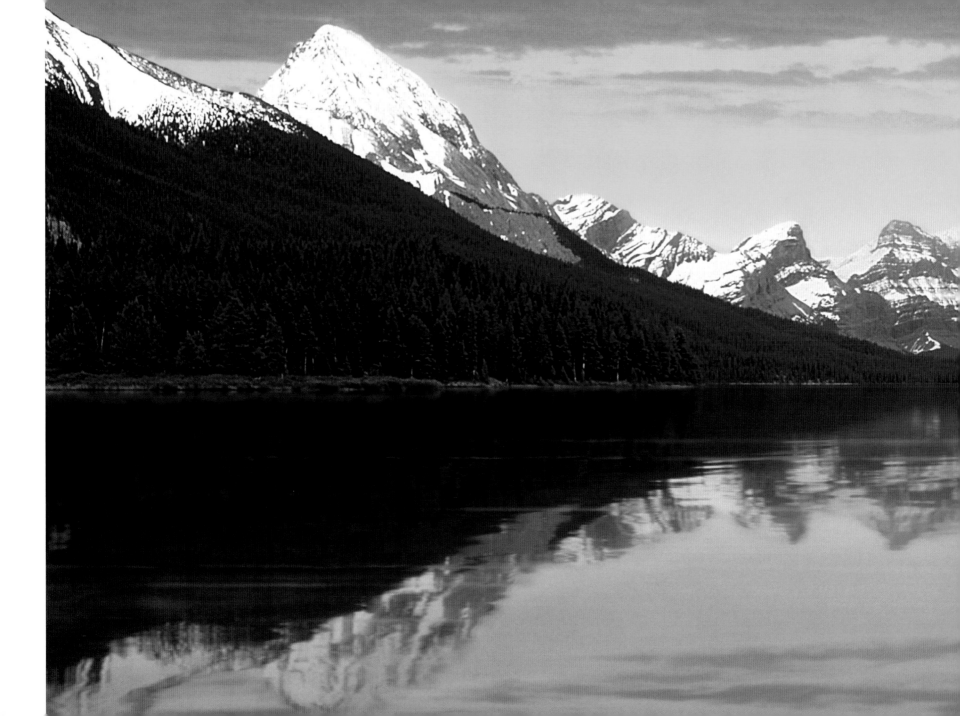

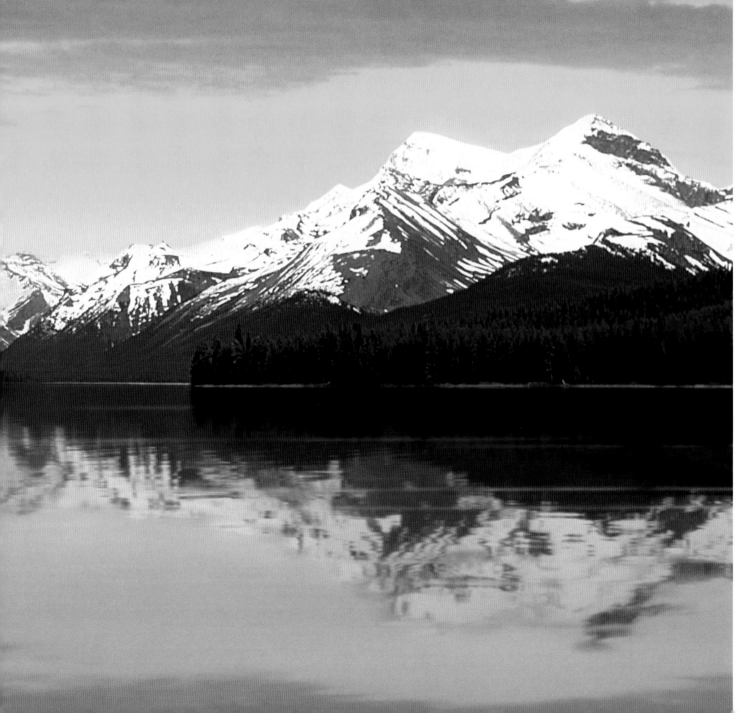

PAGE 80: The snow leopard is not closely related to the leopard. It has long, woolly fur that helps to protect it from the extreme cold of the mountainous habitats it frequents.

PAGE 81: Although snow leopards are rare, they are distributed across most of the mountainous regions of central Asia, from Russia and Mongolia through China, Tibet, Afghanistan, Pakistan, and India

LEFT: This wonderful view is of Maligne Lake, which at 14 miles (22 kilometers) long is the second largest glacier-fed lake in the Rockies. Jasper National Park, Alberta, Canada.

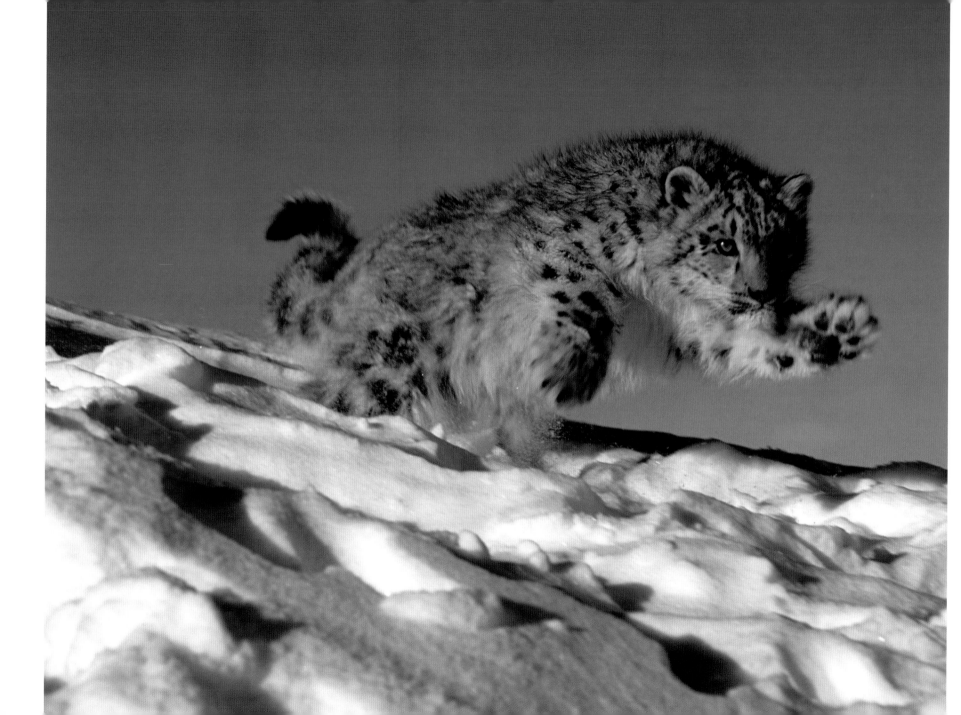

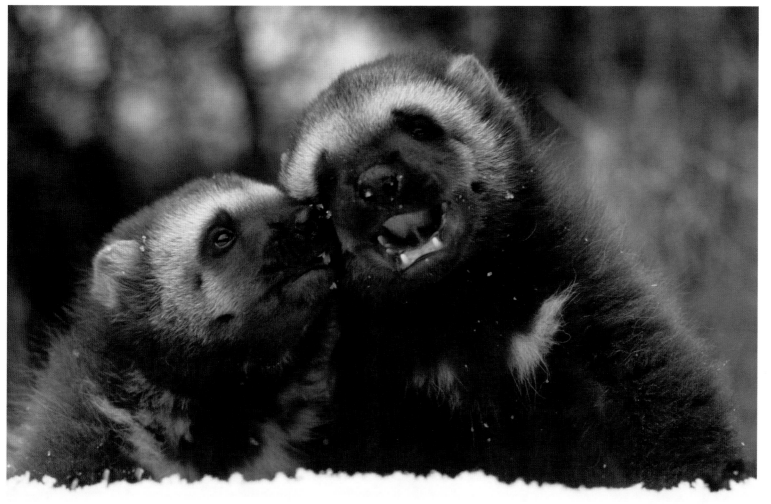

LEFT: Here two wolverine kittens are playing in the snow. Related to mink and weasel, they were once hunted extensively for their dense fur. As a result they have disappeared from most of the eastern United States and Canada.

FAR LEFT: The snow leopard often keeps below the skyline and pounces down onto its victim, with its main prey being wild sheep, goats, deer, marmots, and various other small animals.

PAGE 86: The harp seal is distributed across the North Atlantic and Arctic oceans, from northern Russia to Newfoundland and the Gulf of St. Lawrence, Canada. Here a pup rests in the snow.

PAGE 87: Harp seals give birth to a single pup that weighs about 10 kilograms (22 lbs.) between mid-February and March.

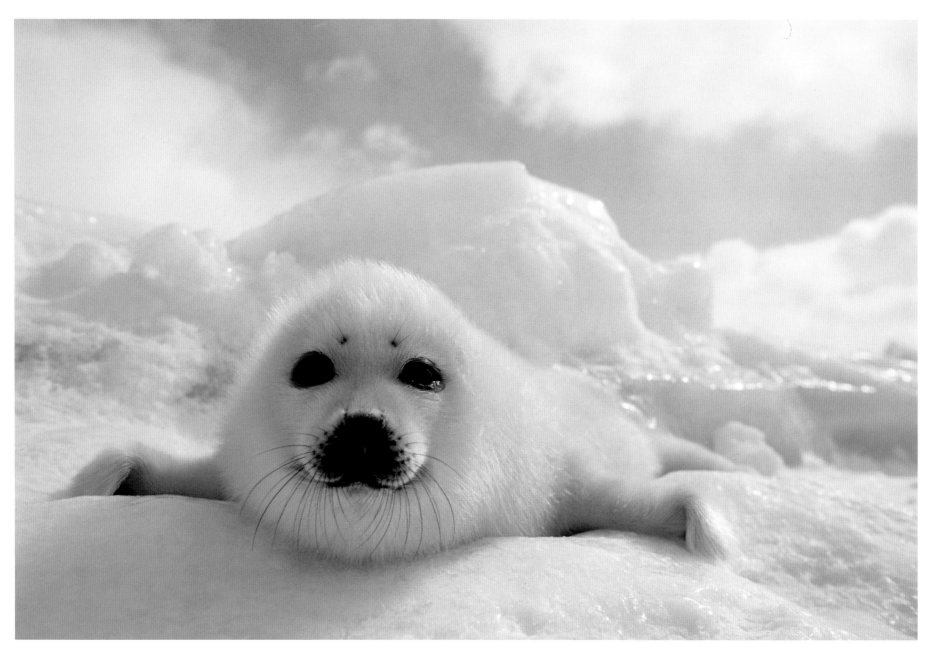

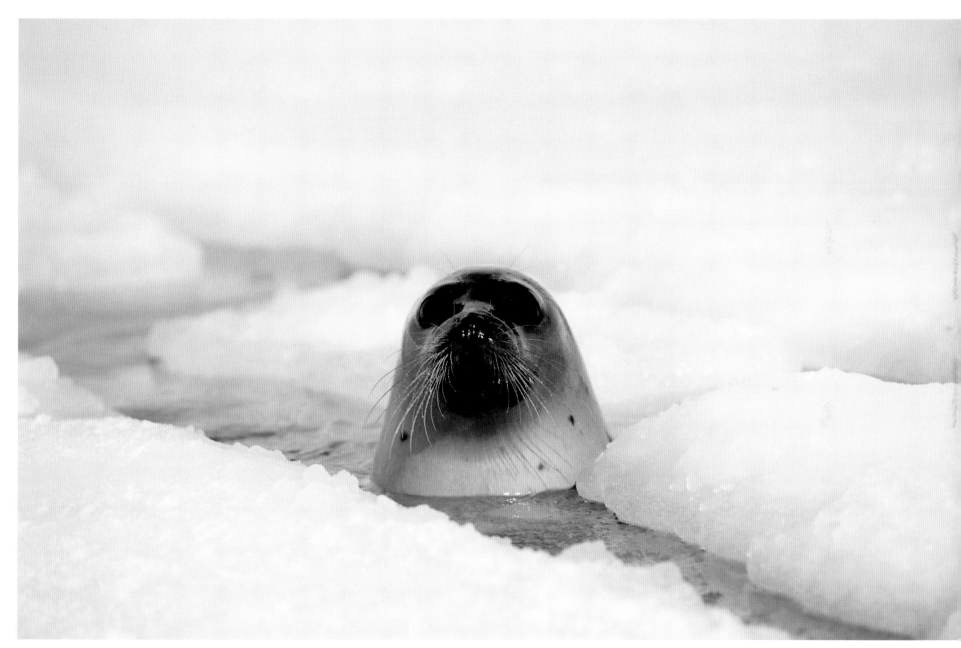

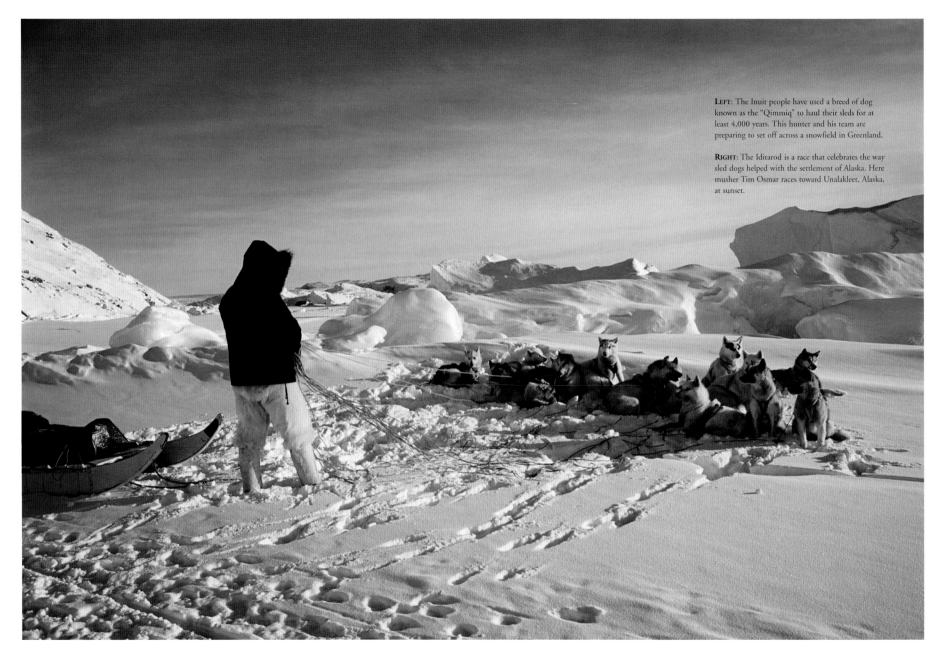

LEFT: The Inuit people have used a breed of dog known as the "Qimmiq" to haul their sleds for at least 4,000 years. This hunter and his team are preparing to set off across a snowfield in Greenland.

RIGHT: The Iditarod is a race that celebrates the way sled dogs helped with the settlement of Alaska. Here musher Tim Osmar races toward Unalakleet, Alaska, at sunset.

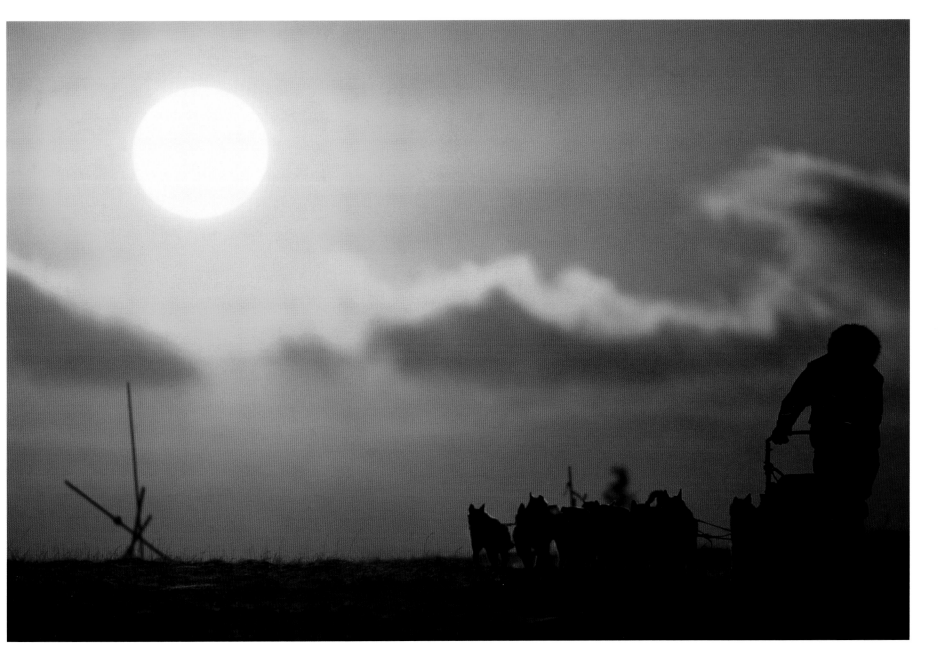

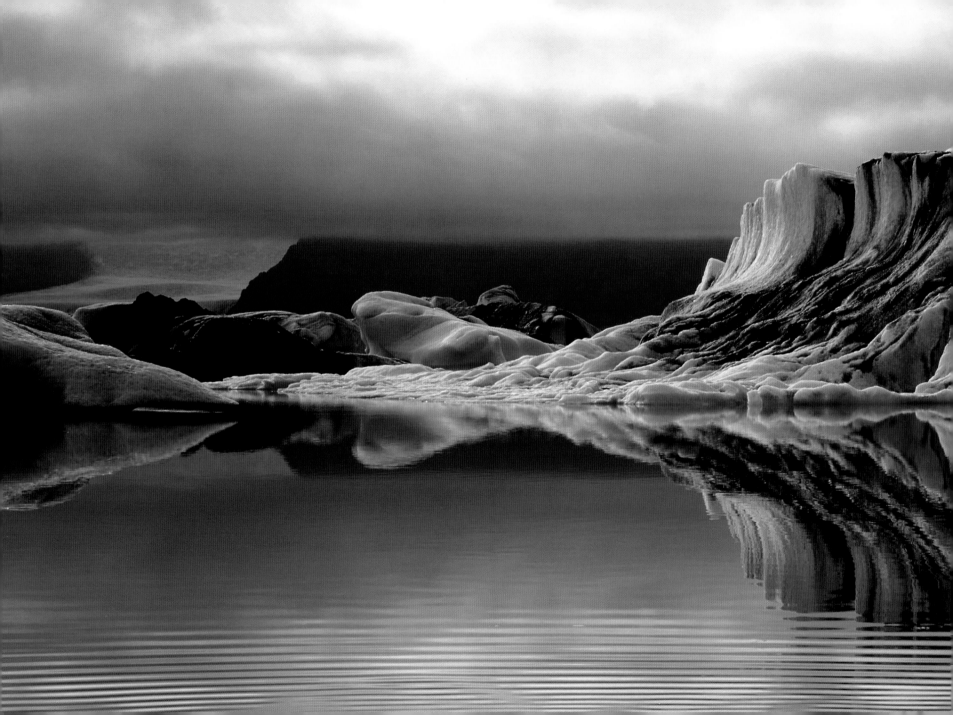

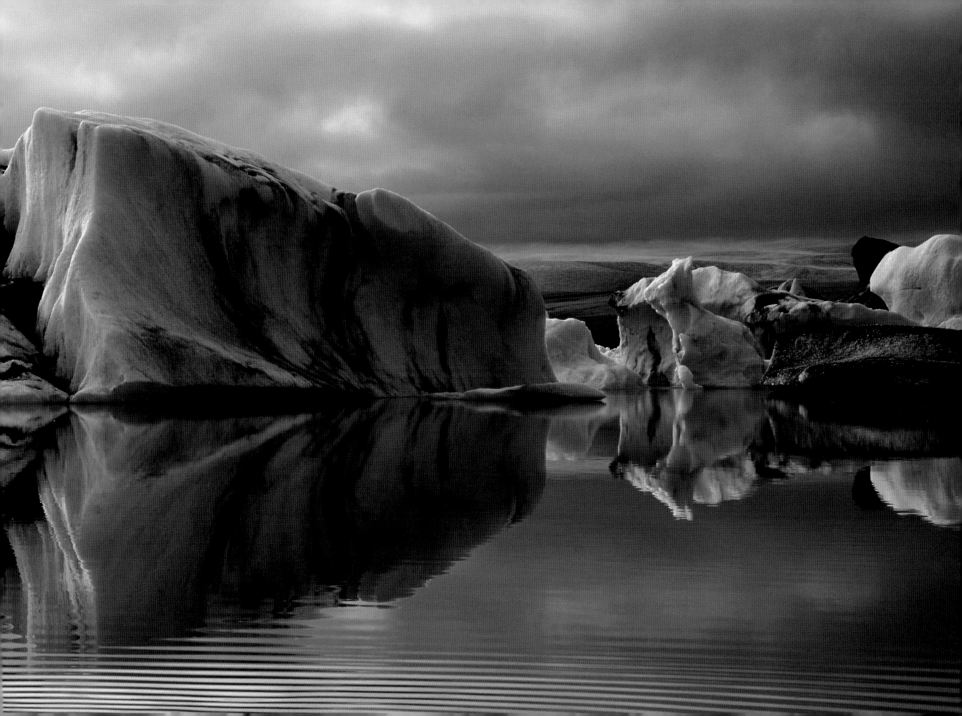

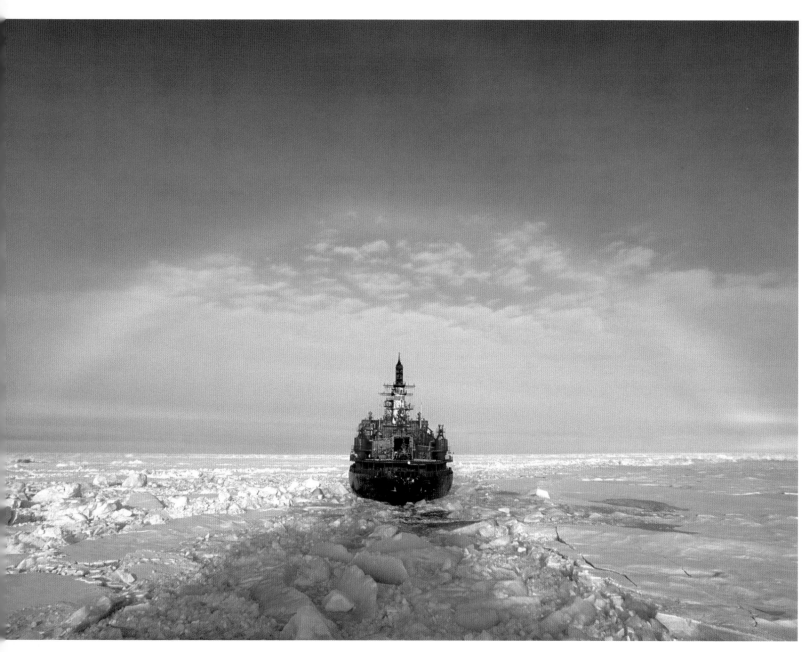

PAGES 92–93: Jokulsarlon is a lagoon off Iceland where several glaciers come to an end. In this image the still waters reflect the magnificent landscape.

LEFT: Icebreakers are specialized ships that can force their way through sheets of pack ice up to five meters thick. This Russian vessel called the *Yamal* is making way off the Greenland coast.

RIGHT: Being both quiet and environmentally friendly, canoes are an excellent mode of transport for those who want to see native subarctic fauna and flora in their natural settings. Alaska.

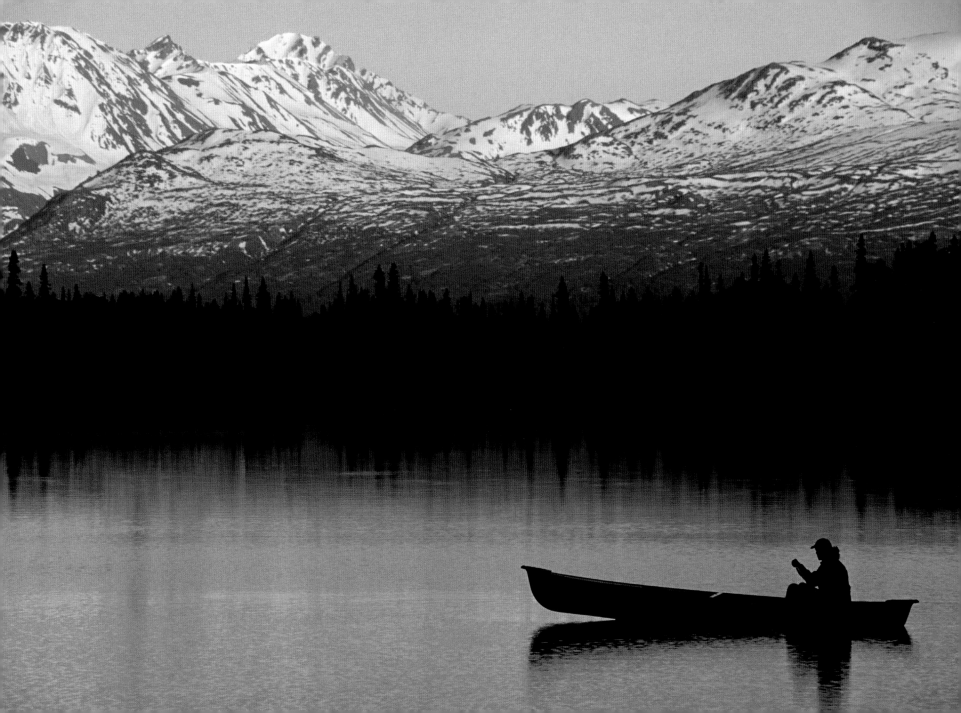

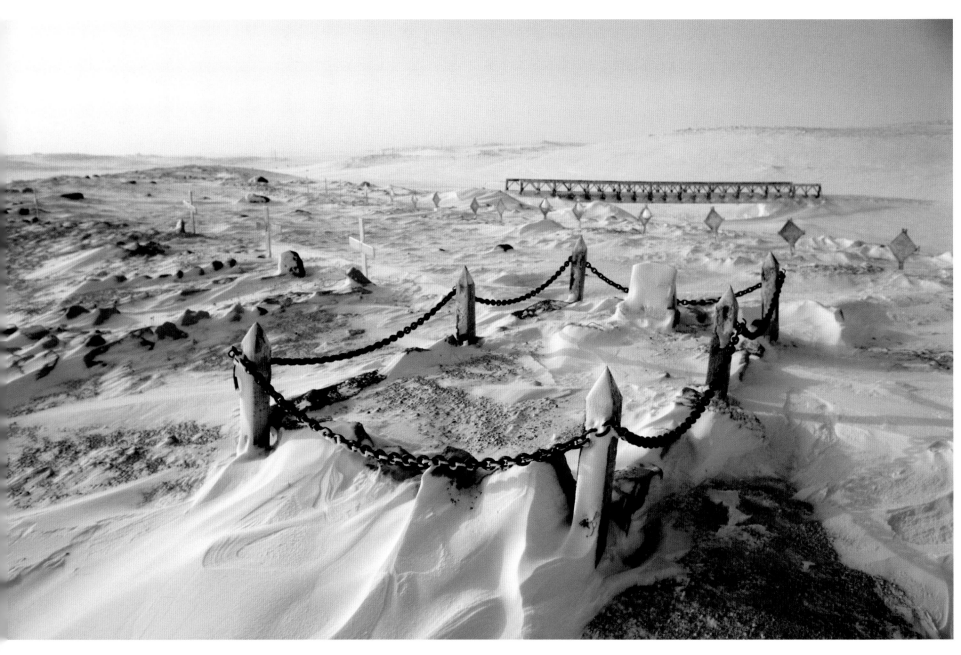

RIGHT: Coyotes are excellent opportunists, being both hunters and scavengers. This individual is feeding off a carcass that was lying in the snow.

FAR RIGHT: When winter comes to Hudson Bay, the sea freezes and polar bears move out onto the ice to hunt seals. They start assembling in late October, a time at which viewing the large animals is popular with tourists. Churchill, Manitoba, Canada.

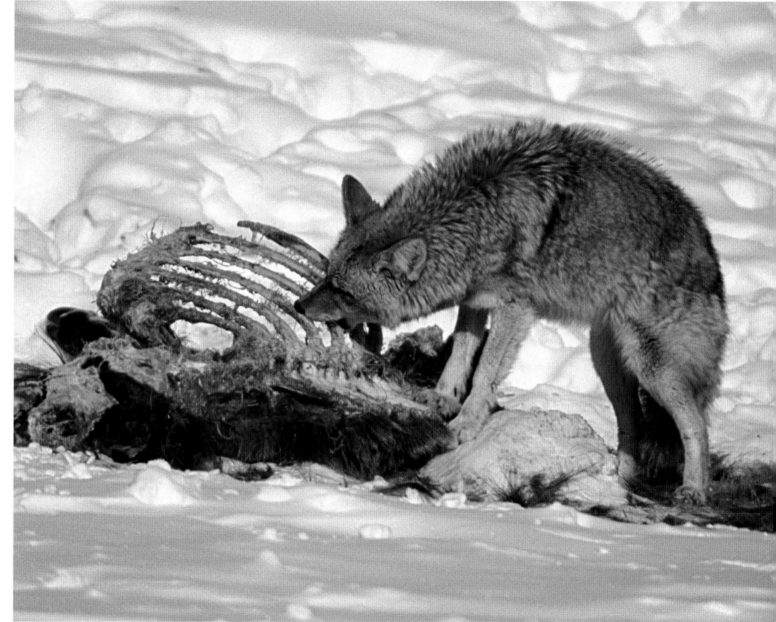

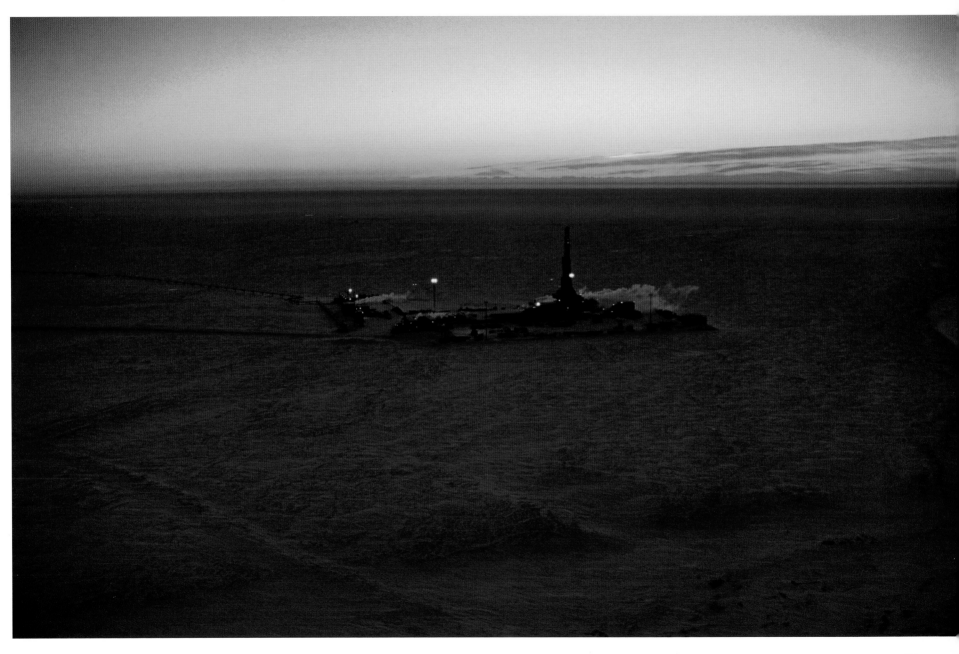

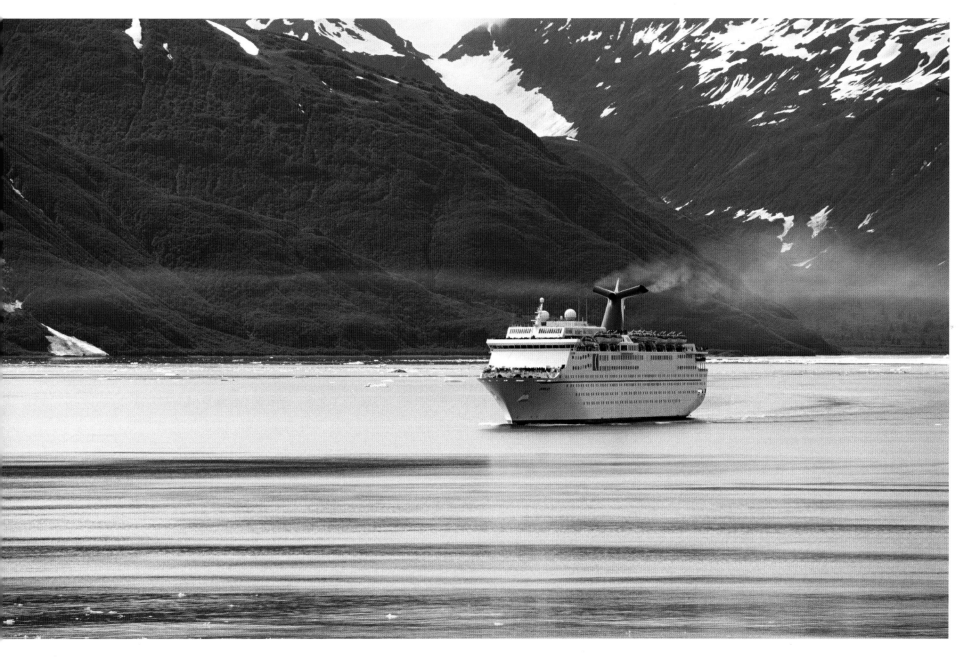

LEFT: This snow-covered Inuit cemetery is situated on Cambridge Bay, which has been the site of native summer gatherings for hundreds of years. Nunavut, Canada.

RIGHT: The Inuit have hunted caribou since they first moved into the region. These days they have the advantage of modern hunting rifles with telescopic sights. Baffin Island, Nunavut, Canada.

PAGE 96: This cruise ship is sailing past shorelines that were completely covered with ice until around 200 years ago. Glacier Bay National Park and Preserve, Alaska.

PAGE 97: Oil was discovered at Prudhoe Bay, Alaska, in 1968, and the oil fields there are now the largest in North America. Unfortunately, they have had a very bad effect on the local environment.

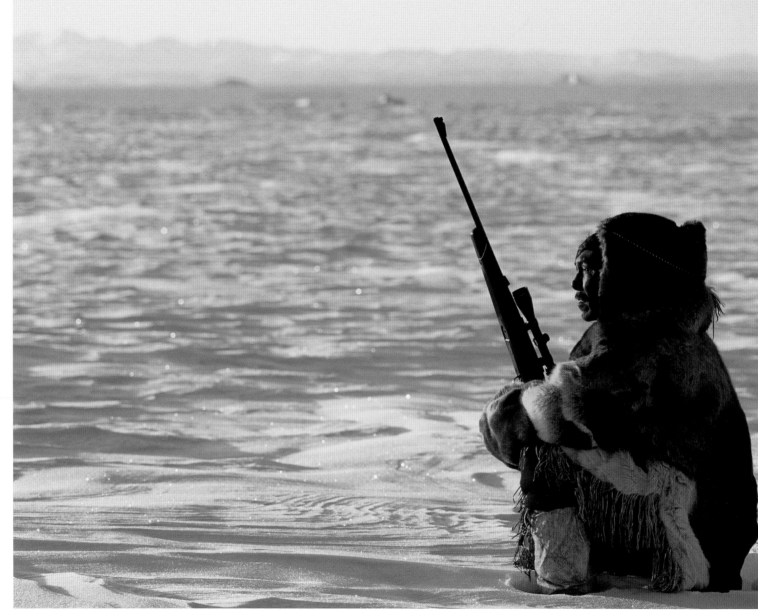

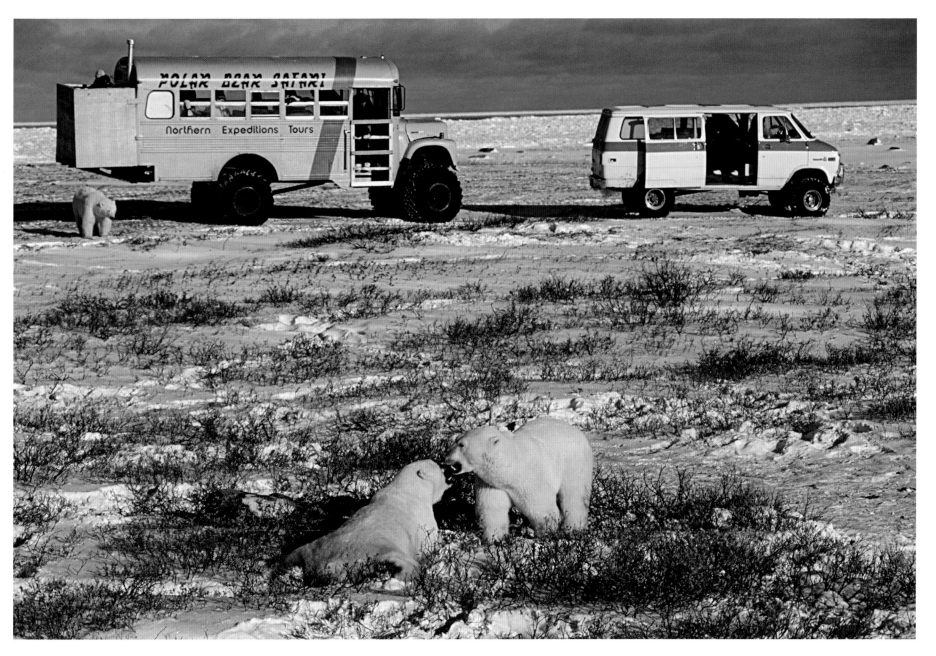

ABOVE: As with any mountainous region, the weather in Alaska can be calm one moment and extreme the next. Here an aerial view shows clouds gathering.

RIGHT: The Saint Elias Range, located in southeastern Alaska and southwestern Yukon Territory, is the highest coastal range in the world. This peak is in the Kluane National Park, Canada.

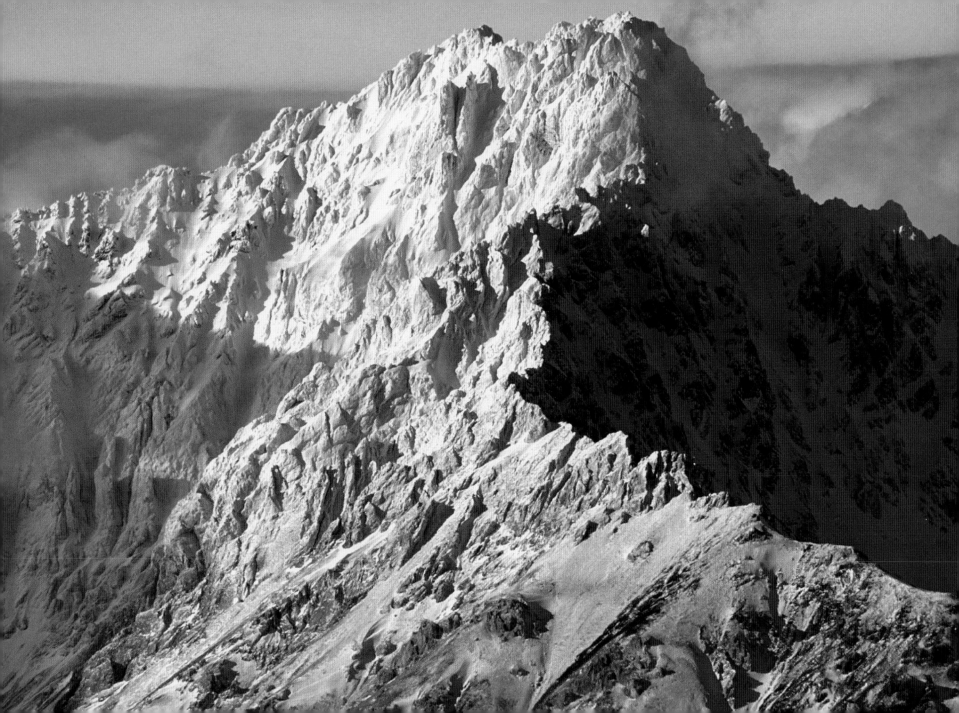

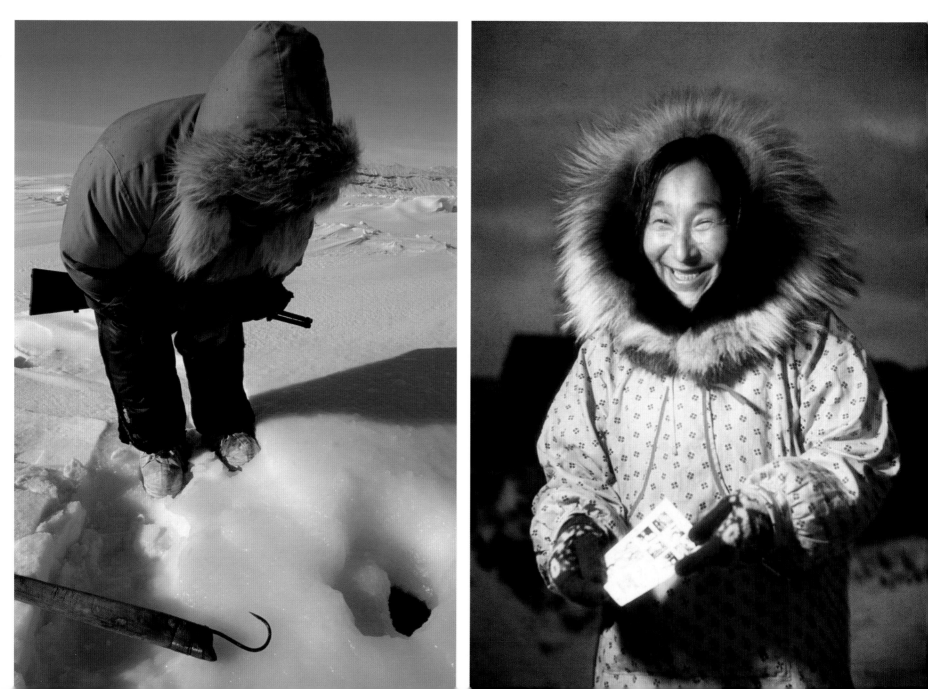

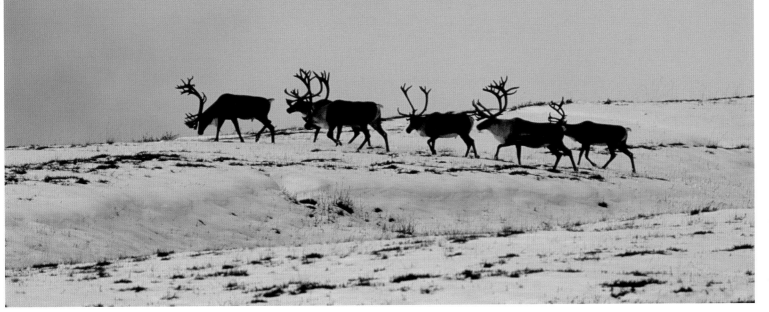

LEFT: A reindeer herd in the snow. Many of the animal species found in the subarctic range over wide areas, and are therefore also found further north in the true Arctic.

CENTER LEFT: A laughing Inuit woman standing in the snow in Tutoyaktuk which is in the district of Inuvik, Northwest Territories, Canada. Although the Arctic Region has an extremely harsh environment, there are several native peoples who live nowhere else.

FAR LEFT: An Inuit hunter stands watching a seal's breathing hole in the ice on frozen Resolute Bay. When a seal comes up to breathe he will shoot it and hook it with a sharp hook.

PAGES 104–105: Icebergs are formed when ice breaks away from glaciers. With global warming, where once there was ice between six and nine feet thick, there is now water. The pole is melting for the first time in more than 50 million years. As glaciers retreat, more of their bulk is leeched away as run-off water rather than icebergs.

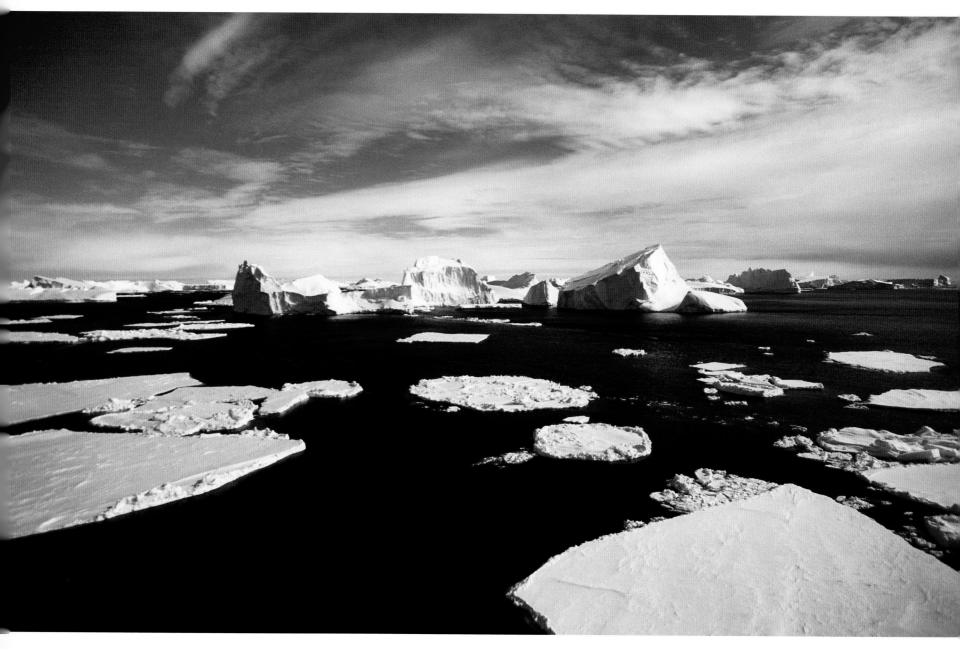

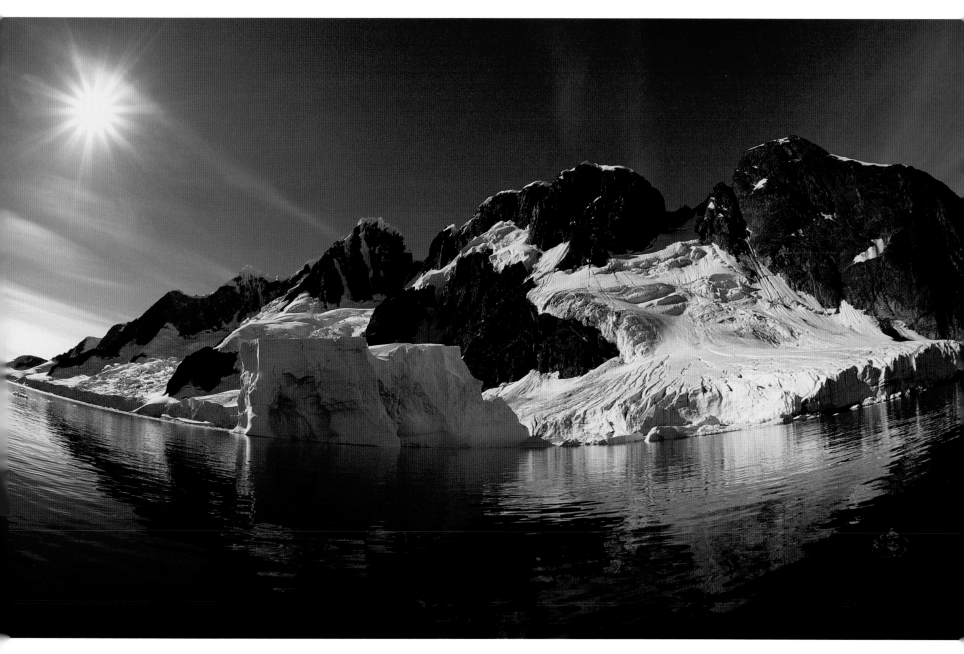

THE ANTARCTIC REGION

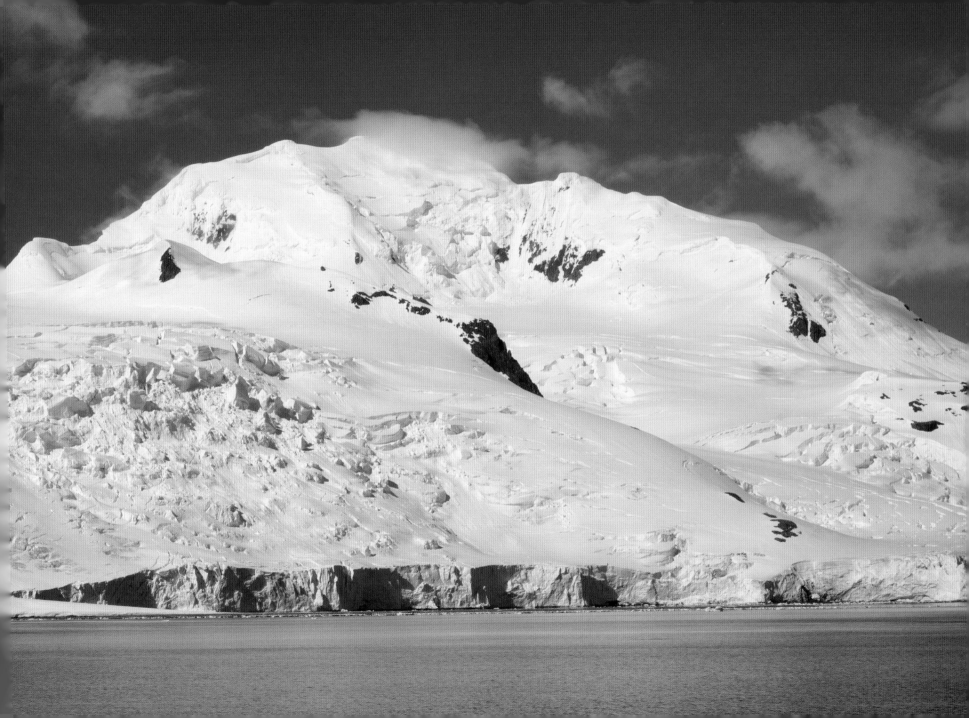

Introduction

The Antarctic Region is the area south of the Antarctic Circle, centered on the South Pole. By far the greatest landmass in the region is Antarctica itself, covering more than 13 million square kilometers. Antarctica has many high mountains and glaciers, and is the only uninhabited continent on Earth. All the islands south of 60 degrees latitude are considered to be part of the Antarctic Region, even though they lie outside the true demarcation line. These include the South Orkney Islands, Peter I Island, Scott Island, and the Balleny Islands. At the South Pole, which has an altitude of 2,800 meters, there is a comparatively large American-run research station called Amundsen-Scott.

The subantarctic region is comprised of southern Chile, Patagonia, and New Zealand, as well as many islands. Heard Island, Macquarie Island, and the McDonald Islands belong to Australia, and the Auckland Islands and Campbell Island belong to New Zealand. Bouvet Island (also known as Bouvetøya) belongs to Norway, and the Crozet Islands and the Kerguelen Islands belong to France. The Prince Edward Islands are South African territory, and the South Georgia Islands, the South Sandwich Islands, and the South Shetland Islands all belong to the United Kingdom.

For many years the ownership of Antarctica was argued over by various countries; however, these disagreements were all stopped when a treaty was put into force in 1961, at the height of the Cold War. Signed by twelve countries, including the United States and the Soviet Union, it was composed of several different agreements known collectively as the "Antarctic Treaty System." The treaty set Antarctica aside as a scientific reserve and banned all military activity within the Antarctic Circle. It also banned any nuclear testing and the disposal of any radioactive waste. This treaty was ahead of its time in many ways, and has ensured that Antarctica has not suffered from adverse commercial exploitation.

Simple plant forms can still be found in all the ice-free areas, however. Even in what are probably the harshest non-frozen habitats on Earth—the desert valleys of Victoria Land—primitive algae, fungi, and lichens manage to survive by secreting themselves in crevices and holes across the rocky terrain. Elsewhere, there is a much greater plant diversity, with the region having a total of around 300 to 400 species of lichens, 20-odd species of macro-fungi, 25 species of liverworts, about 100 species of mosses, and many hundreds of species of algae.

The environment of the Antarctic region is too harsh for the vast majority of animal species to survive. This, coupled with its complete isolation from other landmasses, means there are no native land mammals. In addition, there are no higher insects, reptiles, or amphibians, and it is only in the places where vegetation exists that small arthropods can be found. Where the region consists of frozen deserts, the only animals able to survive are a few species of microscopic nematode worms, making these the least diverse habitats on

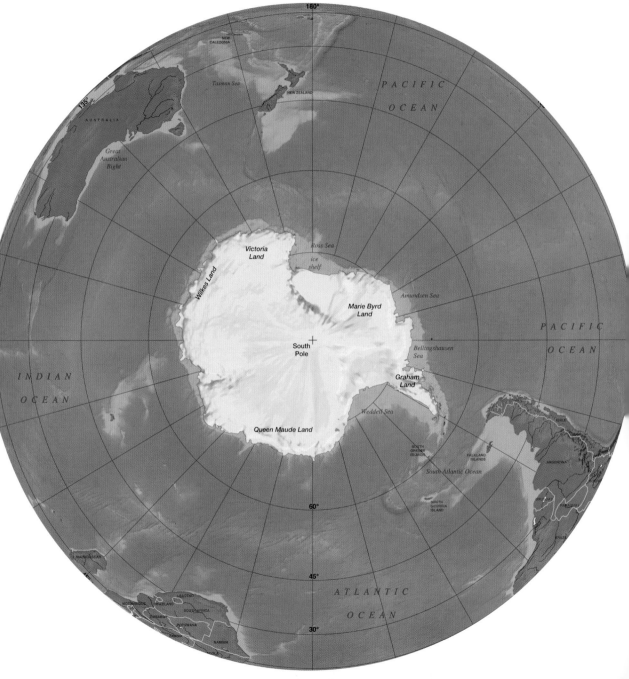

PAGES 106–107: Half Moon Island is a popular destination for cruise ships that visit Antarctica. It has a large colony of chinstrap penguins, and whales are often seen off the coast.

LEFT: Map showing Southern Hemisphere and Antarctica.

RIGHT: Tourism within the Antarctic Circle is becoming increasingly popular— here a Holland America Line cruise ship passes through the morning mist in Lemaire Channel, Antarctica.

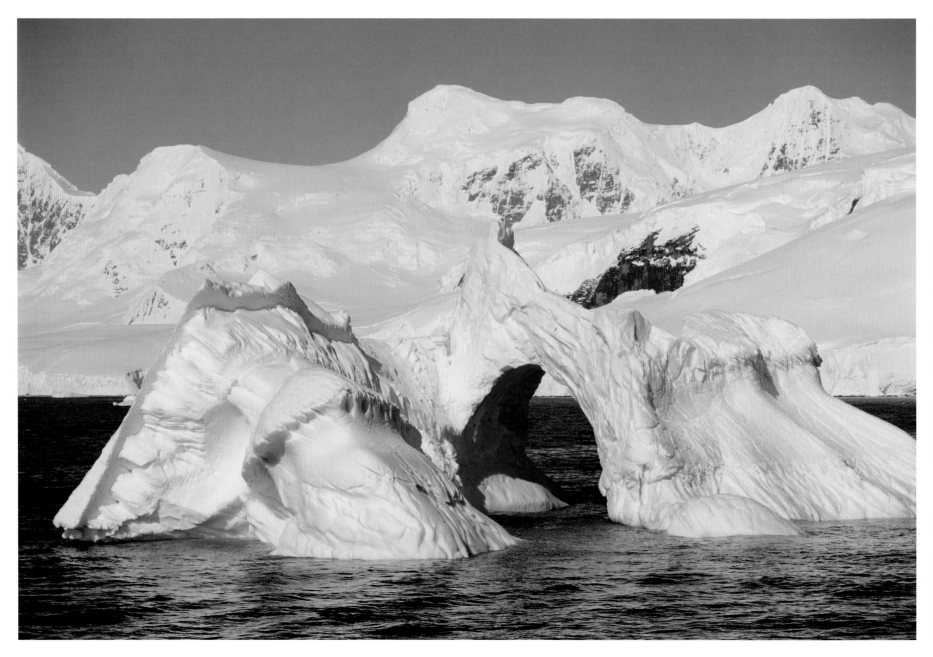

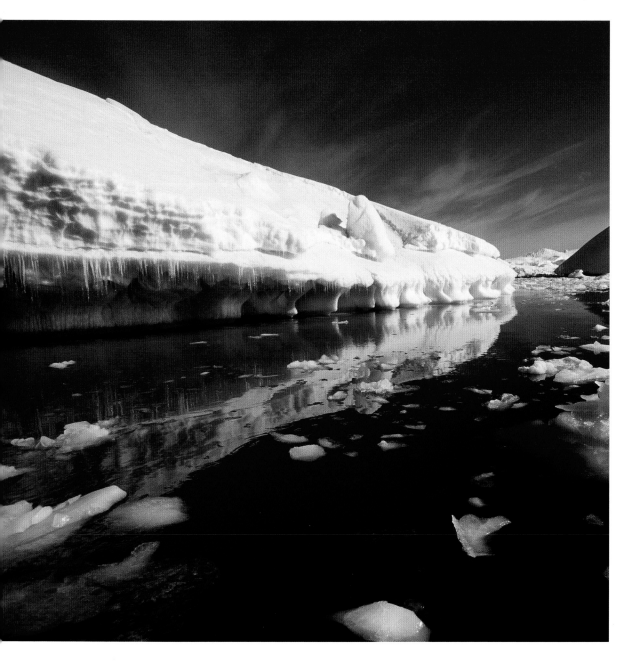

Earth. There are, however, many marine animals and bird species to be found. In the past mankind heavily exploited many of the region's animals, but this has changed in recent years, and now all the flora and fauna of the region are protected by the Antarctic Treaty System.

While the opportunities for life on land are severely restricted, the seas of the Antarctic abound with life. At the bottom of the food chain are myriad small creatures that are collectively known as plankton. The larger members of this group are small shrimp-like crustaceans known as "krill"—the name comes from a Norwegian word that means "whale food." Krill (*Euphausia superba*), which grow to a maximum length of about 60 millimeters and live for up to five years, often live in dense swarms. These swarms can be anything from a few meters across to several kilometers long. They are an immensely important part of the food chain, and all the larger predators—including fish, squid, penguins, seals, and whales—rely directly or indirectly on them.

From the earliest explorations until comparatively recently, mankind has exploited the marine mammal fauna of the Antarctic region by hunting them ruthlessly. Over this dark the period some species exhibited a dramatic decline, and it is only since they have been given protected status that their numbers have begun to recover. Since seals are able to breed very quickly, their populations have grown very quickly. Baleen whales, however, take much longer to reproduce, and if all goes well it will still be many years before their numbers return to anything like their former extents. There is the risk that other human activities will have an adverse impact—in particular, there is great concern that commercial fisheries will upset the ecosystem and prevent the populations of these majestic creatures from recovering.

Many of the marine mammals that are found in the Antarctic region are also found in the southern reaches of the subantarctic. Several species of whale, for instance, migrate from temperate zones through the region in their journey southwards. Others, such as the long-finned pilot whale (*Globicephala melas*), are distributed throughout most of the seas of the world, including the subantarctic. Some of the smaller species of marine mammal have more restricted ranges— Commerson's dolphin (*Cephalorhynchus commersonii*), for instance, is found around the Kerguelen Islands and up into the temperate zone along the western south Atlantic coasts. The subantarctic fur seal (*Arctocephalus tropicalis*) is similar in habit to its Antarctic cousin, but is distributed throughout the more northern parts of the subantarctic region. While all these wonderful animals were once hunted mercilessly, conservation measures have helped their populations recover.

LEFT AND FAR LEFT: As icebergs melt they often develop dramatic shapes; in the one shown here (**FAR LEFT**) —in the Gerlache Strait, Antarctica—a beautiful architectural arch is forming.

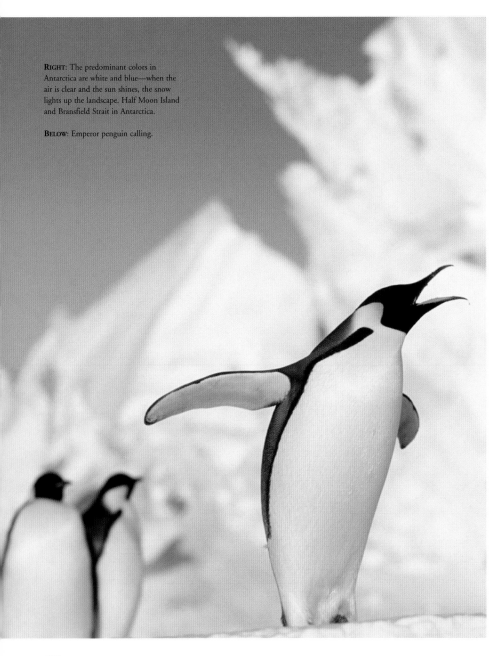

RIGHT: The predominant colors in Antarctica are white and blue—when the air is clear and the sun shines, the snow lights up the landscape. Half Moon Island and Bransfield Strait in Antarctica.

BELOW: Emperor penguin calling.

Further work is needed, however, as several species of marine mammal have gone extinct in recent times.

At the other end of the size spectrum, there is less need for concern. While the diversity of the many invertebrate species in the region is somewhat limited, they are not under any kind of environmental threat. They range from the microscopic—nematode worms and rotifers through to larger creatures such as earthworms, beetles, spiders, flies, and mollusks.

While the fauna of the region does not vary tremendously between the Antarctic and the subantarctic regions, there is an enormous difference in the plant diversity. This is because the climate gets much milder as one moves northwards towards the temperate zone. The predominant plant species of the region is the tussock grass—it is very hardy, growing up to 2 meters in height. It often forms dense thickets where conditions are favorable—these then provide valuable cover for many bird species. Where the land is too wet for grasses to grow, bogs tend to form—these often cover large areas and provide a habitat for many species of mosses and lichens as well as larger organisms such as ducks and other birds. In the areas that are too dry for tussock grasses to proliferate, extensive grasslands form; these are made up of a variety of low herbage. As with the introduction of alien animal species, humans have also been responsible for many nonnative plants becoming established in the region.

The Exploration of The Region

The presence of a large continent where Antarctica lies was suspected by explorers for many years before it was actually discovered. The unknown landmass was referred to as "Terra Australis Incognita," which translates as "The Unknown Southern Land." The idea was first put forward by the Greeks, who thought that since there were a lot of countries in the northern hemisphere, there must also be land in the southern hemisphere so that the world would be properly balanced.

The first actual discoveries in the region were all as a result of pioneers attempting to navigate around Cape Horn, at the tip of South America. When Magellan sailed to the north of Tierra del Fuego in 1520, he thought that the coast might be the edge of a great continent. This hypothesis was refuted when Sir Francis Drake sailed the *Golden Hind* through the Strait of Magellan in 1578. Upon reaching the Pacific, Drake's ship was blown far enough south by a storm that he could clearly see that the "great landmass" was merely a group of islands. In 1616, a Dutch expedition confirmed this observation by sailing around Cape Horn.

In 1619, a Spanish expedition led by Bartoleme and Gonzalo Garcia de Nodal was blown off course—this took them into uncharted waters where they discovered some small islands which they named Islas Diego Ramirez. Another navigator who thought he had seen Antarctica included the Dutch pilot Dirck Gerritsz, who, in 1622, saw what were in all probability the South Shetland Islands. More than fifty years later—in 1675, a British merchant named Anthony de la Roch

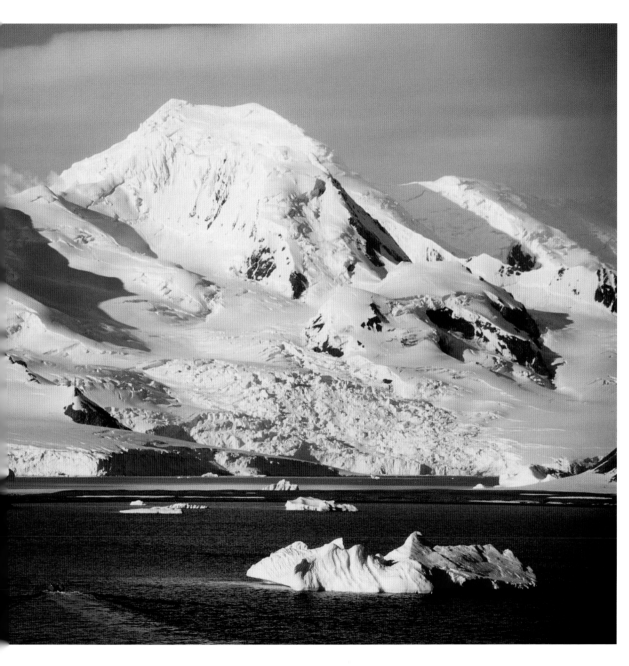

sought shelter in a bay of what is likely to have been the island of South Georgia.

It was not until September 1699 that there was a systematic search for the unknown southern continent. This was when the English scientist Edmond Halley set out on an expedition aboard a ship named the *Pink Paramour* to measure the true longitude of various ports in South America and Africa. His mission also included making recordings of magnetic variations, and searching for the mysterious Terra Australis Incognita. Although he crossed the line known as the Antarctic Convergence—where the cold waters of the Antarctic flow northwards and meet the warmer, southerly moving surface water of the subantarctic zone—bad weather forced him back.

On New Year's Day 1739, a Frenchman named Jean-Baptiste Charles Bouvet de Lozier sighted what he thought was the fabled continent—but it was, in fact, what is now known as Bouvet Island. He was followed by another Frenchman in 1771; Yves-Joseph de Kergulen-Trmarec was given the task of finding the southern continent. Although he did sight an unknown island in early 1772, he did not manage to make a landfall and returned with wildly exaggerated stories about it being a temperate paradise. When he returned in 1773, it became quite clear that in reality the island was a barren wilderness—although he was disgraced, the islands still bear his name.

When Captain James Cook went to the South Pacific in 1768, he searched for Antarctica, but could not find it, but this was not a complete failure. He made many chart recordings, and as a result showed that the continent must be much further south than previously thought. In 1772, he began one of the greatest human voyages of exploration ever undertaken when he returned to the region with the ships *Resolution* and *Adventure*. In January 1773, they were the first ships in human history to cross the Antarctic Circle. Cook managed to get within 80 miles of the continent's coast; however, he was forced back by the enormous amount of pack ice. He then sailed north until the worst of the winter had passed, and then returned to try again. He made two determined attempts to sail farther south, both of which were again foiled by pack ice. The farthest he got was 71^0 of latitude, in what is now called the Amundsen Sea.

Cook was not easily deterred, however, and he once again rode out the winter by returning to the tropics. In 1775 he made his way south again, and made many new discoveries including Willis' and Bird Islands. Cook also rediscovered and named South Georgia 100 years after it was first sighted. On January 26, 1775, the *Resolution* sighted the South Sandwich Islands, which were the southernmost land ever seen. As a result of his voyage, Cook managed to prove that if there was indeed a southern continent, it was much smaller and much more inhospitable than had previously been thought. He was convinced that there was no future for mankind in the area, and so there were no other large-scale, government-funded expeditions for another 60 years. It was, however, Cook's mention of the large numbers of seals and

whales that was, in fact, responsible for the large numbers of people that began venturing to the region within a decade.

At this time in human history, there was no understanding of such things as conservation, and many seal populations on the region's islands were driven to the verges of extinction. Vast numbers of fur seals and elephant seals were also slaughtered, along with southern right whales. For several years, the seals of the more southern islands were safe; however, when a merchant captain named William Smith accidentally discovered Livingston Island in the South Shetlands in 1819, he also found the extensive seal colonies there. He returned a few months later and found Desolation Island, which he claimed for Great Britain. As soon as word got back to the sealers, they started massacring the newfound seal populations. The large numbers of seal boats in the region also led to the discovery of Rugged Island and Smith Island.

At more or less the same time, an Englishman named Edward Bransfield was sent as part of a Royal Navy expedition to map the area. On January 16, 1820, he sighted Livingston Island, and then on January 22, landed on King George Island. After this he found Deception Island, Tower Island, and the Bransfield Strait. On January 30 his ship sailed within sight of the mountains of the Antarctic Peninsula, and Bransfield named the area "Trinity Land." Bransfield then continued his voyage, and discovered Gibbs Island, O'Brien Island, Elephant Island, Seal Island, and the Clarence Islands. He was also the first person to ever sail into the Weddell Sea—however, he was not the first person to lay eyes on the Antarctic mainland. He was beaten by only two weeks by Captain Thaddeus von Bellingshausen, who was in command of Russia's first government-sponsored Antarctic expedition. On January 16, 1820, he found that his way was blocked by the Finibul Ice Shelf—since this was part of Antarctica, Bellingshausen claimed the long-sought honor.

The first actual landing on the continent of Antarctica was at Hughes Bay on February 7, 1821, by men of the ship *Cecilia*—a sealer, under the command of Captain John Davis. Although the sealers had more or less wiped out most of the animals they sought, they also made many new geographical discoveries in the region. When they discovered that were no more seals to be found, the commercial ships left the area. At this stage, the governments of France, Great Britain, and the United States began sponsoring new expeditions to find and claim the lands of the Antarctic.

One of these missions was led by Captain James Clark Ross, who had already made a name for himself by discovering the magnetic North Pole in 1831. For his task—to find the South Pole—he took two specially strengthened ships; his own was the 370-ton *Erebus*, and the other was the 340-ton *Terror*, captained by his friend, Commander Francis Crozier. They left England in early October 1839, and sailed to the Antarctic via Tasmania. They crossed the Antarctic Circle on New Year's Day 1841, and then made a treacherous voyage towards the magnetic South Pole through seas covered with thick ice. On the way

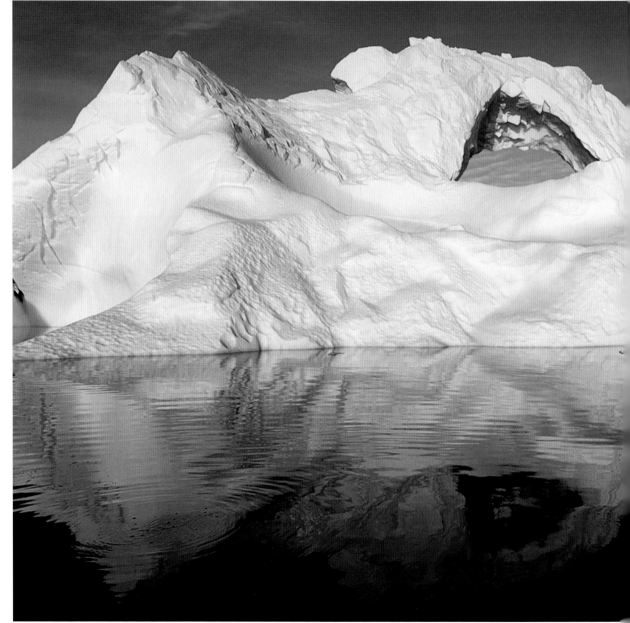

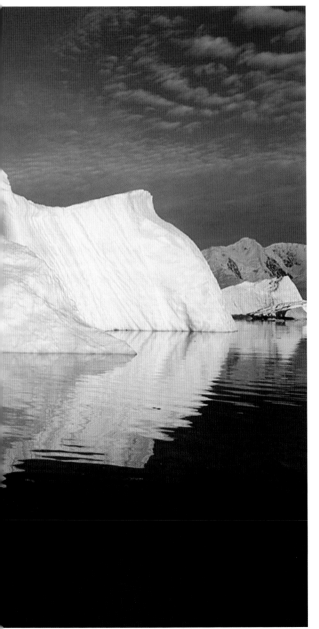

they discovered a new sea—later to be called the Ross Sea, but were disappointed to then find land long before reaching their destination. Ross had been hoping to be able to sail more or less all the way, but nevertheless, made the most of his new sightings. He named the mountains that lay before him the Admiralty Range, and then set about giving names to all the individual peaks that he could make out. After this they discovered Possession Island, and named the region Victoria Land in honor of their monarch.

A few days later, they found and claimed Franklin Island, and then continued on their way. Shortly after, they were amazed to discover a very active volcano, with smoke and ash billowing out from the top. This, at an elevation of 12,400 feet, they named Mount Erebus. They named the nearby smaller, extinct volcano Mount Terror, in honor of their trusty sailing vessels. They did their best to find their way closer to the pole, but found that their path was blocked by an ice shelf that soared vertically in front of them—in places it was as much as 200 feet high. Ross did his best to find a way around it, but after sailing for 200 miles along the ice shelf, he decided that he would have to abandon the search before winter set in. After over-wintering in Tasmania, Ross returned in January 1842, and made another perilous journey through vast areas of broken pack ice. For several weeks he made a determined search along the edge of the ice shelf, but was again forced to give up as winter approached. The two ships then headed for Cape Horn, but were nearly lost when in high seas they collided and were seriously damaged trying to avoid an iceberg.

After spending five months in the Falkland Islands, Ross headed back to the Antarctic for a third time, but after finding that his target—the Weddell Sea, was frozen solid with impenetrable pack ice, he gave up and set sail for home. Incredibly, he and his crew had spent a total of four years and five months at sea. After this heroic voyage, there were few other scientific expeditions until 1897—this was in response to calls for further exploration that had been made at the Sixth International Geographical Congress in July 1895. There were, however, many trips made by whalers—this was because they had more or less wiped out the whale populations across the rest of the world and they had nowhere else to go. Many further geographical discoveries were made by these commercial sailors, including the Bismarck Strait, the Neumayer Channel, Dundee Island, Foyn Land, and King Oscar II Land.

In August 1897, the Belgian Antarctic Expedition left Antwerp under the command of Lt. Adrien Victor Joseph de Gerlache in the ship *Belgica*. Gerlache made many new finds, including the Gerlache Strait and Brabant, Lige, Anvers, and Wiencke Islands. This was followed in 1898 by the British Antarctic Expedition, which was the

first to deliberately put scientists on the mainland for the whole winter. In February 1900, members of the crew climbed the Ross Ice Shelf and traveled south by sled as far as their provisions allowed. This marked the start of the exploration of Antarctica's vast interior.

One of the best-known explorations was conducted by Captain Robert Falcon Scott who set out on the National Antarctic Expedition aboard a specially constructed ship called the *Discovery*. Scott discovered King Edward VII Land on his way towards the pole, and after setting up camp on Ross Island began his explorations. On one such trip in December 1902, Scott, Edward Wilson, and Ernest Shackleton managed to reach a latitude of 82°16'S, but they were forced to turn back due to a combination of snowblindness and an inadequate diet. Around this time, there were several other expeditions mounted by various countries, and many hardships were endured by the intrepid crews who were often forced to overwinter under arduous conditions with nothing to eat but penguin meat.

On New Year's Day 1908, Ernest Shackleton set out from New Zealand to find the South Pole in the ship *Nimrod*. They managed to get within 97 miles of the pole, before being forced to abandon their journey. Three members of his crew then claimed a victory for Britain that had been sought-after for many years when they became the first humans to reach the south magnetic pole on January 15, 1909.

While Shackleton had been trying to reach the pole, a French Expedition, under Jean-Baptiste Charcot made many new discoveries, including a natural harbor at Port Circumcision and Marguerite Bay. He also conducted many extensive geographical surveys, including most of the coast of Graham Land.

In January 1911, two separate expeditions set out to claim the geographic South Pole. One was led by Roald Amundsen in his ship the *Fram*, who began his journey at the Bay of Whales. The other was by Robert Scott in the Terra Nova, who set off from Cape Evans, on Ross Island. Amundsen used dog teams and sleds to cross the harsh landscape, and on his way discovered and named the Queen Maud Range. He and his four colleagues continued on their way, and finally reached the South Pole on December 14, 1911. Scott's mission was broader than Amundsen's—he was not just interested in reaching the pole, but also intended to conduct many scientific and geographic studies on his way. His men explored the Dry Valleys and the Koettlitz Glacier and surveyed the coast of Victoria Land.

On November 1, 1911, Robert Scott finally left for the pole itself, but did not have the distinct advantage of dog teams—instead, he and his four colleagues hauled their sleds themselves. This made their progress extremely slow, and when they reached the pole they found that Amundsen had been there first. They ran into a series of severe storms, and ran out of food; none of them survived the return journey.

Around the time that the South Pole was reached, many other expeditions explored the area—the main efforts were mounted by the Japanese, Germans, and Australians. The most famous, however, was

LEFT: When there is no breeze, the water becomes still and adds another dimension to the stunning landscape—here an arched iceberg is reflected in Dorian Bay, Wiencke Island, Antarctica.

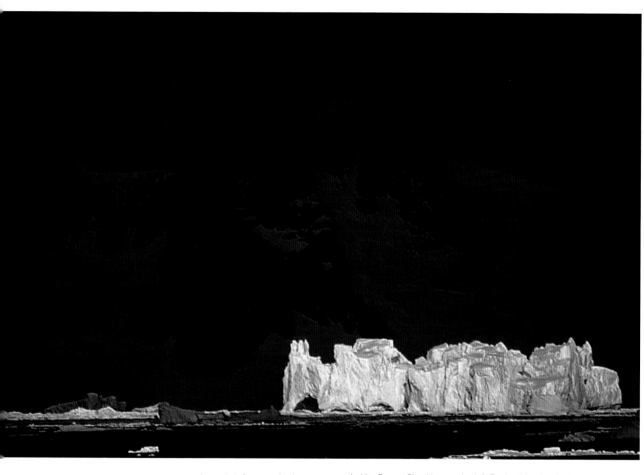

most of the whales and the industry collapsed. These days a lot of Antarctic surveying work is carried out from aircraft or satellites, although there are a large number of permanent research stations where valuable work continues.

The Climate & Environment of the Antarctic Region
Antarctica is the coldest place on Earth, with the lowest temperature ever recorded, -88°C (-126°F). In the middle of winter so much of the sea around it freezes into pack ice that the continent effectively doubles in size. A perhaps unexpected consequence of the extreme cold is that in many parts of Antarctica there is very little snow. This is because the low temperatures cause nearly all of the water vapor in the air to freeze soon after it comes off the sea. Some of the inner regions of the continent are so dry that they are in effect cold deserts.

The predominance of permanent ice cover on the Antarctic continent means that only about 1 percent of its land area is suitable for plant growth. Most of the interior is too harsh for much to survive, although along some of the more northern fringes of the continent the environment is a little more conducive to life. Most of this is distributed along the coasts and islands of the Antarctic Peninsula, where there is sufficient soil for tundra to form. This region supports two species of flowering plants—the Antarctic hair grass (*Deschampsia antarctica*) and the Antarctic pearlwort (*Colobanthus quitensis*).

The Geography of the Antarctic Region
Starting at the Greenwich Meridian—longitude 0—and moving eastwards, the first sea to be encountered is often called the Southern Ocean, although this term. The reason for this is that if one claims the existence of a Southern Ocean—which completely encircles Antarctica—then none of the other oceans touch Antarctica or its nearby islands. Here, we are refering to the waters that runs along the coast of Queen Maud Land, where research stations run by the United Kingdom (Halley), Argentina (Belgrano II), India (Maitri), Russia (Novolazarevskaya) and Japan (Syowa) are located. After this is Enderby Land, where Russia has a second research station (Molodezhnaya). The Southern Ocean then gives way to the southernmost reaches of the Indian Ocean. This breaks on the shores of Mac Robertson Land, where Australia has a research station (Mawson) and the western parts of Wilkes Land, which has research stations run by China (Zhong Shan), Russia (Progress, Mirnyy, and Vostok) and Australia (Casey). The eastern parts of Wilkes Land meet the South Pacific Ocean, which runs all the way around Antarctica until it reaches the coast of Chile, on the South American continent.

Wilkes Land then gives way to Victoria Land, which has research stations run by France (Dumont d'Urville) and Italy (Terra Nova). Between Victoria Land and Marie Byrd Land is a massive inlet of the Ross Sea. This is known as the Ross Ice Shelf, and is home to research stations run by the United States (McMurdo) and New Zealand (Scott). The Bentley sub-glacial trench is located in Marie Byrd

ABOVE: As icebergs age, they become increasingly eroded by a combination of warm air and strong winds. This example in the Gerlache Straits, Antarctica, is a shadow of its former self.

RIGHT: A fierce blizzard blows over the site of Capt. Robert Falcon Scott's 1911 polar expedition camp at Cape Evans, Ross Island, Antarctica.

led by Ernest Shackleton who left England in 1914 in the ship *Endurance*. His trip nearly ended in tragedy when the ship was trapped by ice and crushed—his men endured terrible hardships, including surviving for 105 days with no supplies. At times all they had to eat was boiled seal bones and seaweed; through Shackleton's superb leadership though, all survived. They were rescued after Shackleton and five crewmembers made a perilous journey by rowing a boat through 800 miles of the most treacherous waters in the world to reach South Georgia Island.

Since Shackleton's day, expeditions and scientific work have continued across much of the Antarctic continent, but for most of the twentieth century the largest amount of activity in the region was conducted by whalers. By the mid-1960s, however, they had killed off

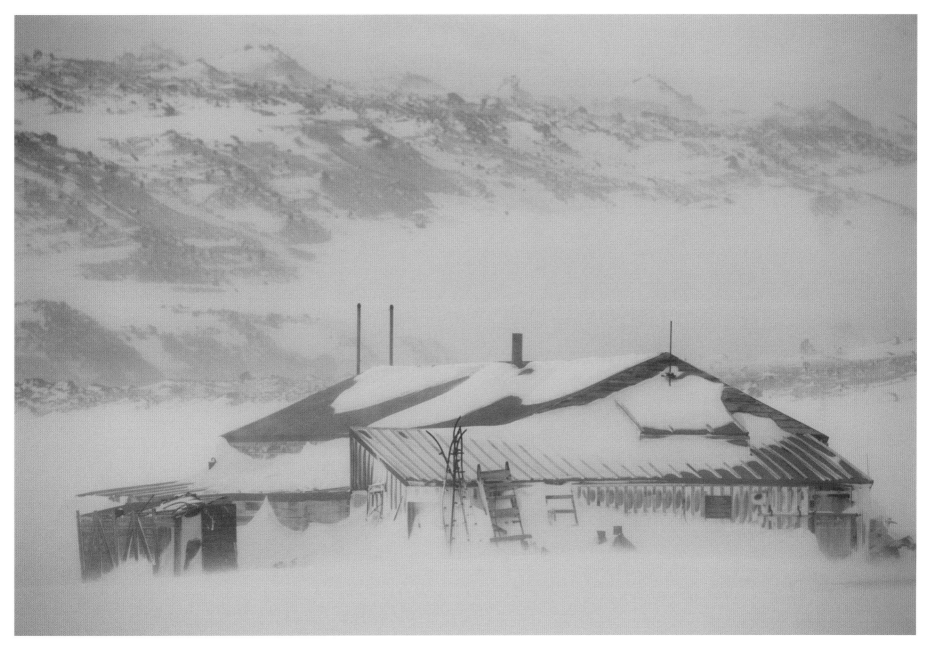

Land, and at 2,540 meters below sea level, it is the lowest point in Antarctica. Between the coast and the South Pacific Ocean is the Amundsen Sea, which in turn becomes the Bellingshausen Sea off the area known as Ellsworth Land. This is home to the Vinson Massif, which, at 4,897 meters, is the highest point in Antarctica.

The next area is called Palmer Land—this reaches out across the Drake Passage towards the coast of South America. Farther around the coast is the Weddell Sea, which lies between Palmer Land and Queen Maud Land. Moving away from coast, the Weddell Sea becomes the Scotia Sea—this is situated between the Falkland Islands and the South Georgia Islands. Having reached Queen Maud Land again, the circumnavigation of Antarctica is complete.

The Fauna of the Antarctic Region

The fauna of the Antarctic is perhaps typified by the penguin, which is found throughout the Antarctic and subantarctic regions. Some live in the southern reaches of the temperate region; however, none are native to the northern hemisphere. There are several different species, all of which are flightless, and many are abundant. With their stream-lined bodies and wings specially adapted for high-speed underwater swimming, they are very efficient marine predators of fish, squid, and crustaceans. Their feathers form a waterproof coat that allows them to spend much of their time diving beneath the waves hunting for prey. When they leave the water they have to endure extremely low temperatures and strong winds—in order to cope with this they have developed think layers of subcutaneous fat to give them the extra insulation needed for such a harsh environment.

They vary tremendously both in size and habit—the largest is the emperor penguin (*Aptenodytes forsteri*), which gathers to breed in large colonies on sheets of sea ice along the edges of mainland Antarctica. Surprisingly, it chooses to do so during the Antarctic winter, and has evolved both physiological and behavioral adaptations to allow it to flourish in the harshest breeding conditions on Earth. One of the ways it survives the extreme temperatures and strong winds is by huddling together in large groups—all the adult birds take turns to stand on the outside, and once they've done their stint, they shuffle back towards the center to warm up.

The Adélie penguin (*Pygoscelis adeliae*) is much smaller than the emperor, and breeds on many of the Antarctic coasts, whereas the chinstrap penguin (*Pygoscelis antarctica*) only breeds on the Antarctic Peninsula. Both species usually lay a single egg in the spring, and the parents share the task of incubation and chick rearing. During this time there is a great risk of attack by both brown skuas and sheathbills, which are major predators of young penguins. Although their numbers are not generally threatened by human activity, there are fears that the increasing numbers of krill fisheries in the southern oceans may cause a reduction in the numbers of certain penguin species.

Other than penguins, there are very few birds that are able to breed successfully on the Antarctic continent. The Antarctic snow

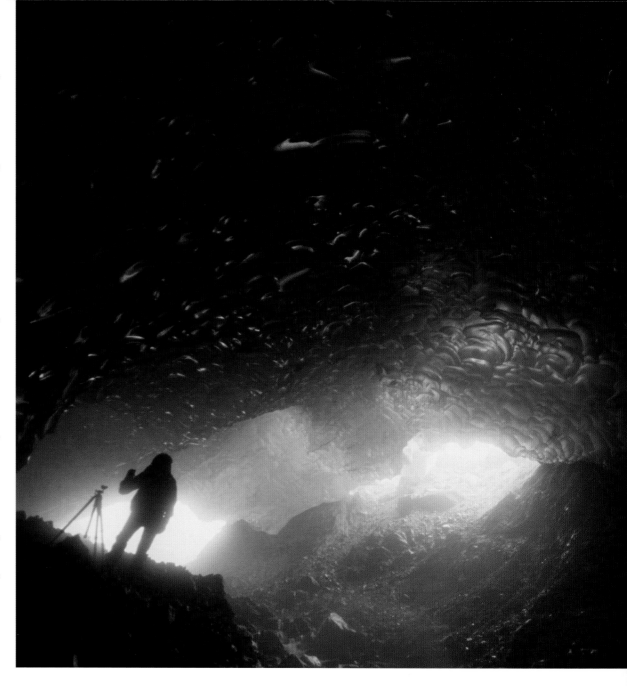

petrel (*Pagodroma nivea*), is abundant all around the coasts of the region. Less common is the Antarctic or south polar skua (*Catharacta maccormicki*), which breeds on the mainland between September and March. It is a very large bird, with black wings that measure around 1.4 meters across. The females lay their eggs directly on the ground, and defend their nesting areas fiercely. Like all the members of the skua family, they are voracious predators as well as great opportunists. They will take food from almost any source that presents itself, often robbing catches from smaller birds. During the breeding season, the eggs and young of penguins form the main part of their diet.

There is a wide diversity of marine mammals in the region, and they form an important part of the marine ecosystem. There are two groups of these fascinating animals—the whales and the seals. Both manage to survive in the harsh environment as a result of physiological adaptations, such as the evolution of thick layers of blubber. These serve as insulation, and in times of hardship, as an emergency food reserve. While whales have smooth skins, most seals also have a layer of fur—this provides them with extra insulation when they crawl out of the relatively warm sea and into the freezing winds that scour the landscape.

Whales can be divided into toothed and baleen species. Those that hunt prey, such as fish, squid, birds and seals are all toothed whales—these include sperm whales (*Physeter macrocephalus*), orcas or killer whales (*Orcinus orca*), as well as many different kinds of dolphins and porpoises. Baleen whales differ from their toothed relations in that they do not hunt prey—instead, they feed on vast quantities of plankton that they filter from seawater through special fibrous plates. The two main species in the area are the blue whale (*Balaenoptera musculus*), and the humpback whale (*Megaptera novaeangliae*).

Many of the whales found in the Antarctic region are temporary visitors—they move into the region during the summer to exploit its rich food reserves, but return to warmer waters further north as winter approaches. The seas of the Antarctic are far too cold for whales to breed in—their young, known as "calves," are usually delivered in tropical or subtropical waters. In late spring, when they have grown large enough to withstand the rigors of the Antarctic seas, they begin the long journey to the region. The calves stay with their mothers for several years, learning from them all the while. It is only when the calf reaches independence that the mother will breed again.

Seals are also divided into two main groups—the true seals and the fur seals. There are six species to be found in the region—the leopard seal (*Hydrurga leptonyx*), the Ross seal (*Ommatophoca rossii*), the Weddell seal (*Leptonychotes weddellii*), the crabeater seal (*Lobodon carcinophagus*), the elephant seal (*Mirounga leonina*) and the

LEFT: Ice caves are compelling and yet mysterious places—here a photographer contemplates the wonderful ambience of an ice tunnel near Antarctica's McMurdo Sound.

Antarctic fur seal (*Arctocephalus gazella*). All of the seal species in the region are hunters, with most preying on fish and squid, although krill is another major food source for some. The leopard seal lives up to its name, since it is also a voracious predator of penguins and other seals.

When spring arrives and the seals are ready to breed, they seek out suitable places to deliver their pups. Ice shelves are the preferred locations for leopard seals and Ross seals (which are usually solitary), as well as Weddell seals and crabeater seals (which gather together in loose groups). Antarctic fur seals, which are related to sea lions, and elephant seals breed in dense colonies spread along the shoreline. Since the amount of available dry land is severely restricted, possession of good breeding spots is fiercely contested, with the males (known as "bulls") fighting for the best positions. The dominant bulls then assemble harems of females (known as "cows") around them. Since other bulls constantly do their best to "steal" cows, harem owners cannot afford to drop their guard, and do not return to the sea to feed until all risk has passed. During this time they rely on the reserves of blubber they have built up over the previous months.

The Climate and Environment of the Subantarctic Region

The subantarctic environment varies considerably across the region—in the most southerly areas, the islands are predominantly made up of a mix of ice and barren rock. Consequently, there are few plants and most of the animals are marine mammals or birds. Those that do manage to survive have evolved specialized physiological features in common with many of their Antarctic brethren. These include features such as increased insulation in the form of subcutaneous fat and extra layers of feathers and down. In the more northerly areas, however, the environment is very different, with much milder climates. As a result, the wildlife is much richer, with about three times as many species of birds as are found in the Antarctic region. Overall, however, the region has a very low biodiversity when compared with the temperate or tropical parts of the world.

The Geography of the Subantarctic Region

Most of the subantarctic region is made up of small islands. Although they provide few homes for humans, there are vast numbers of marine mammals and birds. The Heard and McDonald islands, for instance, are uninhabited, barren places situated in the Indian Ocean about two-thirds of the way from Madagascar to Antarctica. The McDonald Islands are small, rocky places, while more than three-quarters of Heard Island is covered by ice. It has an active volcano called Mawson Peak on the Big Ben Massif, which at 2,745 meters, it is the highest point in the area. The islands have been designated as wildlife reserves by the Australian government, which took over possession from the United Kingdom in 1947.

Macquarie Island is about 34 kilometers long and 5 kilometers wide, and is named after Colonel Lachlan Macquarie (1762–1824), who was a colonial governor and is regarded by many as the real founder of

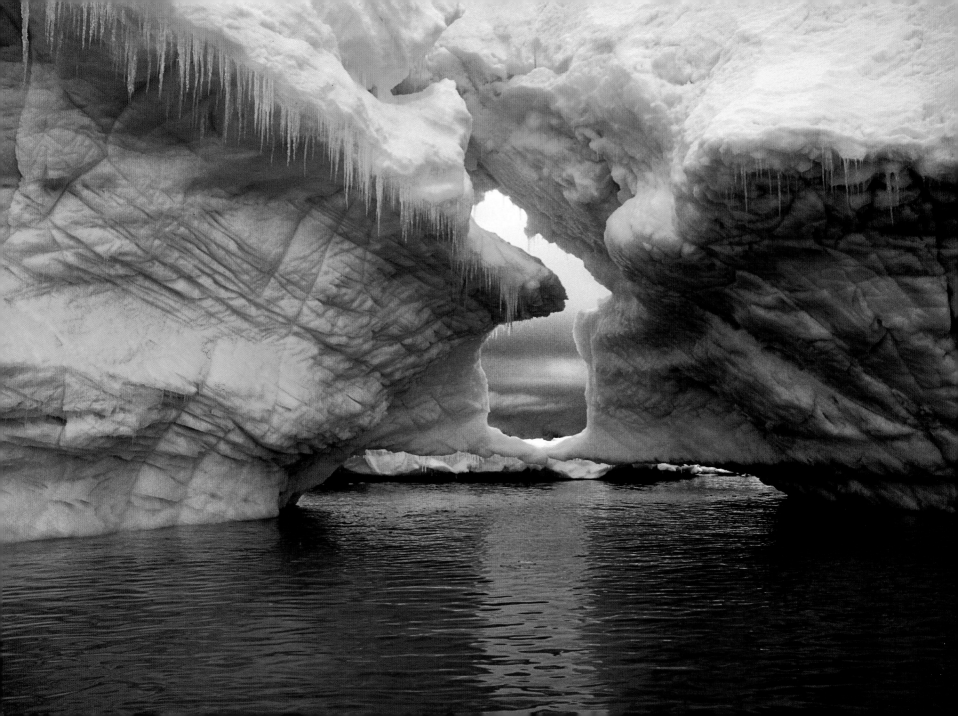

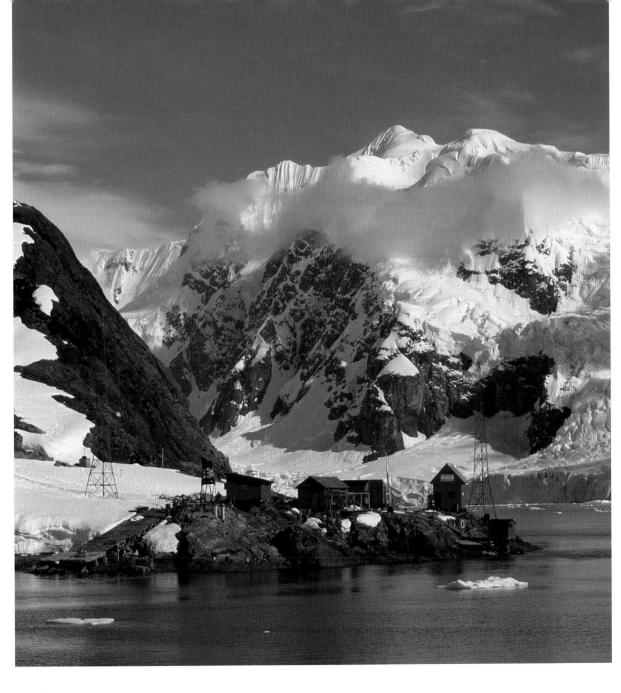

Australia. It is the southernmost point of Australia, and is part of the state of Tasmania. Macquarie Island is located about halfway between Australia and Antarctica. Originally claimed by the United Kingdom, it was transferred to Tasmania in 1890, and made into a wildlife reserve in 1933. It is uninhabited by humans except for a small contingent of scientists from the Australian Antarctic Division. As for wild animals, it is a haven for many marine mammals, including subantarctic fur eals, Antarctic fur seals, New Zealand fur seals and southern elephant seals. There are also several species of penguins, including king penguins, rockhopper penguins, and gentoo penguins, and it is the only breeding site for royal penguins in the world. Rabbits were introduced at some stage, as were domestic cats, which quickly went feral. Unfortunately, the native species of flora and fauna did not evolve to cope with these invaders, and they did a lot of damage. Although the rabbits are still there, the last of the cats were eradicated in 2002 after a considerable amount of work by the reserve wardens.

Campbell Island is located about 700 kilometers south of New Zealand, and has an area of 114 square kilometers. It was named by its discoverer, Captain Frederick Hasselburg, after the owner of the sealing company that he worked for, on January 4, 1810. Although this volcanic island has a bleak, rocky landscape, during the breeding season it has the world's largest population of royal albatrosses.

The Auckland Islands are located 465 kilometers from the South Island port of Bluff, New Zealand, and are composed of two main islands—Auckland Island with a land area of 510 square kilometers and Adams Island with an area of around 100 square kilometers. Both are mountainous places, with several peaks more than 600 meters high. There are also numerous smaller islands, including Disappointment Island and Enderby Island. The islands were discovered by a whaling captain named Abraham Bristow in 1806, and he named them after Lord Auckland, a friend of his father's. There were several attempts to establish settlements on the islands; however, none of them was successful. The island has recently become the main breeding ground for the New Zealand sea lion.

Bouvet Island was discovered in 1739 by a French naval officer, after whom it was named. It is located in the South Atlantic Ocean, southwest of the Cape of Good Hope in South Africa. It is an uninhabited volcanic island that is almost entirely covered by glaciers, and has a forbidding coast that makes it very difficult to land by sea. It was designated as a wildlife reserve in 1971, and in 1977, Norway—to whom the islands belong—set up an automated weather station there.

The Crozet Islands are an archipelago of six small volcanic

FAR LEFT: The bluer an iceberg is, the less air there is trapped within it. These icebergs, complete with a fresh covering of snow and recent icicles are floating in Antarctica's Gerlache Strait.

LEFT: The Antarctic region is very popular with research scientists who study everything from weather patterns to animal behavior. This is Almirante Brown Station, Paradise Bay.

islands in the southern Indian Ocean that were discovered on January 24, 1772, by a French explorer named Marc-Joseph Marion du Fresne. Because he had already named another island after himself, he named these islands after his second-in-command. The islands have a mild climate considering their location, and as a result they once had an abundant marine mammal population. Within fifty years or so of being discovered, however, most of the islands' seal population had been wiped out by hunters, and after this it was a base for whalers for many years. In 1938 the islands were designated as a wildlife reserve, although the natural ecosystem was severely damaged by introduced animals such as mice, rats, cats, pigs, and goats. Efforts have been made to eradicate these pest species; however, so far only the pigs and goats have been successfully removed. On a brighter note, the islands are home to around 2 million pairs of macaroni penguins, as well as king penguins, eastern rockhopper penguins, and a small colony of gentoo penguins. There are also many fur seals, southern elephant seals, petrels, and several kinds of albatross, including the wandering albatross.

The Crozet Islands experience, on average, 300 days of rain a year, with an annual rainfall of over 2,000 millimeters. The winds exceed 100 kilometers per hour on around 100 days per year. Over the years, the treacherous waters around the coasts of the islands have claimed many ships, and survivors often went years before they were found. Many perished before they were rescued, however. These days the islands continue to be uninhabited apart from the staff at a scientific research station called Albert Faure, which was established at Port Albert on the island of Île de la Possession. The researchers there conduct work on meteorological, biological, and geological studies.

The Kerguelen Islands are located in the southern Indian Ocean, and were discovered by Yves-Joseph de Kerguelen-Trémarec in February 1772. They form an archipelago of about 300 islands, with the largest being Grande Terre, although it was originally named "Desolation Island" after its harsh climate and bleak landscape. Grande Terre is 150 kilometers long, and 120 kilometers wide, with the highest point being Mont Ross, with an elevation of 1,850 meters. The Cook Glacier covers much of the western part of the island. The Kerguelen Islands were heavily exploited for the large number of fur seals, but before long the colonies had been hunted to destruction. Even though human hunters finished their work long ago, the native animals are still suffering due to the large number of feral cats that plague the islands. Although the islands have no resident human population, there are permanent research facilities that are staffed by up to a hundred scientists at a time.

Although the Prince Edward Islands were named by James Cook in 1776, they were, in fact, first discovered over one hundred years earlier in 1663, by a Dutchman named Barent Barentszoon Ham. His discovery was quickly forgotten, however, since his measurements were incorrect and he gave the wrong latitude for the islands—and consequently no one else could find them. The larger of the two main

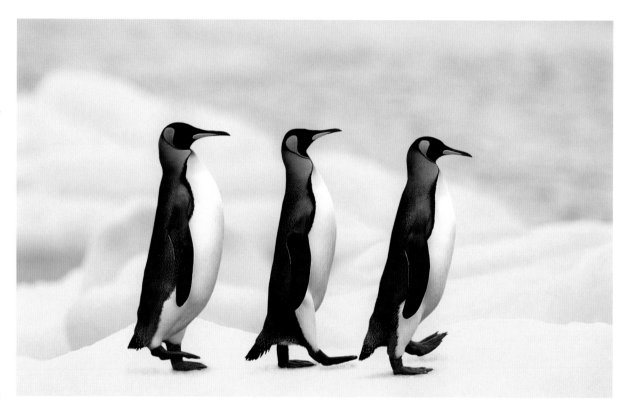

islands is Marion, at 290 square kilometers, and it also has the highest point—the State President Swart Peak at 1,230 meters. The weather on the Prince Edward Islands is usually very bad, with low temperatures, high winds, snow, and rain being predominant for most of the year. There are no human inhabitants on the islands, and the right to land there—even for scientific research—is heavily restricted by South Africa, to whom they now belong. This is in an attempt to protect the environment there—unfortunately, early explorers had no such qualms, and left a legacy of rats and mice. In an attempt to control their spiraling numbers, five domestic cats were introduced. These multiplied to more than three thousand, and did even more damage to the local wildlife than the rodents did. In more recent years, wildlife wardens have managed to exterminate the cat population, and the native bird life is now recovering. The most numerous species are king penguins, gentoo penguins, rockhopper penguins, macaroni penguins, and petrels, of which there are hundreds of thousands. There are also large numbers of albatrosses, fur seals and elephant seals.

The South Georgia Islands and the South Sandwich Islands are

ABOVE: Outside captivity, penguins can only be found in the Southern Hemisphere.

RIGHT: When tourists visit the Antarctic, they have to abide by strict regulations—all the fauna and flora are protected, and no trash can be left behind. Here a cruise ship passes the Antarctic Peninsula.

located about 1,000 kilometers east of the Falkland Islands. Apart from scientists from the British Antarctic Survey, they are uninhabited by humans. Over the last two centuries, however, they have been important staging posts for many explorers bound for Antarctica, as well as bases for whaling operations. The islands are home to many thousands of birds and seals, which rely almost entirely on the local fish stocks to survive. In many other parts of the world, bird and marine animals have suffered terribly as a result of over-fishing by humans, so the United Kingdom government (which administers the islands) has imposed a 200-mile exclusion zone around them. The

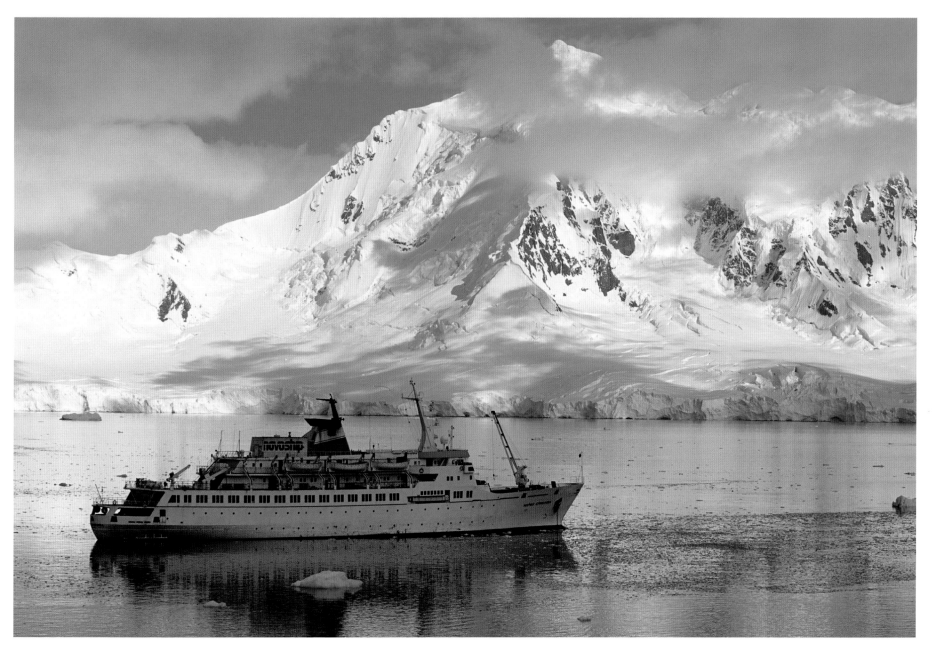

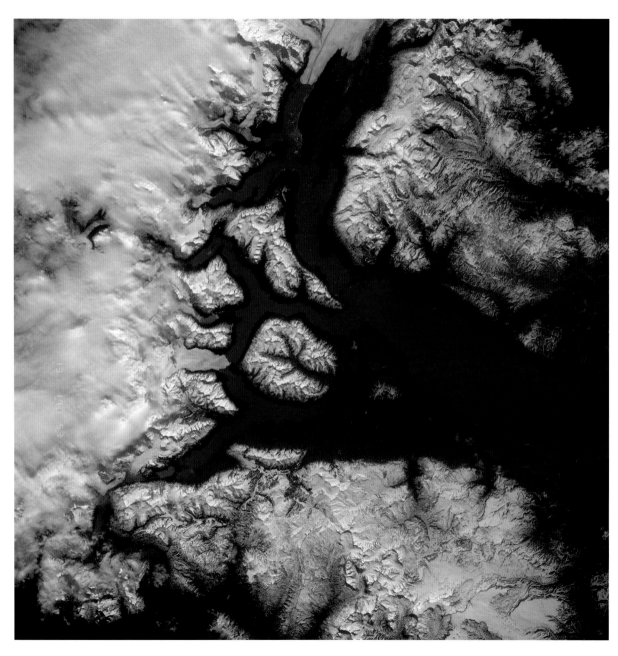

dramatic scenery and flourishing colonies of wild animals makes these remote islands a real draw for specialized tourist ships, and organized cruises are becoming very popular with people who want to see truly unspoiled landscapes.

The South Shetland Islands were fist sighted in 1819, and are comprised of four main island groups that lie just off the Drake Passage, in the South Atlantic Ocean. They are about 120 kilometers north of the Antarctic mainland between the tip of South America and Palmer Land on the Antarctic Peninsula. The island group is more than 540 kilometers long; eleven of the major islands are volcanic, as are several of the minor ones. About 80 percent of the land is glaciated, and the highest point is Mount Foster, on Smith Island, at an elevation of 2,105 meters.

The Fauna of the Subantarctic Region

There are no naturally occurring reptiles or amphibians in the subantarctic region, although many domestic animals and pest species have been introduced. Whether this was deliberate, as with rabbits, chickens, cats, pigs, sheep, cattle, and reindeer, or accidental, as in the case of rats and mice, their effect on the local environment has often been catastrophic.

Since the subantarctic environment is mostly ocean, the few areas of land that are accessible from the sea are in great demand from marine mammals and flightless birds during the breeding season. The gentoo penguin (*Pygoscelis papua*), for instance, breeds on many subantarctic islands in the southern spring, with the females usually laying a single egg. Both parents share the task of incubating and rearing the chick; however, much like the penguins in the Antarctic region, it is not until the young have reached full size that they are relatively safe from attack by predatory brown skuas and sheathbills. Many of the region's islands are also used as breeding grounds by the macaroni penguin (*Eudyptes chrysolophus*), and the rockhopper penguin (*Eudyptes chrysocome*), as well as the larger and better known king penguin (*Aptenodytes patagonicus*).

Although penguins are superbly adapted for hunting underwater, the fact that they are flightless is a serious disadvantage during the breeding season. Some species walk great distances from the sea in order to build nests and foster their young; however, they can only access places that can be reached on foot. Bird species that can fly have a far greater choice—these include albatrosses, petrels, fulmars, prions, shearwaters, skuas, and sheathbills, all of which nest on higher

LEFT: This is a view of the Canal de los Tempanos (Channel of the Icebergs) in southern Argentina—part of subantarctic Patagonia, as seen from space by the space shuttle Discovery.

RIGHT: These snowy peaks on the Antarctic coast are too steep for any depth of snow or ice to form—as a result, their shape and color makes them stand out against the background landscape.

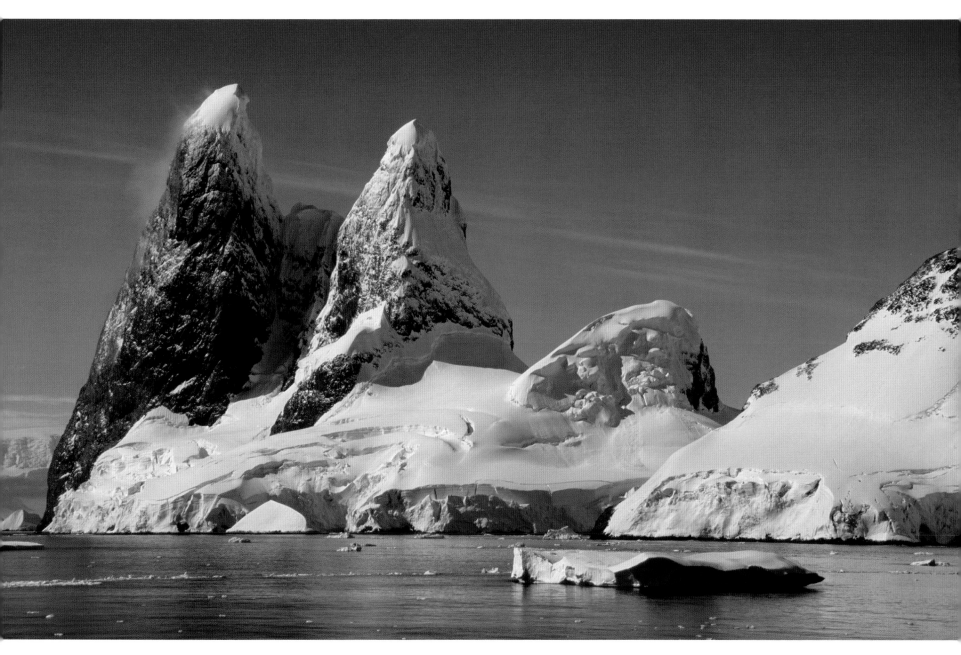

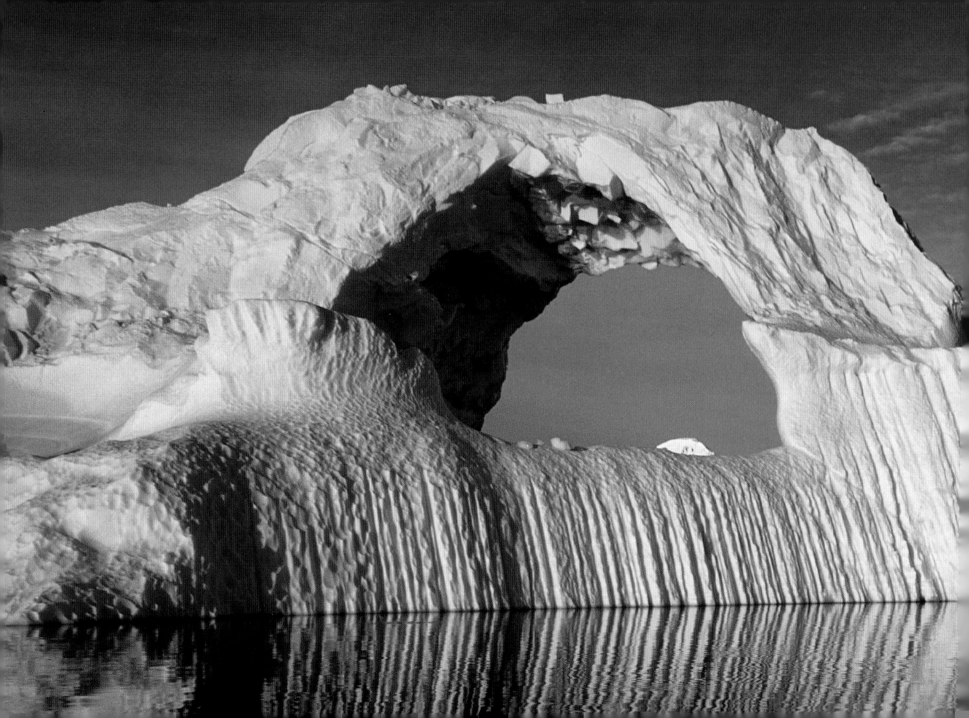

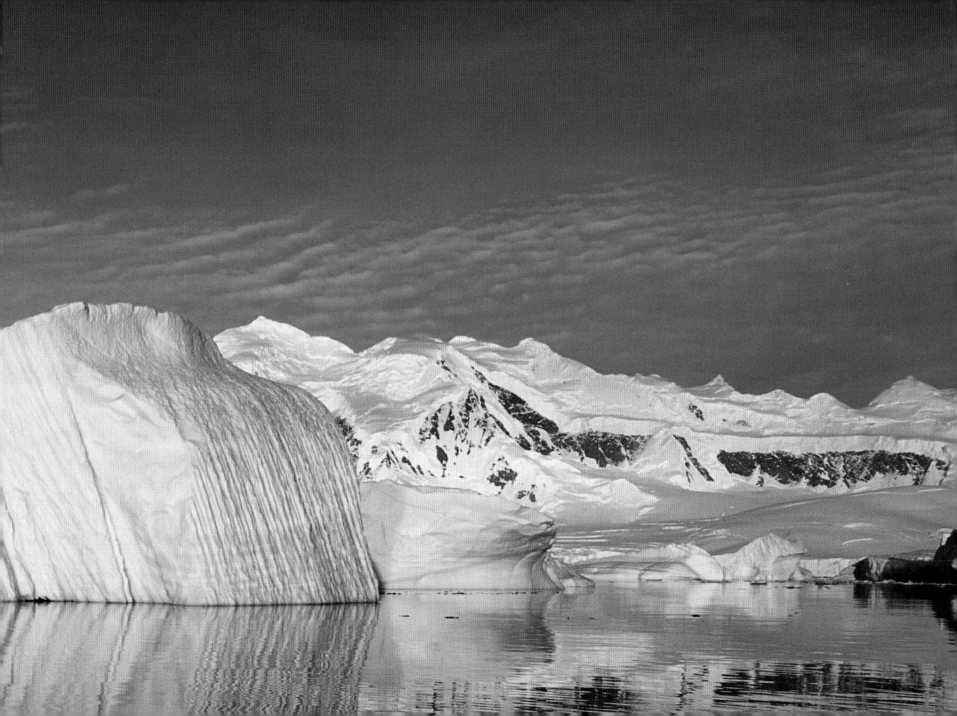

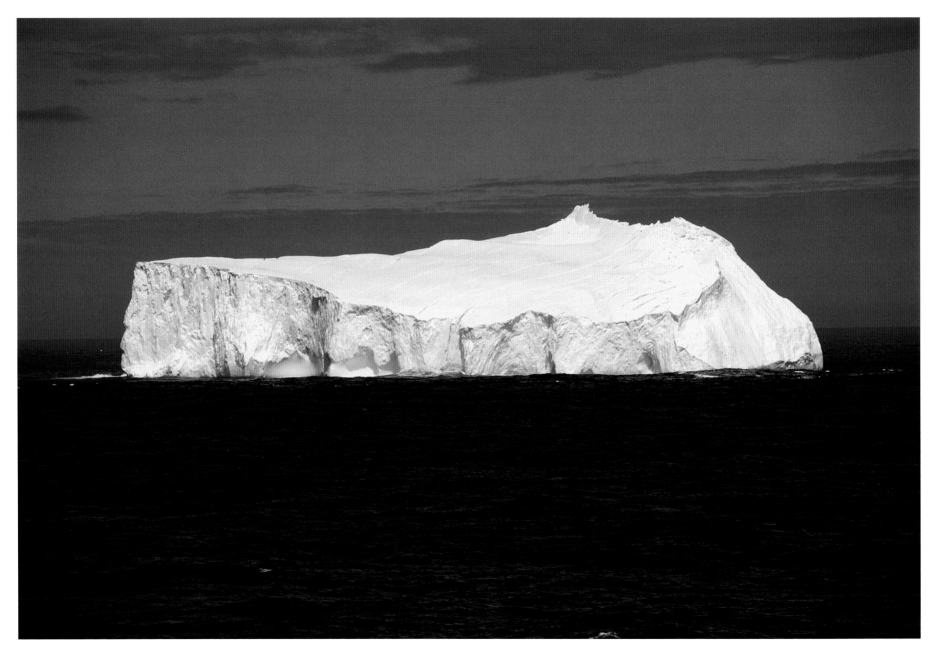

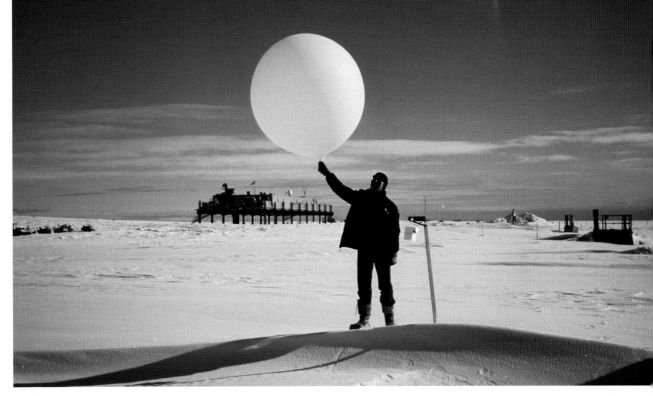

ground. The diet of these species is mostly made up of fish, crustaceans, and squid; however, they will usually take advantage of any other available food. Often this will be the eggs or young of other birds, or dead mammals such as seal pups that have succumbed to the weather.

There are also several other species of birds in the region; most of these are seabirds, and include various kinds of gulls, terns, and two species of cormorants. On land there is the South Georgia pipit (*Anthus antarcticus*), and two species of sheathbill—these are scavengers that search the shoreline for food. On South Georgia and the Kerguelen Islands freshwater ducks can be found, and although other birds visit from warmer areas, few survive for long.

The subantarctic region is a haven for seabirds and marine mammals—a major reason for this is the fact that huge quantities of fish and other creatures teem in the seas there. Cephalopods—mostly squid and octopus—form a large part of the diet for many of the larger predators, such as whales and seals, as well as many bird species. As a result, if there is to be any hope of maintaining their populations, it is vital that commercial fisheries in the region are tightly controlled.

There are various commissions in place whose duty it is to monitor commercial fishing operations; however, it remains to be seen just how effective they will be in the long run. Currently, there are real problems with the exploitation of the region's stocks of the Patagonian toothfish (*Dissostichus eleginoides*). These are fished for with longlines that stretch for vast distances. Unfortunately, the longlining techniques used also result in the accidental capture of large numbers of albatrosses and petrels. While the longlines are being set, the pieces of fish being used as bait float on the surface, and the birds dive down and attempt to eat them. They then get hooked and dragged below the surface and drown. These practices are not restricted to the region—elsewhere they are also used to catch tuna and swordfish, where they take a further toll on albatrosses. Many scientists believe that longlining and other fishing practices are responsible for the dramatic decline in the numbers of these beautiful birds, and that before long they will become extinct. It has been estimated that more than 100,000 albatrosses are killed every year in this way.

There are several agencies that are doing their best to try and reduce the accidental catch of albatrosses. They are working with fishermen to try and develop the best methods to achieve this. One of

these uses weights to ensure that the baits do not float on the surface; setting the lines at night has also been tried, as have various configurations of bird-scaring devices such as colored streamers. All these have been successful—they deter the birds and they are cheap to implement. On top of this, the fishermen take home a better catch as they haul up fish rather than dead albatrosses. This is not the end of the story, however, as the message still has to reach many of the fishermen, who are skeptical about the research work.

One of the species most affected by longline fishing is the wandering albatross (Diomedea exulans). It is the largest seabird in the world, with a wingspan that reaches 3 meters, and a body mass that exceeds 12 kilograms. It is the master of long-distance flight, and it is distributed all the way from subtropical waters right down to the seas of the Antarctic. Amazingly, it can cover up to 10,000 kilometers in a mere ten days or so.

In November, with the breeding season approaching, the wandering albatross starts to gather in colonies on remote islands, such as those in South Georgia. They choose to nest on wide-open areas of grass where they can perform their ritualized courtship displays. All albatrosses only lay a single egg, which is laid in December; they have a very long incubation period, and do not hatch

until April. The chicks are then fed on fish, squid, and carrion throughout the winter, and in late spring—usually November—they fledge. The parents usually then migrate to Australia or other distant shores for a year before returning to begin another brood. It takes ten years or so before the young reach sexual maturity, so depleted populations take a long time to recover—it is, in fact, one of the slowest reproductive rates of any bird in the world. They are very long-lived creatures, with some adults reaching more than sixty years old.

There are four species of albatross that breed on South Georgia—the wandering albatross, the black-browed albatross (*Diomedea melanophris*), the gray-headed Albatross (*Diomedea chrysostoma*), and the light-mantled sooty albatross (*Phoebetria palpebrata*).

Like the wandering albatross, the gray-headed albatross only breeds every two years, but instead of open grassland, it chooses steep coastal places to breed. The light-mantled sooty albatross is also biennial, but it seeks out cliffs on which to build its rudimentary nests. Of the subantarctic albatrosses, the black-browed albatross has the highest reproductive rate—it breeds every year, and takes less than four months to raise its young.

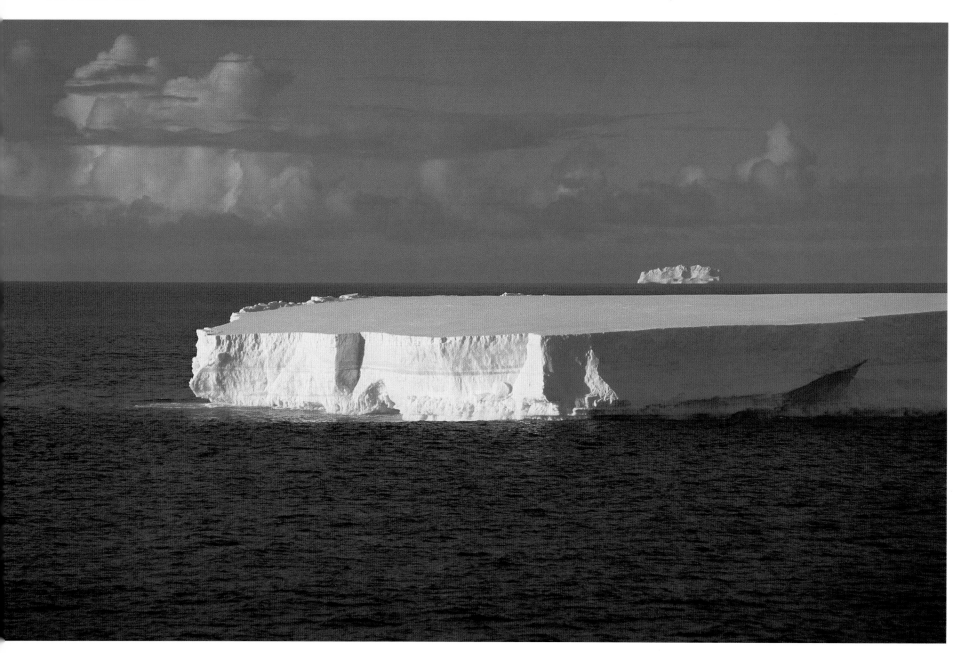

LEFT: Antarctic icebergs can have sheer sides which rise more than 200 feet from the sea. They can take thousands of years to form, but may only take a few months to melt.

RIGHT: When an iceberg floats out to sea, it is possible to get a view of the many layers of ice from which they are formed. Sometimes—as here—you can also see ice caves running through them.

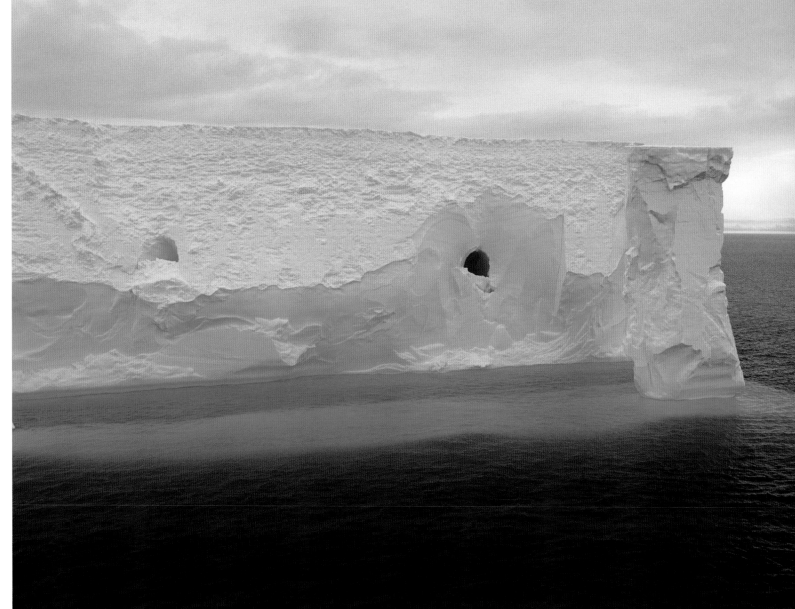

PAGE 132: Not all icebergs have flat tops. This one which has broken away from a glacier has an extremely jagged profile caused by the extreme internal pressures built up over the years.

PAGE 133: As the seasons change, the sea ice alternates freezes and thaws. This can leave icebergs rising out of what is otherwise an entirely flat landscape.

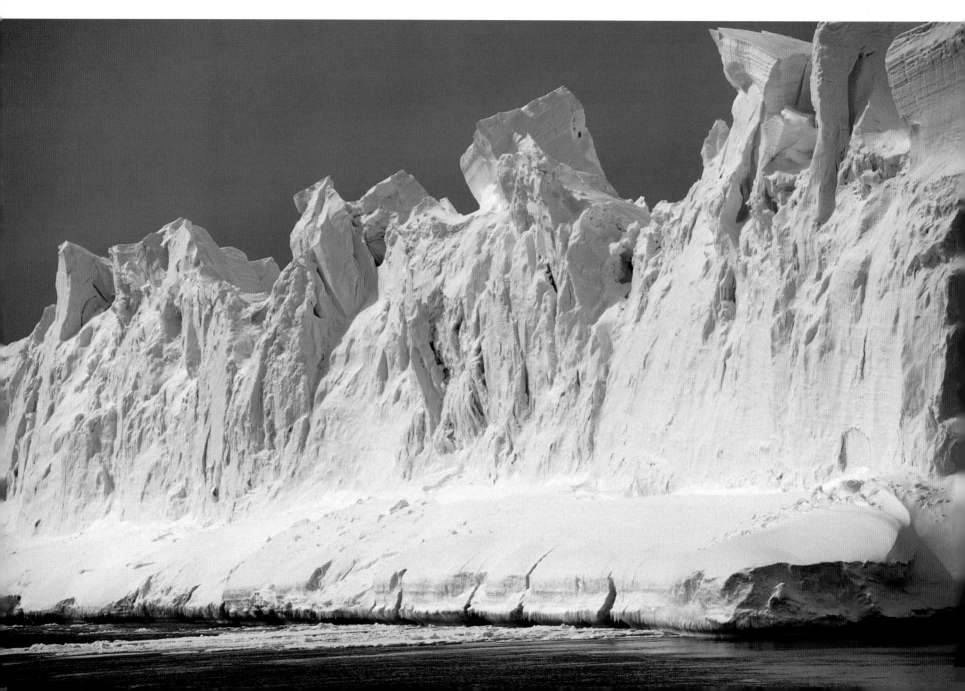

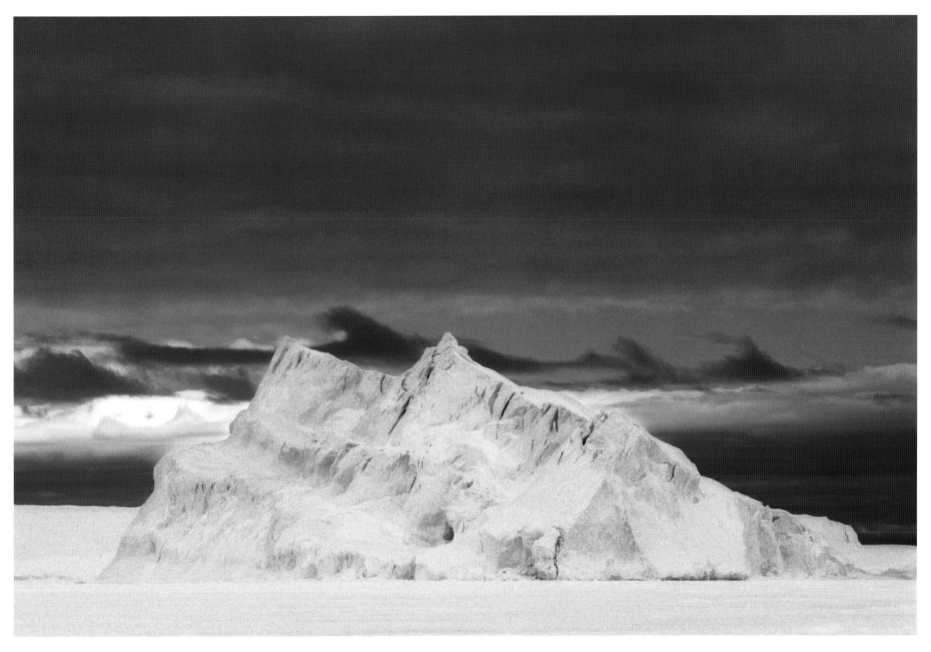

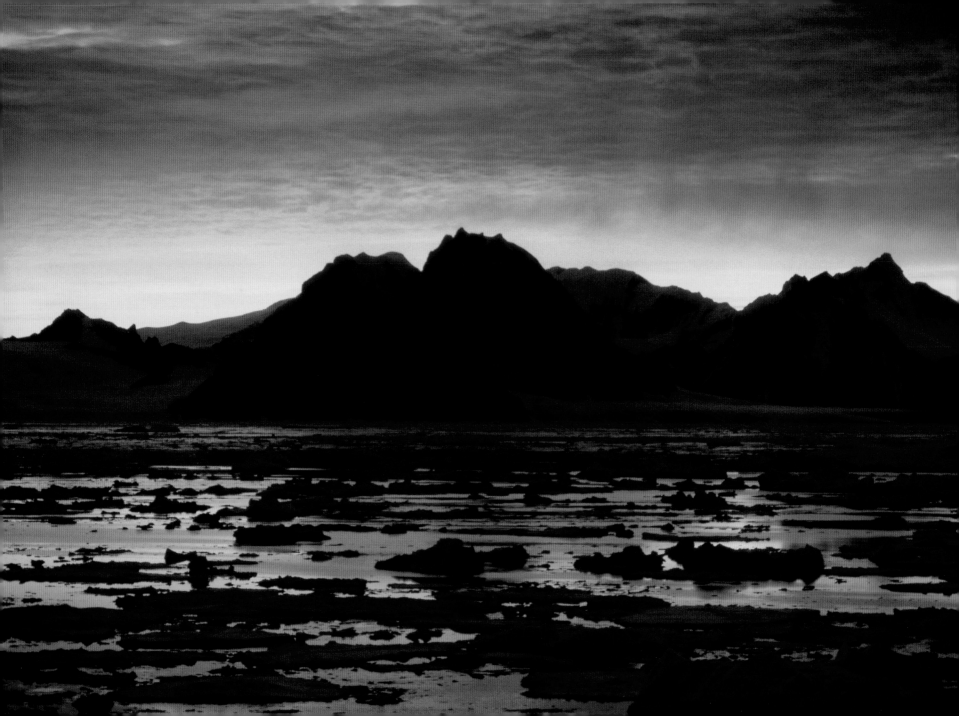

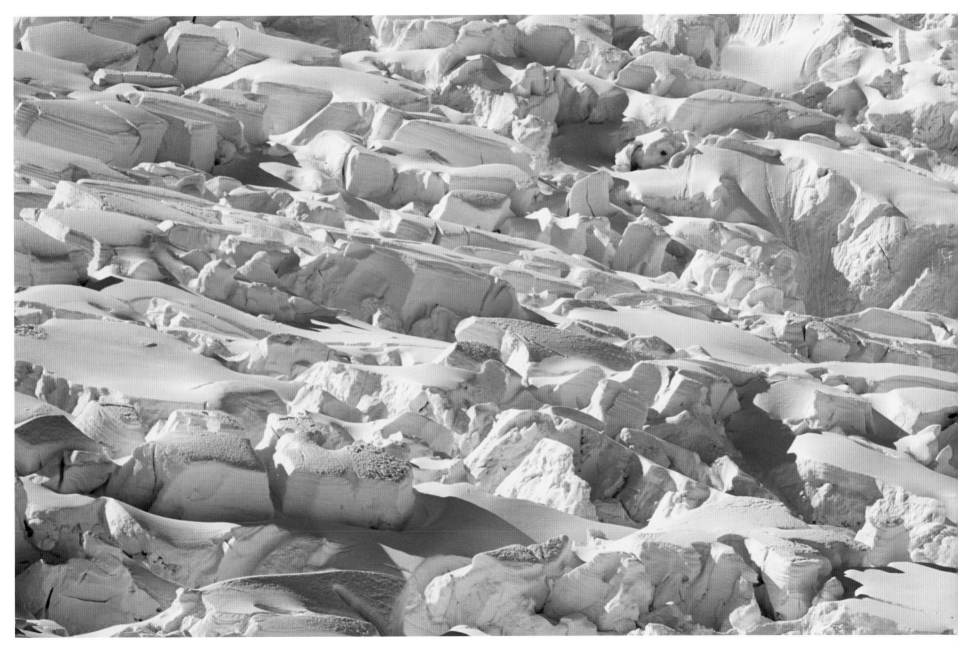

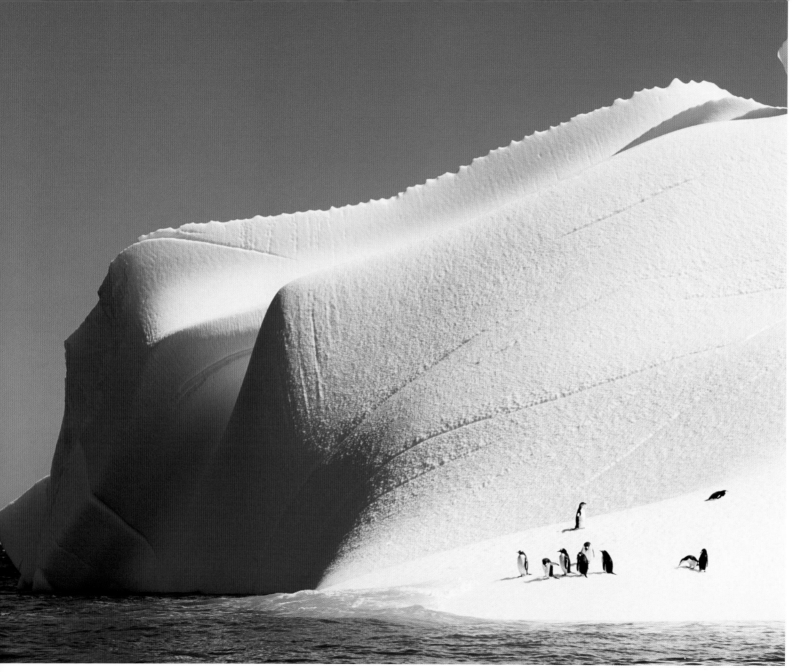

PAGE 134: Sunrise over the Antarctic landscape can be a magical time—here mountains are silhouetted while floating ice reflects the red sky in a particularly dramatic fashion.

PAGE 135: Here large chunks of ice can be seen on a glacier on the Palmer Peninsula, Antarctica. They are formed by the pressure generated by the glacier's constant movement.

LEFT: Icebergs are favored resting places for many species of birds—here a small group of gentoo penguins enjoy the warming rays of the sun. Drake Passage, Antarctic Peninsula.

RIGHT: Many different species of whales and dolphins can be seen in the Antarctic region—here a humpback whale surfaces gracefully in Fournier Bay, Antarctica.

PAGES 138–139: The colony of emperor penguins on the Dawson Lambton Glacier, Antarctica, can comprise between 5,000 and 10,000 brooding pairs and a further 2,000 to 5,000 juveniles.

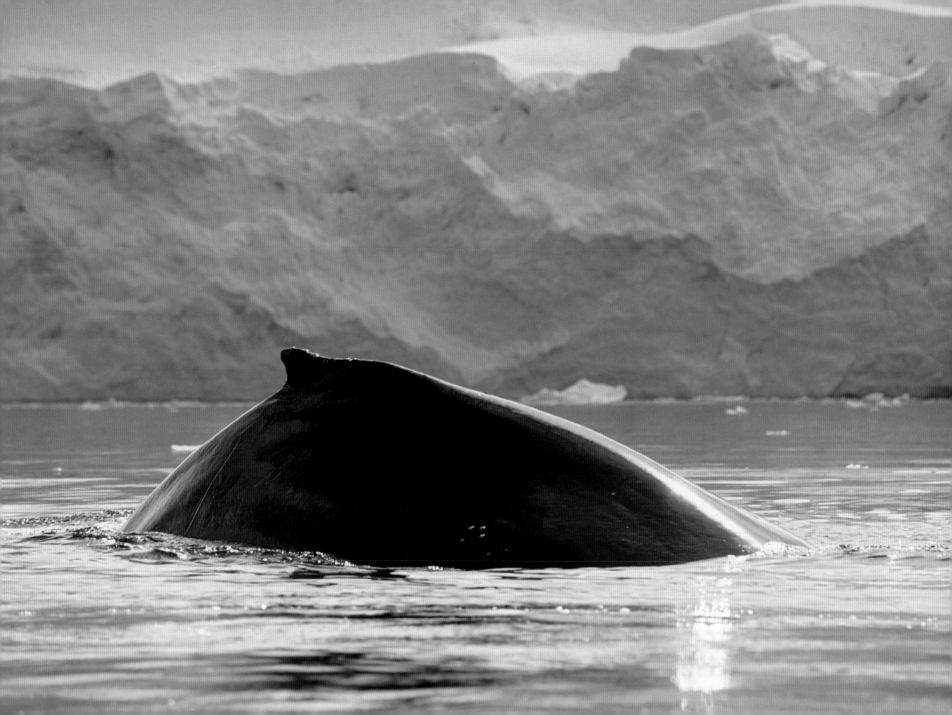

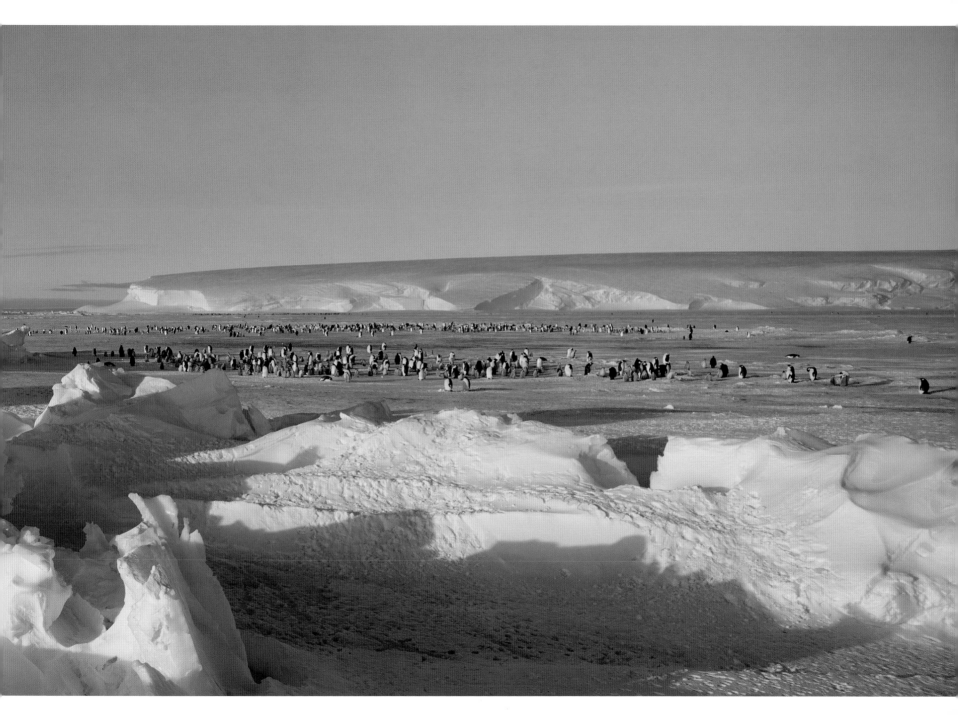

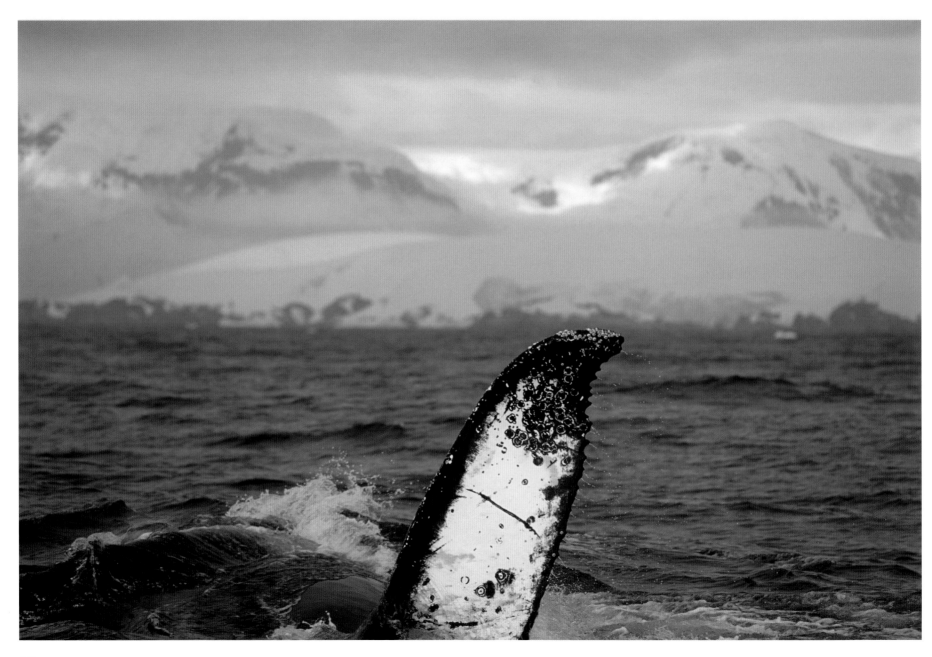

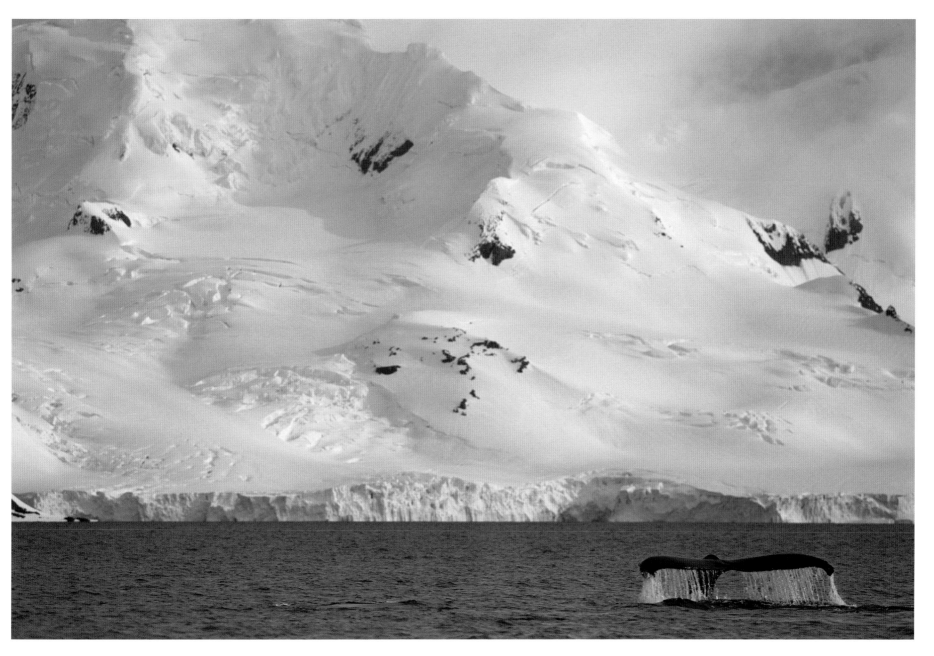

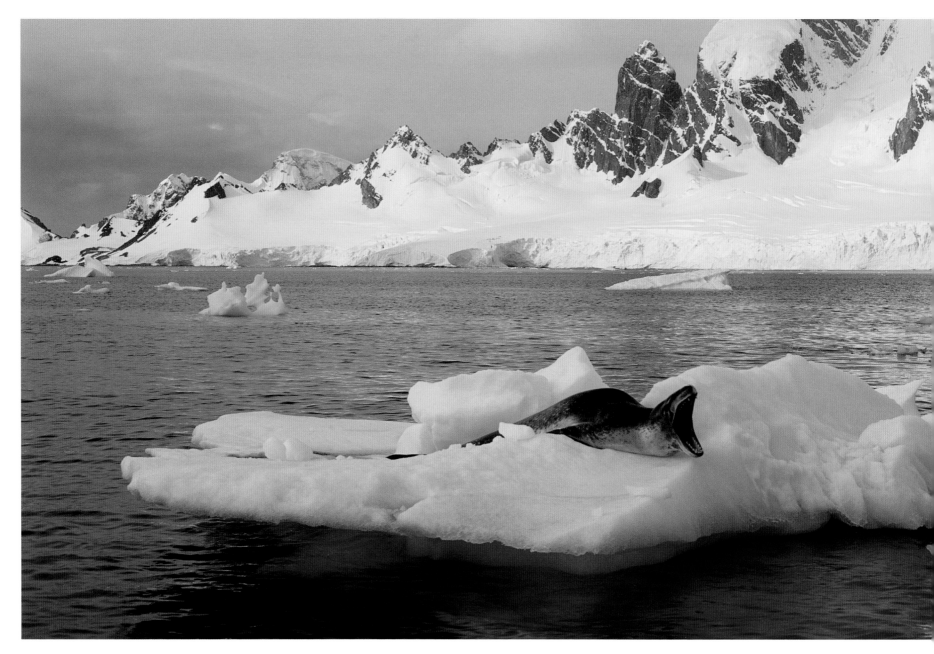

PAGE 140: As winter recedes, the sea-ice starts melting. This releases vast amounts of nutrients causing plankton to boom—this bounty cascades all the way up the food chain.

PAGE 141: The spectacular Antarctic scenery is much enhanced by the presence of marine mammals. Here the massive tail fins of a humpback whale can be seen in Fournier Bay, Antarctica.

LEFT: Some seal species feed on squid and fish, whereas others, such as the leopard seal seen here will also hunt penguins or other seals.

RIGHT: Seals have powerful jaws, as can be seen here on this large specimen that is making a threat gesture on King George Island, South Shetland Islands, Antarctic.

PAGE 144: For penguins entering and leaving water is the most dangerous time—predators such as killer whales or leopard seals take large numbers by lying in wait near their resting spots.

PAGE 145: Penguins usually find it easy to jump off an ice floe, where the sides are steep. However, returning to them can be much more problematic.

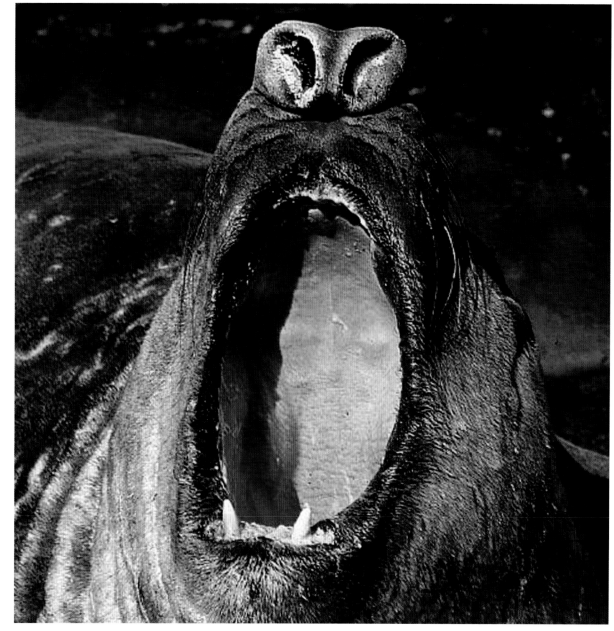

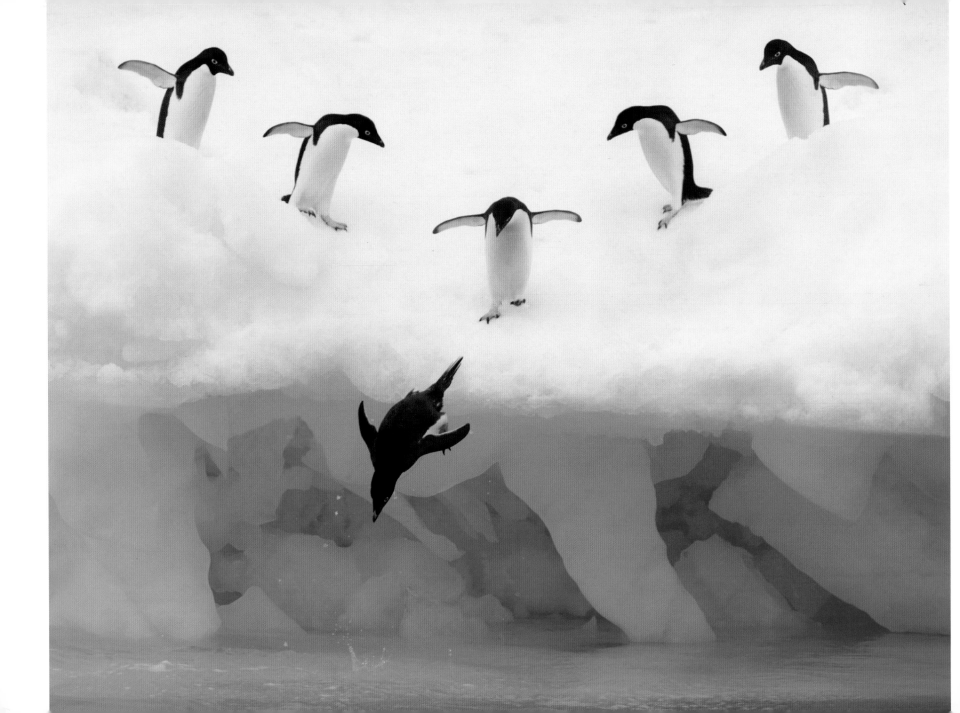

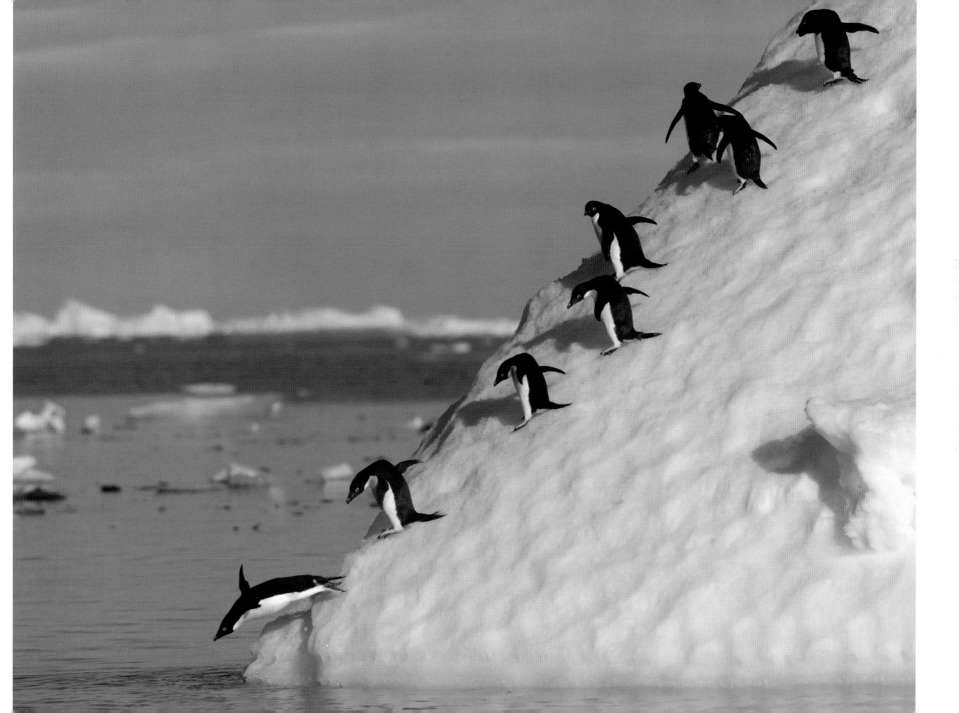

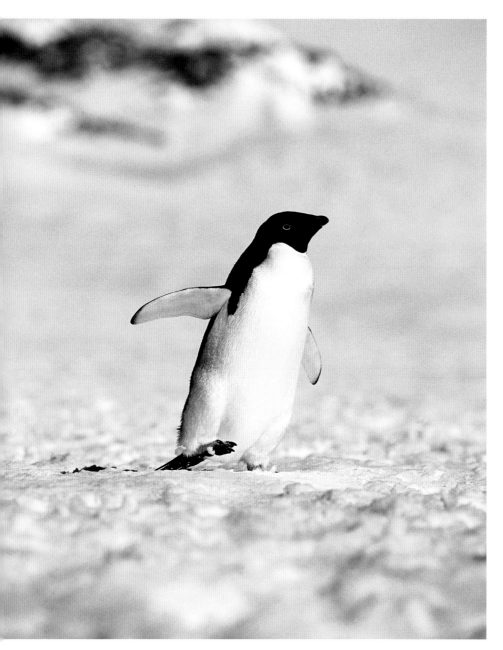

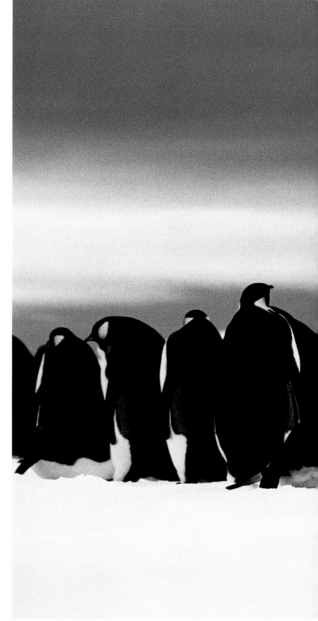

LEFT: The adelie penguin only comes to land to nest—it does this on many of the coasts of the Antarctic region. They feed on a mix of fish and krill.

RIGHT: The emperor penguin is the largest of the many species found in the Antarctic region.

PAGES 148–149: Adelie penguin Rookery on Petermann Island in Antarctica.

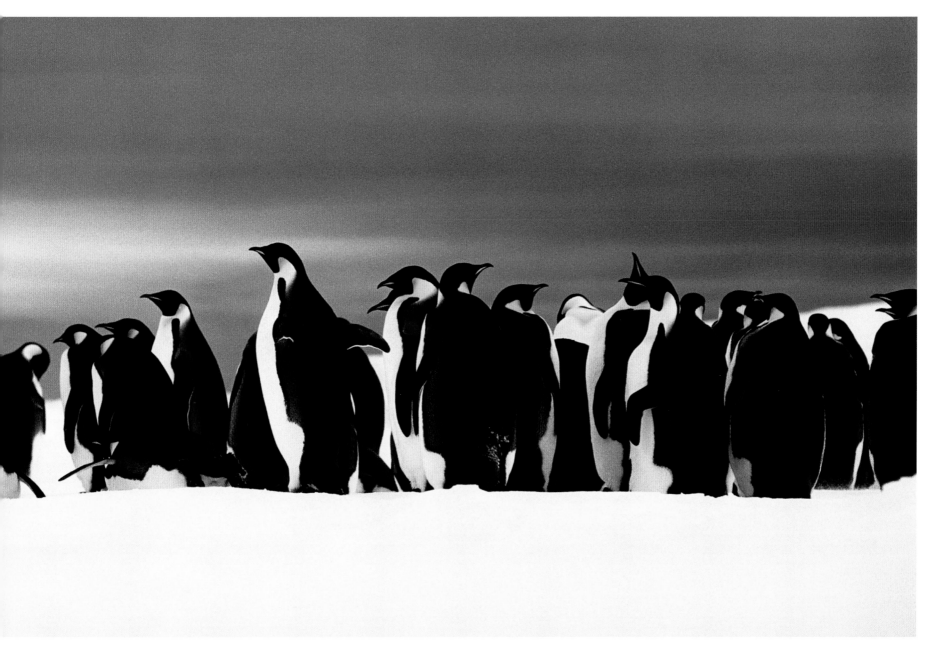

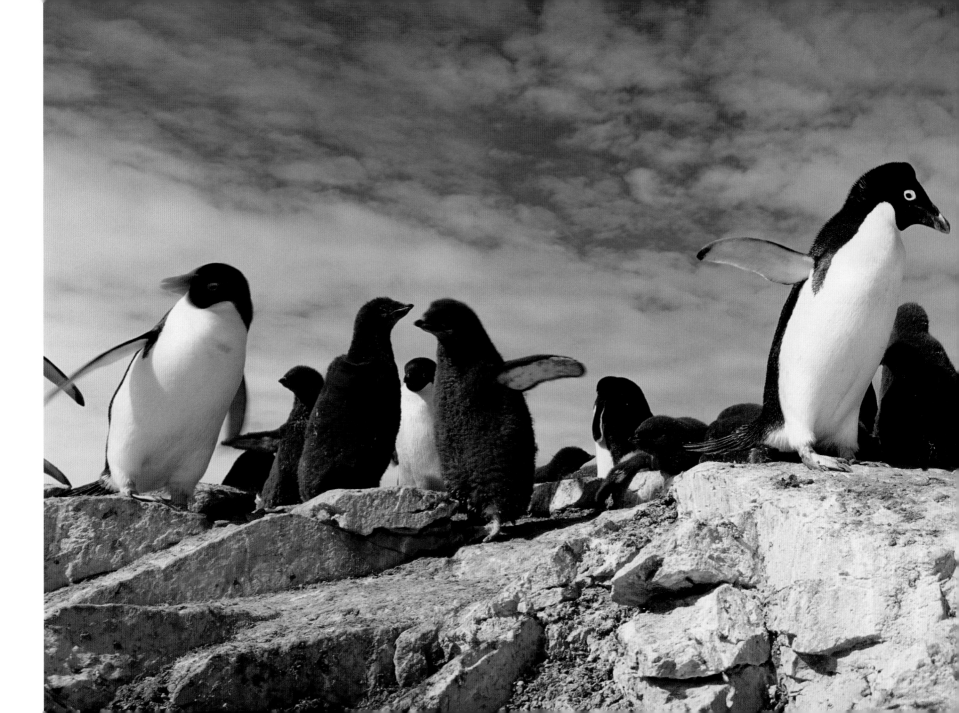

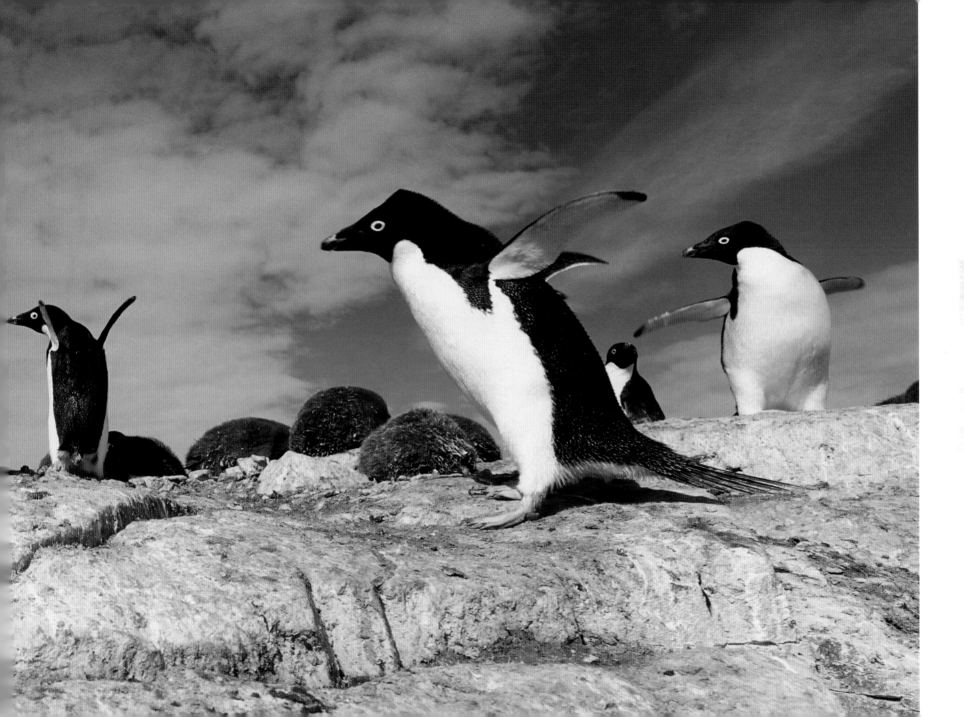

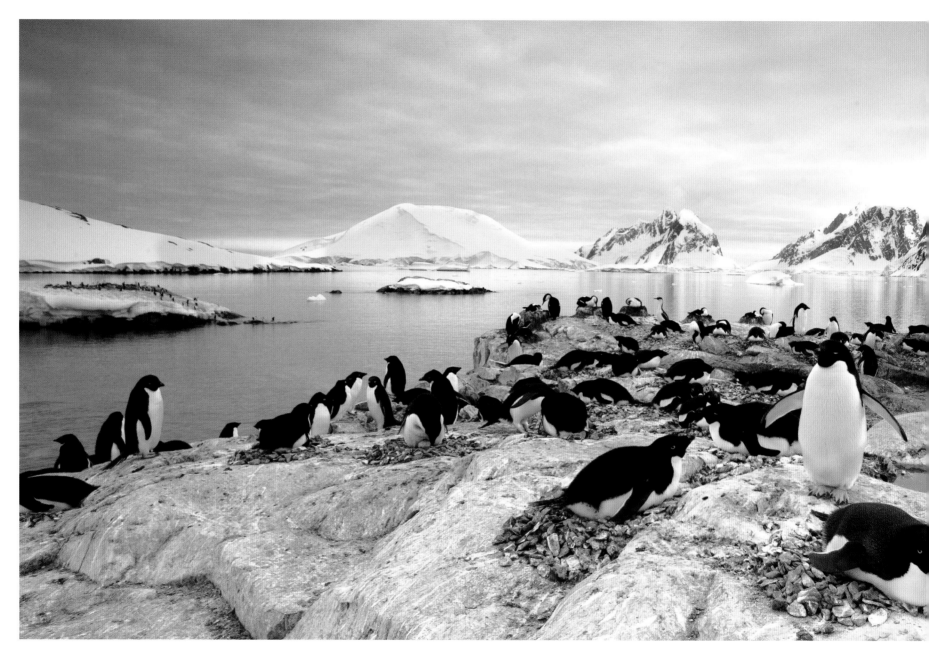

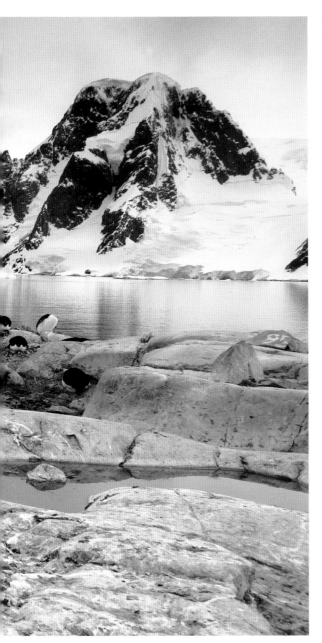

LEFT: When its time to breed, penguins often gather together in large colonies where they make rudimentary nests from seaweed and whatever else they can find.

RIGHT: The orange streaks on the king penguin can sometimes be confused with the orange ear patches found on the emperor penguin when courting.

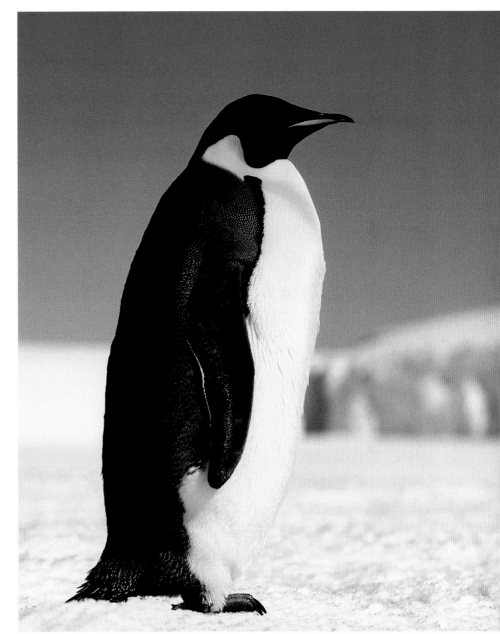

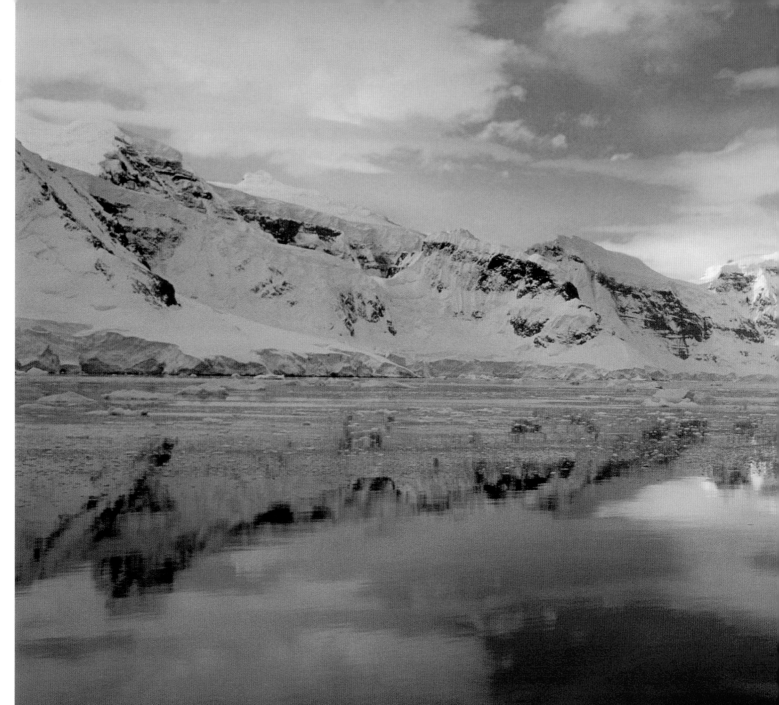

RIGHT: The limpid sea makes for perfect reflections. The first survey of rocks from the islands in the Gerlache Strait, Antarctica, demonstrated that they are the result of volcanic activity.

PAGES 154–155: Icebergs in Paradise Bay in Antarctica.

PAGE 156: The king penguin is the second largest species. This individual is sporting its winter coat—the extra feathers provide added insulation to help it survive the harsh conditions.

PAGE 157: Adelie penguins launch themselves into the ocean. The smallest living on the Antarctic Continent, Adelies are about 28 inches tall and weigh less than 10 pounds.

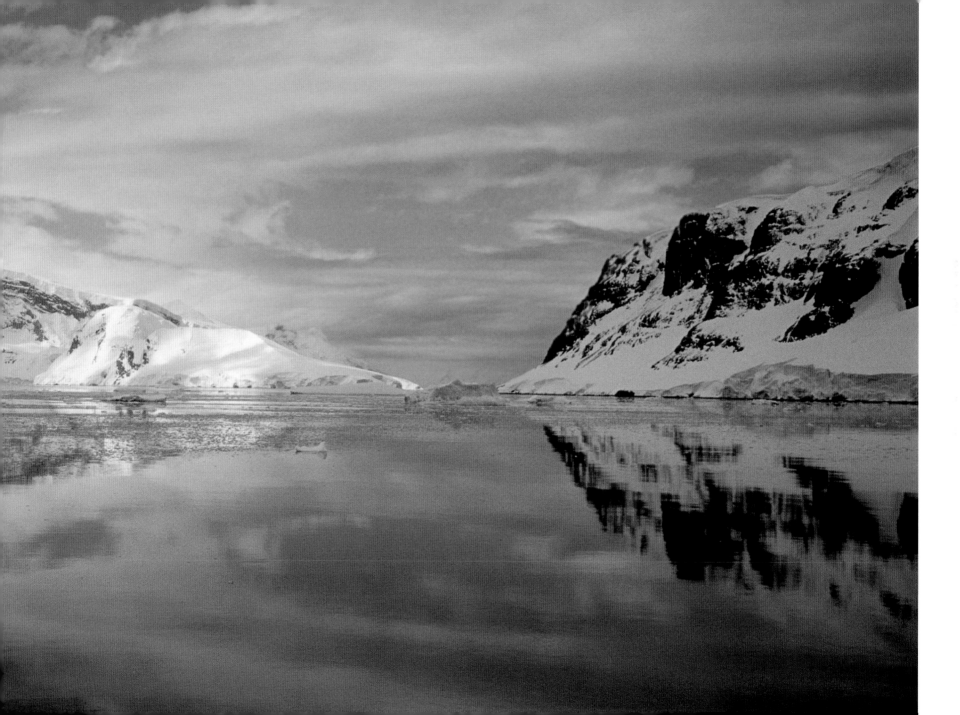

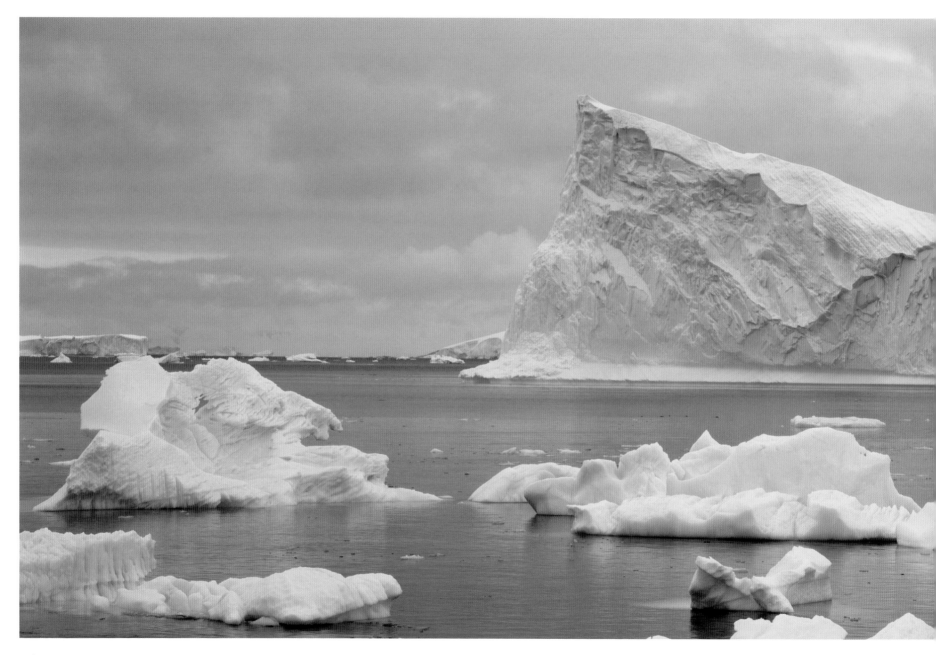

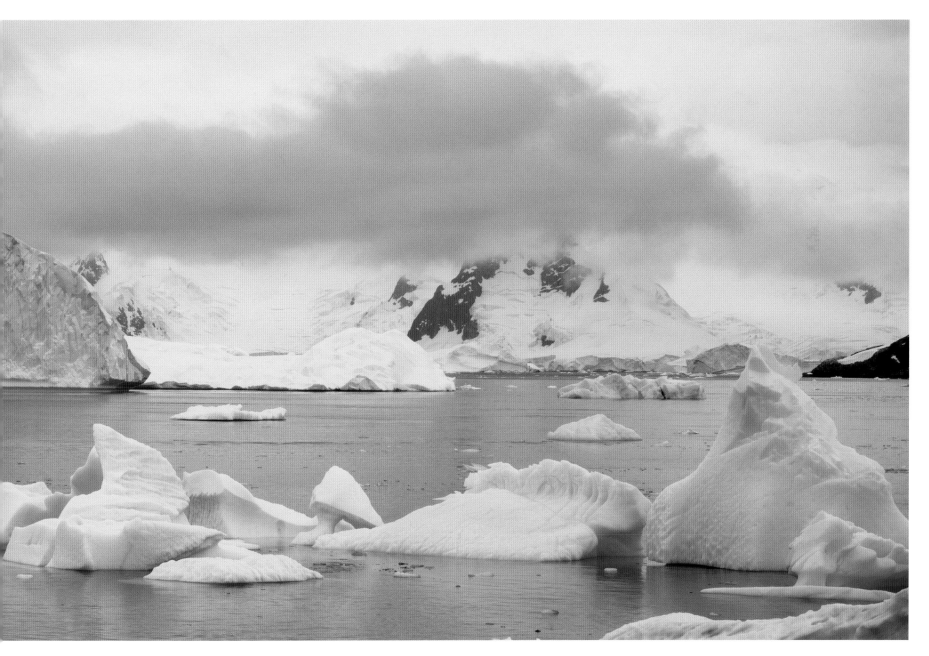

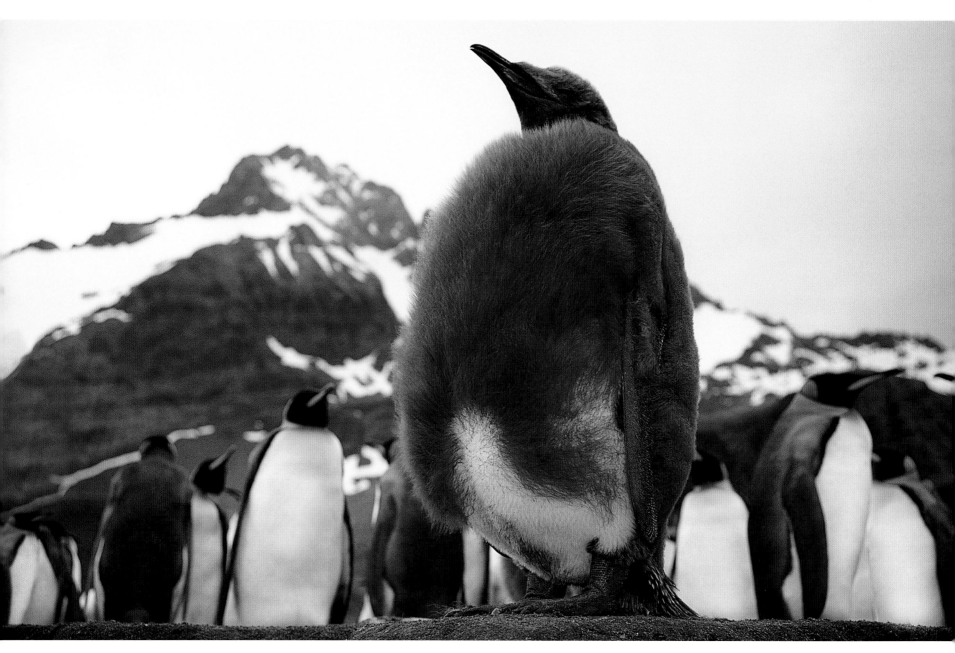

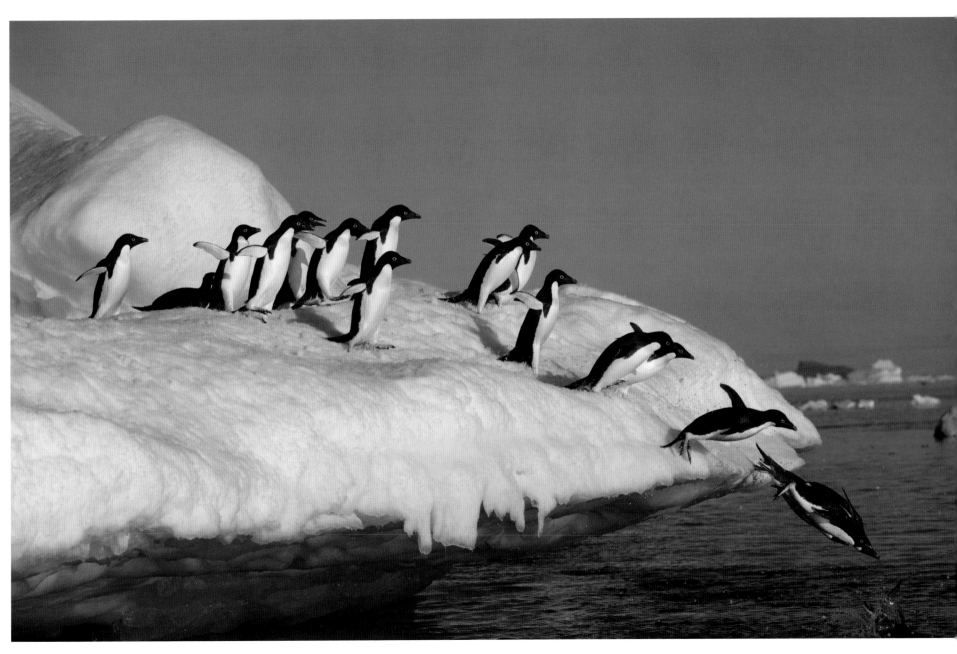

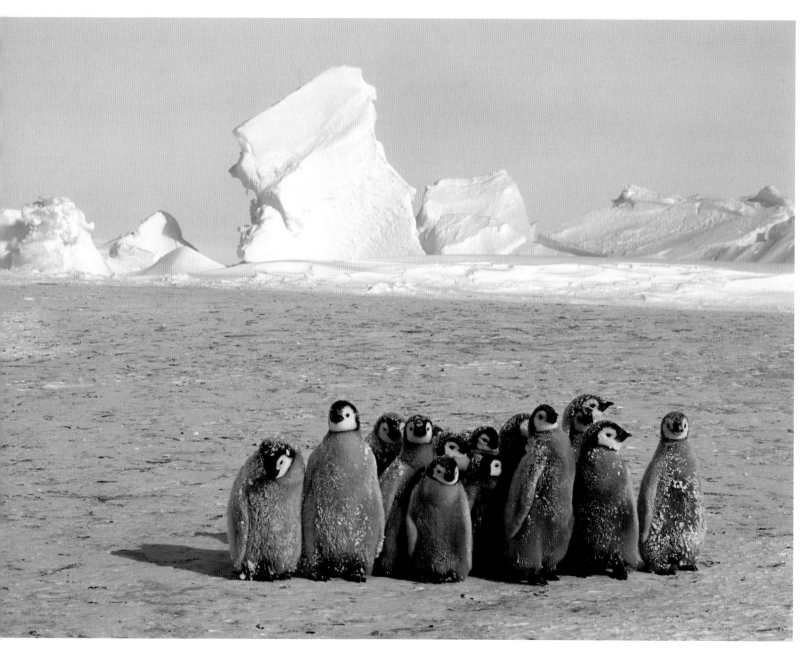

LEFT: Well you'd look cold too! These emperor penguin chicks are huddling together for warmth and protection. When they reach full size they will stand up to 44 inches high and weigh up to 90 pounds.

RIGHT: Chinstrap penguins often share their colonies with gentoo and adelie penguins—these individuals are on the beach at Baily Head, Deception Island, Antarctica.

PAGES 160–161: Icebergs near Cuverville Island.

PAGE 162: King penguins, which feed on squid, fish, small crustaceans, and plankton, are in turn preyed on by leopard seals, skuas, petrels, and orcas.

PAGE 163: Emperor penguins only lay a single egg. It is incubated by the male who rests it on his feet as soon as it is laid to keep it off the ice until the chick hatches some 65 days later.

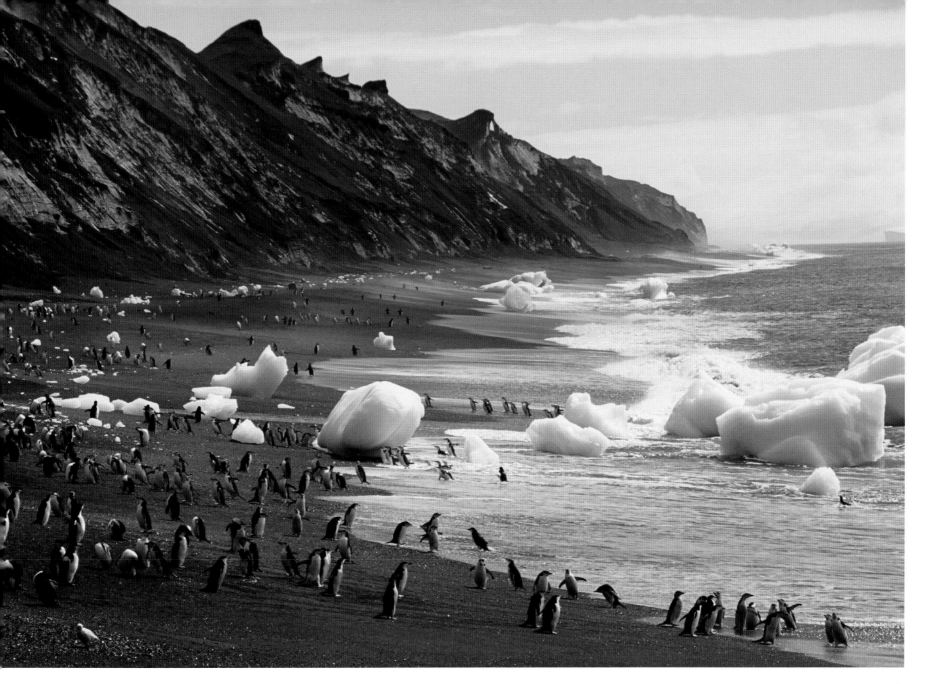

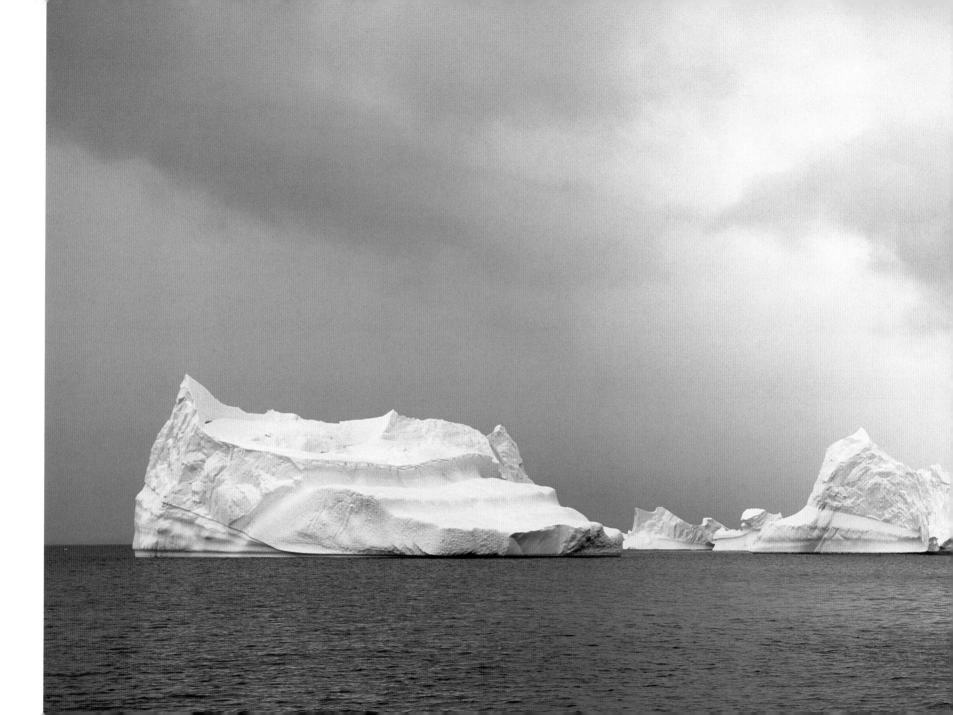

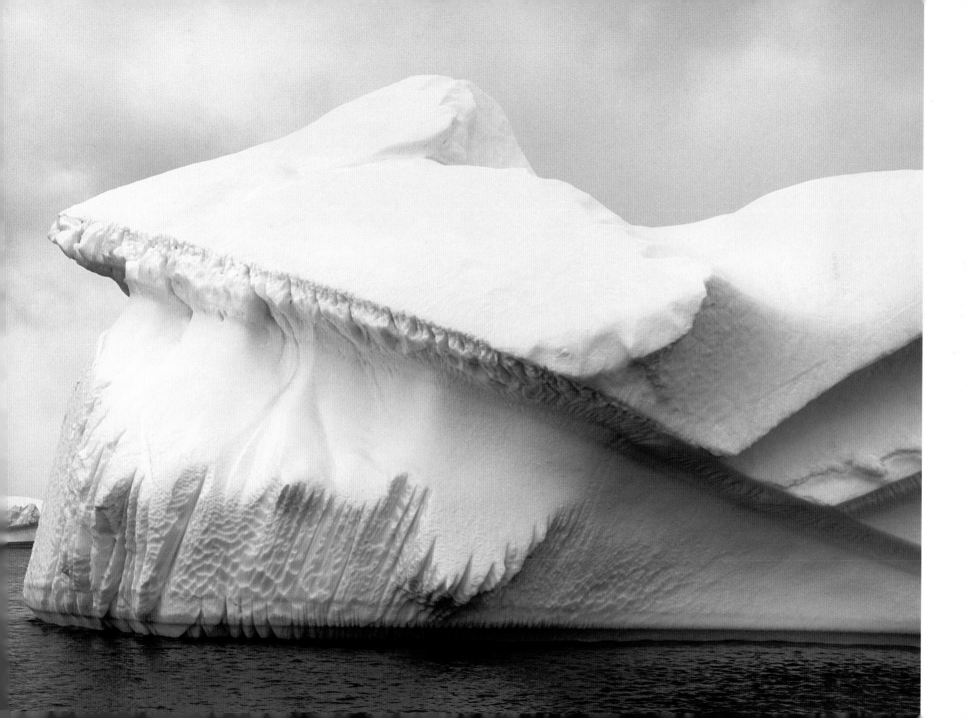

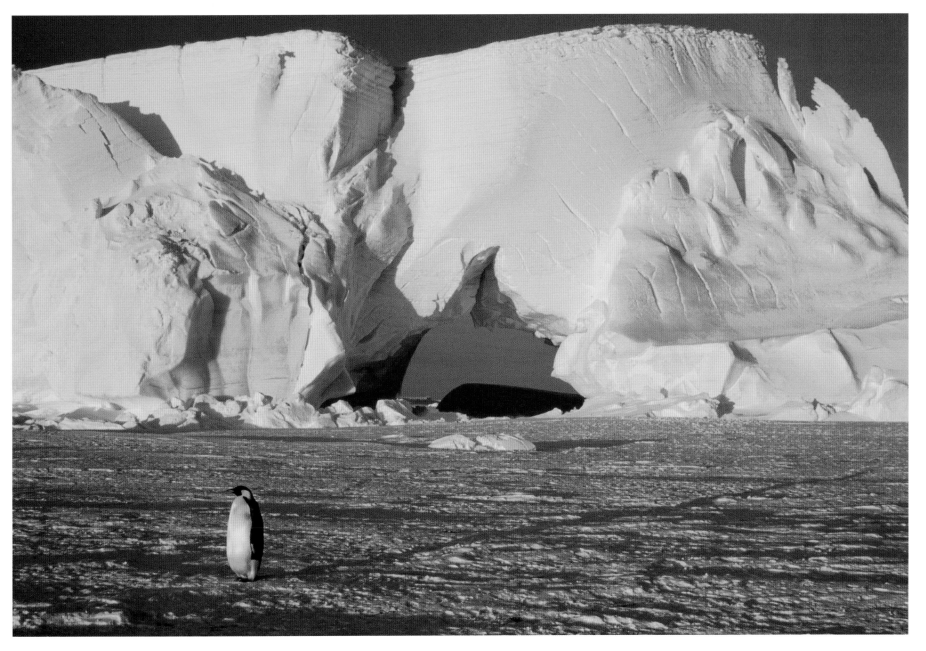

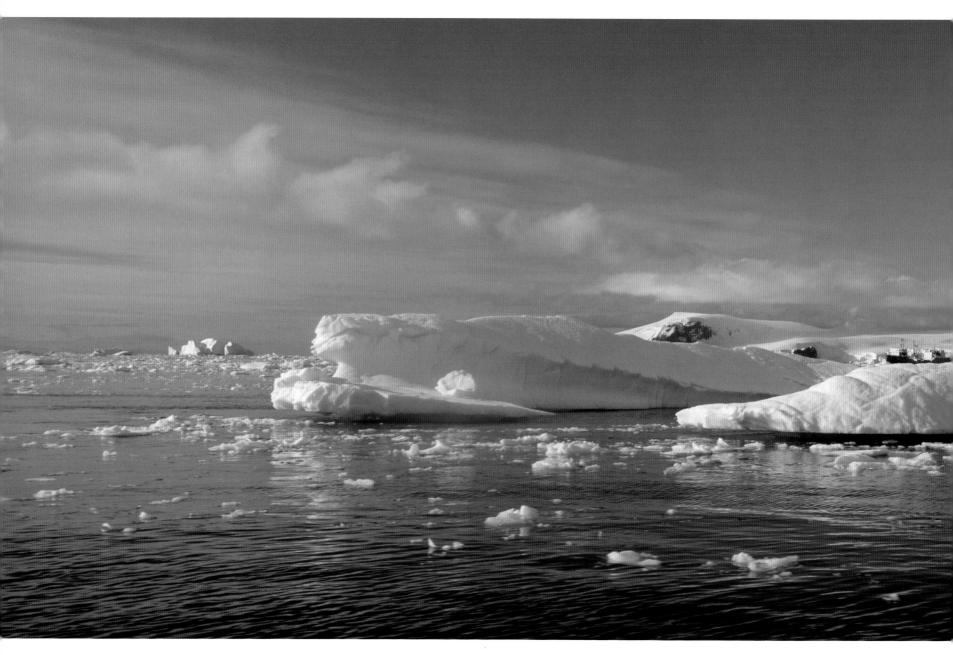

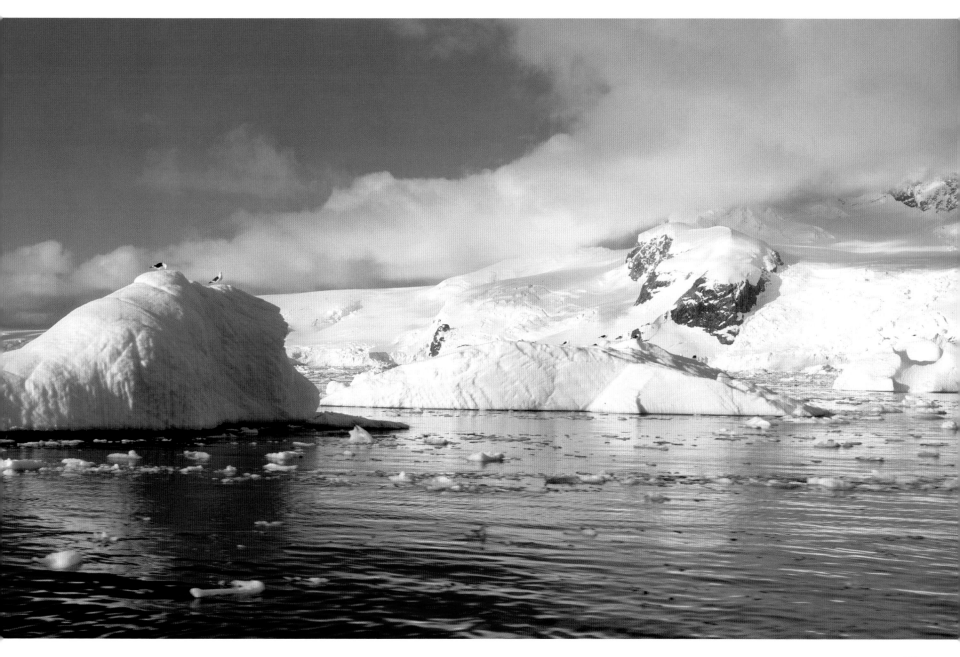

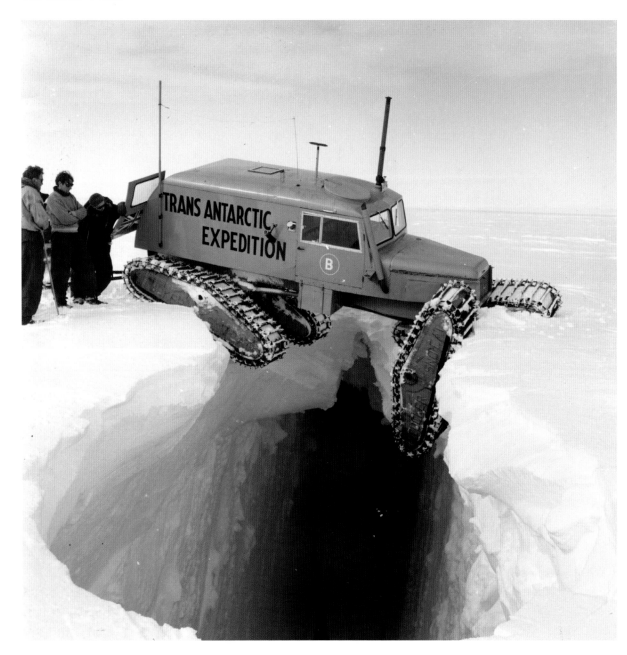

PAGES 164–165: As winter approaches, the sea ice around Antarctica freezes and its area grows from 4 million square kilometers to 19 million square kilometers—more or less doubling the size of the continent.

LEFT: Explorers not only have to contend with extreme weather, but also a very dangerous landscape. This Snowcat nearly fell into a crevice that was covered by a thin layer of snow.

RIGHT: These tourists on a specialized cruise ship are enjoying the good weather and getting a close-up view of the coast of the Antarctic Peninsula, Antarctica.

PAGE 168–169: Icebergs off the Adare Peninsula.

PAGE 170: When a glacier reaches the sea but does not break up, it forms what is known as an "ice-tongue," floating out over the sea—this is the Drygalski Ice Tongue, Victoria Land, Antarctica.

PAGE 171: The tail fluke of a humpback whale can be seen through a hole in an iceberg. These whales migrate to Antarctic feeding grounds during the winter, then move north to warmer breeding grounds in the summer.

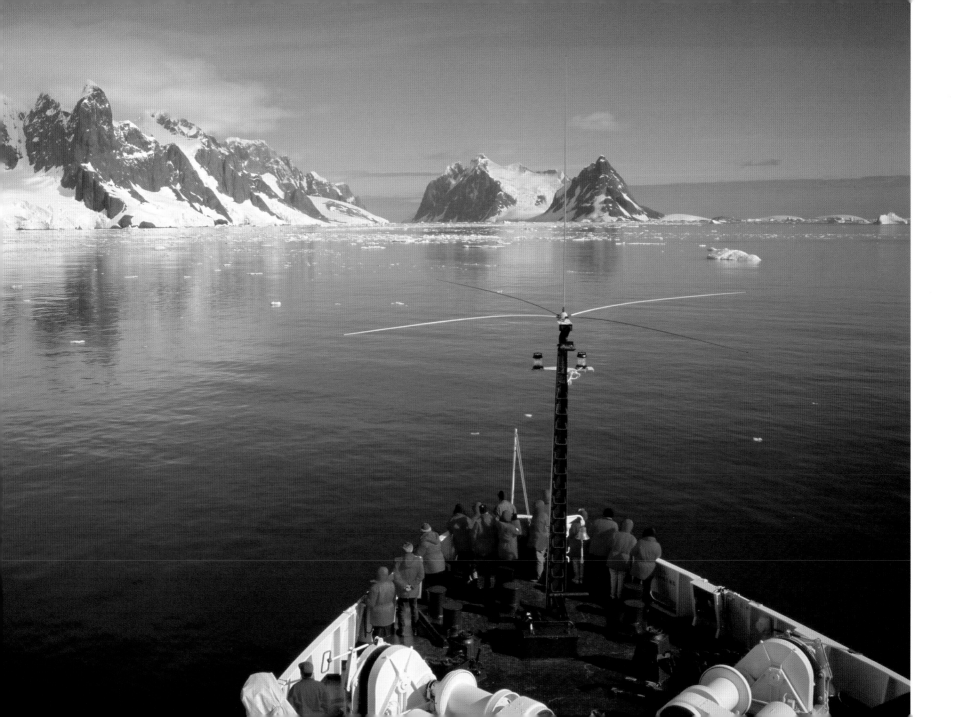

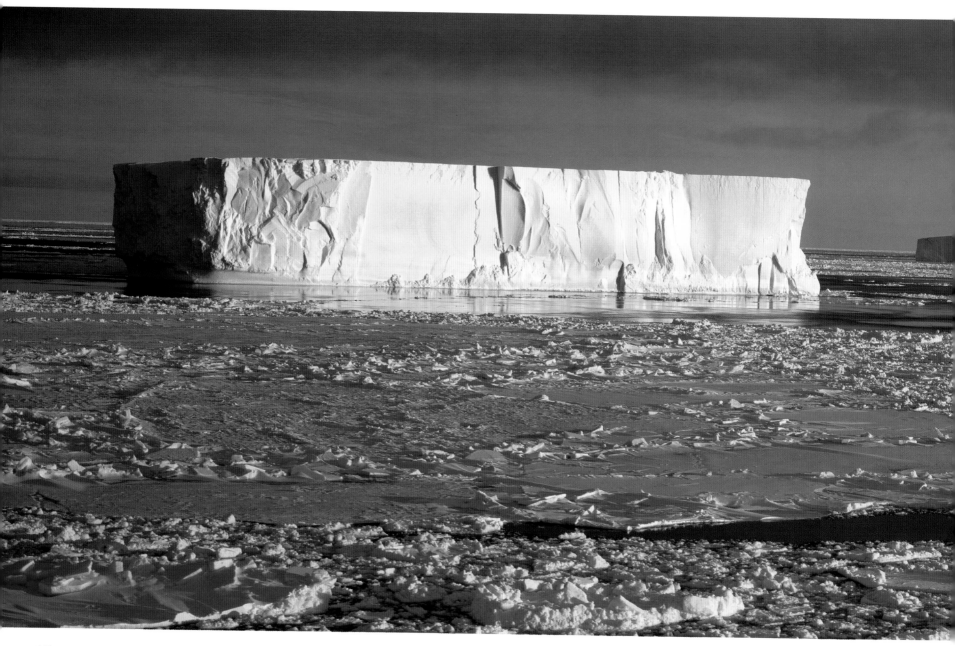

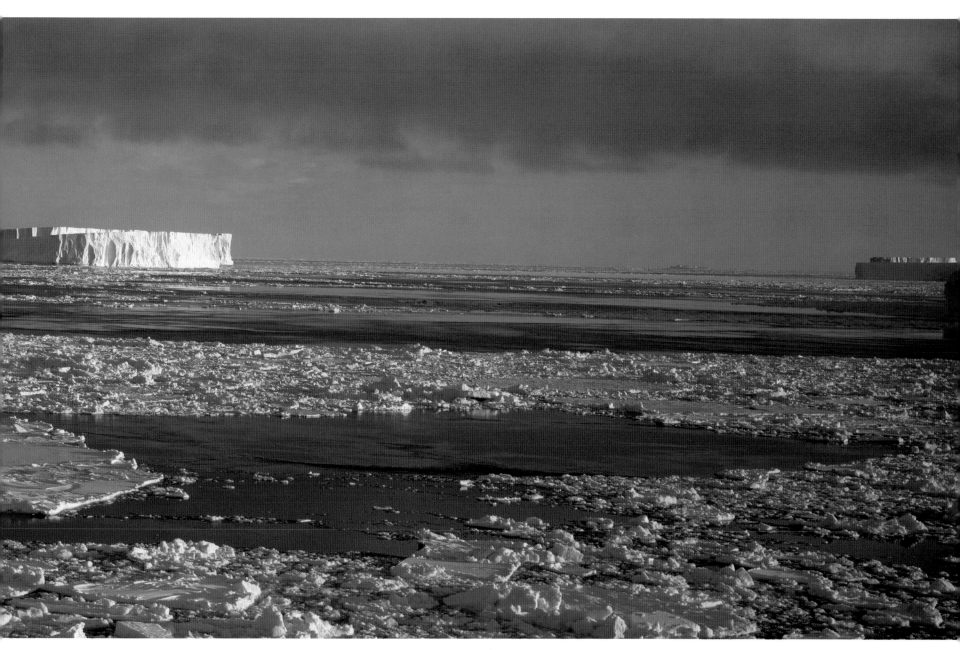

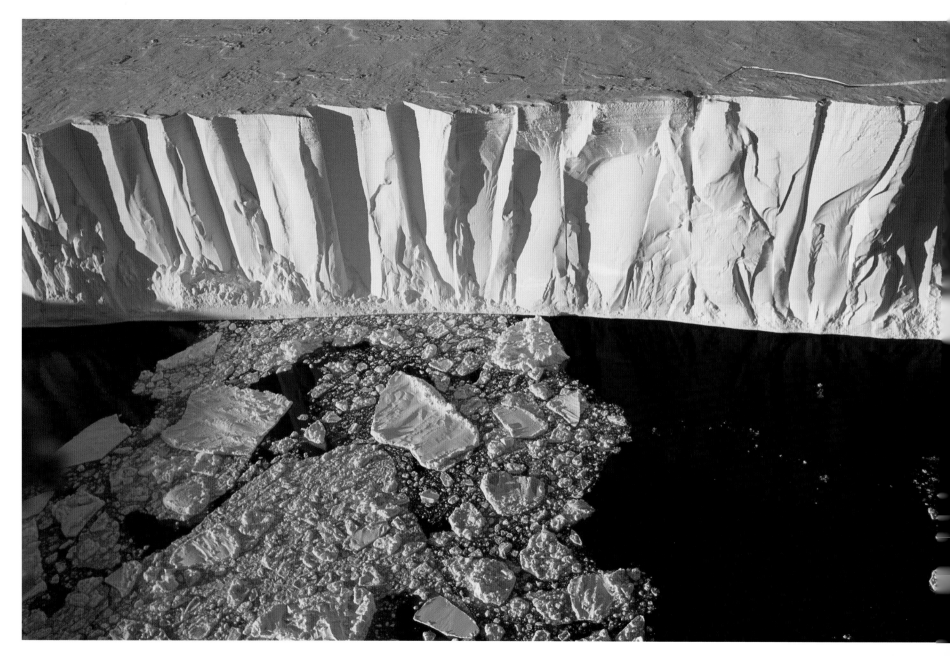

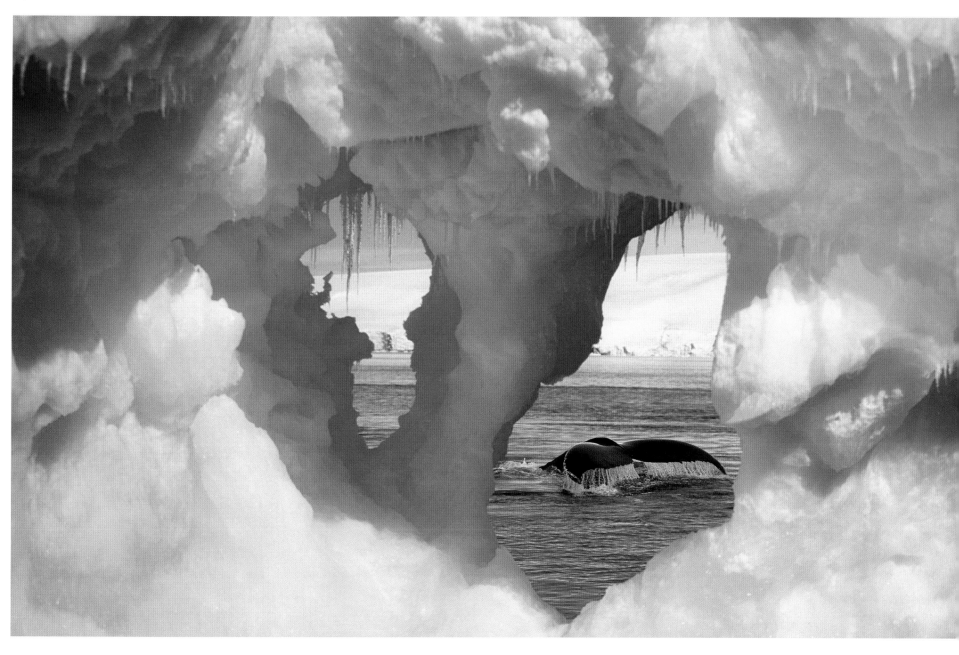

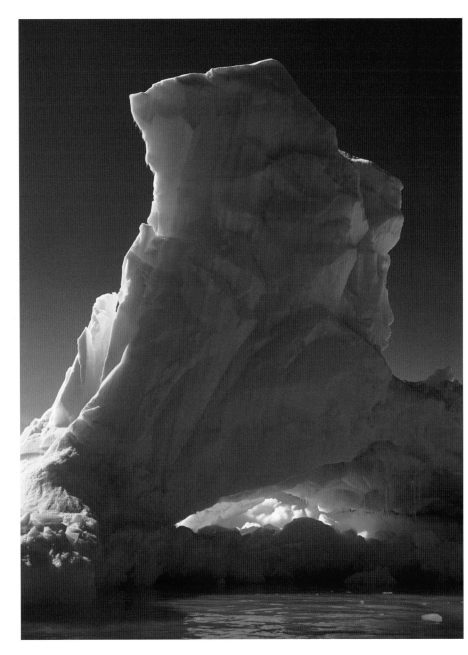

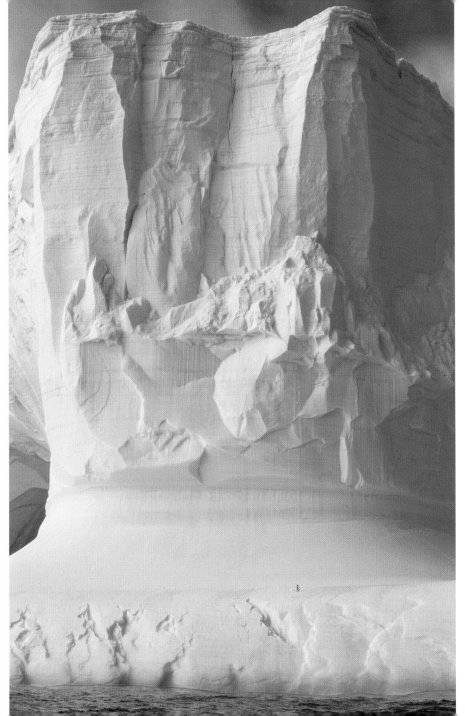

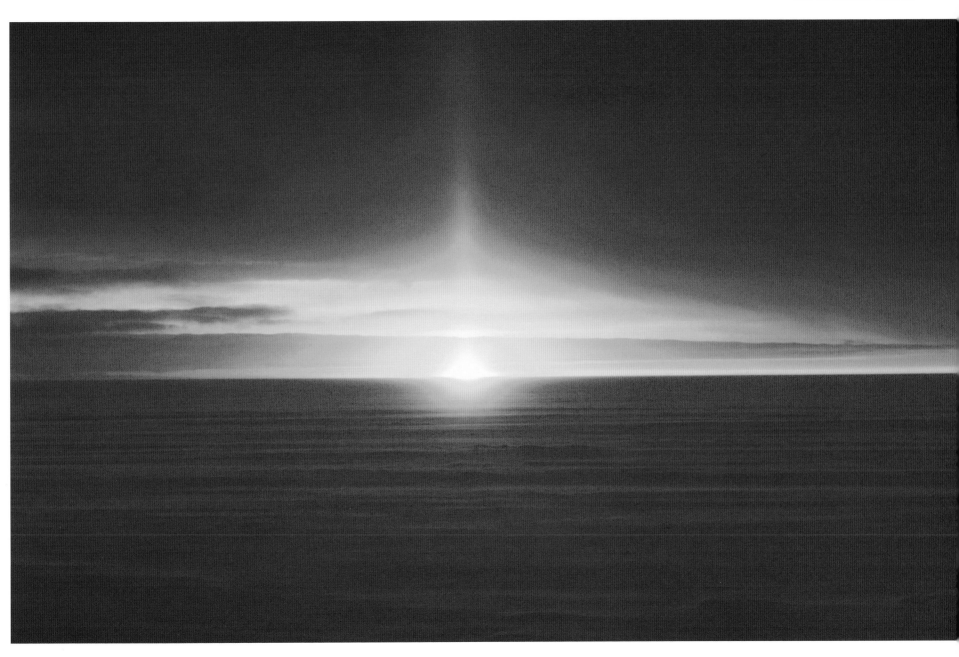

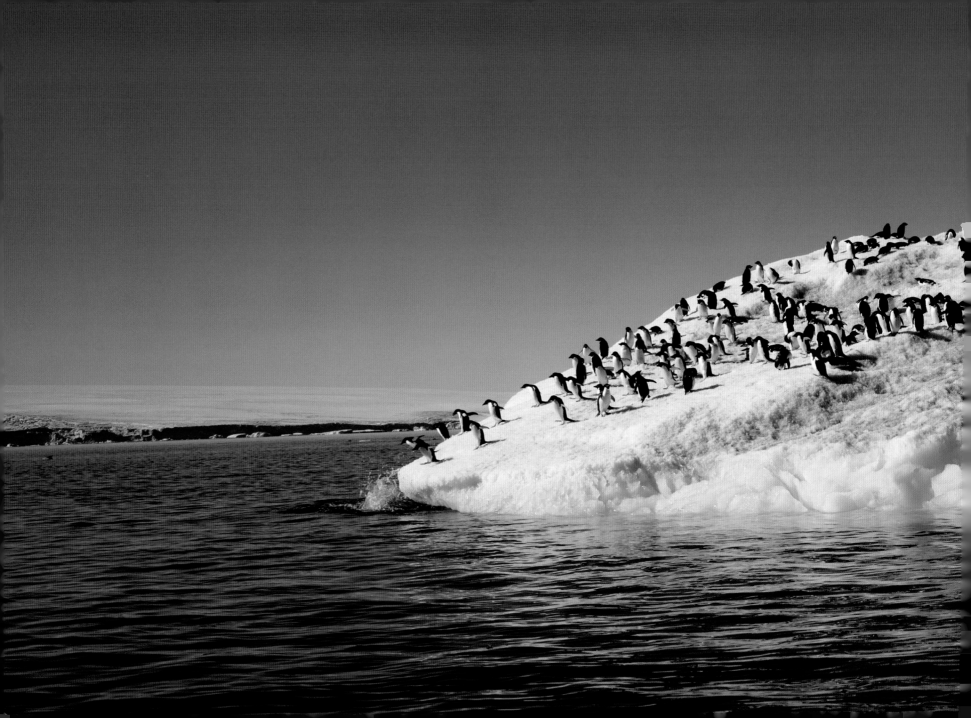

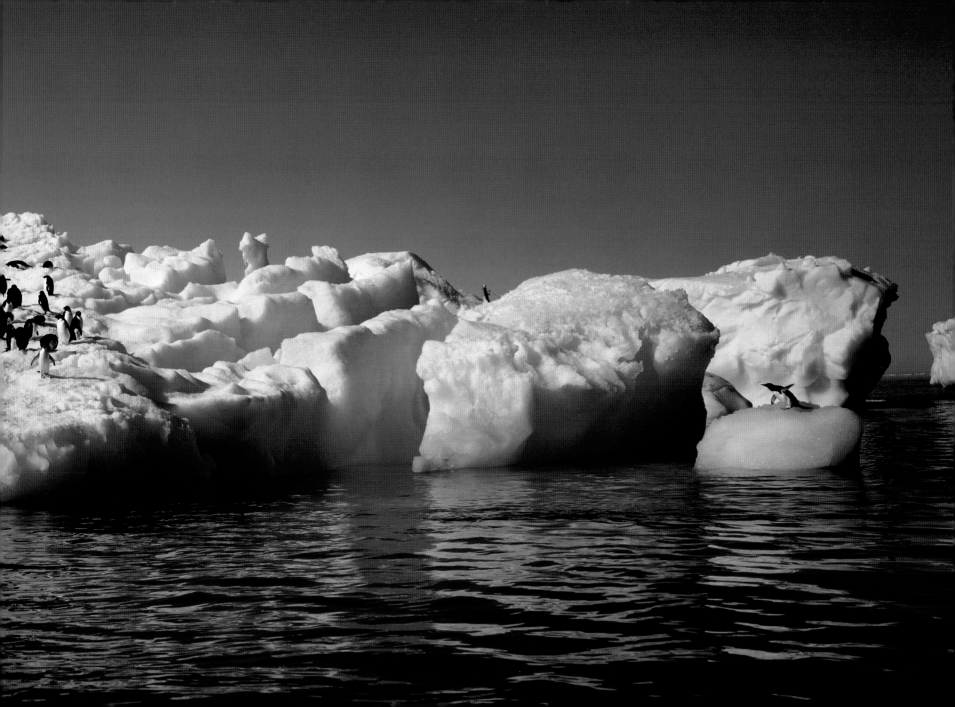

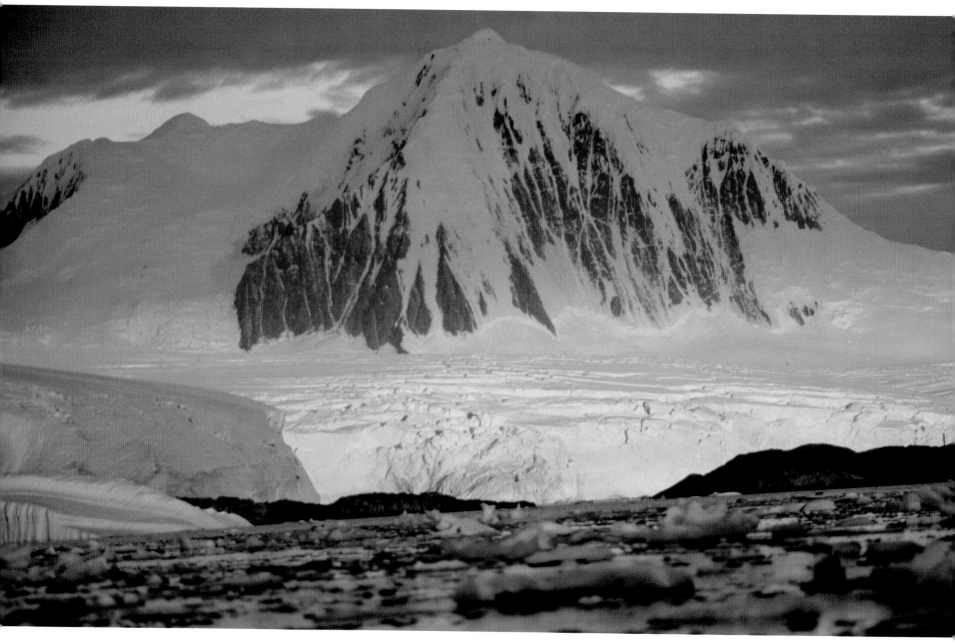

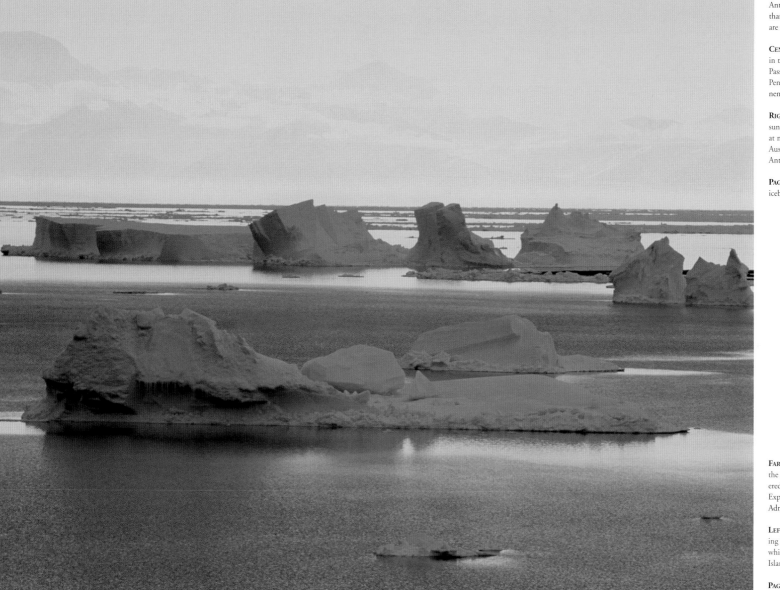

PAGES 172–173:

LEFT: The icebergs that form in the Antarctic region tend to be much larger than those that form in the Arctic; they are also much more numerous.

CENTER: This massive iceberg is floating in the treacherous waters of the Drake Passage, which lies between the Antarctic Peninsula and the South American continent.

RIGHT: During the summer the Antarctic sun never sets—this photograph was taken at midnight on Law Dome, inland from Australian Casey Station, Wilkes Land, Antarctica.

PAGES 174–175: Adelie penguins on an iceberg.

FAR LEFT: This is the Gerlache Strait off the Antarctic Peninsula, which was discovered in 1897 by a Belgian Antarctic Expedition under the command of Lt. Adrien Victor Joseph de Gerlache.

LEFT: These spectacular icebergs are floating in the glacial waters off Cape Bird, which is on the northern end of Ross Island, Antarctica.

PAGES 178–179: Pack ice on Brabant Island.

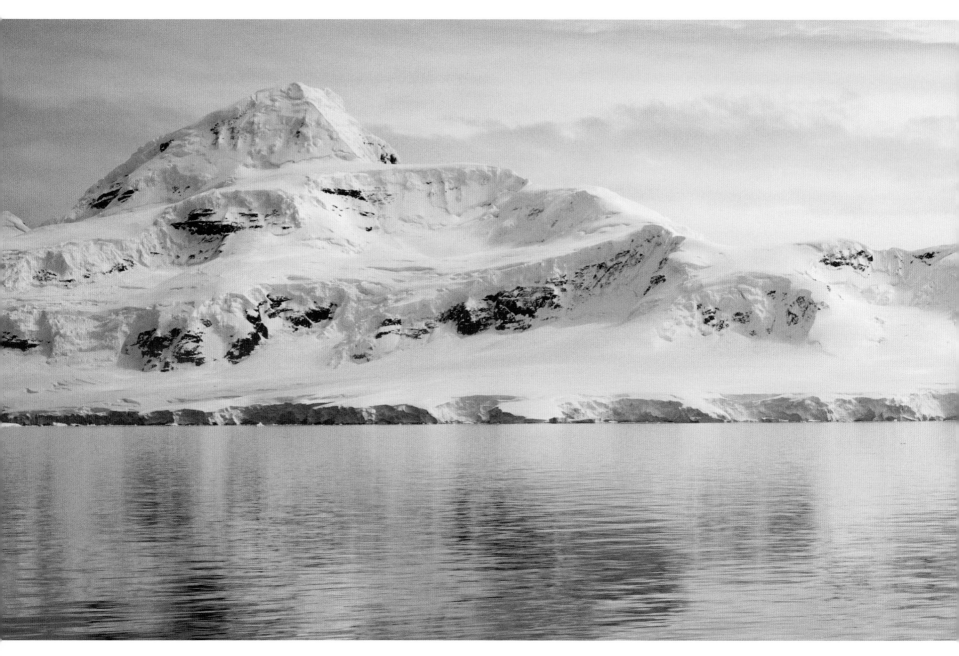

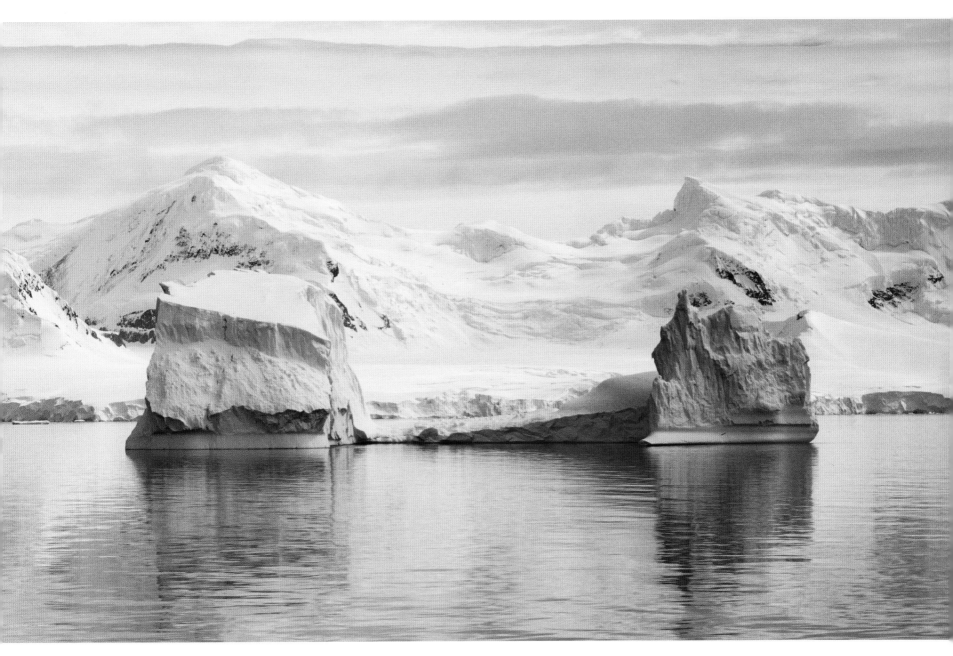

RIGHT: When an iceberg is warmed by the rays of the sun, it starts to melt and fresh water trickles down its sides. If the air then cools below freezing, the runoff turns into icicles.

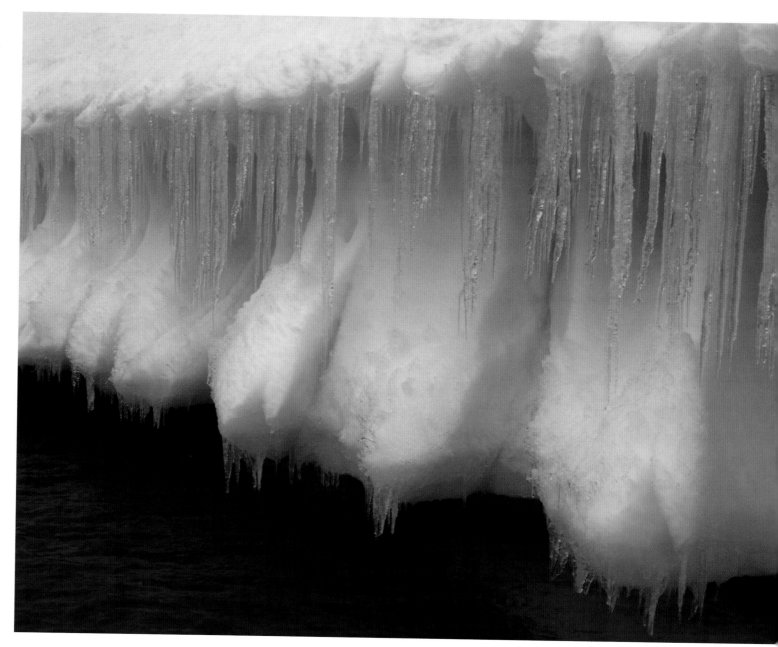

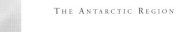

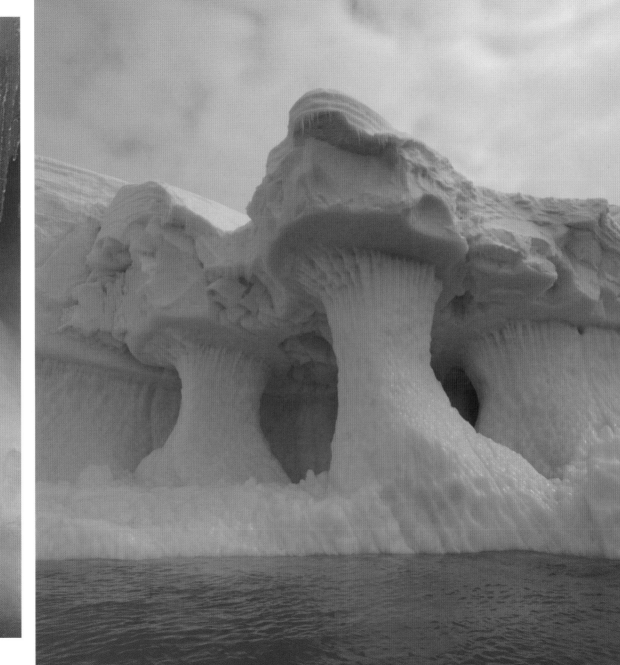

LEFT: After Gerlache discovered and named the Gerlache Strait, he went south and his ship, the *Belgica*, became trapped in the ice for an entire winter.

PAGES 182–183: Paradise Bay is well named for the spectacular scenery of mountains like Bryde Peak, glaciers and icebergs.

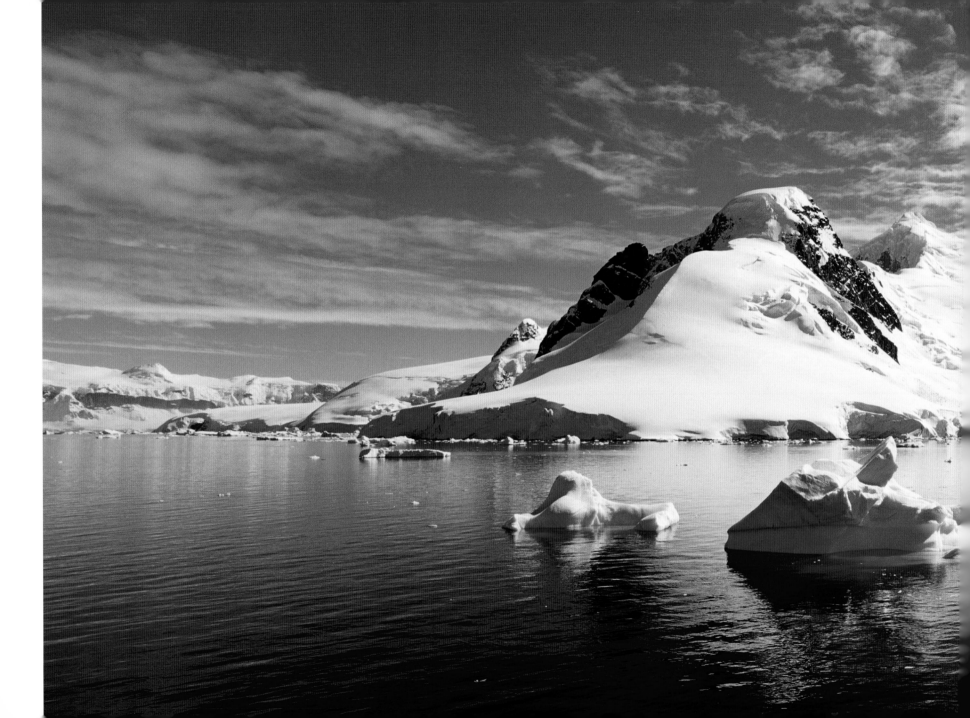

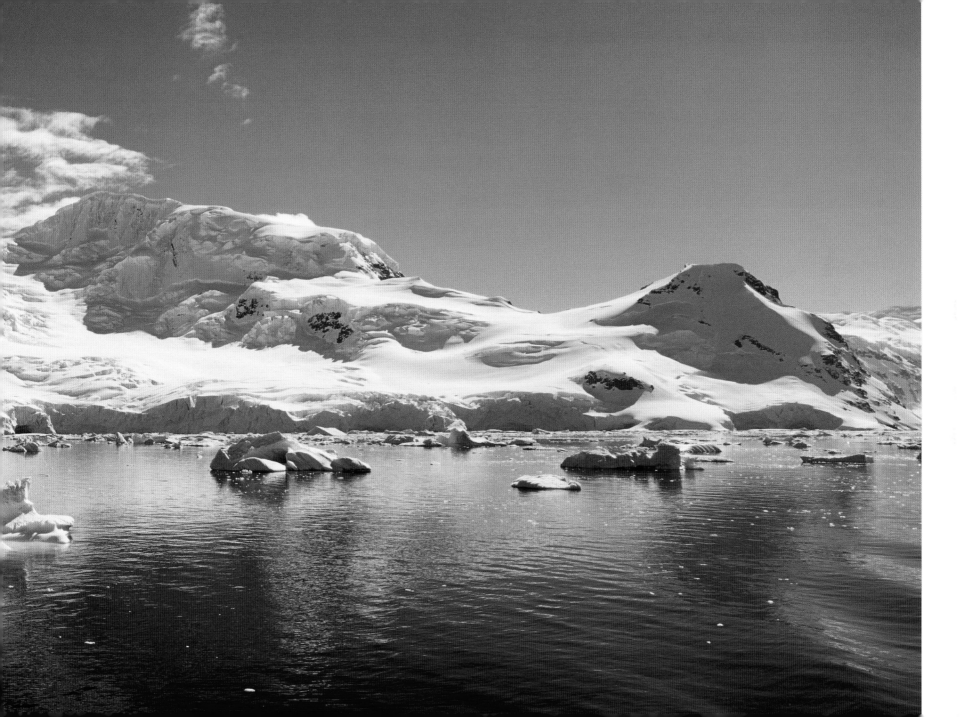

RIGHT: The pack ice shown here is frozen seawater that formed elsewhere and floated to its current location. Its great weight has the effect of eliminating waves, which allows further ice to form.

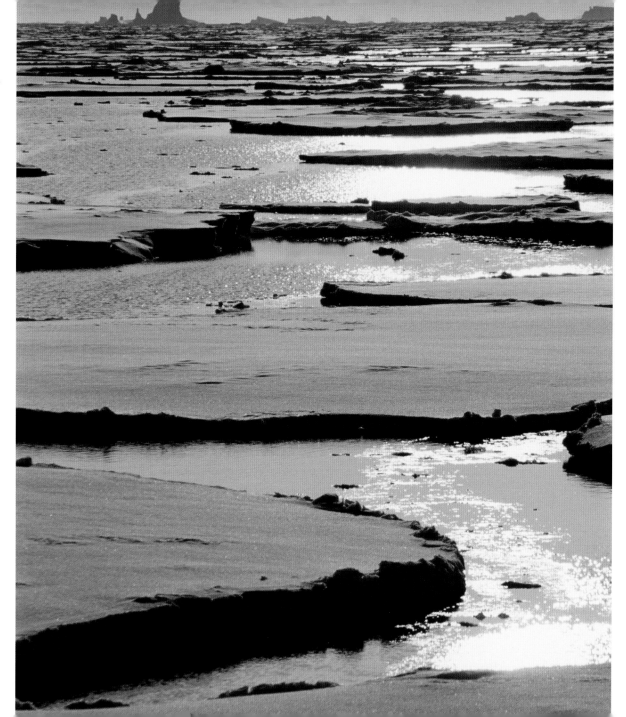

RIGHT: The Antarctic Peninsula has a warmer climate than areas closer to the South Pole. As a result, it is home to far more birds and animals.

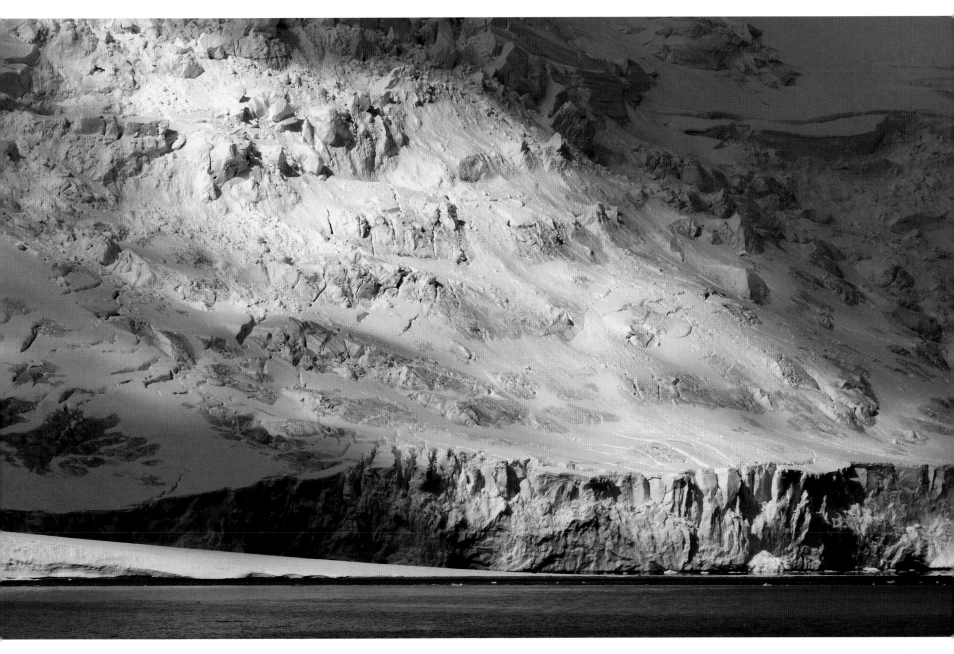

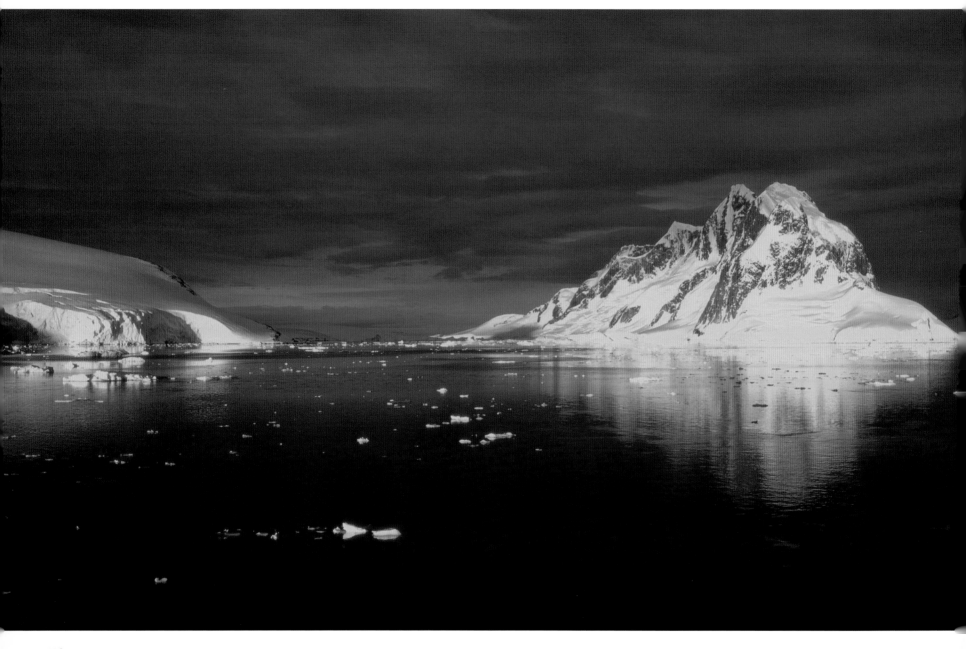

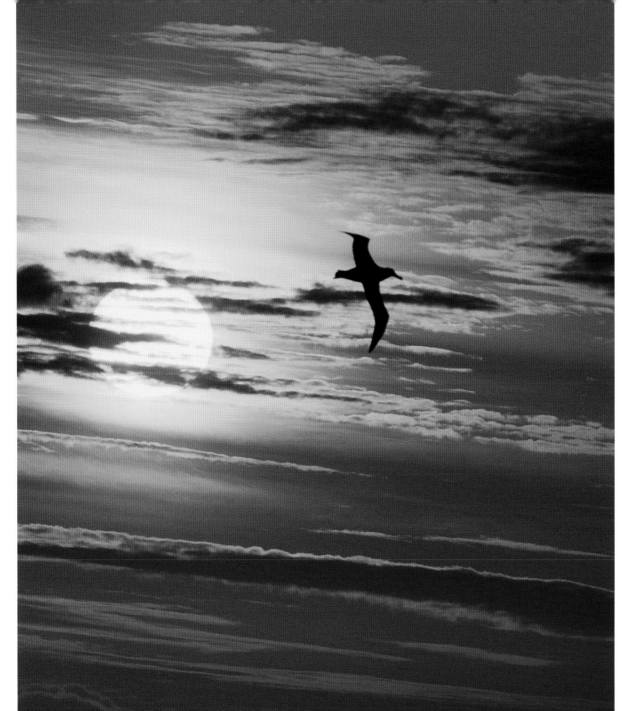

LEFT: Many visitors to the Antarctic Peninsula regard it is being one of the most beautiful places on Earth—here it is lit by the rays of the midnight sun.

LEFT: The wandering albatross— silhouetted here against the setting sun— is the largest member of this fascinating bird family. It travels enormous distances in its search for food before returning to its breeding grounds.

PAGE 188–189: Another view of Paradise Bay.

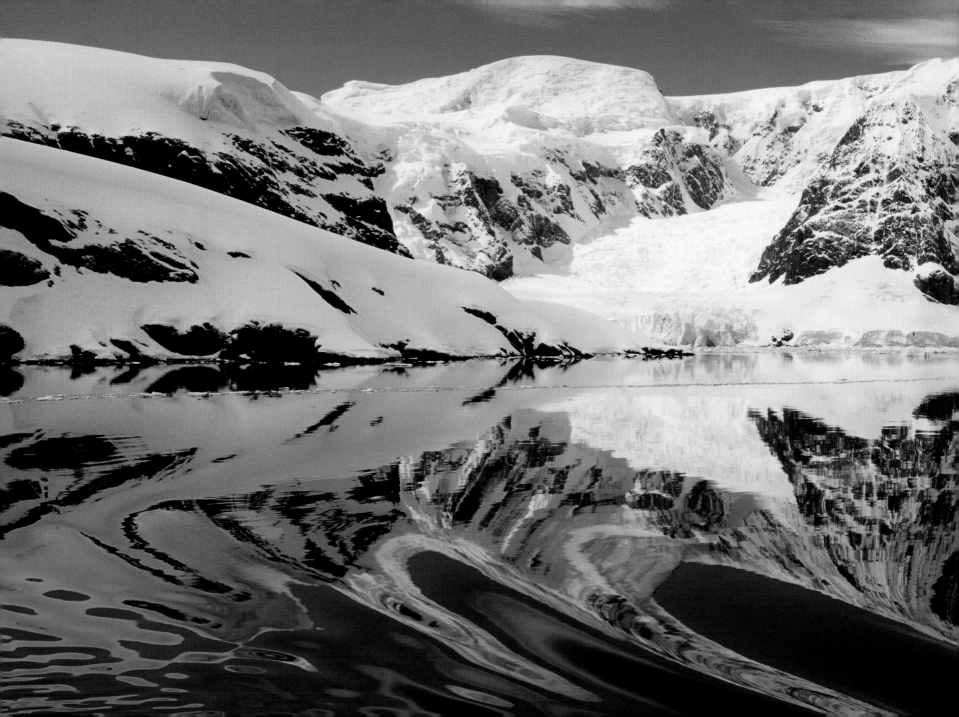

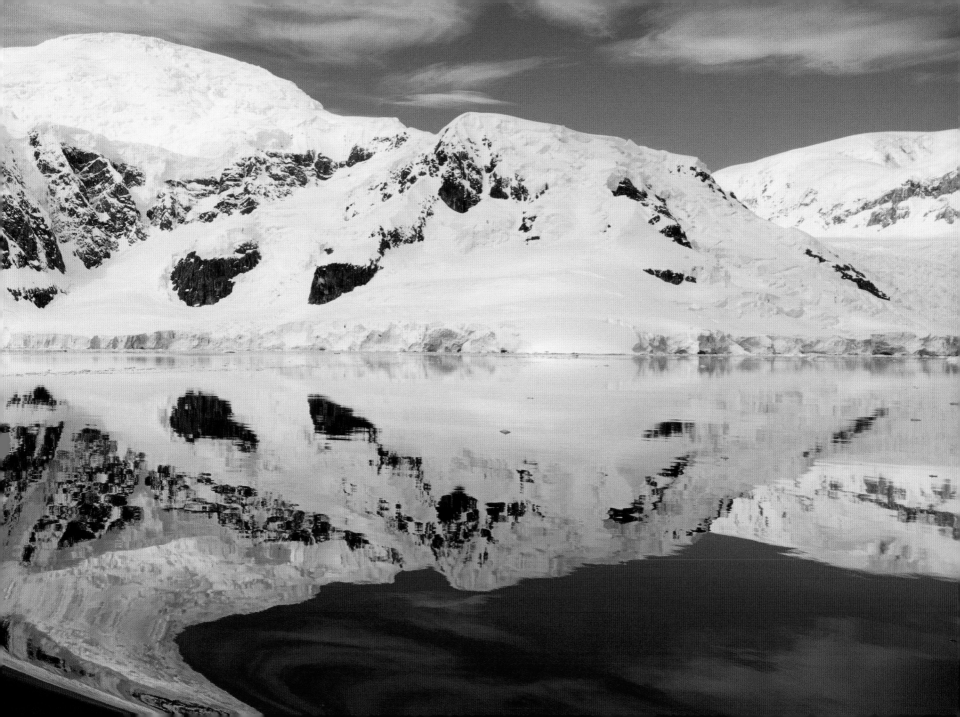

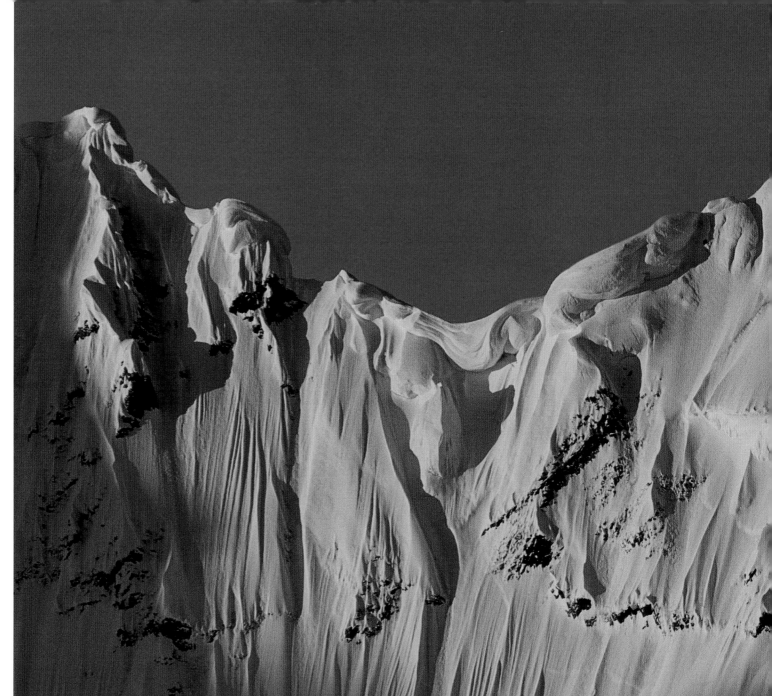

RIGHT: The Fief Mountains—here lit by the early morning sun—are located on Wiencke Island, Antarctica. The large island is part of the Palmer Island Archipelago.

PAGE 192: The temperature at the core of an iceberg is very stable, remaining between -15 and -20 degrees Centigrade.

PAGE 193: This Antarctic iceberg is so big that the boat passing through the arch in its center is dwarfed. The position of such icebergs is recorded and monitored to ensure that local shipping can be warned.

PAGES 194–195: Another view of Paradise Bay.

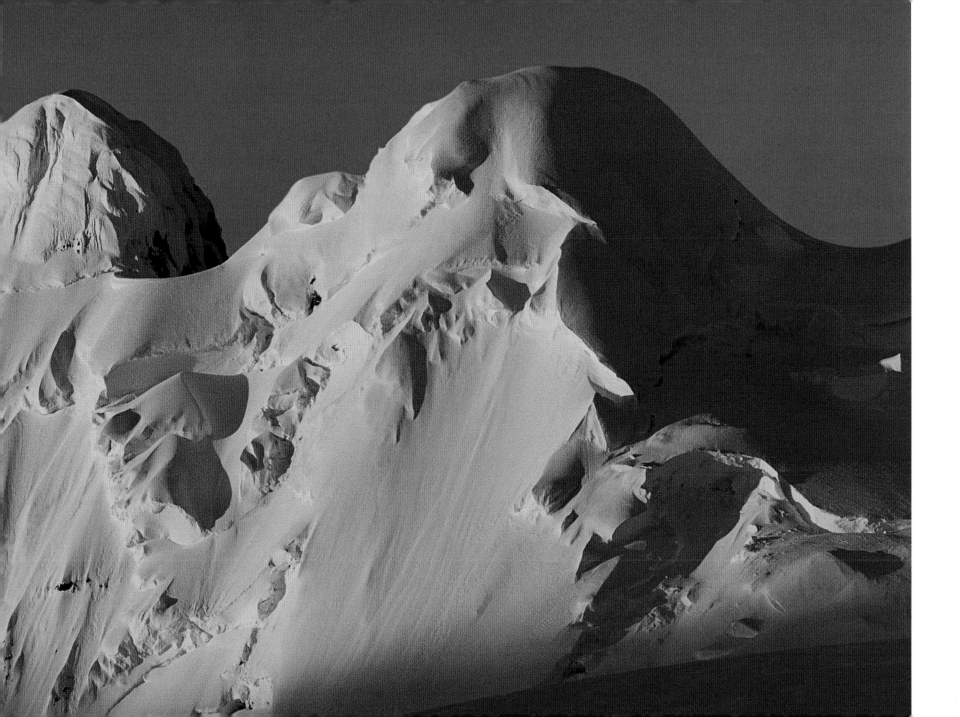

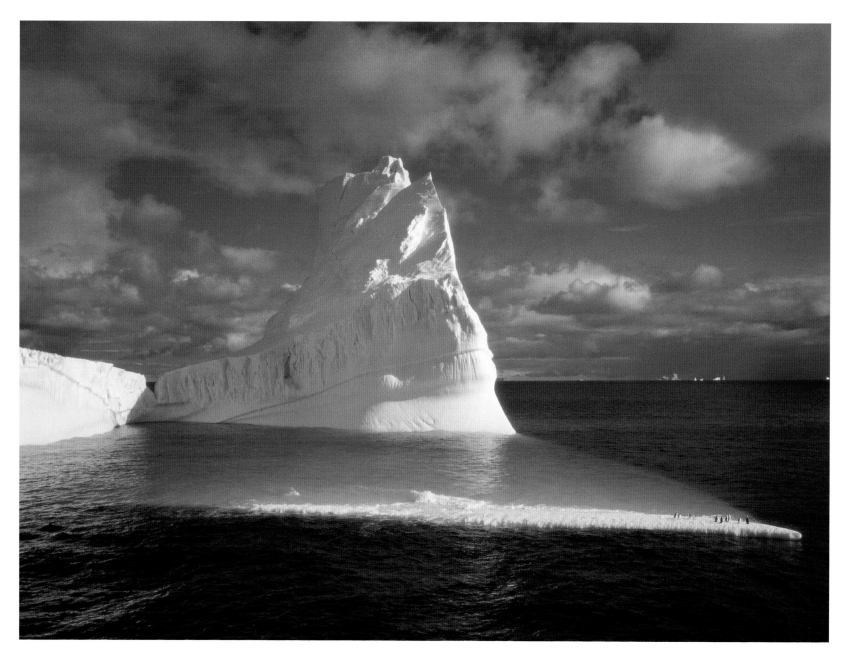

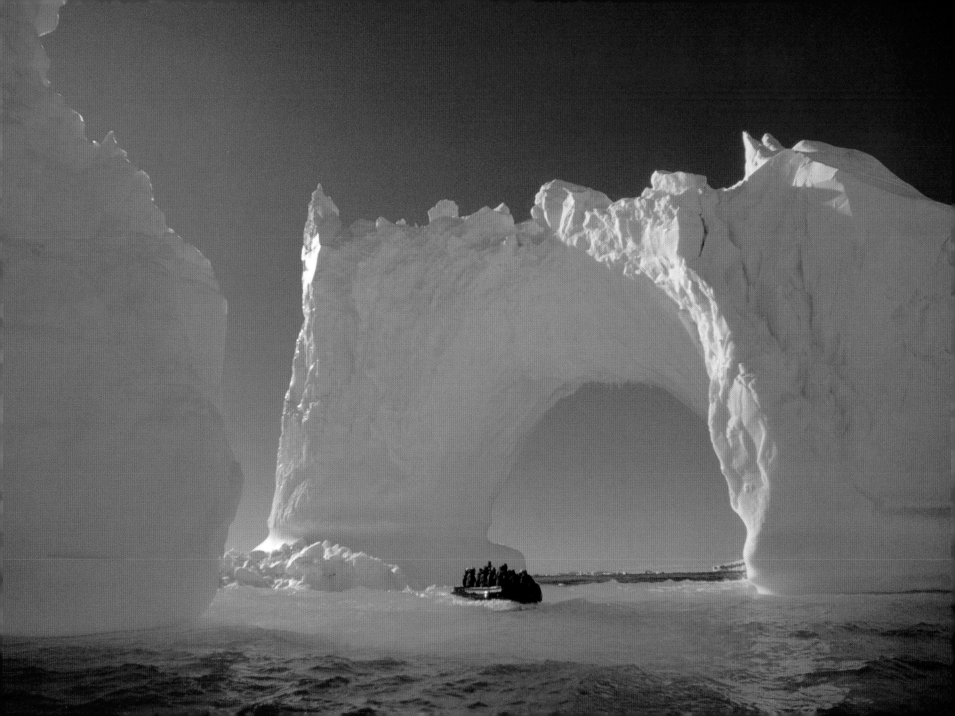

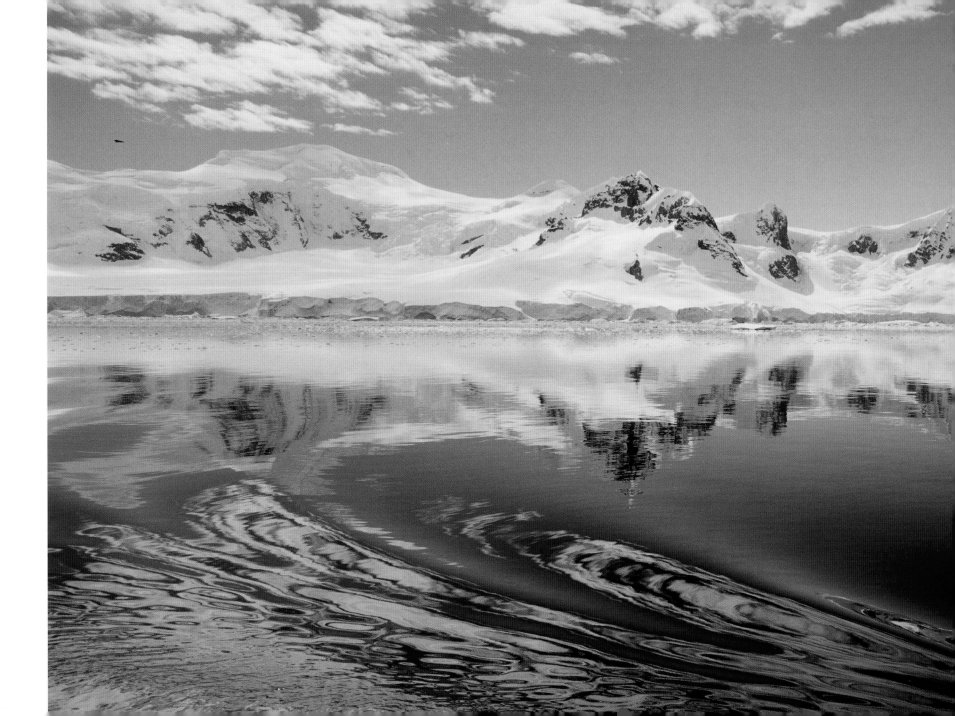

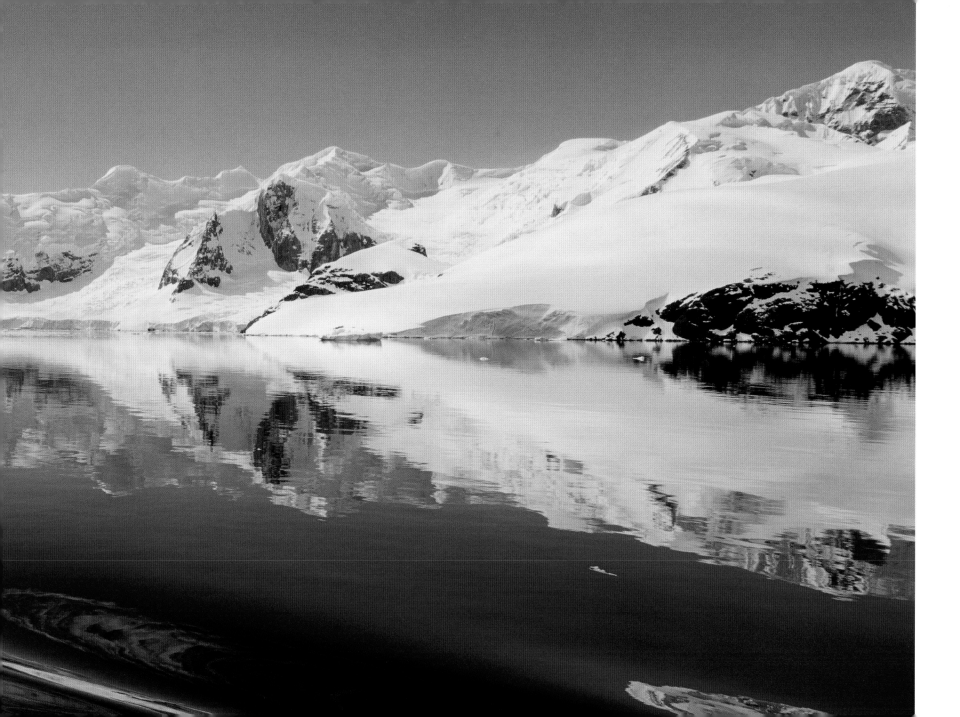

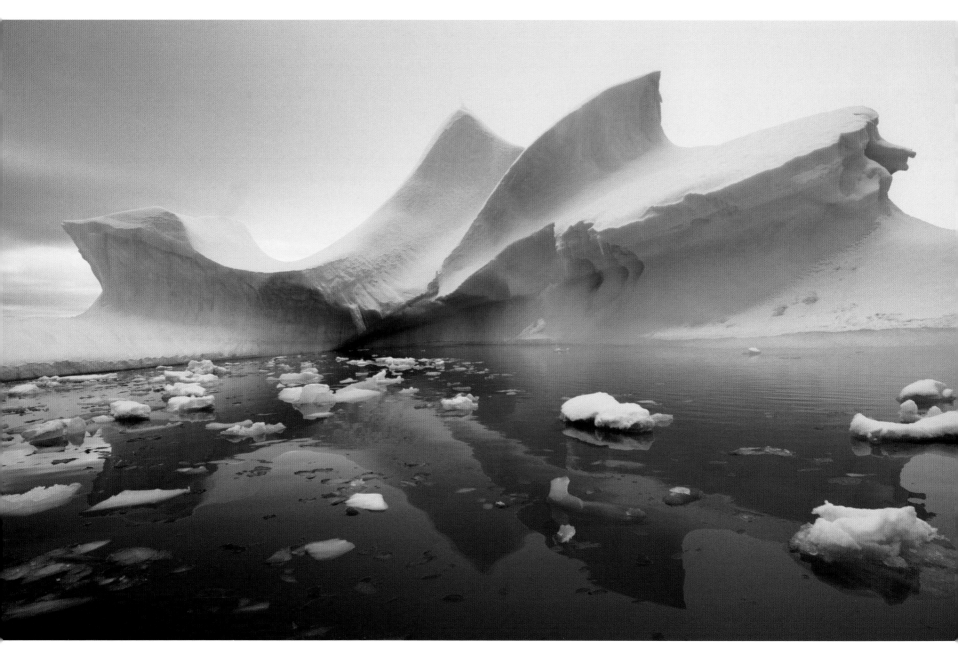

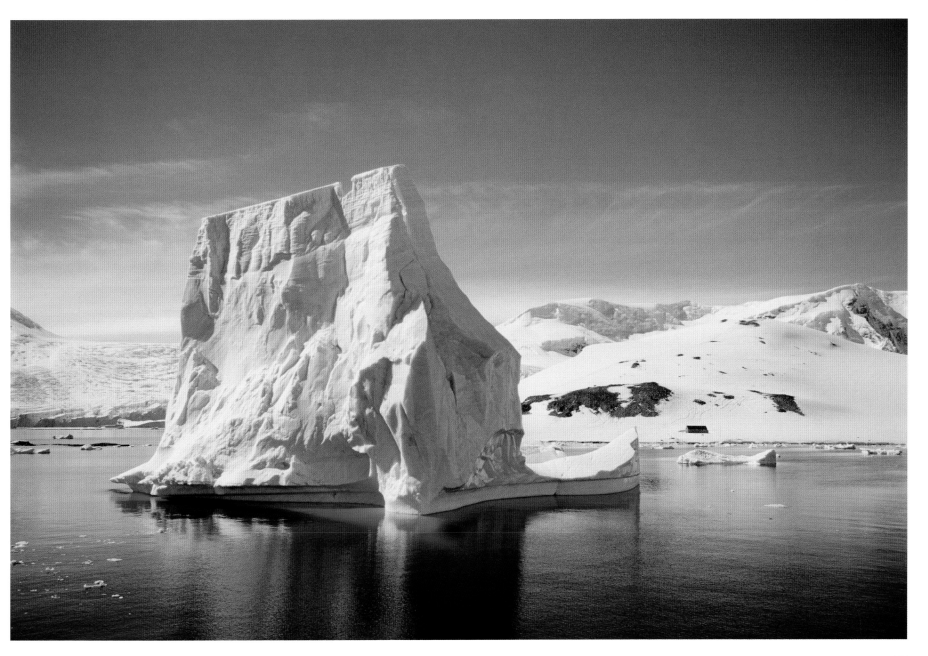

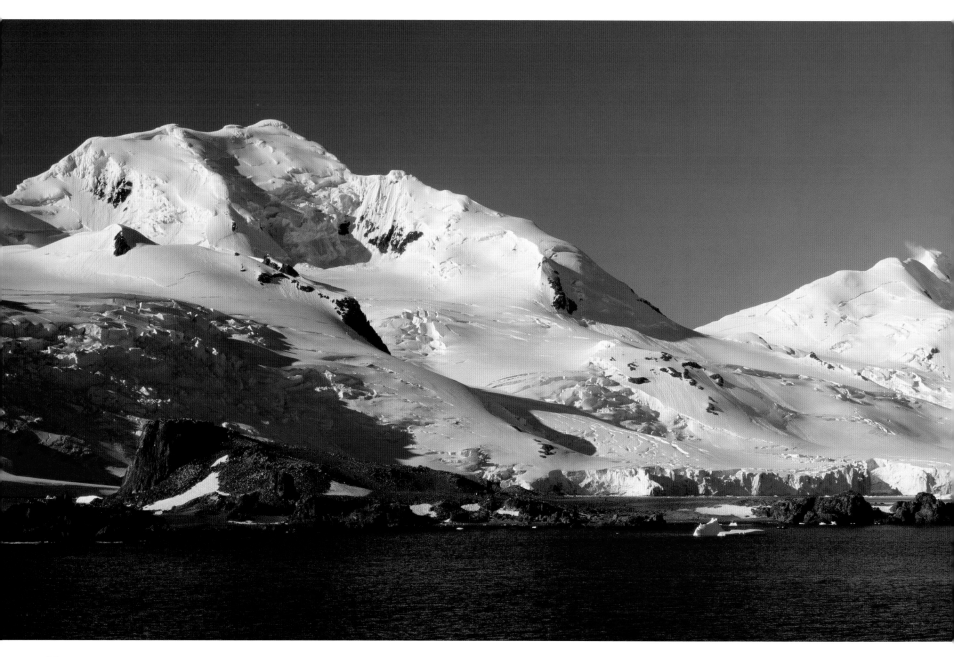

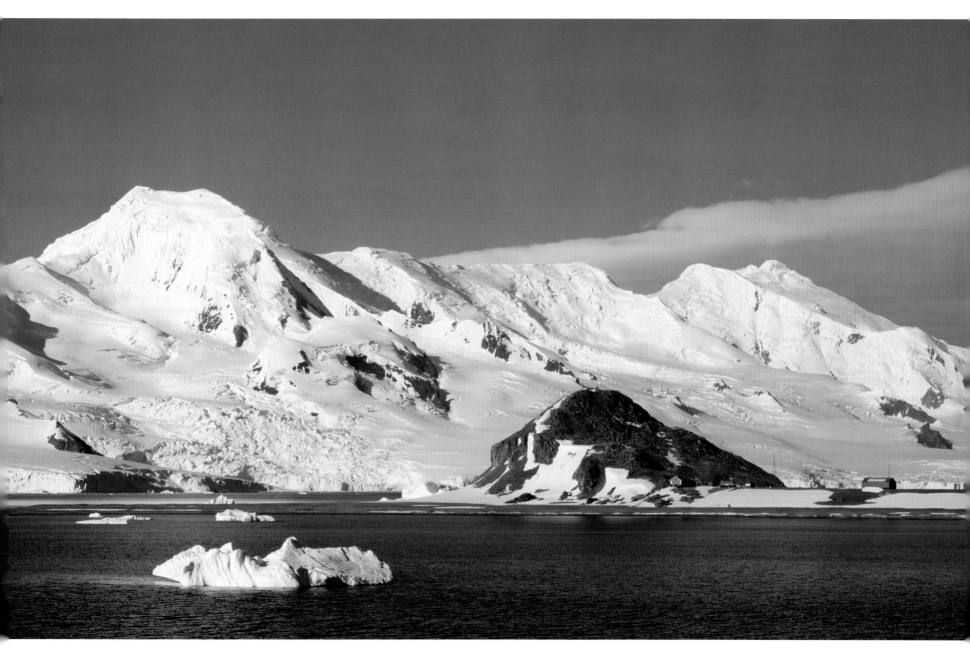

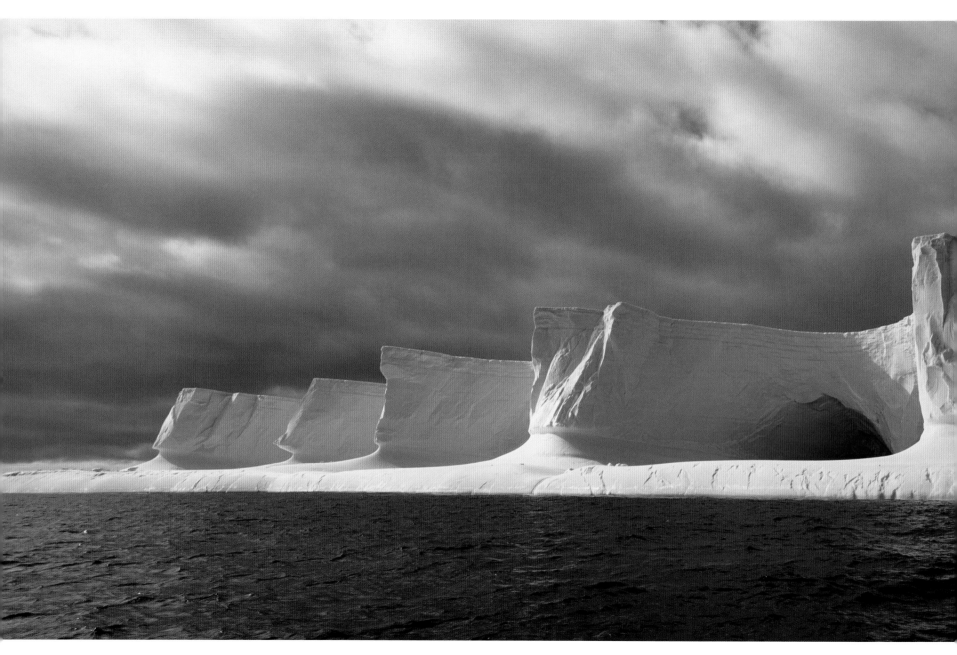

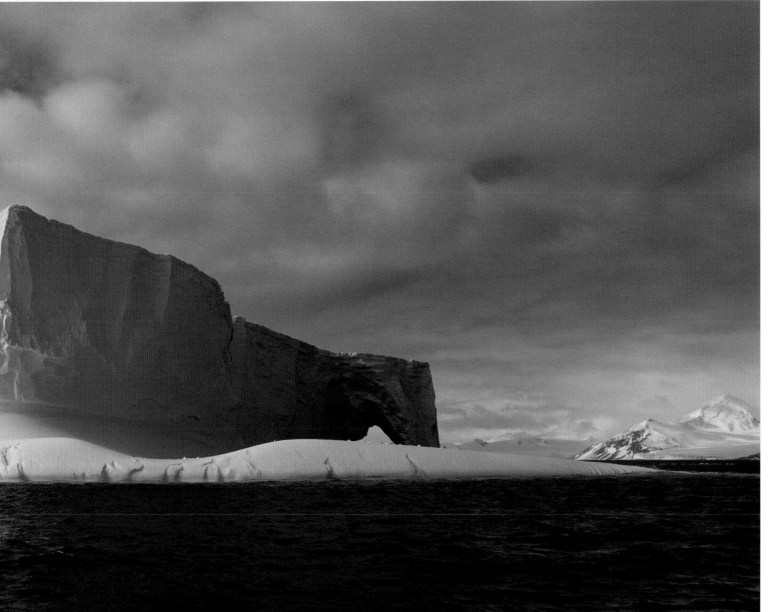

PAGE 196: Especially large icebergs can even cause local penguin populations to die out if they drift between colonies and the bird's feeding areas—both the adults and young can starve to death.

PAGE 197: This massive iceberg is floating serenely near the Trinity Peninsula, which is on the extreme northeast portion of the Antarctic Peninsula.

PAGES 198–199: Half Moon Island and Bransfield Strait in Antarctica.

LEFT: Tabular iceberg in the Bransfield Strait, Antarctica.

PAGE 202: The waters off Brabant Island, Antarctica, are a haven for all forms of marine life, and are a favorite spot for hardy whale watchers.

PAGE 203: Zodiac boat tour off Elephant Island, Antarctica.

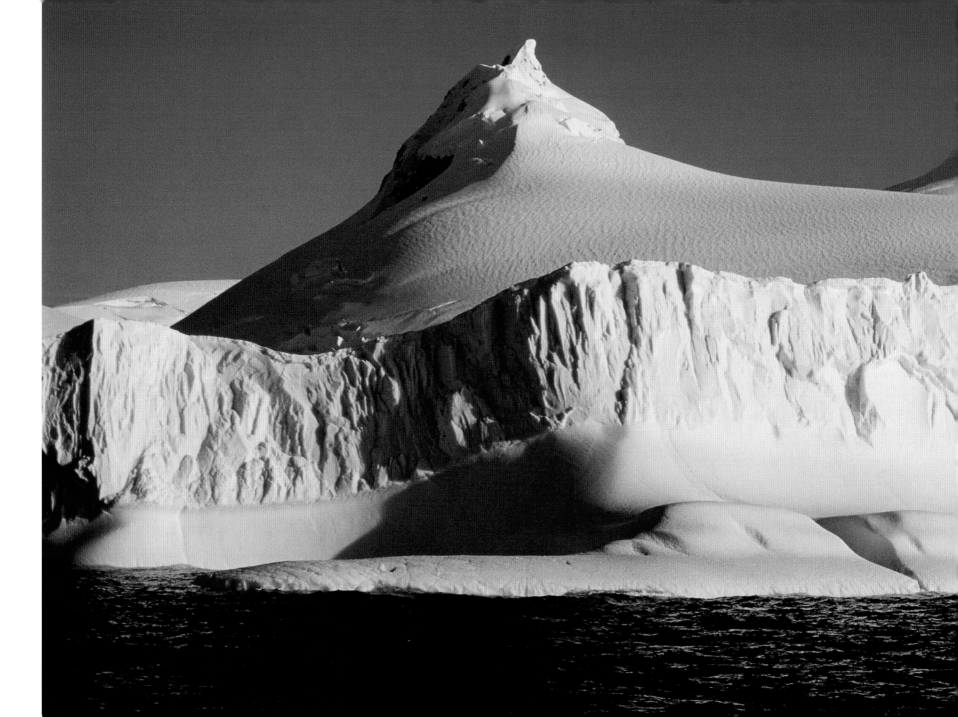

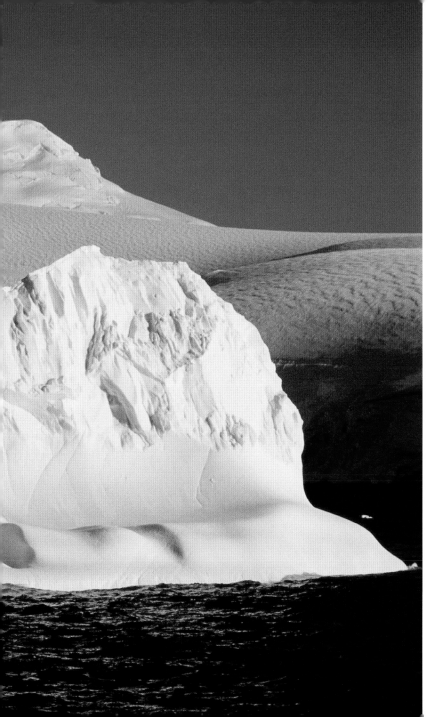

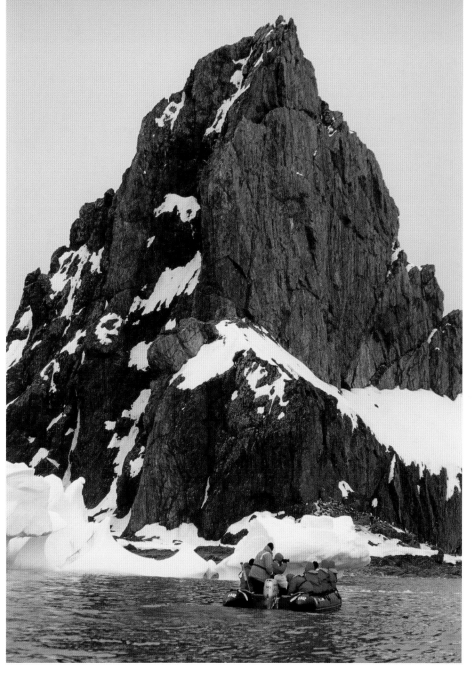

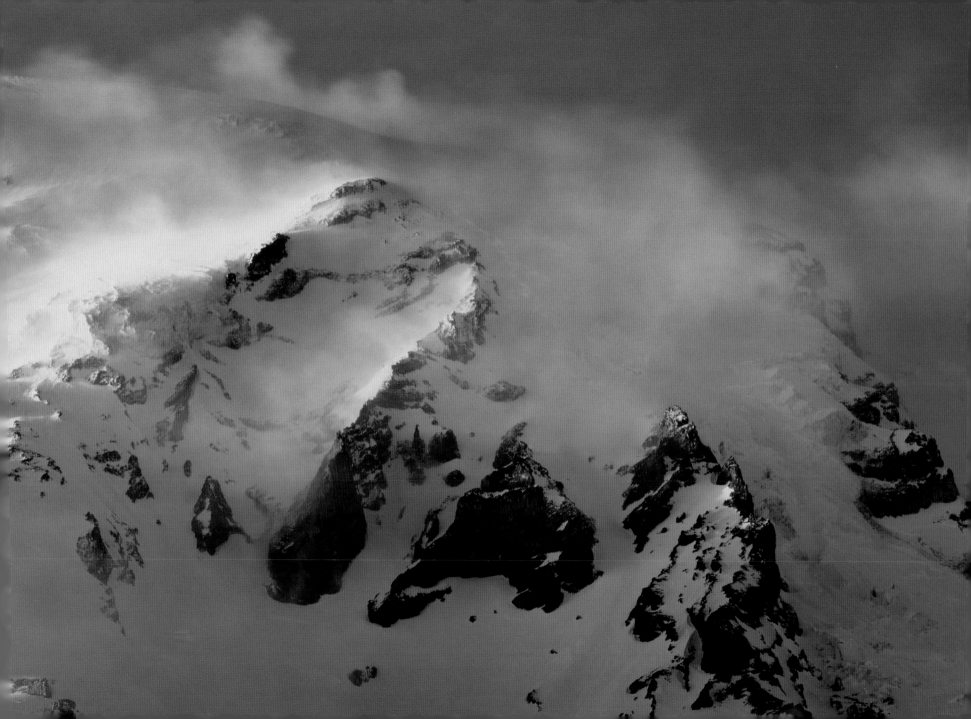

Introduction

There are many areas of the world that are not in either of the polar zones, and yet still qualify as "frozen regions"—these have been gathered together here in one section as "Non-Polar Alpine Regions." There are many different definitions as to what constitutes an alpine region—in this book they are considered to be any place that is above the treeline, or experiences severe winters.

Since temperatures drop with elevation, many of the places presented here are actually in what are otherwise tropical zones. Examples of this include the mountain ranges of East Africa and Papua New Guinea. If you climb up a mountain, a good rule of thumb is that every 100 meters of altitude increase is equivalent to moving 80 kilometers towards the pole—this is known as the "dry adiabatic lapse rate." With this in mind it is not hard to see why the climate can be so extreme in mountainous areas.

Since most alpine areas are inherently difficult to reach, only a small percentage actually suffers from direct contact with humans. An exception to this is where mountaineering or leisure pursuits are particularly popular, such as in the Alps and the Himalayas. Many of the better-known mountains are covered with litter that has been left behind as a result of the years of expeditions that have passed by. The problem is that the costs of collecting and removing the tons of debris are simply prohibitive. On Mount Everest, for instance, there are large numbers of discarded oxygen cylinders that were abandoned once they were empty. At the altitudes where they have been dumped the corrosion rate is very low, and so these thick metal containers will persist for thousands of years if they are not retrieved.

One of the consequences of global warming is that many of the world's ski resorts no longer have sufficient snow to stay open for the full season. Many are therefore trying to find ways to reach higher areas that were previously only accessible to mountaineers. In the Austrian Tyrol, for example, this has provoked a heated argument, due to proposals to open a new ski resort beside the pristine Gepatsch glacier—the second largest glacier in the eastern Alps. If this were to happen, it would mean that several ski-lift stations, restaurants, and other buildings would be constructed on previously untouched land. Operating these facilities would also pollute the surrounding areas, further damaging the fragile ecosystem. It has been estimated that losses to tourism as a result of fewer skiers visiting alpine regions could seriously damage local economies. It has been estimated that Switzerland, for example, could lose up to $1.6 billion per year before long. This is clearly a matter that needs reasoned debate—environmentalists prefer the idea of encouraging tourists to take up hiking at lower altitudes where the ecosystem would be under less pressure. Against this are ranged various commercial organizations that can see large profits to be won from investments in high-altitude resorts. At the end of the day, it will be those who have the most political influence who will win.

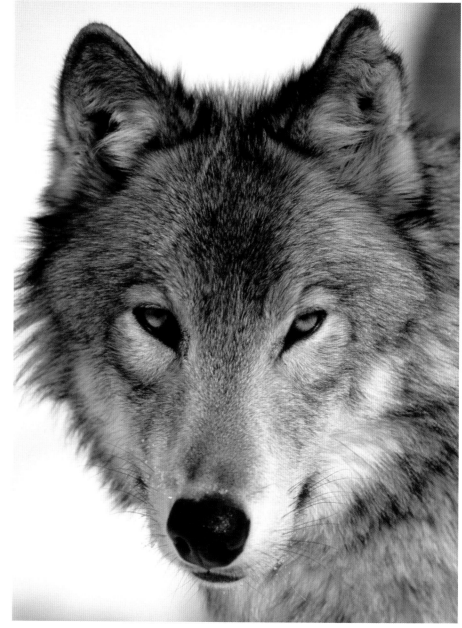

RIGHT: Wolves are by nature better suited to subarctic and arctic environments. Wolves have, however, returned to wild mountain areas—such as Montana in the United States—since being killed off in the early twentieth century. Today, some 75 years after they were exterminated in Montana they are thriving in Glacier National Park.

FAR RIGHT: This is the point where the Perito Moreno Glacier meets the Canal de los Tempanos, near El Calafate in Argentina. Santa Cruz Province, Los Glaciares National Park.

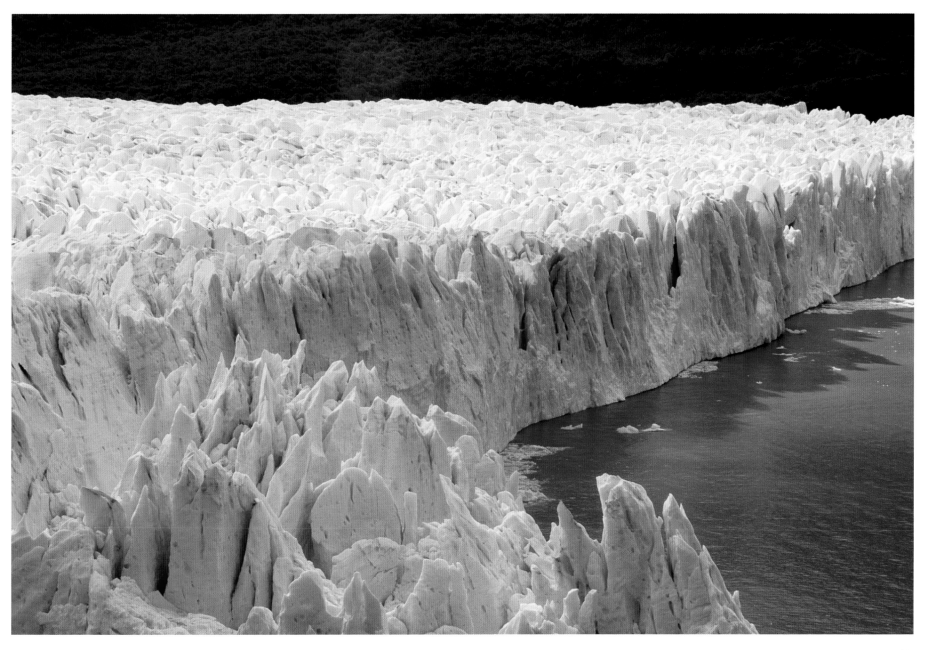

The Climate and Environment of the Non-Polar Alpine Regions

The habitats of the alpine regions above the treeline are typically made up of rock, ice or, where there is enough soil, alpine or montane tundra. This is usually well drained and free from permafrost. Many of the animals and plants of this zone are so specialized that they cannot live anywhere else. The evolutionary pressures of surviving in such harsh environments have resulted in animals that have developed many different solutions to the problem. In New Zealand, for instance, there is the kea, which is a kind of parrot, but unlike any other on Earth. On the North American continent there is the pika, which is a small rock-dwelling rodent, as well as the Rocky Mountain goat, both of which are supremely well suited to life at high altitudes. Other parts of the world also have plants and animals that have adapted to alpine conditions.

One of the problems with trying to conserve alpine habitats is that when damage occurs—such as wildfires or over-grazing through poor agricultural management—the area's recovery rates can be extremely slow. By far the greatest problem threatening alpine environments, however, is climate change due to global warming. There is very little that can be done about this on a local level, and since there is still no consensus as to what is actually happening it is very difficult to predict the impact of such changes on any particular location. All that can realistically be done is monitor the situation and support the reduction of greenhouse gasses.

The Geography of the Non-Polar Alpine Regions

The alpine definition used here includes many famous mountain ranges, such as the Alps, the Andes, the Appalachians, the Atlas, the Himalayas, and the Pyrenees. There are, however, several other ranges that are not so well known to the wider world. These include the Altai, the Caucasus, the Drakensbergs, the Sierra Nevada, and the Urals.

The Alps

The Alps are one of the great mountain ranges of Europe, and stretch from France in the west through to Liechtenstein, Switzerland, Germany, Italy, Austria, and Slovenia in the east. The highest peak is Mont Blanc at 4,810 meters, which is located on the French-Italian border.

The Altai

The Altai are a range of mountains that stretch through Central Asia for about 2,000 kilometers (1,200 miles) from the Gobi Desert in the east to the West Siberian Plain. They pass through Chinese, Mongolian, Russian, and Kazak territories.

RIGHT: The mountainous areas of New Zealand are remote and prone to extreme weather. Even so, they are popular with skiers, mountaineers, and experienced hikers.

FAR RIGHT: Map showing the main mountainous areas of the world.

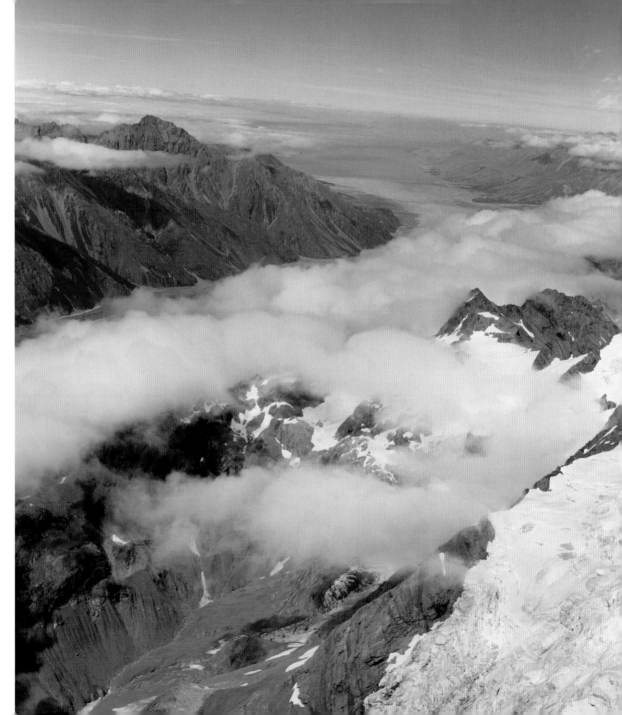

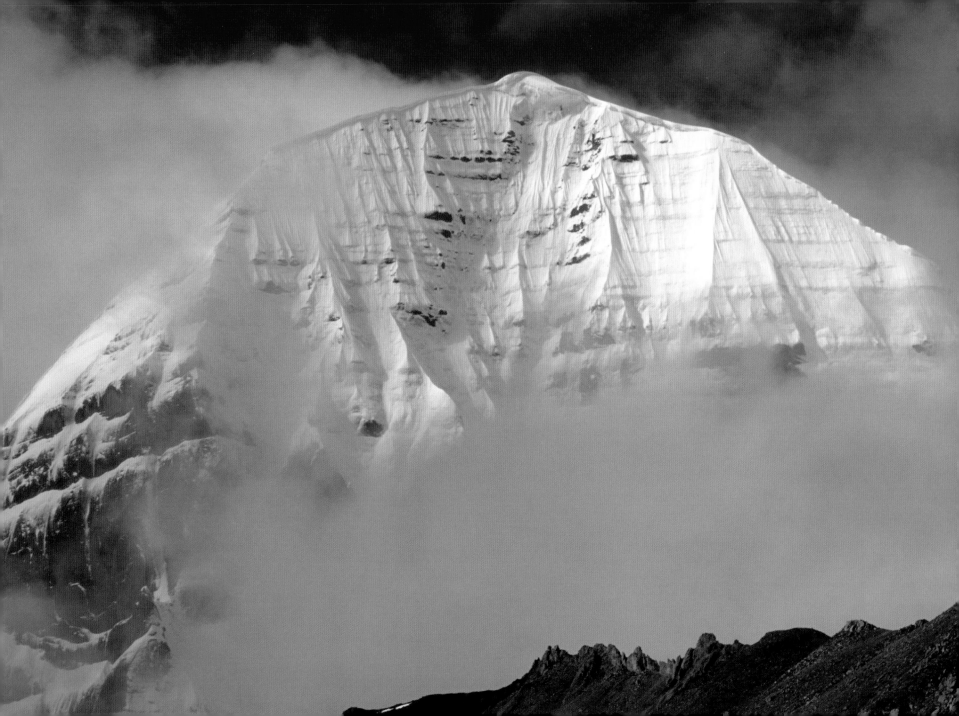

LEFT: This is the north face of Mount Kailas in Tibet, where many of Asia's longest rivers begin, including the Indus, the Sutlej, and the Brahmaputra.

The Andes

The Andes are an extensive range of mountains and highlands that run along the entire length of the western coast of South America. They have an average height of about 4,000 meters (13,000 feet), and about 7,000 kilometers (4,400 miles) long and about 500 kilometers (300 miles) wide.

The Appalachians

The Appalachian Mountains run through North America from Alabama in the United States to Newfoundland and Labrador, in Canada. The Appalachian system is composed of smaller ranges with average heights of around 3,000 feet—the highest peak though is Mt. Mitchell in North Carolina, which at 2,040 meters (6,684 feet), is the second highest point in eastern North America.

The Atlas

The Atlas Mountains are situated in northwest Africa, and form a demarcation line between the Sahara Desert and the Mediterranean and Atlantic coastlines. They run for around 2,400 kilometers (1,500 miles), from the Rock of Gibraltar, through Morocco, Algeria and Tunisia. The highest peak is Toubkal, which rises 4,167 meters (13,671 feet) above southwestern Morocco.

The Caucasus

The Caucasus Mountains are located between the Black Sea and the Caspian Sea, and border Asia Minor. They run through Georgia, Armenia, and Azerbaijan, as well as parts of the Russian Federation. The highest peak is Mount Elbrus, at 5642 meters.

The Drakensbergs

The Drakensberg Mountains are located in the eastern part of South Africa, and at up to 3,482 meters (11,422 feet) in height they are the highest in the region. They run for about 1,000 kilometers (600 miles), and separate KwaZulu-Natal Province from Free State Province.

The Himalayas

The Himalayas are probably the best-known mountains in the world. They are located across the northern section of Nepal, to the south of China. Eight out of the ten highest peaks in the world are found there, including the highest, Mount Everest at 29,035 feet.

The Pyrenees

The Pyrenees are a mountain chain that runs for 450 kilometers from the Atlantic to the Mediterranean, forming a barrier between France and Spain. Many of the peaks reach over 3,000 meters in height, and there are several permanent glaciers on both sides of the border.

The Sierra Nevada

The Sierra Nevada is a range of mountains in the western United States, running north to south in eastern California and western Nevada. The range is about 650 kilometers (400 miles) long, and is to the east of California's Central Valley, and to the west of the Great Basin.

The Urals

The Urals are a mountain range that runs for some 2,500 kilometers north–south through western Russia. They reach from the coast of the Arctic Ocean as far as the steppes of northern Kazakhstan. The highest peak is Mount Narodnaya, at 1,895 meters.

The Fauna and Flora of the Non-Polar Alpine Regions

The vegetation of the alpine zone usually has a high proportion of mosses, lichens, and liverworts, and where conditions permit, grasses, low-growing heathers, and ground-hugging willow trees. The alpine tundra supports a wide variety, of often rare or endangered animals, from small invertebrates such as butterflies, beetles, and spiders through to larger creatures such as birds. In the breeding season the alpine habitat attracts many migrant species. In Northern Europe, these include dotterels, ptarmigans, snow buntings, purple sandpipers, shore larks, and Lapland buntings. In addition to these, there are also predators, such as the golden eagle and the peregrine falcon.

As one descends below the treeline, subalpine forests, or montane grasslands are often encountered. Sometimes the flora is mostly composed of stunted trees or dense shrubs. In the mountains of Africa, there are strange plants, such as giant groundsels and giant heathers. One of the characteristics of the plants of the alpine and sub-alpine zones is that they all have a very slow growth rate. During the short summers they store as many nutrients as they can assimilate in their roots—this helps them survive the low temperatures of the harsh alpine winters. When spring arrives, alpine meadows the world over become a riot of color as the plants burst into flower.

There are many different threats to subalpine habitats—while these will vary from place to place, those that can be prevented include overgrazing through poor agricultural management, and damage caused by recreational visitors. There are answers to these problems if there is the political will to support them. For a start, if sufficient funds are available, it is possible to provide incentives to farmers to enable them to take on more environmentally friendly practices. As for reducing the damage caused by hiking and mountaineering—this is usually only a problem when too many people visit the same places. There is no single answer, however, it has been found that the greatest problems occur when access by road, path, or rail is too easy. Closing off or removing roads from areas where the habitat is under threat is one easily implemented solution.

Moving down from the subalpine zone, the forests—where they exist—are made up of full-size trees; however, they tend to be limited to coniferous species such as spruce and pine. These areas often experience long, harsh winters and so are included in this section on non-polar alpine environments. Where mankind has not

interfered, the border between this and the zone below it is often marked by the presence of the main species of deciduous trees. These include oak, ash, beech, and sycamore.

In some montane regions, such as parts of the Altai Mountains, instead of subalpine forests, there are mountain sub-deserts. These are formed due to a combination of high summer temperatures and a low rainfall. As if this is not enough to make it hard for plants to survive, the soil often has a high salt content as well. The only species of vegetation that can survive in this environment are those that are "xerophytic"—drought-tolerant—and "halophytic"—salt-tolerant. The predominant animals in this zone are rodents, although there are also significant numbers of antelope. As a result there are also several kinds of predators—these include eagles, hawks, and kestrels as well as bears and lynx. In some places in the Altai Mountains the sub-desert is replaced with what is known as "mountain steppe." This is a zone that rises up to about 6,600 feet, in which scrubby grasses and shrubs grow; it shares many of the animal species though.

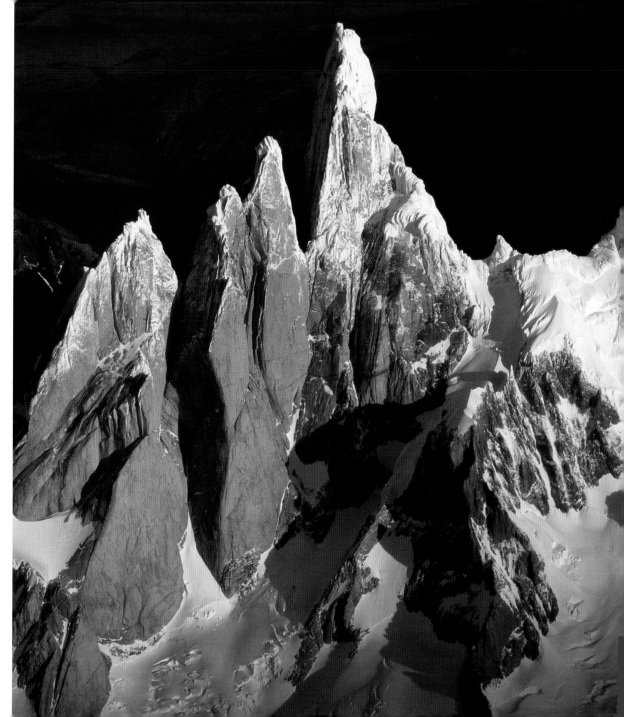

RIGHT: At 10,280 feet (3,133 meters) high, Cerro Torre is the tallest of four adjacent mountains that form a chain in the Parc Nacional Los Glaciares, Patagonia.

FAR RIGHT: Wind blows snow from mountain top near Juneau, Alaska.

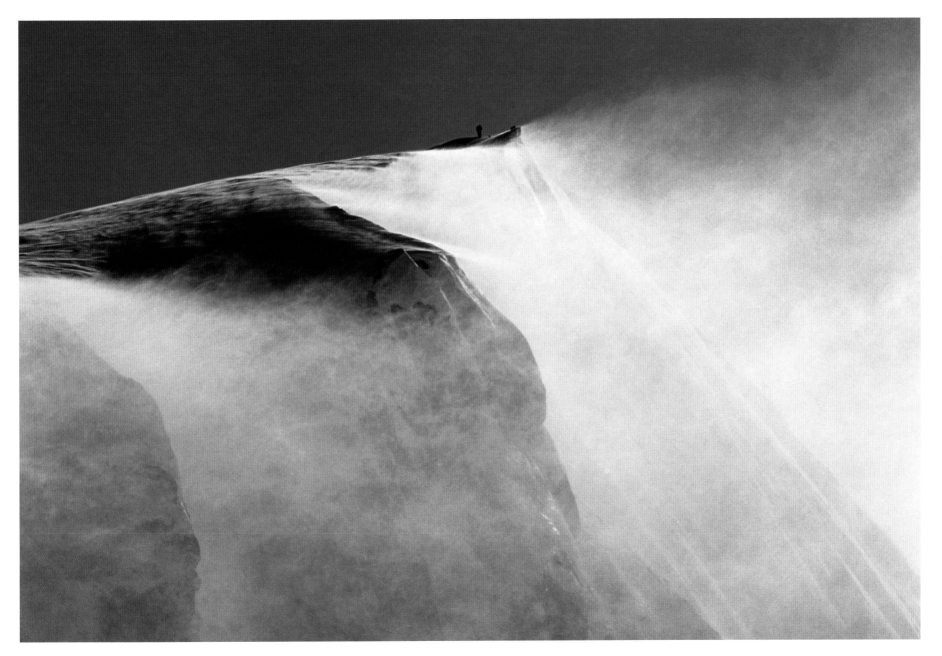

RIGHT: The Kailas mountain range in Tibet lies to the north of the Great Himalayas. Mount Kailas is the tallest mountain in the region at 6,718.2 meters (22,027 feet).

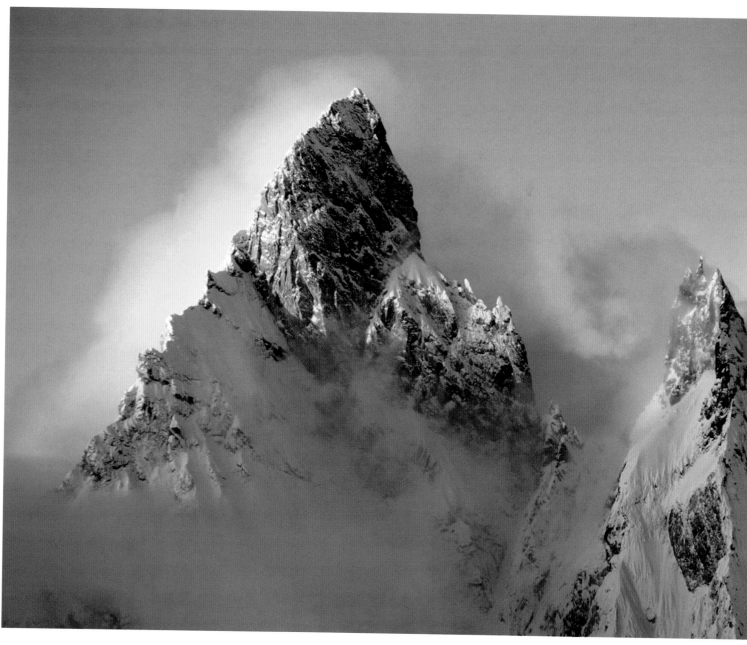

LEFT: The Aiguille Noire de Peuterey lies above the southern valley of the Mont Blanc massif, near Courmayeur, Italy. Here the mists rolling over its peak are lit by the early morning sun.

RIGHT: There are 12 peaks above 12,000 feet in the Grand Teton National Park, Wyoming. Here Mount Moran (12,605 feet/3,842 meters) can be seen beyond the beautiful Snake River.

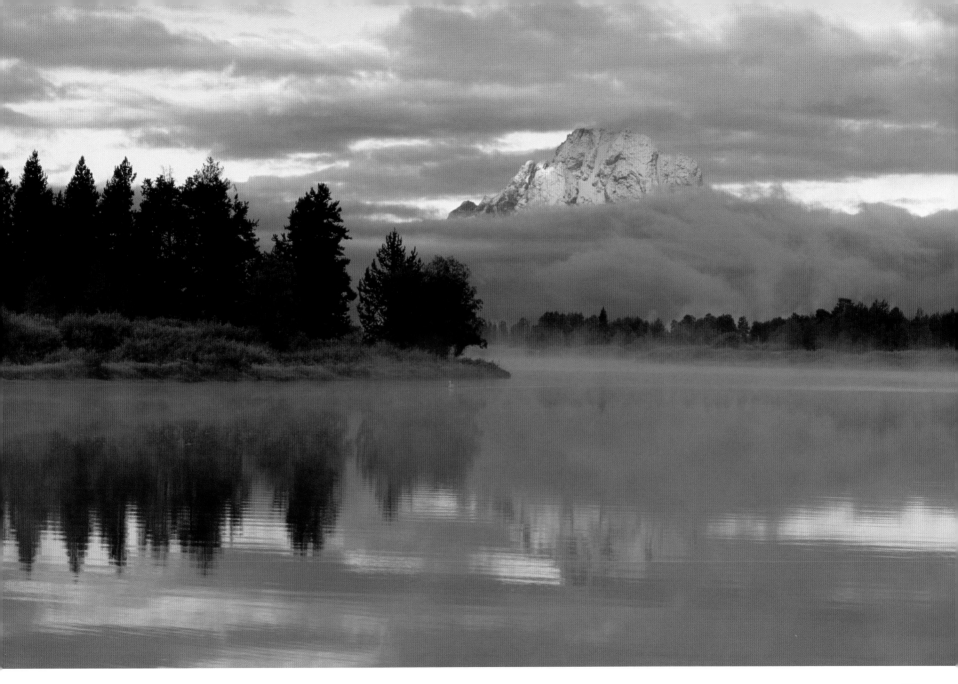

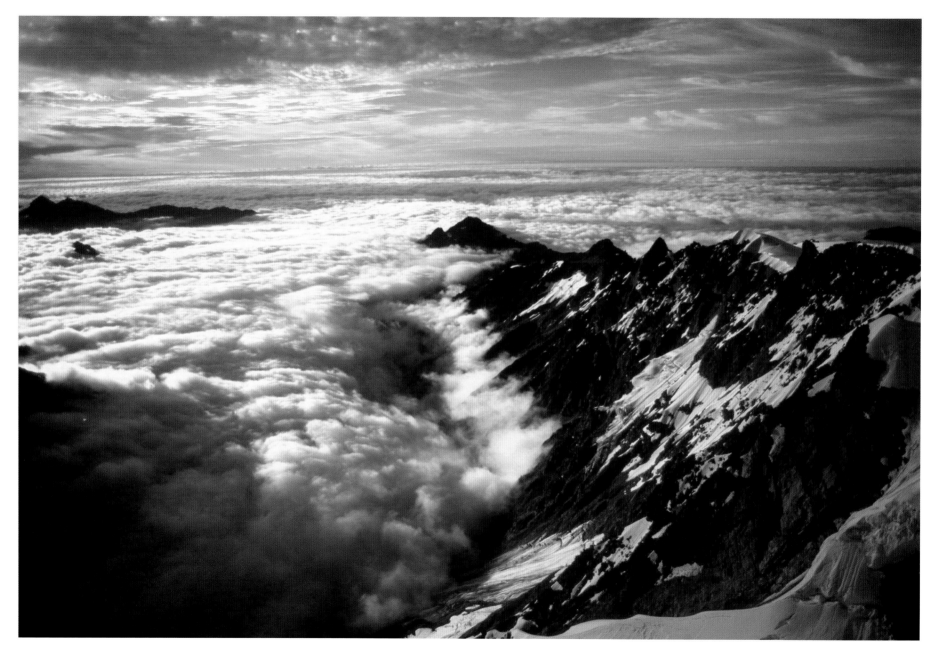

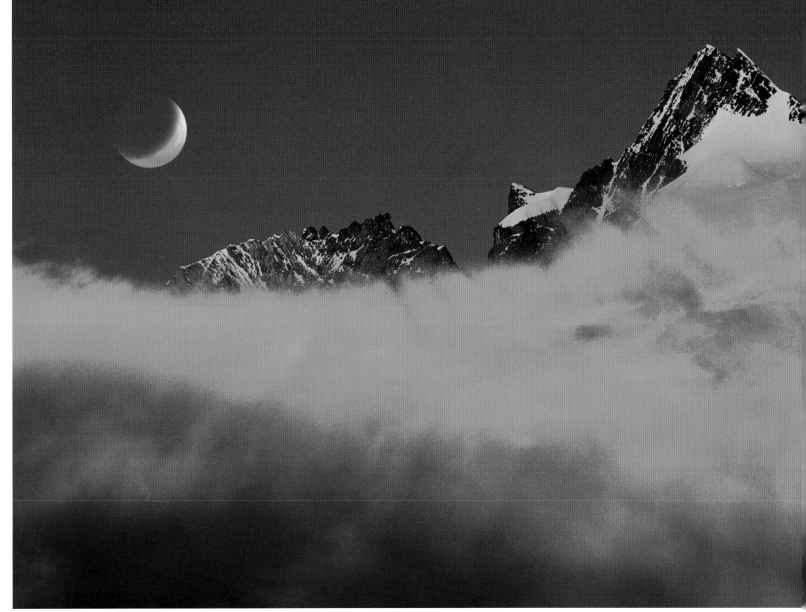

LEFT: Glaciers cover 40 percent of the breathtaking Aoraki/Mount Cook National Park in the heart of New Zealand's South Island. The park is also part of Te Wahipounamu—South Westland World Heritage Area.

RIGHT: As the mist is lit by the last rays of the setting sun, the moon rises over the Grosglockner, which at an elevation of 3,798 meters is the highest mountain in Austria.

PAGE 220: Crater Lake and Wizard Island were an important feature in native Klamath Indian folklore, and so were kept secret from white explorers until gold prospectors came across them in 1853. Crater Lake National Park, Oregon.

PAGE 221: Mount Everest seen from the Tibet Autonomous Region, China. More than 600 climbers from 20 countries have successfully reached the summit by various routes from both north and south.

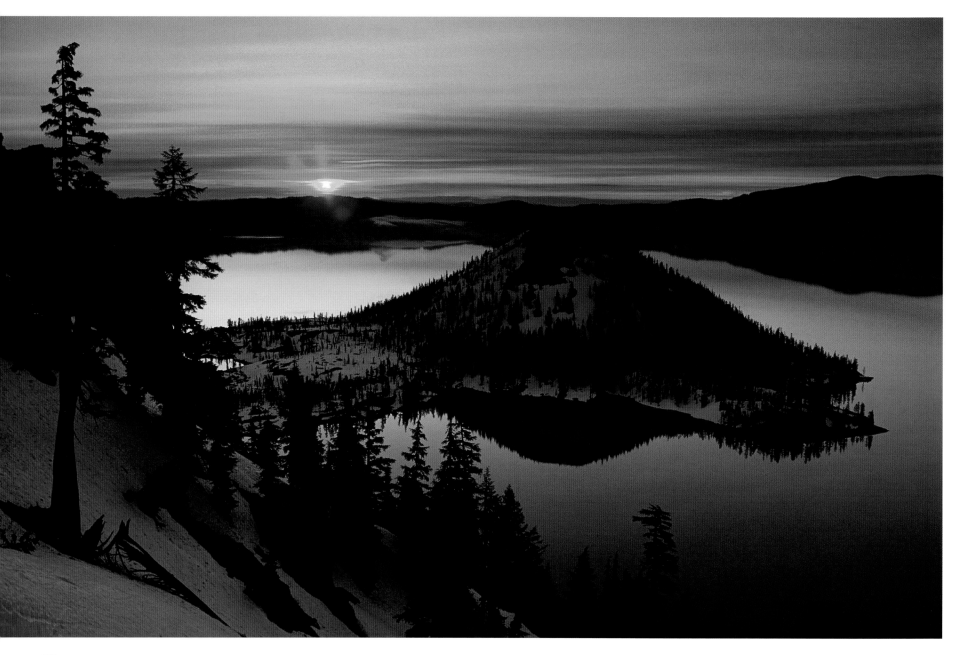

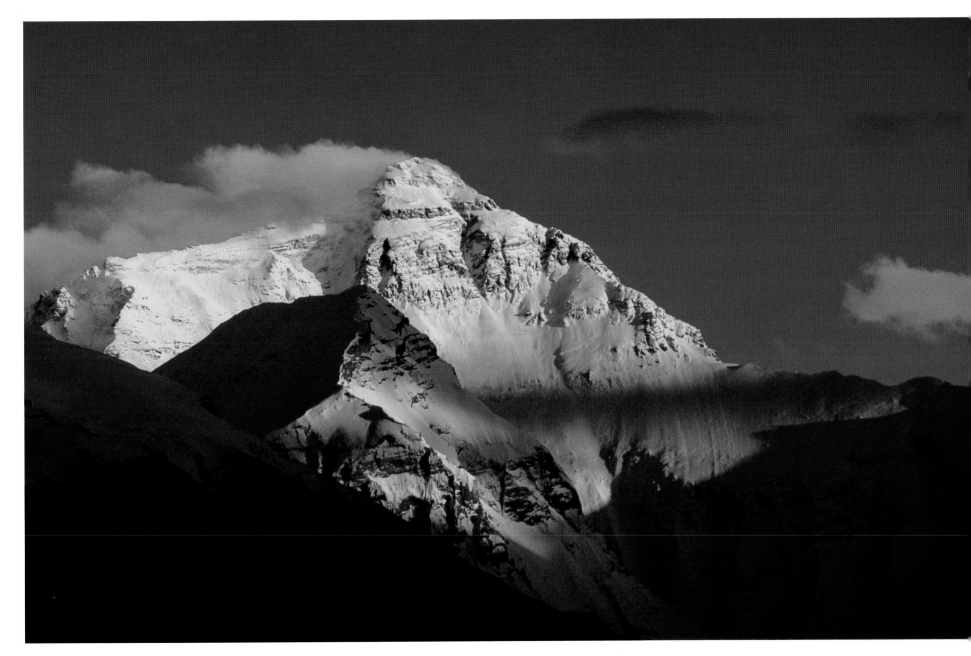

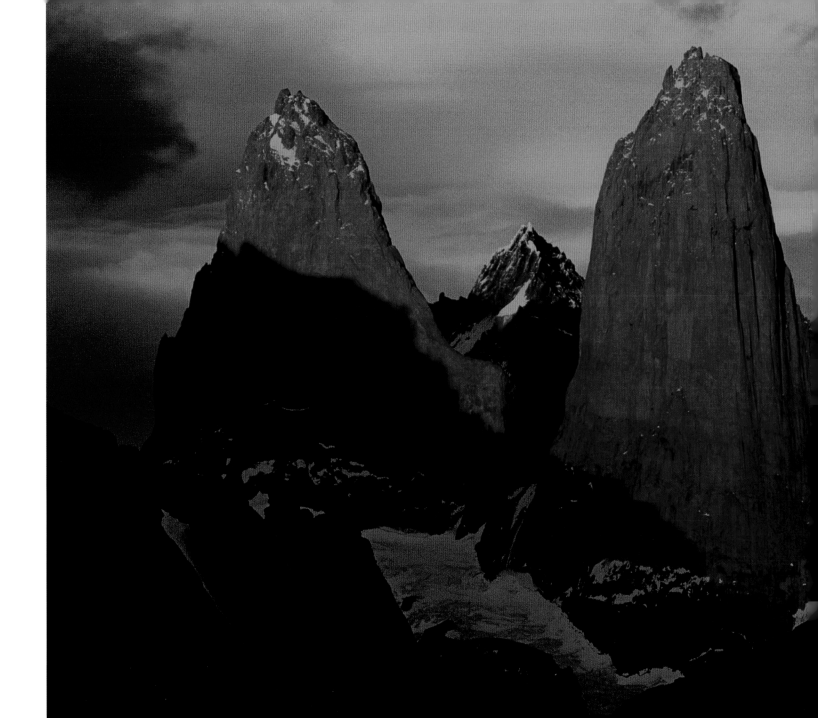

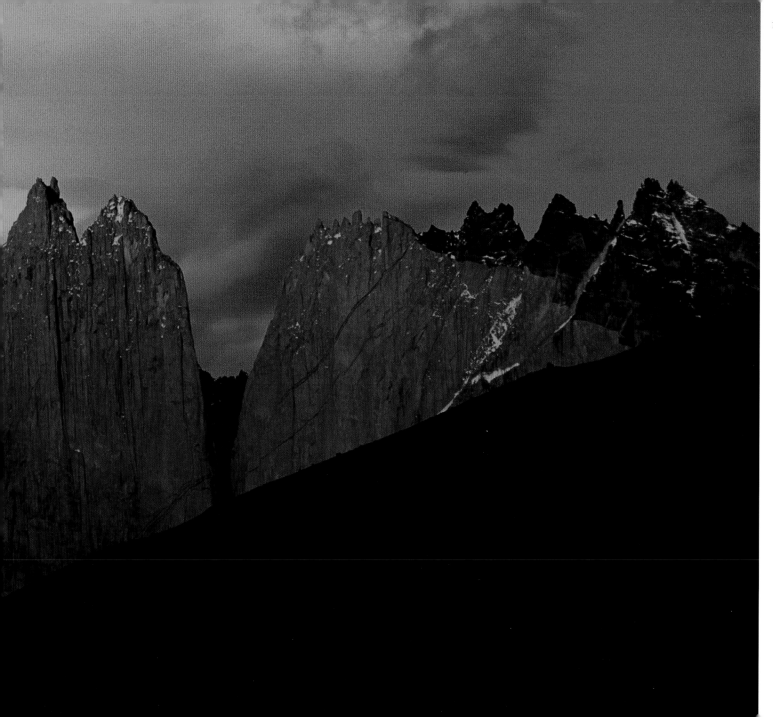

LEFT: The unusual shapes of the granite monoliths seen here in the Torres del Paine National Park, Chile, were formed by the scouring action of glaciers over many thousands of years.

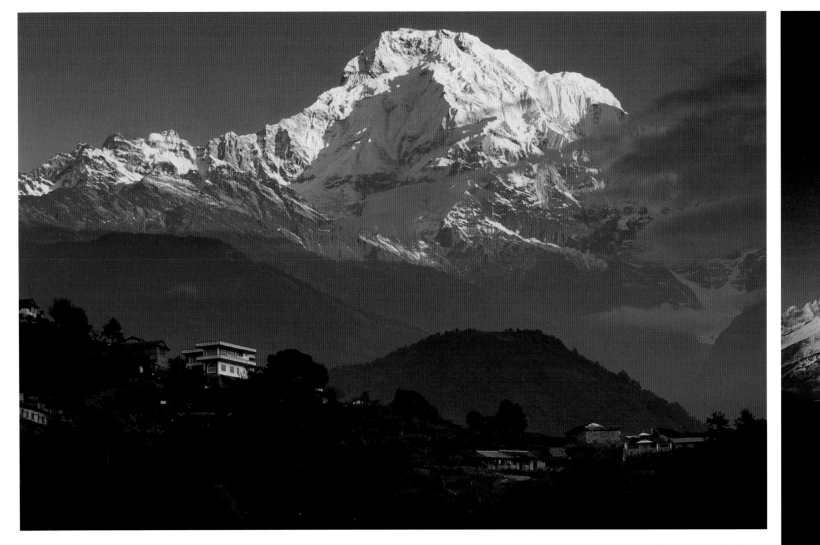

ABOVE: Annapurna in Nepal is the tenth highest mountain in the world. The name comes from the Sanskrit word which means "Goddess of the Harvests" or "The Provider."

RIGHT: The moon sits high above the Teton Range, Grand Teton National Park, Wyoming. Archaeological evidence shows that humans have lived in the area for more than 8,000 years.

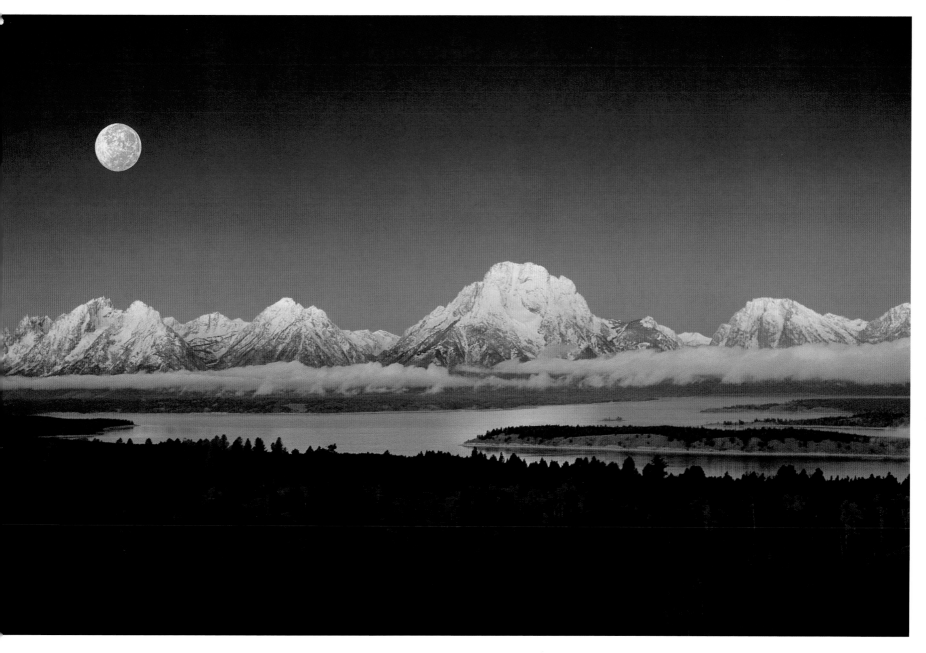

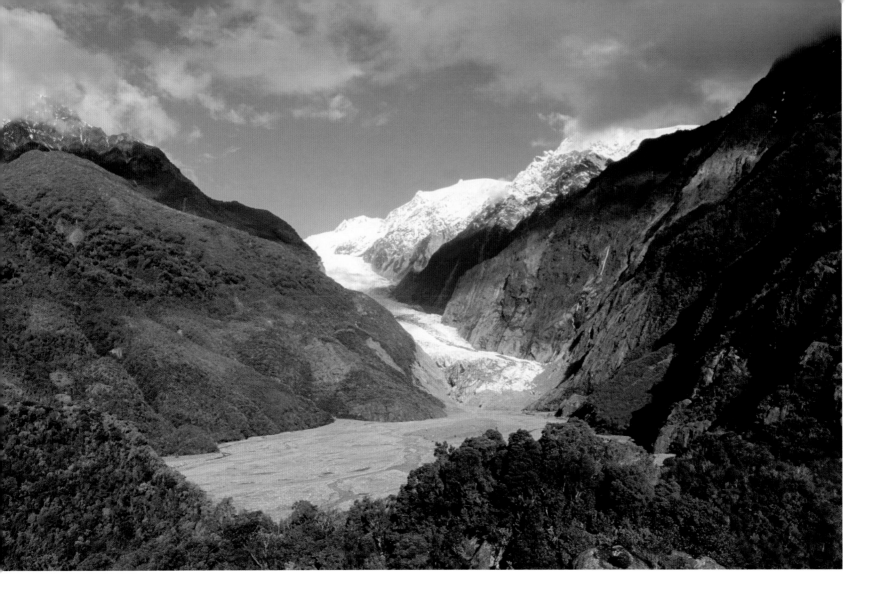

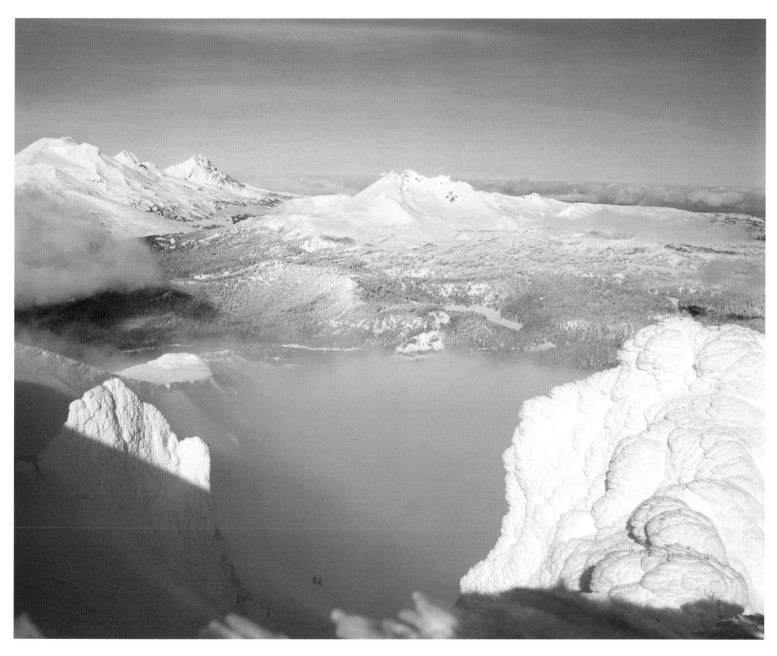

FAR LEFT: The Franz Josef Glacier in New Zealand was named by an early explorer after the Emperor of the Austro-Hungarian Empire. It is around 7,000 years old, and is the remnant of a much older glacier.

LEFT: The Three Sisters and Broken Top mountains are part of the 25 kilometer long Mount Bachelor volcanic chain in Oregon. The most recent eruption was about 8,000 to 10,000 years ago.

PAGE 228: Deer Creek State Park in Utah is well named, for it is an area of outstanding natural beauty that is home to large numbers of mule deer, as well as a variety of other fauna and flora.

PAGE 229: Here the Cerro Paine Grande rises behind two llamas in the Torres del Paine National Park, Chile. Other animals of the region include guanacos, condors, mountain lions, and a wide variety of birds.

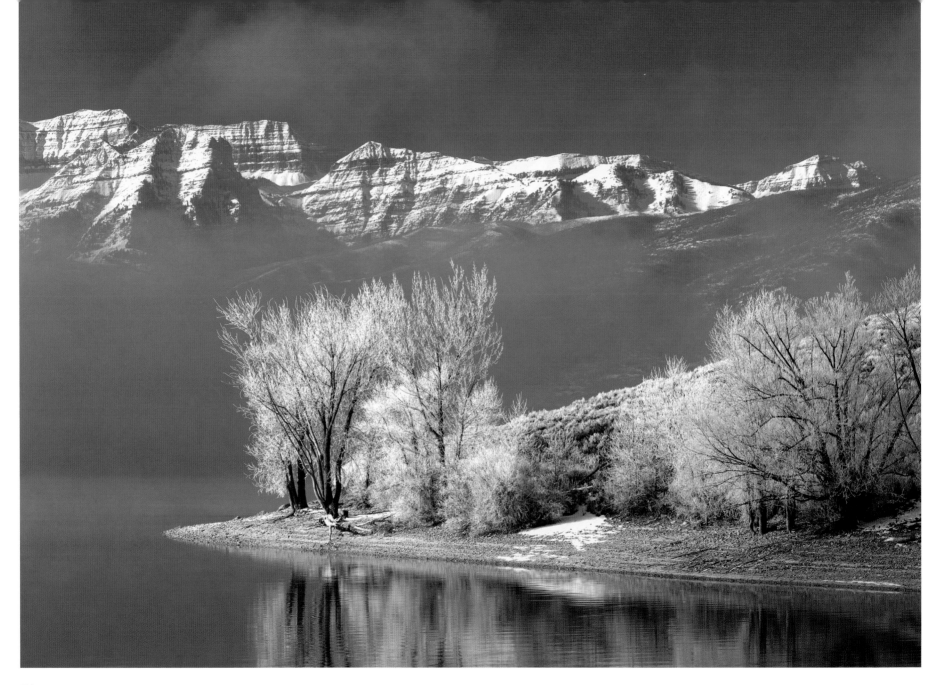

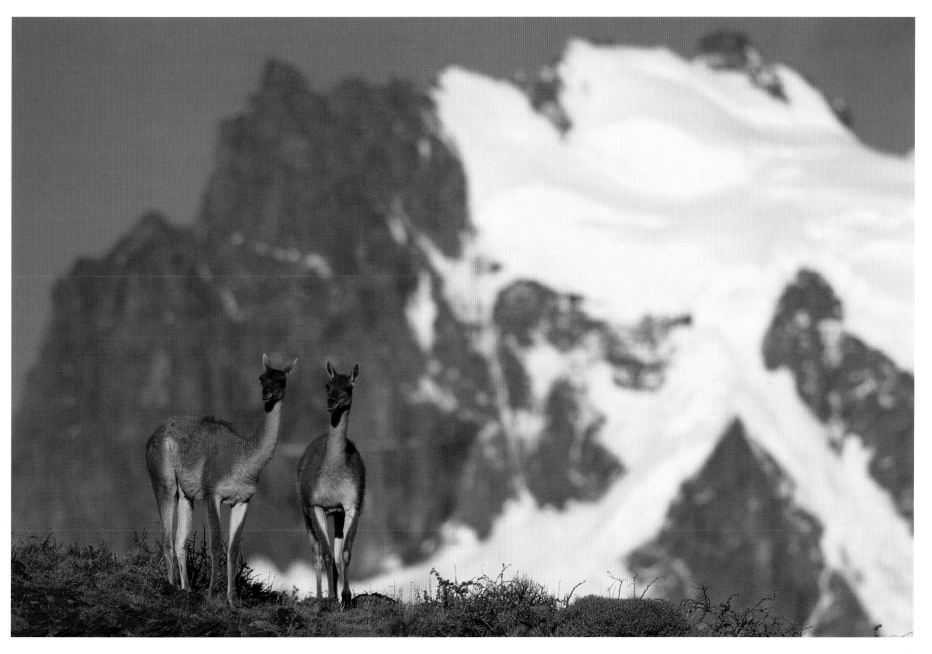

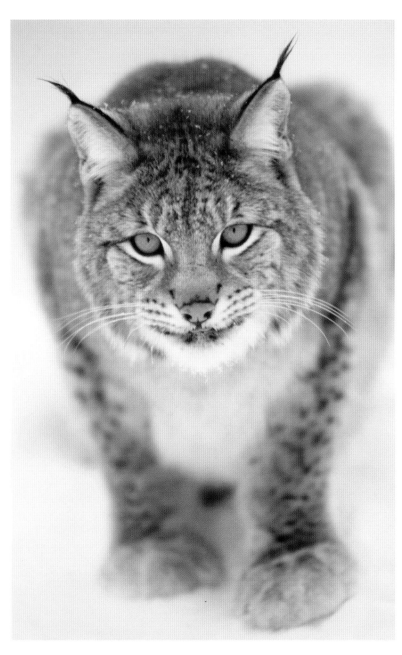

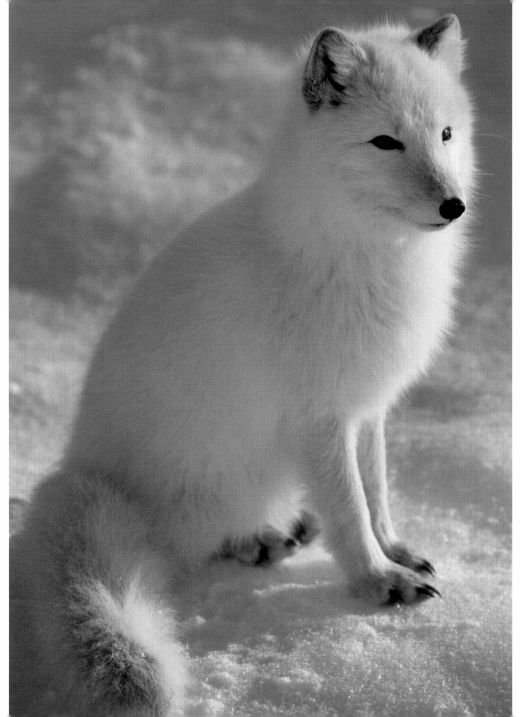

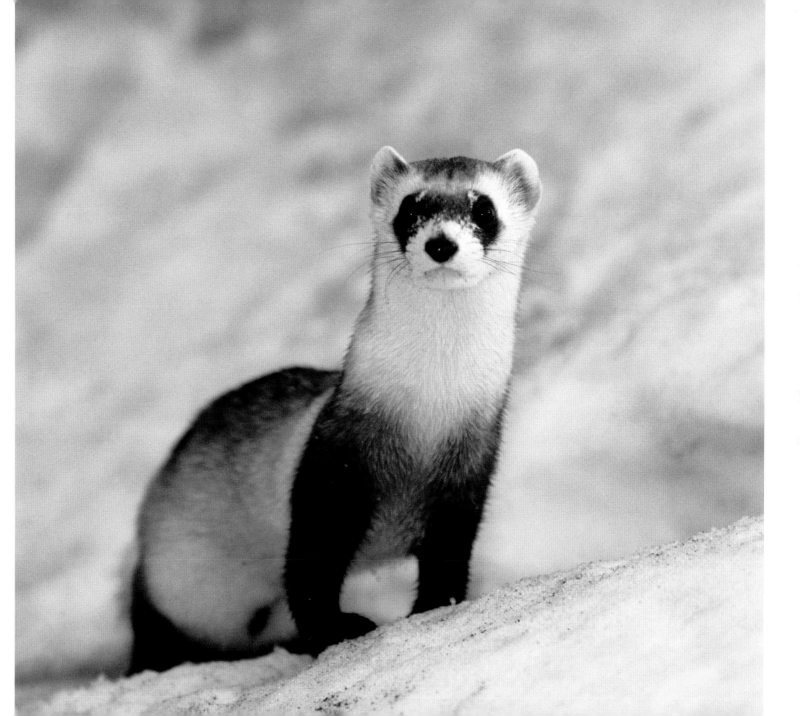

LEFT: An arctic fox on the frozen ice pack of Churchill, Manitoba in its winter—white—coat. As the name implies, arctic foxes range further north than other foxes.

FAR LEFT: Lynx in winter in Finland. There are a number of different Lynx including the Eurasian which ranges in both the north of Europe and also in the high mountains such as the Alps.

RIGHT: The black-footed ferret is one of the most endangered mammals in North America. Their historical range was from the Canadaian borders all the way to the Gulf of Mexico, although the last few were seen in northern Wyoming.

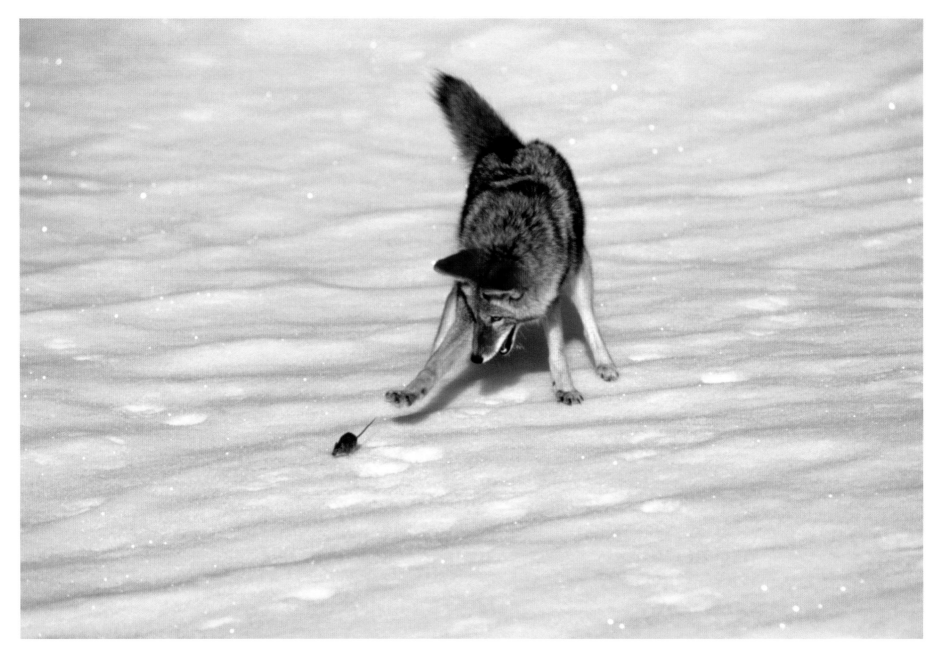

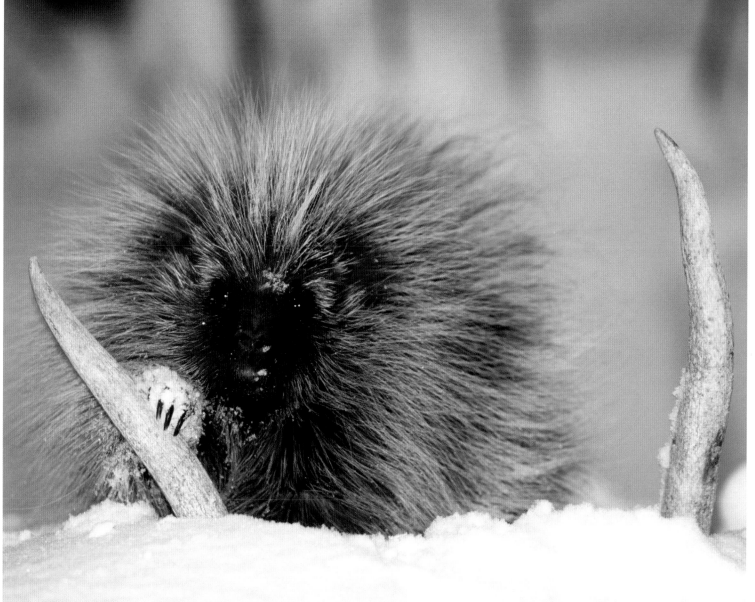

LEFT: A porcupine is framed by a set of antlers in wintery Montana.

FAR LEFT: Coyote chasing a mouse. The coyote can be found all over the United States. Originally native to the prairies, it followed the settlers as they moved across the country and can now be found all over the United States.

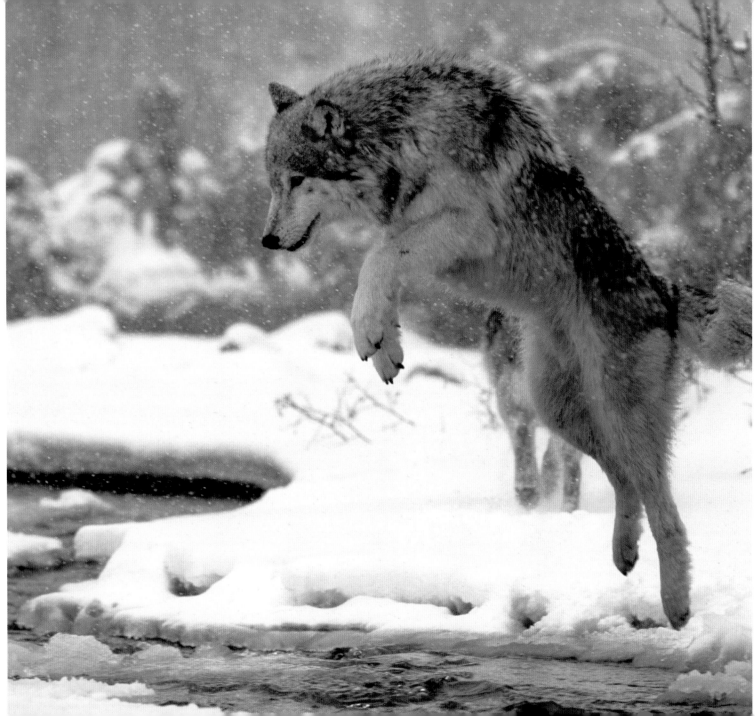

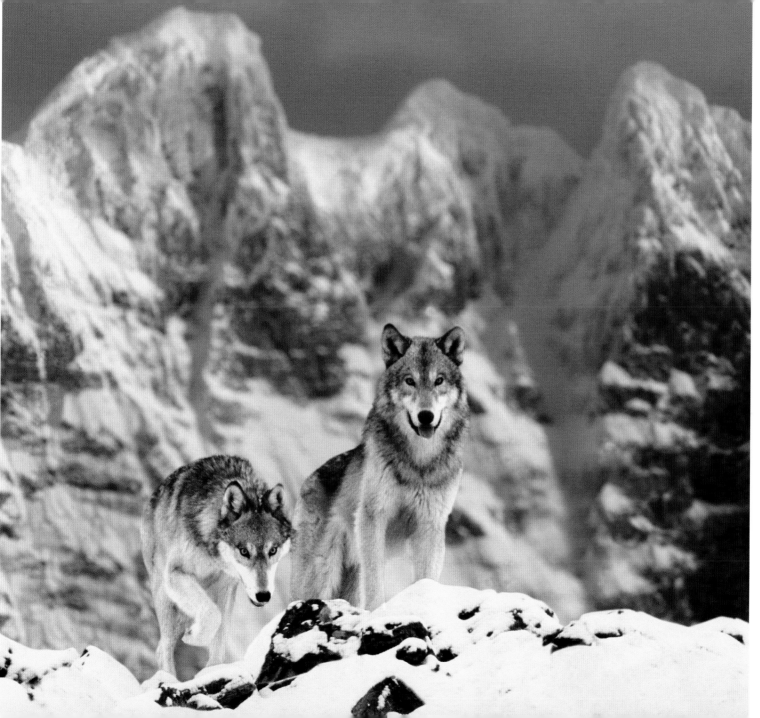

LEFT: Wolves can survive quite happily in mountainous regions.

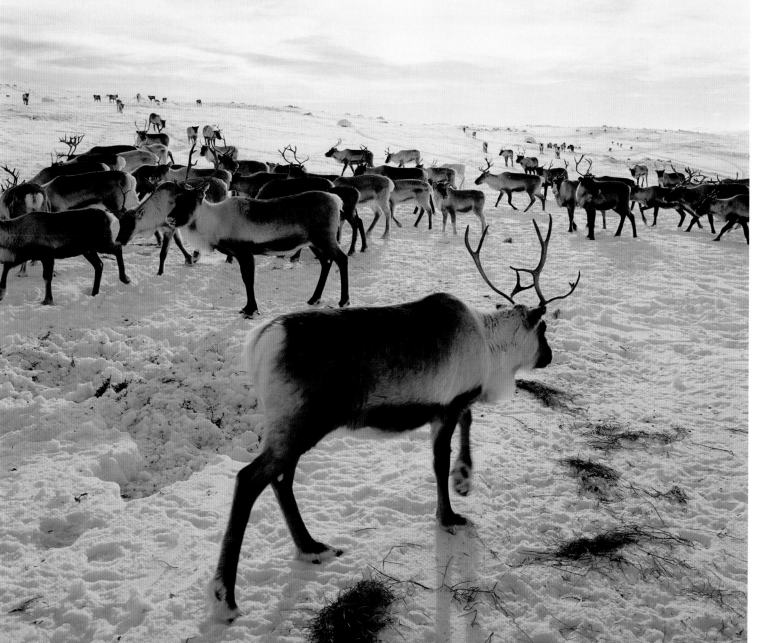

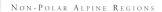
FAR LEFT: The state bird of Alaska, the willow ptarmigan lives in all major treeless areas in Alaska, Russia, Scandinavia, and Finland. They are not to be confused with the white-tailed ptarmigan which is strictly North American.

LEFT: The reindeer is a medium-sized member of the deer family that is found in arctic tundra and mountainous areas in Russia, northern China, Canada, Alaska, and Scandinavia.

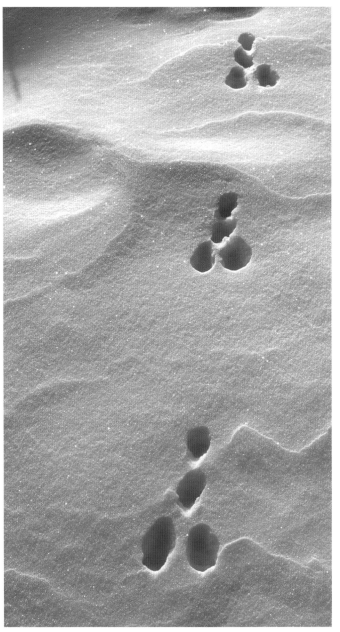

FAR LEFT: Trapped for its pelt that made fine hats, the beaver was almost extirpated from the United States by the end of the nineteenth century. It can be found all over Canada.

LEFT: Snowshoe rabbit tracks mark the pristine snow. This rabbit can be found in the higher regions of the United States.

RIGHT: The snowshoe rabbit is an expert at evading predators like the lynx and the coyote—it can run at up to 27 mph, and jump 10 feet in a single hop.

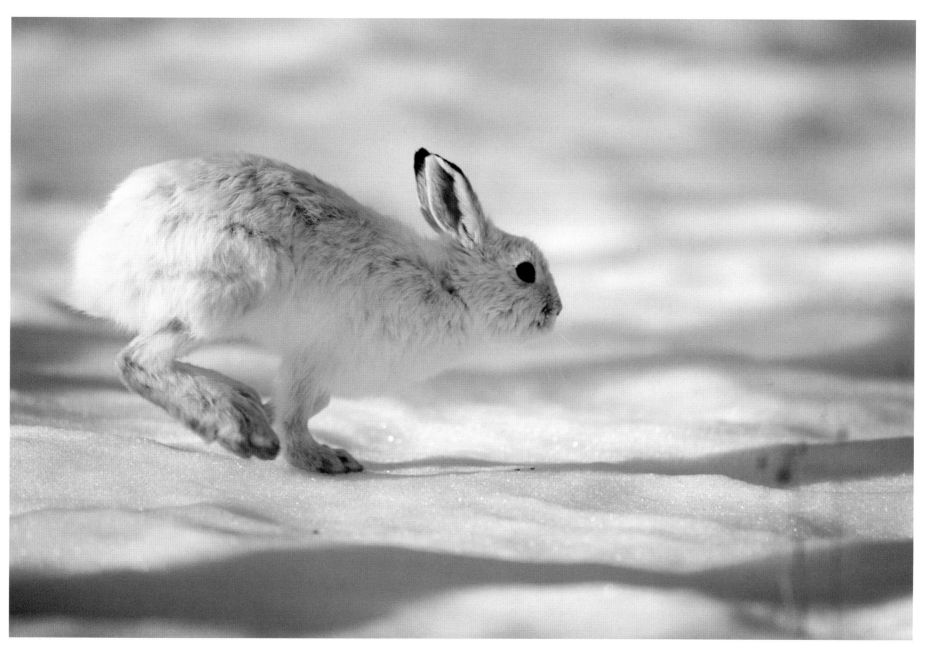

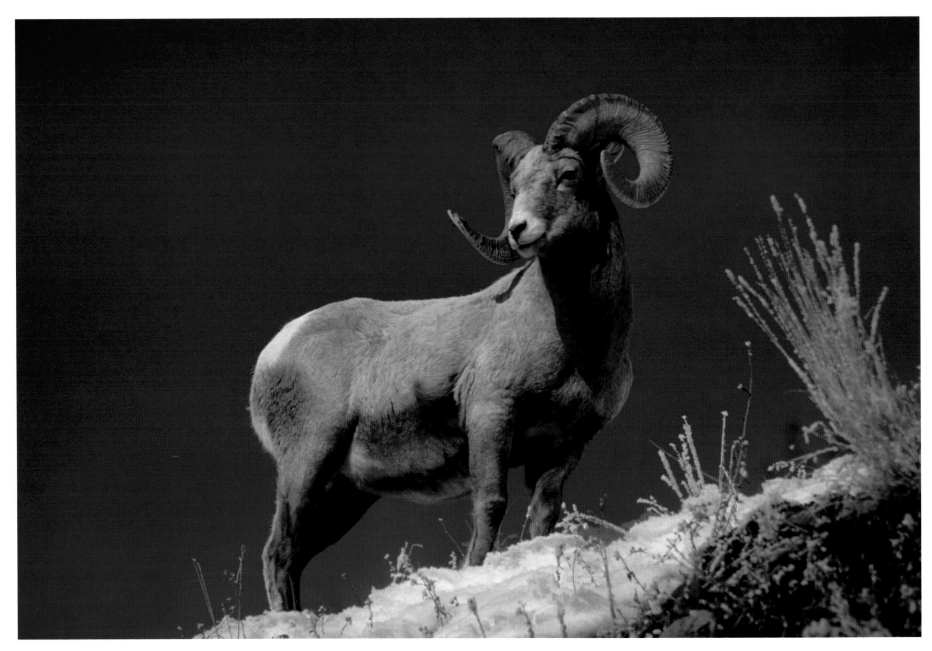

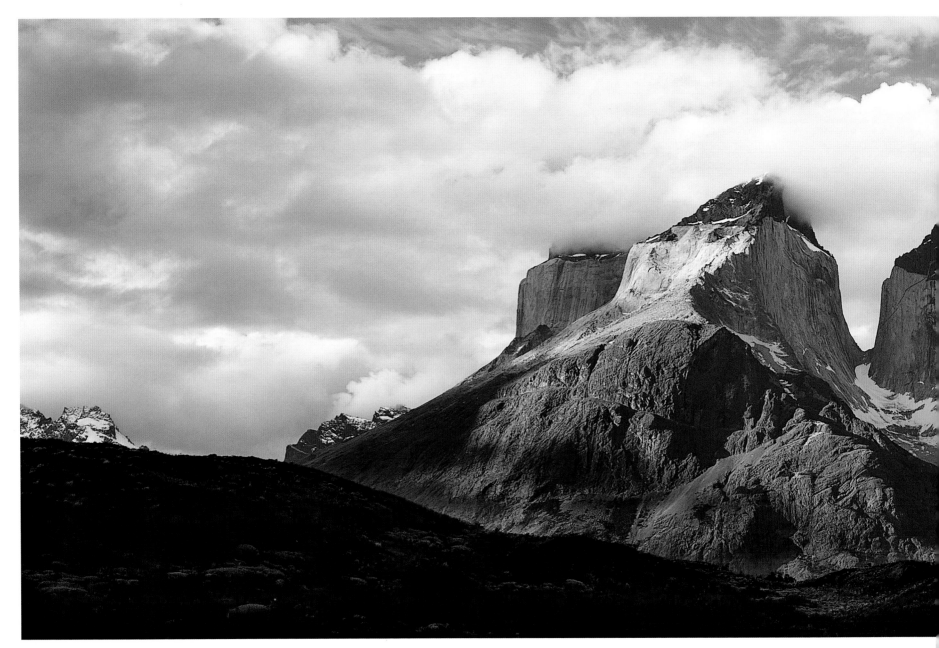

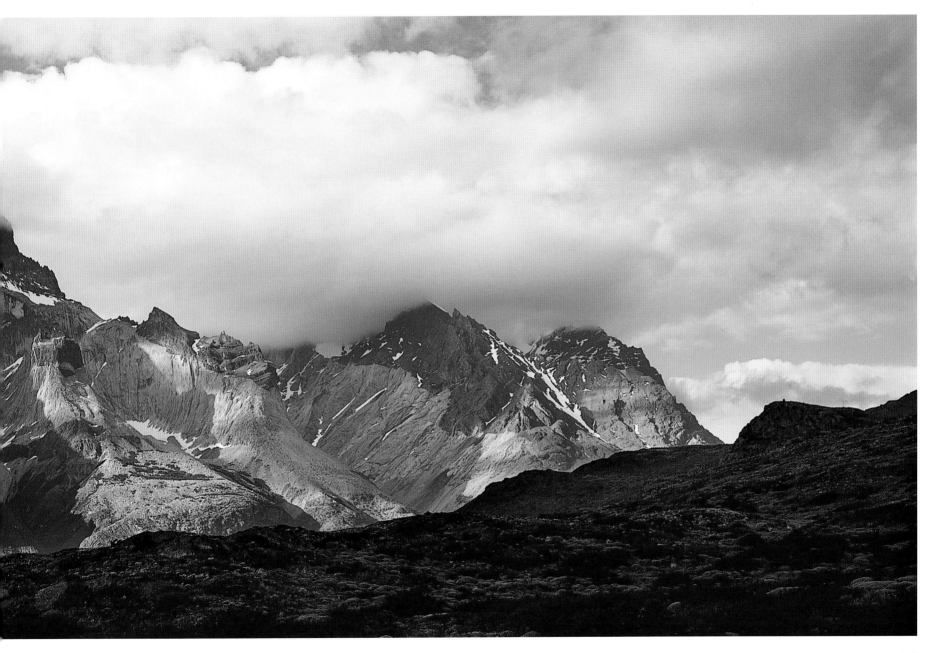

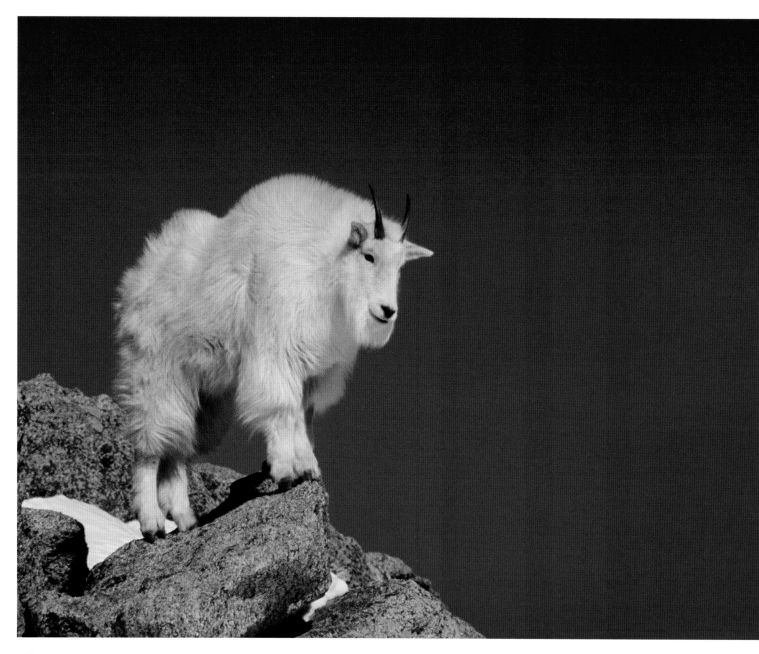

PAGE 240: Although bighorn sheep usually only form small groups of 8 to 10 individuals, sometimes they gather in herds of up to 100 animals. Yellowstone National Park.

PAGE 241: The mountains of the Andes rise above San Pedro de Atacama, an area that has been continuously inhabited by humans for at least 10,000 years. Antofagasta Region, Chile.

PAGES 242–243: The mountains of the Torres Del Paine National Park in Chile are part of the Patagonian Andes. The reserve has an area of around 2,400sq km, making it a popular hiking destination.

LEFT The Rocky Mountain goat, which only lives at high elevations, is more closely related to the antelope than the goat. Mount Evans Wilderness Area, Colorado.

RIGHT: The mountain cottontail—as its name suggests—prefers a mountain habitat to the rest of the cottontails which can be found all over North America.

PAGE 246: This hardy individual has set up camp in the Togwotee Pass in the Bridger-Teton National Forest in Wyoming, which is named after Jim Bridger, one of the famous mountain men of the region.

PAGE 247: There are more than nine million acres of National Forest in Utah—its windy ridges make it particularly popular with paragliders. Wasatch Mountains. Uinta National Forest, Utah.

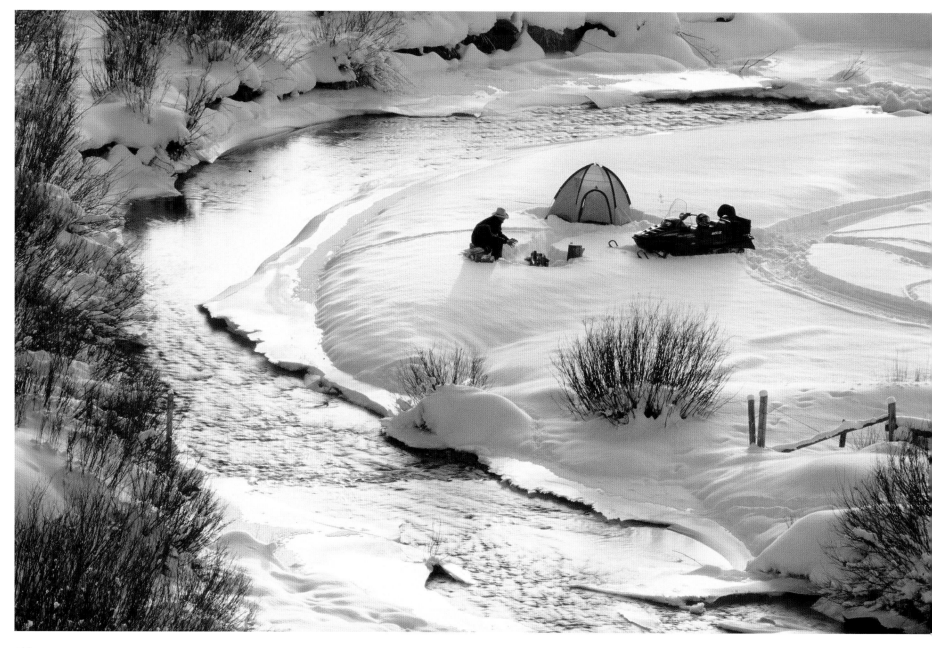

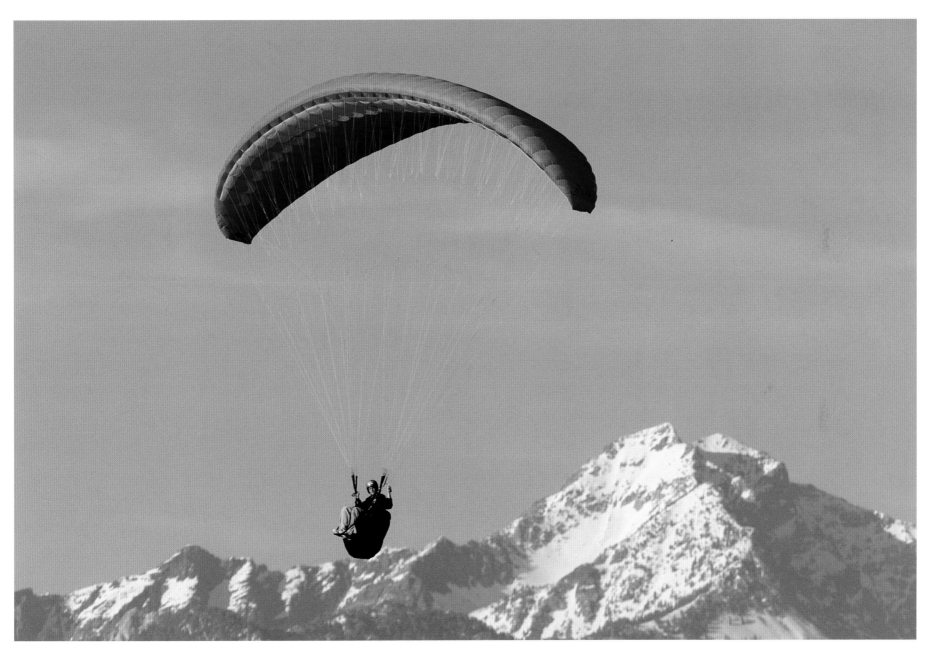

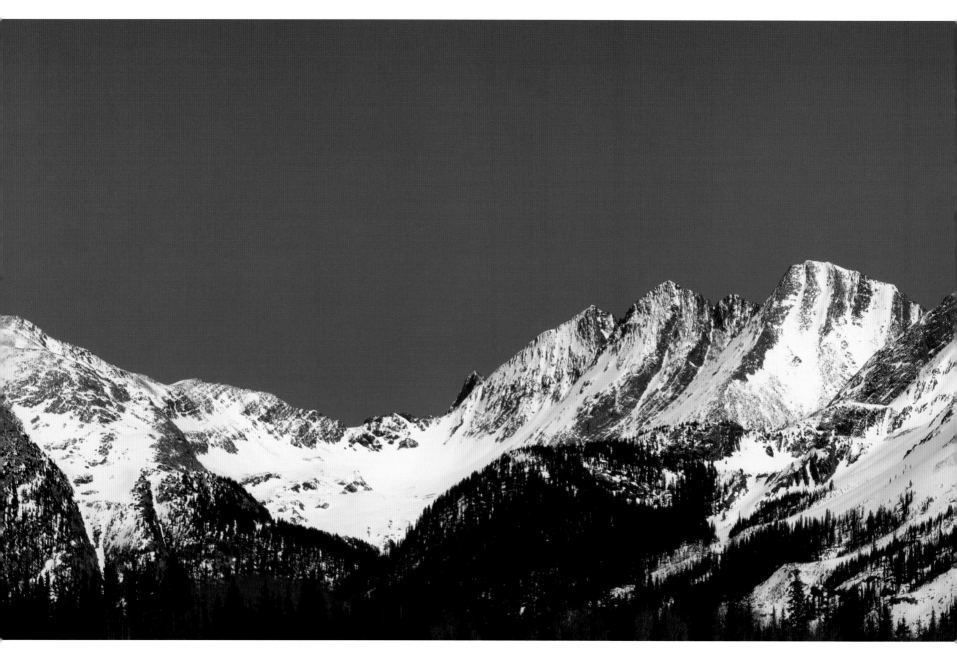

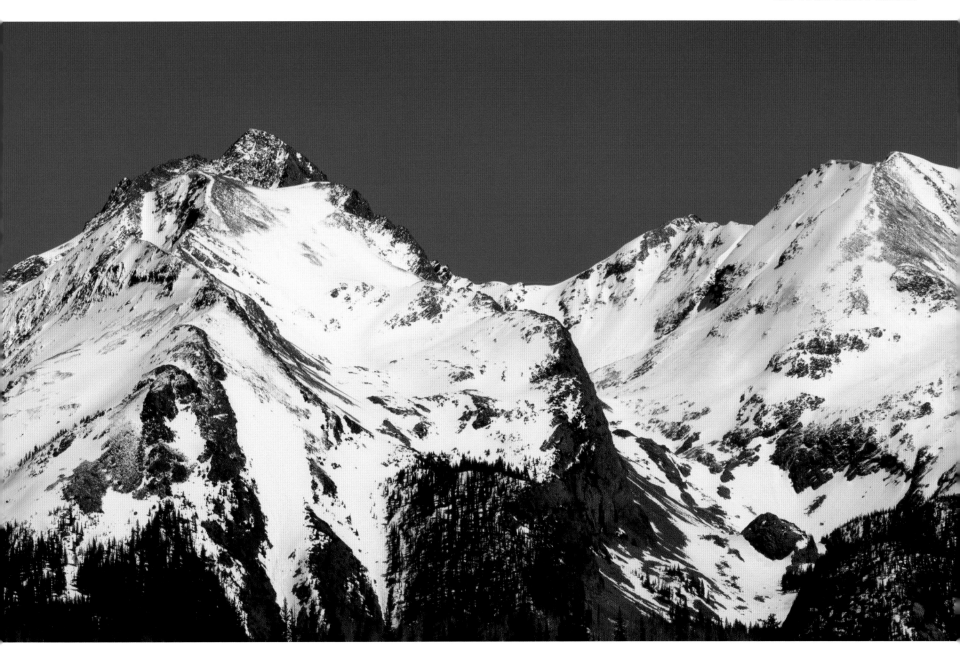

PAGES 248–249: The San Juan Mountains cover more than 12,000 square miles of southwestern Colorado, and hundreds of the peaks are more than 13,000 feet high; many are in excess of 14,000 feet.

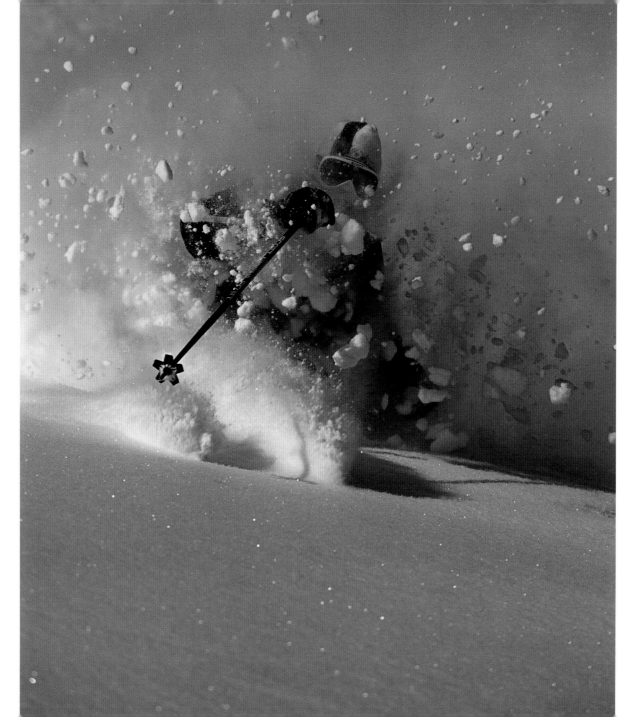

LEFT: Although Alta in Utah only has a population of 370, it has more than 500,000 visitors during the skiing season. It has excellent snow, but snowboarding is not permitted.

RIGHT: The W.M. Keck Observatory is located at an altitude of 4,200 meters (13,800 feet) to take advantage of the clear skies on Mauna Kea, Hawaii, Hawaii.

LEFT: The peaks of the Teton Range are part of the Rocky Mountains. Because there are no foothills, they rise dramatically from the valley floor. Grand Teton National Park, Wyoming.

FAR LEFT: For those who wish to ski on the fresh, untouched slopes of the San Juan Mountains in Colorado, a helicopter provides the best means of access.

PAGES 254–255: The lands of the Grand Teton National Park, Wyoming, were used by native Indian hunter-gather peoples, including the Shoshone, Bannock, Blackfoot, Gros Ventre, and Crow tribes.

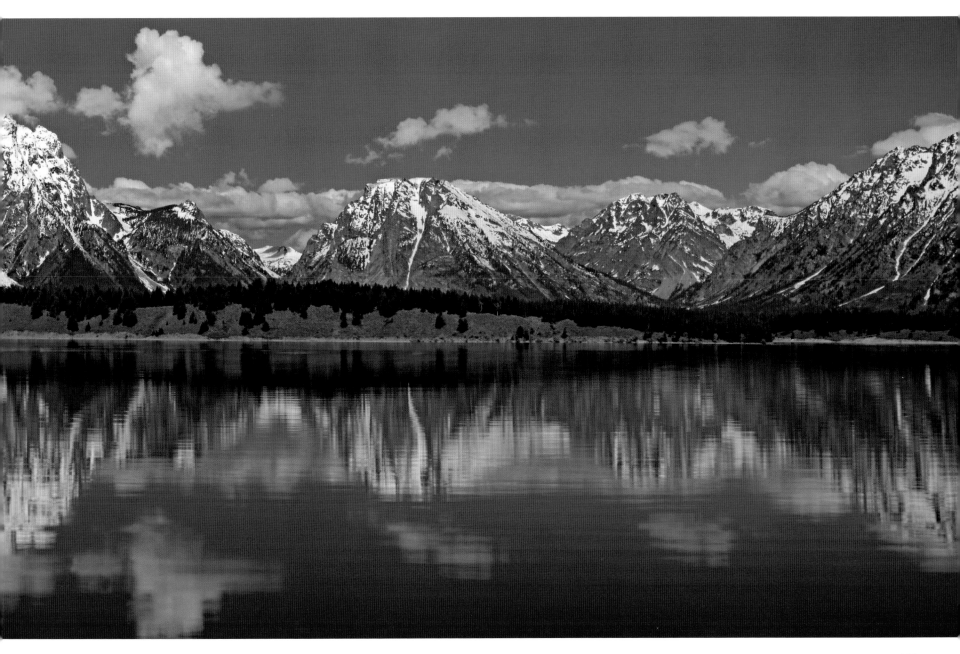